PRIVATISING CULTURE

PRIVATISING CULTURE

Corporate Art Intervention
since the 1980s

◆

CHIN-TAO WU

吴金桃　著

VERSO

London • New York

First published by Verso 2002
© Chin-tao Wu 2002
All rights reserved

1 3 5 7 9 10 8 6 4 2

Verso
UK: 6 Meard Street, London W1F 0EG
USA: 180 Varick Street, New York, NY 10014–4606

Verso is the imprint of New Left Books

ISBN 1–85984–613–0

British Library Cataloguing in Publication Data
A catalogue record for this book is available from the British Library

Library of Congress Cataloging-in-Publication Data
A catalog record for this book is available from the Library of Congress

Typeset by M Rules
Printed by Biddles Ltd, Guildford and King's Lynn

For my brother, Chin-ho,
who did not live to read this,
and my mother,
who is not able to read this:
with love.

給母親陳淑和三哥金河

CONTENTS

	Acknowledgements	ix
	List of illustrations and credits	xiii
	List of tables	xix
1	Introduction	1
2	Public arts funding in America and Britain: preliminaries	16
3	The changing role of government in the arts	47
4	Guardians of the enterprise culture: art trustees	83
5	Embracing the enterprise culture: art institutions since the 1980s	122
6	Corporate art awards	159
7	Showcases of contemporary art within corporate premises	188
8	Corporate art collections	212
9	Conclusion: from conservatism to neo-conservatism	271
	Notes	305
	Bibliography	357
	Index	377

ACKNOWLEDGEMENTS

This book began life as a University College London PhD thesis in the History of Art (*Privatising Culture: Aspects of Corporate Intervention in Contemporary Art and Art Institutions During the Reagan and Thatcher Decade*, 1997). The process of completing this dissertation was a very long one, in the course of which I had many happy moments of intellectual discovery, but also an enduring and profound sense of alienation. Working within a white, predominantly Euro-centric discipline and institutional framework, I felt myself to be a member of a marginalised race, studying a marginalised subject. Nor does the completion of this work necessarily bring with it a full range of compensations. Although the academic study of art history can never, by definition, be isolationist, its internal structure, particularly in Britain, continues to be largely wedded to the status quo, and the question that remains unanswered is why it cannot, and should not, change.

I am nonetheless extremely grateful for all the encouragement and help that the UCL History of Art Department has given me over the years. The staff were exceptionally supportive, giving me time, showing me patience, and allowing me to grow at my own pace. New financial pressure on universities (itself part of the process of privatising culture) is likely to make such kindness and understanding increasingly difficult, if not impossible, in the future. I owe a special debt of gratitude, of course, to my supervisor, Andrew Hemingway, for all the hard work he undertook on my behalf, and

to Tom Gretton for always making himself available to answer my queries and questions and for providing a wide range of help.

For my first visit and field work in the United States in 1990, I would like especially to thank Hong Li-ju and her husband, Hsing Tai-Kang. They not only generously provided food and accommodation, among other things, for my more than two months' stay in Washington, DC, but Li-ju also introduced me to the faculty and fellow postgraduates in the Department of History of Art at the University of Maryland. Their stimulating questions and probing helped me focus my research area in the gestation of my thoughts and ideas. I would also like to extend my gratitude to the entire staff of the Visual Arts Program at the National Endowment for the Arts in Washington, DC, particularly Michael Faubion and Jackie Harmon. They not only generously gave me their precious time, but also helped me with an exceptionally warm and open welcome, just as if I had been a member of their staff.

I would like to thank all those who granted me the opportunity of interviews with them, or who completed questionnaires for me. Without their kindness and co-operation, this study could never have been completed.

In undertaking the survey questionnaires, I was very fortunate in having the expert advice of Martin Roiser of the Department of Psychology at Thames University, Angelia Dale in Social Statistics at the City University, and Stephan Feuchtwang in Anthropology at the London School of Economics and Political Science. I would specially like to thank Stephan Feuchtwang. He not only gave me several sessions of private tuition on survey methodology in general, but he also guided me through my survey project, a kindness all the more appreciable because, when I first asked his help, he hardly knew me at all. I would also like to thank Joan Carlson and her sons Jim and Kevin McAuley, who, between them, took almost all the copies of my questionnaires to the United States to post for me.

I would also like to thank all those friends and individuals who helped me, in one way or another, in the course of the entire project: David Baker, Anna Bara, Sarah Douglas, Tom Griffin, Jay Heywood, Eric Moody, Gerald Vinten, Jill Walters, Marketa Zvelebil, Jennifer Williams at the British American Arts Association (in London), Ruihua Chang, and Teresa Lin (who in particular helped me through the minefield of issues relating to accountancy).

I am also very grateful for Jane Beckett, Carol Duncan, Justin Dyer, Matthew McDermott, Gregory Sholette and Julian Stallabrass, who have read part or the whole of the manuscript and made insightful comments. For help with English in particular, my special thanks are due to Ian Short of Birkbeck College.

I was awarded a Taiwanese Government Scholarship for four years between 1987 and 1991, and am extremely grateful for this long-term support. The Central Research Fund of the University of London provided part of the funds to allow me to undertake my first research trip to the United States in 1990, while the Graduate School at University College London awarded me two travel grants in 1994 and 1995 respectively, to speak at conferences in Germany and America, the latter also including part of a research grant to tidy up the loose ends of my research in New York and Washington, DC. I am also very grateful for a J. Paul Getty post-doctoral fellowship at University of East Anglia in 1998–99, which helped fund research trips to Asia, and enabled me to bring a truly international perspective to this book.

I should like to thank all those friends in Taiwan who not only extended to me their emotional support over the course of the project, but have also generously provided the financial assistance to enable me to complete it: Chun-hua Chang, Shui-ping Chen, Chi-ming Ho, Vassilis Vagios, Pi-hua Wang and Jui-yin Yu, and those who helped me with my domestic life on that side of the world: Ju-chuan Wang, Ju-chin Wang, Huei-yu Chen and Ming-dar Tsai. Without their generosity and friendship, this project would never have seen the light of day. Last of all, I should like to record my sadness that my brother Chin-ho and my mother did not live to see the completion of my project. I thought of them often as I was writing up this book. To my mother in particular, I owe gratitude for her patience with me for being unable to fulfil my filial duty over the many years that I have spent in Britain. She gave me the freedom to pursue my own interests, a freedom that someone of her generation and upbringing would not normally have been inclined to grant. Above all, I am grateful for her resilience, which has given me the strength to bring the present project to completion.

LIST OF ILLUSTRATIONS AND CREDITS

Figure 1 Richard Wentworth, *Toy*, 1983, galvanised and tinned steel, 31 cms × 41 cms × 62.5 cms, Arts Council Collection, Hayward Gallery, London. Courtesy the artist. Photograph Eileen Tweedy. 40

Figure 2 Exhibition at the Tate Gallery, London, 1998, in honour of Janet de Botton's donation. 114

Figure 3 BMW's Z3 displayed at London's South Bank during the *Objects of Desire* exhibition, sponsored by BMW at the Hayward Gallery, 1997–98. 123

Figure 4 Display list of donors to Tate Gallery's Capital Campaign, during refurbishment, 1998–99. 139

Figure 5 Rachel Whiteread, *House*, October 1993–January 1994, Bow Road, London, an Artangel/Beck's commission. Courtesy the artist and Artangel. 147

Figure 6 *House* label designed by Rachel Whiteread for Beck's beer. 148

Figure 7 Façade of Museum of Modern Art, Oxford, with sponsor's banners, 1997. 156

Figure 8 Yasumasa Morimura, *Self-Portrait (Actress)/After Red Marilyn*, 1996. Courtesy the artist and Luhring Augustine, NY. 176

Figure 9 Reproduction of Van Gogh's *Starry Night over the Rhône*, claimed by ABN–AMRO Bank as 'public art', in Taipei, 1998. 184

Figure 10 Sculptural court at the Whitney Museum of American
 Art at Philip Morris, New York (with notice of
 prohibitions in use of space), 1990. 190
Figure 11 Banner proclaiming 'public space' at the corporate
 premises of Sony, New York, 1995. 192
Figure 12 Views of Dean Clough Industrial Park, Halifax, 1999. 196
Figure 13 Publicity for Dean Clough Studio artists, the
 'goodwill' of the property developer on full public
 display, 1999. Photographed with kind permission from
 Dean Clough Ltd. 196
Figure 14 Christian Boltanski, *Lost Workers Archive*, beneath
 Henry Moore Foundation Studio, May 1994 onwards,
 a work commemorating blue-collar workers made
 redundant after the closure of Crossley Mills and not
 re-engaged in Dean Clough. Photographed with kind
 permission from the Henry Moore Foundation. 197
Figure 15 View of photography exhibition, *Washington: Project
 of a City*, by Steve Gottlieb, held at law firm in
 Washington, DC, 1990. 202
Figure 16 Photography exhibition held at law firm Freshfields in
 London, 1992. Courtesy Freshfields. 203
Figure 17 Leaflet advertising the *Drive!* exhibition at the so-called
 BMW Gallery in New York. Courtesy BMW. 206
Figure 18 View of dealing room in an international financial
 institution featuring Annabel Grey's *Hanging Panels
 on a Railway Theme for the Dealing Room*, ink on raw silk,
 acoustic screens, London. Author's photograph, 1992. 228
Figure 19 Jean Dubuffet, *Group of Four Trees*, 1972, fibreglass,
 aluminium and steel, 42′ high, Chase Manhattan
 headquarters, Wall Street, New York. © ADAGP, Paris
 and DACS, London 2001. Author's photograph, 1990. 229
Figure 20 Reception lobby of law firm Fried, Frank, Harris, Shriver
 and Jacobson, Washington, DC, featuring Martin
 Puryear's *In Winter Burrows*, 1985, tinted pine,
 74″ × 127″ × 1¾″. Grateful thanks to Fried, Frank,
 Harris, Shriver and Jacobson for permission to reproduce. 232

Figure 21 Hospitality room of international manufacturing firm,
London, featuring William Tillyer's *English Landscape*,
1986. Author's photograph, 1992. 234

Figure 22 Sculpture display in front of Joseph E. Seagram & Sons,
Park Avenue, New York, 1990. 235

Figure 23 Ludgate Development, London, featuring sculpture by
Steven Cox, 1994. 238

Figure 24 Barry Flanagan, *Hare on Bell*, 1983, bronze, at Equitable,
New York. © the artist, courtesy Waddington Galleries,
London. Author's photograph, 1990. 239

Figure 25 Richard Serra, *Fulcrum*, 1987, off Eldon Street,
Broadgate Development, London. © ARS, NY and
DACS, London 2001. Author's photograph, 1994. 240

Figure 26 Office at law firm Fried, Frank, Harris, Shriver and
Jacobson, Washington, DC, featuring four lithographs
by Joel Shapiro, *Untitled # 6, 7, 10, 11*, 1979–80,
22″ × 30″ each, edition of 30. Grateful thanks to Fried,
Frank, Harris, Shriver and Jacobson for permission to
reproduce. 248

Figure 27 View of staff canteen at international bank, London,
featuring works by William Scott referred to as 'Pots and
Pans' by staff. Author's photograph, 1992. 262

Figure 28 Office at international bank, London, featuring work by
Barbara Hepworth referred to by staff as 'Fried Eggs'.
Author's photograph, 1992. 262

Figure 29 Office at international accountancy firm in Washington,
DC, featuring Leslie Kuter's *Portrait of Two Accountants*,
1998, wool. Author's photograph, 1990. 264

Figure 30 Reception lobby of law firm Fried, Frank, Harris, Shriver
and Jacobson, New York, featuring Donald Judd's
Untitled, 1977, anodised aluminium and galvanised steel,
61″ × 110¾″ × 6″. Grateful thanks to Fried, Frank,
Harris, Shriver and Jacobson for permission to reproduce. 266

Figure 31 Social exclusion from, and free admission to, the
National Portrait Gallery under New Labour, London,
1999. 282

Figure 32 Banners advertising Sainsbury's exhibition at National
 Portrait Gallery, London, 1999–2000. 297
Figure 33 British Telecom's commercial showcase, masquerading as
 the 'Talk' zone, at the Millennium Dome, London, 2000. 302

COLOUR PLATES

Plate 1 Poster for *Absolut Vision: New British Painting in the 1990s*
 exhibition, 1996–97, at Museum of Modern Art, Oxford,
 featuring Glenn Brown's *Searched Hard for You and Your Special
 Ways*, 1995, after the painting *Small Boy in the Pierrot Costume* by
 Jean Honoré Fragonard.
Plate 2 Chris Ofili, *Imported*, 1996, oil paint, glitter, polyester resin,
 map pins and elephant dung on linen with two elephant dung
 supports, 121.9 cms × 91.4 cms, now known as 'Absolut Ofili'.
 Reproduced by kind permission of The Absolut Company.
Plate 3 Van Gogh as salesman for the Dutch ABN–AMRO Bank,
 advertisement at Taipei Airport, 1998.
Plate 4 Old-style décor and art collecting at a London merchant bank,
 1992.
Plate 5 Roy Lichtenstein, *Mural with Blue Brushstroke*, 68′ × 32′, at
 Equitable, New York. © The Estate of Roy Lichtenstein/
 DACS 2001. Author's photograph, 2000.
Plates 6, 7 Gerhard Richter, *Untitled*, *c*. 1985, triptych, oil on canvas,
 atrium at The BOC Group, Windlesham, Surrey. Author's
 photograph, 2000.
Plate 8 Oliver Carr Building, Washington, DC, featuring Lincoln
 Perry's *All in the Golden Afternoon*, 1989, oil on canvas. Author's
 photograph, 1990.
Plate 9 Sol Lewitt, *Wall Drawing # 580 Tilted Forms*, 1988, double
 drawing with colour ink washes superimposed and black grid.
 At Deutsche Bank, London. © ARS, NY and DACS, London
 2001. Photograph: Dennis Gilbert VIEW.
Plate 10 Bridget Riley, *Midsummer*, 1989, oil on linen, 164.5 cms × 159
 cms, commissioned by 3i (Investors in Industry) and used here

for 3i Group's 1989 Annual Report. Reproduced by kind permission of 3i.

Every effort has been made to obtain permission to use copyright material, both illustrative and quoted, in this book. Should there be any omissions in this respect we apologise and will be pleased to make the appropriate acknowledgements in any future edition of the work.

Except where otherwise indicated, all illustrations have been photographed by the author.

LIST OF TABLES

1.1 The top federal personal income tax rate in the United States 5
2.1 Marginal tax rates and the price of giving to arts and culture in
 the United States 24
2.2 Estimated 1988 tax expenditure for art museums in the United
 States 26
2.3 Distribution of age of museums by type 28
2.4 Sources of operating income, Metropolitan Museum of Art,
 New York, 1989 29
3.1 Total corporate contributions, and contributions to the arts,
 1975–86 53
4.1 Gender of Tate trustees by decade of appointment 106
4.2 Schooling of Tate trustees by decade of appointment 107
4.3 University education of Tate trustees by decade of appointment 108
4.4 Occupation of Tate trustees by decade of appointment 109
8.1 Reasons for initiating art collections (US) 217
8.2 Reasons for initiating art collections (UK) 220
8.3 Percentage of corporate art collections from all business sectors
 by decade (US) 226
8.4 Percentage of corporate art collections from all business sectors
 by decade (UK) 227

I

INTRODUCTION

Is this a book written by the Other? Someone with a Chinese name writing about contemporary British and American art and culture is bound to raise a few eyebrows, and I have frequently been questioned about my background, and the qualifications I have to deal with my chosen subject. As an outsider, I would be assumed either to be naïvely ill informed, or to enjoy some sort of privileged perspective on the cultural scene that I was attempting to describe. Neither is true.

When I arrived in Britain in 1987, I was immediately struck by the many entitlements that people here had come to take for granted: free libraries, free admission to museums and galleries, free education and, above all, a National Health Service accessible to all. Having grown up in a country where there was no welfare state, such privileges were alien to me. By the time I learned to appreciate how the British system worked, however, many of the entitlements were disappearing, being diluted or transformed into something else. Even before I finished my postgraduate studies in 1996, I witnessed people being turned away from the University of London Library because they were unwilling or unable to pay the £6 required for a day's membership. The growth of the so-called 'enterprise culture' in Britain is something that I experienced at first hand, and such have been the changes in social attitudes that to talk nowadays of the principle of the fair redistribution of social wealth is to run the risk of being categorised among what the New Labour Prime Minister terms 'the forces of conservatism'.

What is studied here is one particular facet of the enterprise culture that has engulfed both Britain and America since the Reagan and Thatcher governments first set it in train in the early 1980s. As its title indicates, the book sets out to describe and analyse the extent to which contemporary culture, and especially contemporary art, has been subjected to the process of privatisation on both sides of the Atlantic. Never before has the corporate world in America and Britain exercised such sway over high culture, in which business involvement had previously been thought of as inappropriate, if not completely alien. Corporations had, of course, for some time been making contributions to art museums and other cultural organizations. In the 1970s, while continuing in the generally passive role of being solicited for donations, businesses had begun to be active participants in the framing and shaping of the discourse of contemporary culture. But unlike its earlier involvement, uneven in practice and limited in scope, corporate intervention in the last two decades has been ubiquitous and all-embracing.

Since the 1980s, corporate art collections have been set up with increasing frequency on both sides of the Atlantic. Using their economic power, modern corporations, armed with their own curators and art departments, have vigorously emulated the former prerogatives of public art museums and galleries by organizing and touring their own collections at home and abroad. They have also successfully transformed art museums and galleries into their own public-relations vehicles, by taking over the function, and by exploiting the social status, that cultural institutions enjoy in our society. The extent of their ambition can be even more clearly illustrated by the art galleries or branches of public museums that they have established within corporate premises, and the art exhibitions that they have either held there or organised to tour the country, as if art had in fact become part and parcel of their everyday business practices. No less aggressive have been the corporate art awards organised by business, in particular in Britain. By rewarding artistic endeavour, corporations have been seeking to place themselves squarely in the spotlight and to elevate themselves to the level of taste arbiters of contemporary culture. In short, business influence is by now well advanced in every phase of contemporary art – in its production, its dissemination and its reception.

The harnessing of the power of corporate capital into what had hitherto, at least in Britain, been an almost exclusively public domain was the most

intriguing aspect of the new artistic consciousness of the 1980s. This at first sight incongruous social development has a multiplicity of causes, foremost among which was a politically inspired change of policy in public arts funding. And it is here that we may be justified in discerning a direct link with the free market policies and ethos of the Reagan and Thatcher decade. The relation between public policy and business sponsorship in Britain in particular has become so close that in 1991 the director of the Association for Business Sponsorship of the Arts (ABSA), Colin Tweedy, went as far as to suggest that arts sponsorship was one of the cornerstones of Thatcherism.[1]

This process is, of course, one that continues to develop, since New Labour no less than the Democrat administration of 1992–2000 seem still to be as firmly wedded to free market principles as their political opponents. In order to understand the longevity of the phenomenon, it will first be necessary to revisit the political environment in which it was conceived and born.

A DECADE OF PRIVATISATION: THE QUESTION OF PUBLIC AND PRIVATE

The 1980s witnessed a fundamental political transformation in the United States and the United Kingdom. After Margaret Thatcher and Ronald Reagan achieved political office in 1979 and 1981 respectively, they and their allies continued robustly to advocate the doctrine of free enterprise throughout their successive terms of office, pushing the political discourse firmly to the right. The postwar social democratic consensus of welfare state capitalism in Britain, and to a lesser degree in America, which accepted and maintained collective public provision alongside the marketplace, was replaced by an aggressive advocacy of the so-called 'free market economy'. The public policies and ideological commitment of Reagan and Thatcher were radical, not only because they significantly altered the role of the state in the political formations and social landscape in both countries, but also because they departed, in a fundamental way, from their predecessors within their own parties, which had publicly endorsed a steady improvement in social services in the 1960s. 'Limited

government', 'deregulation', 'privatisation' and 'enterprise culture', in its various forms and degrees, were the buzzwords of the day and the ideological staple diet of politics on both sides of the Atlantic.

The thrust of the Reagan–Thatcher public policy to substitute the market for government as the key economic and social institution, and to propagate the marketplace ethos of capitalism during their tenure, ran in parallel with equally cogent political action and social engagement by businesses in both countries.[2] The interrelationship between business and government, two of the three pillars of C. Wright Mills' American 'power elite', is evident.[3] What is less clear is the extent to which the Reagan and Thatcher governments facilitated the rise of business power in both societies, or the way these two governments' policies, especially in the economic domain, were actually formulated and transformed by the business elites who oversaw the corporations. This, after all, would have been no more than a logical extension of the close interaction and intimate relations that the two regimes had with business. To answer the latter question is really beyond the scope of this study, and the discussion that follows will therefore focus on the former. In particular Reagan and Thatcher's policies in the cultural sphere will be explored in terms of the discursive formulation of the question of 'public' and 'private', and within that, the analysis will be confined largely to the issues surrounding 'public' museums, especially art museums and galleries.

It may seem a little dubious in the first place to treat America as a nation of collective public cultural provision comparable to a country like Britain, where the whole network of national/local-authority museums and galleries is directly funded by the public purse. It is true that the origin of art museums in America was rooted in the private wealth of old families whose descendants still now sit on their boards of trustees and govern their affairs. The notion that American art museums are therefore 'private' institutions is, however, problematic. Despite the magnitude of the private philanthropic tradition, the fact is that if this money had not been given away, most of it would have been taken away in tax. A brief review of the historical development of the top federal personal income tax rate in the United States (for which the wealthy art donors would be eligible) will clearly demonstrate this point (see Table 1.1). This top rate jumped from 15 to 67% at the time of the First World War, and fell back to 25% for a few

Table 1.1
The top federal personal income tax rate in the United States

Years	Top rates (%)	
1913–15	7	
1916	15	
1917	67	
1918	77	
1919–21	73	
1922–23	58	
1925–31	25	
1932–35	63	
1936–39	79	
1941	81	
1942–43	88	
1944–45	94	
1946–51	91	
1952–53	92	
1954–63	91	
1964	77	
1965–81	70	
1982–86	50	
1987	38	
1988	33	

Source: Tax Foundation, *Facts and Figures on Government Finance.*

years in the 1920s, before rising to around 90% during and after the Second World War. To the extent that the majority of the money concerned is thus tax foregone, it could justifiably be considered as an indirect form of public subsidy. After all, it is each taxpayer that has to 'chip in' ultimately to endorse the private decisions made by the wealthy patrons, either individuals or corporations.

While in the United States the concept of tax expenditure – revenues lost through various arts-related tax incentives or exemptions – has been debated for some time, in the trans-Atlantic conversion the Thatcher government never openly discussed the nature of this private philanthropy and the whole range of implications this would have had if carried out in

full in Britain, not least because of its manifest social unfairness.[4] In their efforts to produce a political and social climate amenable to the enterprise culture, Thatcher and her allies hailed the American model as the only lifeboat on the horizon. Consequently, other ways of looking at the so-called 'American' tradition of 'private support' were deliberately ignored. This is quite clear from government publications and reports in the media, from the speeches of arts ministers, down to the experience of many arts development officers, whose organisations had suffered from the 'financial squeeze' of successive Tory governments.

Like most of the privatisations under the Thatcher regime, the promotion of privatisation itself depended in part on government intervention and subsidies, albeit in contradiction with free market ideology. The privatisation of culture was no exception. Despite the fact that the Conservative party had liberalised the tax regime for private donors (both individuals and corporations) much further and faster than the model they set out to emulate, the government established a Business Sponsorship Incentive Scheme (BSIS) in 1984 to hand out cash inducements for business sponsors. The detail of the scheme will be discussed in Chapter 3, and it is enough to state here that the most insidious and threatening aspect of the whole Thatcher project has been not only the blurring of the boundaries between public and private, and the reframing of the discourse of the debate, but the fact that the Tory government effectively used public money to enhance the prerogatives of private capital.

THE CORPORATION AND THE CORPORATE ELITE

A central premise of this study is that contemporary art, along with other cultural products, functions as a currency of both material and symbolic value for corporations, and in a different way for their senior executives, in Western capitalist democracies of the late twentieth century. Although most of the empirical data in this study take the company as the unit of analysis, corporations are not just abstract concepts, but commercial institutions run by men (and a few women) with their distinctive social traits and aspirations. On the basis of this research, coupled with other findings, it is evident that the initiatives and leadership of the chief executive/chairman, or in the case

These high-powered grey-suited men, to paraphrase DiMaggio's description of cultural capitalists, are the 'cultural managerial capitalists'.[9] They are not traditional capitalists in the sense that the majority of them do not make their wealth, or have it bequeathed to them, from industrial enterprises like those of the nineteenth century did; instead these chairmen/chief executives are professional managers who emerge through the so-called 'managerial revolution'.[10] Their power within the corporation is achieved through their corporate position rather than family lineage. But they are capitalists nevertheless, in two senses. At the top of the corporate ladder, they are the managers of large capital, and thus in turn often have substantial vested interests in the company's profits such as 'stock option' plans and year-end bonuses. Secondly, their managerial interests are not necessarily distinguishable from ownership interests; profit maximisation is still the primary concern of these managers, according to various research findings.[11]

As family capitalism declined in the twentieth century, so did the archetype of the nineteenth-century magnate art patron, that cultural capitalist so capably analysed in DiMaggio's essay. The cadre of new cultural managerial capitalists referred to in this study is more often than not the byproduct of an incomplete transformation of family capitalism into institutional capitalism and their uneasy coexistence in the business community today.[12] People such as David Rockefeller are representative of the transitional phase in this transformation. His significant personal wealth notwithstanding, it was as chairman of the Chase Manhattan Bank that he initiated a corporate art collection in the United States during the sixties.[13]

The majority of the chairmen/chief executives I am referring to do not enjoy the family inheritance that Rockefeller did. But they are nevertheless individuals who possess, and whose families possessed, substantial volumes of different forms of capital in the terms of Bourdieu's analysis. Despite the relative availability of universal higher education since the Second World War in Britain and the United States, and despite a number of 'up-from-nowhere' achievers, the world of top corporate management continues to be dominated by an economically privileged, and thereby socially and educationally prominent, class in both countries.[14] These executives, more often than not, come from an upper-class background and

case of businesses is oblique. There are different levels and forms of domination. The economic strength of a company in the marketplace is a form of domination over other competitors, but companies (in particular the multinationals) are also dominant in our consumer society, in the sense that they exert a profound influence over our living space, the political process, and our individual choices.

It is in maintaining this influence that the accumulation of corporate cultural capital makes economic sense. The material and symbolic exchange in the case of corporate art collections is an obvious and direct one, but in most instances what companies acquire from their arts participation is quantitatively less tangible. Alert to their symbolic standing in people's (consumers') minds, companies utilise the arts, replete with their social implications, as another form of advertising or public-relations strategy, or, to adopt the jargon of corporate culture, to go in for 'niche marketing': a way of striving to gain an *entrée* into a more sophisticated social group through identifying with their specific tastes. It is in this locus of vested interests that the pursuit of cultural capital as a means to economic ends, or the conversion of cultural into economic capital, assumes its most transparent, and sometimes politically pernicious, form. The Philip Morris Companies, for instance, after some thirty years of cultivating and accumulating cultural capital by ceaselessly distributing their effortless gains, was able to cash in by calling on eminent arts institutions to 'lobby' on its behalf against anti-smoking legislation in 1994 in New York, a matter that will be dealt with in more detail in Chapter 5.

THE MEDICI OF THE ENTERPRISE CULTURE

If the application of the concept of cultural capital in corporate analysis is in need of further research and refinement, it is less so in the case of top executives. On this individual level, Bourdieu's concept of cultural capital provides a useful analytical tool, particularly in conjunction with Max Weber's notion of the status group, and contemporary writings by the American sociologist Paul DiMaggio and other scholars who have explored the subject of corporate elites in relation to the political economy of capitalism.[8]

competence in the way Bourdieu argues, this analysis will be more concerned with cultural capital in the second sense, namely the social status and value that accrue to a company engaged in cultural practices. Yet, unlike the bourgeois/petit bourgeois in Bourdieu's analysis, the commercial enterprises in this study actually own the means to materially appropriate the works of art, as evidenced by their enormous art collections. The term cultural capital as I use it thus refers to this form of ownership, as well as to the material appropriation of symbolic objects.

But there is an obvious limit in applying a Bourdieuian conceptual apparatus to the study undertaken here. Although the material interests that companies and individual members of society own or control, and the material conditions under which they have to operate, may be similar, the concept of class structure and formation of which Bourdieu speaks, and which is fundamental to his reading, is not readily applicable to an understanding of the corporate domain. The dichotomised schema of the dominant and the dominated, and their associated cultural practices and social distinction, has limited use here in the analysis of companies.

This may have more to do with the state of social sciences research than with the impossibility of pursuing a similar line of inquiry. As companies had never entered into the cultural sphere as social agents in such a collectively dominant way as they did in the 1980s, they have yet to be seen as an object of inquiry in terms of their economic positions, social relations and cultural practices, except for a few case studies in which attempts have been made to explore exceptionally notorious instances.[7] Apparently when social scientists address the issue of market capacities of companies, and/or their domination, they limit their comments to the economic activities and positioning of companies. Interestingly enough, it is in journalistic writing that a possible interpretation of companies' social advancement in their arts endeavours is often perceived and articulated.

In contrast to the individual level, where the relationship between economic wealth and cultural capital is freely interchangeable, and where the accumulation of cultural capital usually serves specifically to reproduce and consolidate the position of the dominant class, the purpose of business's efforts to secure cultural capital is not as straightforward. One cannot simply speak of the domination of companies in the same way as one can of a ruling class. In other words, what is being dominated in the

of professional firms the senior partner(s), is the single most important deter-
minant in any form of corporate arts intervention.[5] These top executives, 'an
elite within an elite', in particular those overseeing large corporations, are
often reported in the media as having great or even 'mad' passions for art.
Their close involvement in corporate arts ventures cannot be conceptualised
as purely incidental, but rather has to be understood as a locus of social dis-
tinction to which their elite status and class aspirations are anchored.
Corporate intervention cannot accordingly be fully appraised without
addressing both these interrelated elements.

The theory of 'cultural capital' developed by the French sociologist Pierre
Bourdieu is conceptually useful for understanding the system of taste and
value, of which contemporary art is part, within the general structure of
political, economic and social formations. Bourdieu's main interest in the arts
is as a form of hegemonic ideology, in which the transmission of the arts from
generation to generation serves to preserve and reproduce the dominant
position of a dominant class. Cultural capital, his widely influential concept,
thus serves as an 'instrument of domination'.[6]

Additionally, Bourdieu constructed rigorous arguments about the social
relations between economic capital and cultural capital, which can be
applied to both individuals and economic entities such as companies.
While individuals can demonstrate cultural capital without actually dis-
playing much financial capital, however, the opportunities for businesses to
do so can only be realised as a function of their economic power. Thus, the
venturing into the cultural arena by all the companies in this study has
been possible only because of a substantial accumulation of economic
capital.

What Bourdieu means by cultural capital has to be modified to some
extent, and specifically delineated here in the analysis of corporate 'taste'.
This is partly because when he speaks of cultural capital, he sometimes
means the knowledge of and familiarity with various artistic styles and
products, while at other times he refers to the prestige and social value that
are often conferred on those who have shown such competence. Nor are
the ways in which he uses the term throughout his works always consis-
tent; sometimes it is interchangeable with other terms such as 'symbolic
capital' or 'social capital'. As it is extremely difficult to conceptualise how
a commercial company as an entity can master and demonstrate artistic

have been educated in public schools and the universities of Oxford and
Cambridge in Britain, or their counterparts in America, leading prepara-
tory schools and Ivy League universities. They share with each other the
directorships of various corporations; they are not only active in business
associations and exclusive social clubs, but also the trustees of charitable
and cultural institutions throughout the country.[15] In other words, like ear-
lier entrepreneurs, these corporate elites strive to maintain and consolidate
their dominant position and status within corporate and social life through
an intricate web of economic/social networks and relationships. Engaging
the companies they oversee in the arts and in cultural activities is part and
parcel of this strategy.

This raises the whole question of social status and the values that artis-
tic/cultural products signify in advanced capitalist societies. Art has long
been patronised by those with power and status in society, and artistic prod-
ucts have thus always functioned as a status symbol as well as objects with
market value. To quote Paul DiMaggio: 'they [cultural goods] are con-
sumed for what they say about their consumers to themselves and to others,
as inputs into the production of social relations and identities'.[16] Although
'status distinction', according to Max Weber, is not always linked to 'class
distinction', they are evidently identical in this instance.[17] This is particularly
true in the sense that these corporate elites, through the mediation of the
popular press, intentionally or unintentionally, have cultivated the image of
being art patrons – of being modern-day Medici. They visit galleries, tour
artists' studios and buy at the main auction houses, and all this on top of
their already extremely demanding schedules. They do so as if it is a specific
style of life in full public view, and above the shabby cut-and-thrust of the
business world.

This phenomenon, of business elites using their corporate location as an
extension of their personal interest, is not, of course, mere speculation. An
empirical study of the corporate giving economy of Minneapolis/St Paul
conducted by Joseph Galaskiewicz argues that it serves not only to improve
the company's marketplace position, but also to create and maintain busi-
ness people's position within their elite circles.[18] The universality of the
situation has prompted Americans to coin a term for it: they call it 'incor-
porated pocketbook'. Within the hierarchical power structure of a
corporation, this is, however, taken as a given. It is not to be challenged,

certainly not in public, if the chairman spends a couple of million pounds to refurbish his suite in accordance with his taste and style, as happened in the case of a particular American bank in London which has to remain anonymous. It is only, and very infrequently, to be challenged in court in such celebrated cases as that of Armand Hammer's art scandals in America. In 1989 Armand Hammer, the flamboyant former chairman of Occidental Petroleum in Los Angeles, was accused by the company shareholders of having misappropriated company funds to build an art museum on company property in order to house his personal art collection. Although the legal imbroglio was settled before the case came to trial, this lawsuit is a rare illustration of top executives being investigated in connection with their arts projects, and the true nature of their involvement receiving public exposure in the national media.[19] Is the final product, the Armand Hammer Museum of Art and Cultural Center, a vanity museum designed to boost a rich man's ego? Or is it a monument testifying to the extent to which personal philanthropy and financial advantage are intertwined at the very heart of the American business ethos, and to the fact that corporate position and social advancement are, for the corporate elite, one and the same thing?

It was in order to attempt to find answers to these sorts of questions – and a whole host of allied ones besides – that I was first led to start investigating the wider phenomenon of the privatisation of art and culture in Britain as well as in America. When I started the research for it in the late 1980s, the subject was almost unheard of within the discipline of art history. Although it had been the object of much media reporting and some academic research among the social scientists, it did not, and still does not, seem to be an 'appropriate' subject for an art historian. The material available was scarce and had only very rarely been subjected to any substantial intellectual debate. In particular the collection of data by certain arts agencies and researchers had been undertaken with either an explicit or an implicit political agenda in mind. For example, the data on corporate arts sponsorship collected by the ABSA in Britain, or by its American counterpart, the Business Committee for the Arts, have never undergone any rigorous empirical scrutiny, in particular the figures for the sixties or

seventies, when the subject of arts sponsorship was still in its infancy. Moreover, these were, and still are, the only bodies that have a vested interest in researching into this area, and the only ones that provide the sort of 'authentic' data which circulate in the popular press. The dilemma, then, is that using such prepackaged, and very often incomplete, information presupposes acknowledging its validity. It is not my aim to adopt and give credence to a discourse laid down and developed by these bodies. To do so would inevitably be to endorse the legitimacy of the material and the institutions that produced it.

As a result of the dearth of primary sources, I was obliged to adopt an empirical approach, in both quantitative and qualitative terms. I conducted two questionnaire surveys, one on corporate art collections (289 American and 110 British companies) and the other on corporate sponsorship (303 American and 506 British companies). Their aim was to allow me to draw up a large statistical data set with which to investigate the scale and patterns of corporate art(s) intervention. In addition, in order to remedy those aspects of the study that appeared to defy simple quantification, I conducted detailed and searching interviews with some 150 individuals involved in corporate art enterprises, including senior managers, corporate curators, art consultants, tax inspectors, accountants, city planning specialists, museum professionals and staff from the public arts sector in both countries. I also visited corporate arts collections, exhibitions and galleries in New York and Washington, DC, and virtually all of the corporate art collections in London and the South-East of the UK, except in a few cases where access was denied. In rewriting the PhD thesis as a book, constraints on space left me no choice but to omit most of the statistical methodology and data, the list of persons interviewed (some of whom wished in any case to remain anonymous), of venues and exhibitions visited, as well as some four-fifths of the accompanying notes. For reasons of confidentiality, it has not always been possible to provide the names of certain companies or individuals. The vast majority of this information is, however, in the original thesis, and this is deposited in the University of London Library, where it is available for consultation.

The problem that remains is that the significance of corporate art(s) intervention, and its place in the history of contemporary culture, derive to a large extent from the economic power of the corporations involved, and this

unfortunately cannot easily be measured. To give a comprehensive picture of the actual sums of corporate money involved, and of the extent to which it has affected the art market and the livelihood of the artists concerned, is extremely problematic. In contrast to their often insatiable desire for publicity, corporations, or their spokespersons, tend to become defensively reticent or secretive when it is a question of releasing actual figures. The questions on arts expenditure in my surveys were not infrequently met with responses such as 'confidential'. Accordingly this study cannot provide the sort of easily quotable statistics that most comparative studies on arts and culture traditionally contain.

This book can be roughly divided into three sections. The first part, Chapters 2 and 3, will provide some account of public art funding in Britain and America before the 1980s and examine the changes brought about by the Reagan and Thatcher governments. The second section, Chapters 4 and 5, will explore the often delicate interface between art museums and corporations since the 1980s. It analyses, first, how high-profile corporate business people came to serve on the boards of art museums, examining in particular the trustee boards of the Whitney Museum of American Art in the United States, and the Tate Gallery in Britain. It then investigates the effects that corporate art sponsorship has had on art institutions, and the extent to which these can be seen as having been appropriated by business as public relations agencies.

The next three chapters discuss at length the various ways in which corporations have attempted to integrate themselves into the support-system infrastructure of the art world itself: by showcasing contemporary art within their corporate premises, by organising and sponsoring contemporary art awards, and, last but not least, by building up, on both sides of the Atlantic, extensive corporate art collections. The conclusion investigates some of the developments in the recent past under the Clinton administration in the US and New Labour in the UK, developments that bear witness to the legacy of the privatising of culture initiated during the Reagan and Thatcher years. While this is a study primarily focused on British and American culture, in one or two instances I have taken the liberty of exploring the sort of corporate art intervention that multinationals in both countries have made in Asia. It is, I think, an inevitable consequence of the corporate power of multinational capital that, as the third millennium

unfolds, multinationals in the West should use art as a weapon to further their interests overseas as economic colonisers. This is one small contribution that the imagined Other might be able to make to what, despite the progressive globalisation of the art world, remains a predominantly white and Euro-centric debate.

2

PUBLIC ARTS FUNDING IN AMERICA AND BRITAIN: PRELIMINARIES

Central to this inquiry are the relative roles of the state and of business in relation to the arts in advanced capitalist democracies. The significant inroads that the business sector has made into the cultural arena since the 1980s cannot simply be explained away by invoking the amorphous motive of 'enlightened self-interest'. Instead business intervention in the arts has to be seen and understood in terms of political power within the modern state. This can be created and wielded in a whole range of different ways, and cultural influence is one of the means readily available to achieve this end. By virtue of their private wealth, corporations, like their chief executives at an individual level, command considerable power and influence in society. Their interest in cultural activities, particularly when these are publicly endorsed by government, has to be seen as part of an overall strategy to bring together private economic power and public cultural authority. This is done with the prospect that the cultural capital thus created can, in due course and at the appropriate juncture, be transformed into political power, either openly or otherwise, to serve business's own specific economic interests.

How do the cultural power and authority of the state operate, and through what mechanisms do state power and private capital interact and traffic back and forth? The prime instrument of state power in the field of art and culture are public arts agencies, such as the Arts Council of Great Britain (ACGB) and the National Endowment for the Arts (NEA) in America.[1] On the whole, these agencies are what one might call 'the cultural

gatekeepers' of the state. This does not mean that they are cultural police-men for a monolithic 'official culture', a term very often loaded with derogatory connotations. Nor is this particular function of the agencies as monopolistic as that of the state in its use of regulatory power. Yet, by virtue of their being part of state bureaucracy, they are part of the circuit of a political system, from whose framework they draw their authority and power. They are therefore the state's cultural gatekeepers in the sense that they are the agents of legitimising processes within, and for, the political system.

This is the case even though these agencies have never come high on the political agenda, and thus arguably their power may not be as politically compelling and directly forceful as that of other branches of the state appa-ratus such as, for example, the courts. For all that, their power and authority are in fact real in at least two senses. As the single national institution exclu-sively dedicated to the living arts/culture of the country, each is the most audible and authoritative voice in the land. In this regard, their authority is unquestioned and widely acknowledged. This is why, as is often argued in the arts media, public arts agencies such as the NEA carry with them an 'official seal of approval', a form of political power that is deemed to be far more effective than their limited financial allocations.[2]

Less easy to quantify is the political influence that these agencies may pos-sess by virtue of their situational advantage of being located within a political framework. Their influence is a function of the social composition of the political organisations themselves; that is to say, their members are conveni-ently located and 'networked' in such a way as to have relatively easier access to the corridors of power than those of institutions outside the gov-ernmental machinery. This is to suggest not that such bodies have any major impact on other areas of public policy, but that their bureaucrats, in common with those who staff all state agencies, are woven into an intricate network of social and political life by virtue of their occupation and social origins. As a senior manager of a multinational company pointed out, their own arts sponsorship is not so much targeted towards any particular arts institution as towards other governmental agencies:

For example, one of the permanent secretaries of one of the main departments –
I don't know if it was him so much as his wife – was very involved in setting up

a part of the Tate Gallery, down in Cornwall in St Ives. We contributed a reasonable sum of money towards that. So obviously he is bound to be aware that we are supporting something his wife was interested in, isn't he?[3]

Far from being a trivial matter, this instance illustrates one of the possible channels through which different manifestations of power are connected, and through what mechanisms state power and private capital interact. Precisely how this inner-circle networking affects the transformation of power and influence is a subject that requires further examination and elaboration, provided that it is not too politically sensitive, or even dangerous, to explore it more closely.

This intermeshing of public authority and political power can be applied with equal force to semi-public arts institutions, that is, in the context of this study, to art museums and galleries in America. Obviously it is difficult to claim that American art museums fall within the state bureaucracy in anything like the same way as their British counterparts. Strictly speaking, as they stand at the moment, they do not. To some extent they are not subject to the same rigorous scrutiny of public accountability that state agencies such as the NEA are, not least because most of them are governed by self-perpetuating boards of trustees.

Yet, in the sense that they are prominent in the public domain and engaged with issues of public import, they do enjoy public authority. Their social position as cultural institutions can hence be seen as comparable to other public arts agencies. After all, if museums such as the Museum of Modern Art or the Whitney Museum of American Art in New York had remained the private art clubs of the wealthy, as they had originally been in the late 1920s and early 1930s, they would not have commanded the prestige and power that they enjoy today in American society. To quote Carol Duncan: '. . . to work as ideologically effective institutions, they [American public art museums] required the status, authority, and prestige of public spaces.'[4] And above all, had they not received public assistance in one form or another, they would not have expanded as they did – an issue to which we shall return later.

Nevertheless, however circuitous the route by which this authority and power travel, and however non-political these art institutions would like to claim to be, the political efficacy of art, and of the arts in general, which is

precisely the remit of these institutions, is a testimony to the point in question. The functions and influence that these bodies can perform and exert, either in their own right, or (in the case of public arts agencies) through the arts organisations they fund, are politically useful both within the nation state as well as abroad.[5] It is these functions that prove to be most attractive to business. In particular, given the internationalisation of capital, multinationals have gone hand in hand with arts organisations on to the global stage, or, to be more precise, into the global market. The closeness of this collaboration raises the wider question of just where the dividing line is to be drawn between the two traditional categories of the public and the private.

ART MUSEUMS IN AMERICA AND BRITAIN:
PRIVATE ORIGIN AND PUBLIC PRACTICE

Your contribution is deductible for tax purposes.
A slogan for fund-raising[6]

It is generally perceived that American art museums are 'private enterprises', or, in a more modified version, 'private non-profit' institutions, while their British counterparts are 'public' ones.[7] Such a presumed contrast has become so widely articulated, particularly since the 1980s, that it is invariably presented as an established truth. For instance, Perry T. Rathbone, Director Emeritus of the Boston Museum of Fine Arts, lamented: 'That art museums have been *almost exclusively built and maintained by the private sector* is not sufficiently understood [italics added].'[8] In a similar manner, the millionaire developer and ex-chairman of the British Arts Council, Peter Palumbo, commented: 'Our tax laws do not favour individual donations as much as they do in the United States, where the arts are funded *90 per cent by individuals* [italics added].'[9] These differences between art museums are also assumed to reflect a larger truth about the respective character of arts provision more broadly in Britain and the United States.

Without doubt the public–private dichotomy is not as neat as these propositions uncritically assume. For one thing, 'public' and 'private' are constructed categories rather than simple facts. Central to the conundrum of

public and private is the fact that the boundary between the two is by no means a fixed one, but subject to ongoing political, social and ideological forces that help shape the discourse. For those advocates of enterprise culture in Britain, the 'public', as far as arts funding is concerned, came to refer to one narrowly defined mechanism, namely the annual grants from the Treasury. The rise to prominence of this particular ideological construct was largely the product of conservatives' efforts to privatise culture in the 1980s, in particular in Britain, as I shall discuss in detail below.

In *Ideology and Modern Culture*, John Thompson argues that there are at least two basic meanings to this dichotomy in modern Western democracies.[10] Rooted in liberal political theory, 'the public' refers to the domain of institutionalized political power, which is increasingly vested in the authority of a sovereign state. 'Public' in this sense is synonymous with 'state' or 'state-related'. In contrast to this, the private domain includes private economic activities and the domestic realm.

But 'public' can also be negatively defined by its conventional opposition, 'private'. As Raymond Williams suggested, the primary sense of 'private' in many different uses is one of privilege, 'limited access or participation'.[11] In this second sense, 'public' means 'open' or 'available to the public'. It is this sense of 'publicness' that constitutes one of the key criteria of Jürgen Habermas's utopian concept of the public sphere.[12] In principle the bourgeois public sphere is open to all private autonomous individuals for their rational discourse; to quote Habermas: 'Access is guaranteed to all citizens.'[13] In reality, however, entry to the public sphere is in practical terms more or less restricted to individuals, predominantly male, with property and education. Although Habermas's ideal remains historically unattainable, his arguments concerning the public sphere have nevertheless been very influential in discussions of the category of the 'public' in various disciplines.

These two sets of meanings of public and private, while distinct in themselves, are by no means mutually exclusive. With the development of the constitutional state in the twentieth century, in tandem with the expanded mechanism of state intervention, especially in the post-Second World War era, the public sector, as representing the collectivity of citizenship in a state, has come to assume a relatively greater degree of public accountability within contemporary democracies. By contrast, the private sector, as

represented by business in a capitalist system, has the power and the 'right' to make hundreds of 'private' vital decisions, without even a pretence at democracy.

Between this public/private divide, however, there exists another sector, the so-called 'third' or 'non-profit' sector in America, and the 'charity' or the 'voluntary' sector in Britain. A substantial element of collective policies and functions, which otherwise would have been vested in the authority of the state, has been carried out by those institutions, whose existence is closely bound up with the ambiguous nature of their being public and private at one and the same time.

Institutionally speaking, the majority of the so-called 'private' art museums in America are located within this sector, while their British counterparts are organised by means of its extreme variant, the quango (quasi-autonomous non-governmental organisations). While most of their funds come from the British taxpayer, and their staff are hired and paid according to civil service assessment criteria, these quangos, whether the Arts Council or the trustees of art galleries, claim that their operations are conducted on the 'arm's-length principle', that is, they claim to be somehow outside politics because they do not have to answer directly to Parliament. Be it in America or in Britain, these institutions are generally run by a board of unpaid trustees, who thereby enter the social space of the public institutions. It goes without saying that these people are politically and socially privileged, but they are presumed and expected to act only in their private capacity for the public interest. The Establishment bias of this arrangement is self-evident. This institutional system has added a whole level of complexity to the vexed question of the public and the private.

In general terms, the origins of the oldest established art museums in America and Britain lie in private initiatives rather than being the result of clearly articulated public arts policies. The Boston Museum of Fine Art, the Metropolitan Museum of Art in New York, and Chicago's Art Institute, or the British Museum, the National Gallery and the Tate Gallery in Britain, all owe their existence, to a large extent, to private funds or donations from the rich. The Boston Museum, for instance, was founded in 1870 by the Brahmin elite, while both the collection and the building of the Tate Gallery were given to the nation by Henry Tate towards the end of the nineteenth century.[14]

What distinguishes art museums in America from their British cousins, however, is their institutional arrangements. In the charters drawn up to establish art museums as charitable trusts, for which a board was legally accountable, American museums had followed English precedents of common law.[15] But unlike their English counterparts, whose boards of trustees were appointed by higher state officials (earlier by the monarch and then by the Prime Minister), American museum boards were autonomous and self-perpetuating, regardless of how much public support they received. For instance, although the New York City government contributed $500,000 toward its construction and was responsible for its maintenance expenses, the Metropolitan Museum was, and still is, governed by a board of private citizens, over which the City has no real power.[16] This pattern of governing authority in American art museums was to become the norm in the years to come, except for those specifically funded by government.

This difference was, to a large extent, a reflection of the financial realities of art museums on both sides of the Atlantic. While the American museums were heavily reliant on 'private' contributions, the British equivalents were explicitly funded from the public purse, once government overcame its initial reluctance to accept the private gift of art collections and/or funds. This historical difference has ever since shaped the way in which art museums operate in the two countries. It is also on this ground that the contrast between the American 'private' and the British 'public' systems of arts funding is generally assumed to rest.

However, some social scientists have looked at public funding in a very different light. With the creation of the notion of 'tax expenditure' in the United States in the 1960s, the concept and all its ramifications have been applied to the study of public arts funding, among much else besides of course. What the concept has helped to highlight is the heretofore unaddressed issue of indirect public art subsidies through tax provisions, that is, tax foregone which otherwise would have had to be paid to the relevant tax authorities in the country concerned. There are in fact specific tax rules that affect museum funding directly and dramatically.

The major indirect subsidies for art museums in America are charitable contributions and gifts of property. The charitable contribution was first introduced for individuals in 1917[17] and for corporations in 1935. It allows

the donor to deduct contributions from his or her taxable income and thus reduces tax liability. While the subject will be analysed in the next chapter in specific connection with tax changes under the Reagan and Thatcher governments, I will give some attention here to the issue of art donations to museums, not least because donated artworks have been such an indispensable part of museum life. In fact, it is a perfect illustration of what John Meynaud calls 'the bias of the system',[18] in which the privilege of a rich and powerful minority, to exhume an unfashionable phrase, is protected by law over the rights of the public.

Before the Tax Reform Act of 1986 in the United States, when a donor gave gifts of appreciated property – artworks in this case – to museums, they had 'double tax incentives'. In addition to being able to deduct its fair market value against personal ordinary income, the donor paid no capital-gains tax on the appreciation of the work, for which they would otherwise have been liable should they have chosen, instead, to sell it on the market and donate the cash.[19] For instance, consider the case of a donor in the highest (50%) tax rate bracket in the early 1980s, who had a painting worth $10,000, which cost him $5,000 at the time of purchase. To donate the painting to a museum would give him $6,000 tax saving ($5,000 from a charitable deduction at a 50% rate and a further $1,000 from the dispensation from capital-gains tax at a 20% rate). Therefore in this transaction, the donor actually donated $4,000, with the government, or more precisely the unknowing taxpayers, footing the bill of $6,000. The ratio between the donor's and public money became even more dramatic when between 1944 and 1963 the top federal income rate rose to more than 90% (see Table 1.1).

The ramification of tax benefits is particularly telling, given the fact that gifts of property, and charitable contributions to arts/cultural institutions (a theme to which I shall return in Chapter 3), are highly concentrated within the higher tax bracket groups (see Table 2.1). It is primarily by taking advantage of such tax concessions that wealthy individuals, and later corporations, have channelled their artworks to museums. It is thus not uncommon to think of art gifts to museums as a tax-avoidance strategy for the rich and for some corporations.[20] For instance, KPMG Peat Marwick, a New York-based accounting firm, donated 22 works of contemporary crafts to the Renwick Gallery of the National Museum of

Table 2.1

Marginal tax rates and the price of giving to arts and culture in the United States

AGI group (1)	Marginal tax rate (2)	Per cent itemizers (3)	Per cent property (4)	Gifts to culture (5)	Price of giving (6)
0–10K	2.0	5.1	8.4	.0	.98
10–20K	15.9	20.5	8.7	.0	.83
20–30K	17.9	43.1	8.5	.0	.81
30–50K	21.5	67.2	9.2	.0	.78
50–75K	27.8	85.3	12.9	16.6	.70
75–100K	29.1	85.3	14.8	10.9	.69
100–200K	32.2	92.6	17.2	17.5	.65
200K +	28.9	93.8	30.9	55.0	.67
Total				100.0	.67

Notes and sources (by column):

(1) AGI = adjusted gross income, in K = thousands of dollars; (2) and (3) weighted average in each group, for the Tax Reform Act of 1986, from US Treasury Dept.; (4) Statistics of Income (SOI 1988), Internal Revenue Service, for tax year 1985 (before appreciated property placed under the alternative minimum tax; (5) and (6) for details and explanations of calculations, see Don Fullerton, 'Tax Policy toward Art Museums', in Martin Feldstein, ed., *The Economics of Art Museums* (Chicago and London: University of Chicago Press, 1991), p. 198.

American Art in Washington, DC, in 1994. The tax incentive was specifically mentioned as one of two reasons for the gift.[21] The institutionalisation of the economic interests of either elites or corporations in the cultural sphere is, of course, part and parcel of 'the bias of the system'. Still, what concerns us here is the extent to which a substantial amount of government subsidy, which has always been much larger than direct grants, is so subtly disguised.

The Tax Reform Act of 1986 not only removed the allowance for the appreciated portion of gifts, but also eliminated for some taxpayers the extra tax incentive provided by the dispensation from capital-gains tax.[22] This measure, among others, was intended as a way to combat the fiscal crisis, and had nothing to do with the Reagan regime's perception of any unfairness in the tax system. (This is evident insofar as other tax changes under this administration had substantially benefited the better off rather than the poor.)[23] The ensuing 'public' debate on the issue is of particular significance in this context.

Not only does it exemplify particularly well the kind of power transaction that takes place between public agents and private interests, but it also demonstrates the way in which the hegemonic process operates, in which one particular discourse, framed by arts bureaucrats, resoundingly silences the other.

Framing is of course a conscious selection, a process that is both inclusive and exclusive. What is inclusive, in this case, is the decrease of arts donations, while what is exclusive is the lion's share of public expense in these gifts. Between 1986 and 1993, the year when the 'double tax incentives' for art donors were withdrawn, the tax changes had become 'politically hot', as even a cursory inspection of the entries in the *Art Index* reveals: their repeal was the top legislative goal of museums and arts professionals alike.[24] During the period concerned, 18 articles out of a total 49 entries on the topic of American museum gifts and legacies were devoted to this issue. All but one were in favour of restoring the pre-1986 tax benefits to donors because, it was reported, art museums across the country were as a result experiencing a dramatic decrease in art donations. Nowhere is the issue of the effective subsidies from public money in so-called 'donations' ever raised.

The 1986 law was, to quote Edward Able, director of the American Association of Museums, 'causing a haemorrhage of our cultural and artistic wealth'.[25] Certainly the situation was not straightforward. As far as tax benefits are concerned, if the donor wished to do so, he or she could have sold the artworks and donated the cash to museums instead, a process that was, and still is, tax deductible. But in that case, the donor could lose some part of those 'double tax incentives' given by the pre-1986 tax laws.[26] However, to maximise the benefits for the donor, the representative of the Association testified before Congress: 'Rather than *seeking a benefit for the rich*, we are seeking to induce them to part with wealth' because 'museums serve public purposes, not private ones [italics added]'.[27] By identifying the private agenda as identical to the public interest, these arts managers could then set about protecting what they deemed to be the treasures of the nation. For whose interests ultimately these people are speaking is a question that remains to be answered.

THE MATHEMATICS OF INDIRECT PUBLIC SUBSIDIES

Any attempt to analyse the figures involved in indirect subsidies to the arts requires some indication of how much public money has actually gone to the 'private' art museums. But money, in the arts, is never easy to calculate. The relevant data available from other research are not a perfect measure, not least because they are not collected in terms of the particular focus and ambit of the present study.[28] I thus approach the question on two levels. On the macro level, I attempt to show how much and/or what percentage of public money, both direct and indirect, constitutes the budgets of art museums in general. On a micro level, I aim to illustrate, through the case of the Metropolitan Museum of Art in New York (hereafter the Met), the range of indirect subsidies that have been effectively obscured or hidden from public view. By virtue of its high visibility, this museum, perhaps more than any other in America, is subject to rigorous public scrutiny, and information on its operations is therefore comparatively more readily available.

According to the Association of Art Museum Directors survey in 1989, which covered the operation of 155 art museums across the country in the previous year, Don Fullerton, an economist at University of Texas at Austin, reached an approximate figure of tax expenditure for art museums.[29]

Table 2.2

Estimated 1988 tax expenditure for art museums in the United States

	Amounts ($ million)	% of total
Operating revenue (earned income)	122.4	14.0
Private support (contributed income)	235.0	27.0
Value of art donated	77.3	8.9
Total federal support	95.7	11.0
Total state and local support	168.7	19.3
Endowment income	173.0	19.8
Total	872.1	100.0

Source: Data from Don Fullerton, 'Tax Policy toward Art Museums', in Martin Feldstein, ed., *The Economics of Art Museums* (Chicago/London: University of Chicago Press, 1991), pp. 198–9.

One third of the 35.9% deductible contributions to art museums (27.0% private support and 8.9% value of art donated combined), in other words, about 12%, is tax expenditure. Another one third of the 19.8% non-taxable endowment income (6.6%) is also part of taxpayers' money. Fullerton also mentioned another form of tax expenditure, namely the non-taxation of net operating revenues; this unfortunately could not be estimated because the costs related to the store, restaurant, parking or special events were not available. This part of the calculation aside, the two tax subsidies already mentioned alone constitute 18.6% of museum income (12% plus 6.6%). If we add this amount to other direct federal, state and local support, it brings the public subsidies to almost half of the museums' income.

This estimate is, however, very conservative, but unfortunately no other comparable data are available.[30] The main problem arises from the fact that the 33% top income tax rate in 1988 was almost at its lowest in this century (see Table 1.1). In contrast to a few decades ago, when the top rate was more than 90% (i.e. from 1944 to 1963), art gifts, or indeed any charitable contributions, represented a 90% tax benefit. When the tax rate dropped to 70% in the 1970s, the tax benefit for donors correspondingly decreased to 70%. When the tax rate further reduced to 33% in 1988, for any gifts the US government contributed only 33% of the value. What this meant was, to quote the title of an article by Richard Walker: 'Generosity will cost more, IRS [Internal Revenue Service] tells donors.'[31]

These figures take on added significance if we look at the decade of the establishment of art museums (see Table 2.3). More than half of them, or indeed of museums in general, were set up during the 1960s and 1970s, when the tax rates were comparatively higher. Certainly other factors might have contributed to this phenomenon, but given the close correlation between the wealthy and their preference for giving to the arts (culture), there are good reasons to argue that tax incentives would have been one of the most significant determinants.[32] Unfortunately, there is no systematic evidence to map out any definitive relationship between the two variables. When it comes to the issue of tax incentives and charitable giving, the discourse of the relation, in both America and Britain, is too often framed in terms of lower income tax inducing more giving. Reduction of personal taxation is often deemed to be 'of material assistance to the arts by leaving

Table 2.3
Distribution of age of museums by type

Type	1980s (%)	2nd half 1970s (%)	1st half 1970s (%)	2nd half 1960s (%)	1st half 1960s (%)	1950s (%)	1940s (%)	Pre-1940s (%)	Total (%)
				Decade established					
Aquarium	0.0	57.3	0.0	0.0	0.0	11.5	0.0	31.2	100.0
Arbor/Bot. garden	1.9	9.1	17.2	24.8	0.0	11.9	9.1	26.1	100.0
Art	13.0	18.8	18.5	13.2	5.1	5.5	7.2	18.6	100.0
Children's	35.6	32.6	8.8	0.0	3.4	5.7	2.3	11.5	100.0
General	9.4	9.3	9.1	15.2	8.9	13.5	9.0	25.5	100.0
Historic site	10.5	10.8	10.8	16.3	11.4	14.0	5.3	21.0	100.0
History museum	9.2	14.8	16.9	15.5	12.2	11.2	4.4	15.8	100.0
Natural history	9.4	6.3	14.6	16.2	8.1	9.4	4.5	31.6	100.0
Nature center	11.3	17.2	28.5	12.6	8.7	12.0	2.1	7.5	100.0
Planetarium	18.1	13.7	6.0	21.3	23.9	3.0	0.0	13.8	100.0
Science	10.4	24.4	22.8	5.9	11.1	4.5	6.0	14.9	100.0
Specialized	25.0	27.8	12.2	7.7	13.3	2.1	0.5	11.5	100.0
Zoo	1.4	0.0	3.6	11.9	14.3	9.6	5.0	54.3	100.0
All museums	10.9	14.5	14.8	14.8	9.9	10.5	5.3	19.3	100.0

Number/Per cent missing: 0/0.0% 38 museums did not give a date for year established; year opened was used for these. Rounding results in some rows not totalling 100%.

Source: Data Report: From the 1989 National Museum Survey (Washington, DC: American Association of Museums, 1992), p. 64.

more money in private hands'.[33] The fact remains, ironically, that the lower the taxes, the lower the giving, simply because when the tax rate is low, it costs the donor so much more to give.[34]

HIDDEN SAVINGS

How does indirect subsidy affect the financial configuration of art museums, in particular the Met? A look at its operating income in 1988–89 will show some of the issues discussed above in more detail (see Table 2.4). The City of New York contributed a substantial amount (20.5%) of the Museum's budget. This is of course not always typical for other museums in the City, such as the Museum of Modern Art or the Whitney Museum of American Art. But as public charities these museums are exempt from local property tax for the properties they own. Neither these museums, nor the Met, has ever listed tax concessions given by government in its annual report. As art museums hardly ever trade their properties on the market, any attempt to assess the real market value of their buildings, and what tax expenditure might otherwise have been incurred, remain hypothetical. An estimate for

Table 2.4

Sources of operating income, Metropolitan Museum of Art, New York, 1989

	Amounts ($)	% of total income
Admissions	9,552,263	12.7
Membership	10,530,054	14.0
City of New York (utilities)	5,490,671	7.3
City of New York (guardianship, maintenance)	9,928,337	13.2
Endowment, including the Cloisters	10,830,913	14.4
Net income from auxiliary activities	6,242,984	8.3
Gifts and grants	3,911,163	8.9
Support for special exhibitions	12,034,348	5.2
Other	6,694,106	16.0
Total	75,214,839	100.0

Source: Compiled from *Metropolitan Museum of Art Annual Report for the Year 1988–89*.

1976 is the only figure available.[35] The total assessed value for the Met in that year was estimated at $42 million, including $15 million in land and $27 million in buildings.[36] The estimated property tax, or more precisely tax expenditure, for the Met was then $3.69 million.[37]

Another significant form of indirect subsidy includes about one third of the endowment (14.4%) and membership income (14.0%), that is, 9.47%.[38] There are of course further public subsidies within the categories of Special Exhibitions and Gifts and Grants. However, these categories collapse various sources of income, rendering it difficult to determine the actual percentage of public money involved. In particular Gifts and Grants includes direct grants from federal and state government.

Generally speaking, art museums do not pay taxes on their income from admissions, parking lots, restaurants or gift shops.[39] But art museums are liable to unrelated business income taxes (UBIT) for activities not related to their not-for-profit mission. I have not been able to find any specific figures or calculations here, because compared with other tax incentives, UBIT is not a major one. Nevertheless, William H. Luers, then president of the Met, implied, at a conference in 1989, that some changes proposed in the House of Representatives regarding UBIT could cost the Met as much as $1 million per year.[40]

Another form of indirect subsidy not listed in the Met's annual report was the value provided by the federal indemnification program. Under this program, the federal government agrees to act as an insurer for works of art that are loaned, often by other governments, as part of special exhibitions. As Charles T. Clotfelter argued, 'Although there is virtually no budgetary cost of the program, it has substantial value to art museums in terms of reduced insurance costs.'[41] Unfortunately there are no specific breakdown data for the Met's share, which is certainly larger than most art museums in the United States.

Last but not least, of crucial importance to art museums is the value of donated art. Although the Met does list donated gifts in its annual report, understandably no value is given to each individual piece. While no comprehensive data exist on the value of these objects, William Luers claimed that, in the past, '90% of our collection has come from gifts and bequests'.[42] Later, to illustrate the importance of the tax benefits reinstituted by Congress, it was reported that $42.8 million worth of works of art were

donated to the Museum in 1991, according to Ashton Hawkins, executive vice president and counsel to the trustees of the Met.[43]

Having threaded my way through the minefield of the measured, unmeasured or even the unmeasurable, I do not claim to present a comprehensive or a conclusive portrait of the public/private components involved in museum funding. To close the information gap would require a study as long again as this one. But contrary to claims that American art museums are 'private enterprises', I hope that I have at least shown that the hard revenue figures fundamentally contradict this assertion. At some juncture, this is of course much more than a question of mathematic calculation. The very practice of ambiguously positioning American art museums, being public and private at one and the same time, or at one time and not at another time, exemplifies the hegemonic process at work. Its very indetermination and elasticity allow for a wide range of possible manipulation.

Indeed, the ideological confusion over the nature of American art museums is remarkable. Even a national institution such as the National Gallery of Art in Washington, DC, cannot avoid such ambiguity. In a moderate vein, J. Carter Brown, director of the Gallery, referred to the buildings being 'given from the private sector, as was and is all the art', despite the fact that the maintenance and all the fundamental underlying budget are provided by the federal government.[44] In a more congratulatory mode, the Gallery has been described as 'a gift to the United States from Andrew W. Mellon' in 1941.[45] (The cost of this individual munificence has to be understood in relation to the fact that the top income rate in 1941 was 80%.)

In truth, the entitlement to tax exemption is not a right, but a *privilege* given by Congress for exempt institutions to serve the public interest. The point is made indisputably clear by the litigation involving the Barnes Foundation, a museum whose art collection was bequeathed by Albert Coombs Barnes in 1958. The trustees of the Foundation ran the collection in such a way as to exclude the general public. The Pennsylvania Supreme Court required public access to the Foundation collection if it were to enjoy its tax-exempt status:

> If the Barnes Art Gallery is to be open only to a selected restricted few, it is not a public institution, and if it is not a public institution, the Foundation is not entitled to tax exemption as a public charity.[46]

As charitable corporations governed by boards of trustees, art museums do not have shareholders as such, but the boards are nonetheless responsible to their beneficiaries, that is, the public. In the *Rowan v. Pasadena Art Museum* case, the 'shareholders' of museums are identified unambiguously:

> Members of the board of directors of the corporation [the museum] are undoubtedly fiduciaries, and as such are required to act in the highest good faith toward the beneficiary, i.e. the public[47]

To the extent that American art museums have been publicly subsidised, their *raison d'être* is predicated on the public terrain where their final accountability inevitably resides, regardless of whether or not they are legally or officially part of the public sector. To claim that they are 'private' institutions is, at best, misleading, not to say democratically questionable.

PUBLIC ARTS AGENCIES IN AMERICA AND BRITAIN

But democracy, in politics, is a slippery concept; it is no less problematic when applied to the field of arts and culture. Even within Western democratic societies where public arts agencies may confidently be expected to cater for the needs of the population, it has not always proved so. These agencies and their bureaucrats are not autonomous; they operate inside, not outside, the existing political and economical framework of the modern state. There are nevertheless state institutions, such as the Arts Council of Great Britain (hereafter Arts Council) and the National Endowment for the Arts (hereafter NEA), with a legislative mandate, or a Royal Charter in the case of the Arts Council, that have specific remits and objectives 'to develop and improve the knowledge, understanding and practice of the arts', and 'to increase the accessibility of the arts to the public'.[48]

These grand ideals reflect the origins of the Arts Council and the NEA, which historically took root in a period of dramatic expansion in the role of the state in both countries. The Arts Council, established in 1946, was part of the post-war welfare settlement in Britain, while the NEA, set up by Congress in 1965, was the brainchild of the 'Great Society' of the Lyndon Johnson adminstration in the new optimism of the 1960s. The twenty-year

lapse between the two institutions, to be accounted for by different historical conditions, is less significant when compared to the strong resemblance that the NEA bore to its British precedent.

'THE BEST FOR THE MOST'

The genesis of the Arts Council is of special significance. Strictly speaking, it was not the outcome of any clearly articulated public arts policy, but simply succeeded its wartime precursor, the Council for the Encouragement of Music and the Arts (CEMA), 'in a very English, informal, unostentatious' and 'half-baked' way, as its first chairman John Maynard Keynes phrased it.[49] The CEMA, initiated in 1939 by a grant of £25,000 from a private body, the American-based Pilgrim Trust, was also supported by the Board of Education, which put up twice that amount in order to 'prevent cultural deprivation on the home front' during the Second World War.[50] The driving force was the then secretary of the Trust and the vice-chairman of the CEMA, Dr Thomas Jones, whose vision for the organisation was an extension of the 'social service' to spread the arts.[51]

Despite its slogan, 'The Best for the Most', the CEMA was unashamedly tilted toward the latter: the audience. Music travellers were appointed to give concerts in remote parts of the country in churches, factory canteens, air-raid shelters, village halls, hostels, army camps and rest centres. In the field of visual arts, the CEMA substantially funded the 'Art for the People' travelling exhibitions in 1940, a series of shows initiated by William Emrys Williams in 1935 for touring industrial towns such as Swindon and Barnsley, when he was the secretary of the British Institute for Adult Education.[52] According to the Trust's annual report, the CEMA's art exhibitions attracted more than half a million visitors in their first two years.[53]

In 1942, a CEMA scheme called 'Art for British Restaurants' was set up to provide paintings, lithographs and murals for improvised canteens where meals were served daily to civilian populations.[54] At an auxiliary level, the programme also served to give some employment for artists under wartime conditions. Some of the murals were carried out by established artists such as Duncan Grant, Graham Sutherland and John Piper, while some were executed under the supervision of Piper and Sutherland, and others were

the works of local art students. The CEMA also bought some oil paintings and watercolours for exhibits, 'not to show supreme examples of art, but rather to give illustrations of pleasing and competent contemporary work, which might be bought by *ordinary* people and lived with in *ordinary* houses [italics added]'.[55]

The CEMA's missionary vision for 'ordinary people' was, however, quietly dropped when, at the same time as the withdrawal of the Trust's financial support and Thomas Jones's resignation, John Maynard Keynes took over its chairmanship in 1942.[56] He was, to quote Sir Kenneth Clark, 'not a man for wandering minstrels and amateur theatricals. He believed in excellence.'[57] The focus of the practice at the CEMA was subsequently changed dramatically, with 'the Best' now becoming the centre of gravity.

The shift in focus was not only a matter of personalities, but had more profound implications for public arts funding in general. Keynes was not only one of the most influential economists in Britain at the time, who just 'happened' to have an interest in the arts; he also had close ties with the political establishment, and was well connected in the arts world, in particular with the Bloomsbury Group.[58] Indeed, he was the very epitome of the British tradition of 'the Great and the Good', those people who can freely afford to give up substantial private time for public service. He belonged to the rather more vague category of what Raymond Williams called 'persons of experience and goodwill', a British 'state's euphemism for its informal ruling class'.[59] Keynesian emphasis on artistic 'quality' and 'standards' was later to become dominant in the practice of the Arts Council, as it was Keynes' vision and creation that ensured that a reformed version of the CEMA was to continue into peacetime.

The conflicting views and practices personified in Thomas Jones and John Maynard Keynes, within the institutional framework of the modern state, epitomise a persistent battle between various sectors of society that seek to lay claim to a legitimate culture. The contest expresses itself, at different historical junctures, in various formulations, sometimes reinstating itself in the elitism/populism divide, sometimes declaring itself in terms of the contest between the Establishment and the community, as it did in the 1970s, and at other times transforming itself, as in the debate between the metropolis and the regions in the 1980s. What has ultimately woven these ostensibly different issues together, however, is the centrality of the role

that the structures of power play in these relationships. That is to say, it is precisely the structures of power that are the references or indicators in mapping out these dissensions.

The work of the CEMA may seem to be an ephemeral episode, but for enthusiasts like Roy Shaw it was 'the most vigorous approach to "arts for all" that had ever been seen in Britain'.[60] It is only to the extent that the CEMA reflects an intervention in the landscape of the dominant culture that one may recall, with some justification, the more profound and extensive experience of the cultural projects of the Works Progress Administration (WPA) in the New Deal America of the 1930s. While it is beyond the scope of this study to elaborate on this project, not least because it is relatively well researched elsewhere, it is of significance to draw attention to the common ground that both the CEMA's and the WPA's cultural projects share, despite the great disparity in scale and impact between the two.

The Federal Art Project (FAP) was one of the four nationwide cultural schemes of the WPA set up in 1935. Like the CEMA, established as a result of severe economic and political dislocation, it was a relief expedient programme for visual artists. Also like the CEMA, the FAP promulgated the vision of 'Art for the Millions', as a collection of essays about the project was entitled.[61] Of course, the neatly worded catchphrases 'Art for the Millions' and 'Art for the People' beg serious questions as to what art is meant to be here, and they are rather redolent of the patrician *noblesse oblige* of the process of democratisation of the arts.[62]

However, the administrators of both the CEMA and the FAP, such as Thomas Jones and Holger Cahill, did share the aspiration of what can only be adequately expressed through the concept of 'cultural democracy'.[63] Both programmes sought to achieve its seminal element, that is, cultural access for the public, not only by sending exhibits to various parts of the country, or installing murals in locations that were more accessible to people, but also through the fostering of community participation. This, in particular, was Cahill's approach, influenced by John Dewey's idea of 'art as experience', which aimed to make the arts not only physically accessible, but also 'intellectually and emotionally accessible'.[64] It is through the process of redefining art by changing the very terms of reference used by the dominant culture that the relationship between the public and artists can be re-mediated and re-negotiated, thereby opening up the range of possibilities for the role of the

arts in a democracy. It is also in this sense of maximising popular participation, on which cultural democracy primarily depends, that the significance of the early CEMA and New Deal projects extends far beyond their brief existence.

The kind of idealistic popular participation championed by the early CEMA and the New Deal does not in reality occur very often in Western democratic countries. Often it is the public arts agencies, such as the ACGB and the NEA, that survive by being incorporated into the permanent governmental machinery ('permanent' in the sense that they were originally set up on a long-term basis). Like other forms of social organisation, they illustrate how reliant the arts are on the political process of institutional building if they are to have an active voice within the modern state. In this sense, both organisations can confidently be said to symbolise public ownership in the arts, and in many respects they are the collective voice for contemporary art in the political arena.

With regard to their operations before the decade of the 1980s, I do not intend to take an inventory of all their activities in the field of the visual arts, not least because a mere shopping list of events tends to be superficial. I intend rather to focus on one specific aspect of each agency, that is, the Arts Council Collection and alternative spaces (which, in the NEA's administrative jargon, were called 'Visual Artists Organizations') supported by the Visual Arts Program at the NEA. This may seem to be a surprising choice, but the paradox is deliberate: if these two projects are among the least known activities of each of the supporting institutions, they nonetheless demonstrate the importance of public funding, by the very fact that support was actually given to these marginalised schemes, which otherwise would not have survived the play of market forces. Their invisibility, or low visibility, in the art world is in sharp contrast to the high-profile art establishments of both countries. It then comes as no surprise to find that they are by far the least attractive schemes to corporate patrons.

THE ARTS COUNCIL COLLECTION

The Arts Council Collection, like the Council itself, was transferred from the CEMA, which, as we have seen, first acquired a collection of some 77 original

works, including oils and watercolours, in 1941 for the touring exhibitions that it organised.[65] The Collection, as it stands at present with more than 7,000 pieces, is the largest loan collection of post-war British art, including as it does over 3,000 original paintings and drawings, and about 420 sculptures and mixed media, as well as over 3,500 prints and photographs. In line with the spirit of the early CEMA, the purpose of the Collection, in the words of its current curator, Isobel Johnstone, 'was to circulate modern art in exhibitions around the country'.[66] Unlike collections based in museums and art galleries, it did not, and still does not, have permanent galleries to display its holdings.

At first, purchases were made annually by different members of the Council's Art Department and Advisory Panel, with the aim of 'ensuring that a variety of choice was being represented'.[67] In 1981, the procedure was changed and formalised. Artists living in England could apply for their works to be considered.[68] According to the Collection catalogue, this is aimed at 'having the benefit of keeping purchasers in touch with what is being done outside London and of opening up what may have seemed a fairly closed system'.[69] A group of six purchasers were invited to select works for the Collection, first looking at slides and then making the necessary studio visits. These purchasers included three members from the Arts Council and three outsiders, including artists, critics or museum curators – those people presumably with informed knowledge of the art world.[70]

Until the end of the 1960s, the purchases were made primarily for touring exhibitions organised by the Arts Council, of which contemporary art, along with modern art, has been the key but not the sole feature. Before local-authority-maintained galleries were improved through the Arts Development Strategy in the mid-eighties, these touring exhibits were of significance in bringing original works to places where no public collections existed.[71] To quote Hugh Willat, then secretary-general of the Arts Council: 'No one else was tackling this task on this scale, nor could anyone else undertake it.'[72] This was particularly true for contemporary art exhibitions, when at the time few galleries were able or willing to offer them on tour. The Council was praised by the Museums and Galleries Commission as 'the most productive single originator of travelling exhibitions for museums and galleries' in the country,[73] despite the fact that the service had been under considerable criticism for being too centralised and for perpetuating 'a paternalistic approach' since the late 1970s.[74]

Most works not on exhibition loans are lent on a long-term basis to other public institutions, where the public have 'some' access, places such as art galleries, universities and colleges, libraries, hospitals and local and district authority offices. The Collection includes some 2,000 photographs. They are housed in Sheffield University Library where they are available for loan or for reference use. At present, about 70% of the paintings, and some 25% of the sculptures and mixed media, are on loan either to exhibitions or to public institutions.[75]

By virtue of its operations, the Collection has functioned both as 'patron and publicist for the artist', in that by purchasing contemporary artworks, the Council not only provides direct financial support to living artists, but through its extensive tours also significantly increases the exposure of their work.[76] This form of patronage is especially important in Britain, in two ways. First, whereas in America fellowships for individual artists were the biggest single category of support in the Visual Arts Program at the NEA since its inception in 1965, the Arts Council had not succeeded in providing similar support to artists.[77] This is crucial for younger artists in particular since, because of its very limited budget, the Council tends to buy from them long before their reputation in the art world is well established. Its purchasing policy, as encapsulated by Tom Lubbock, is: 'Buy young, buy cheap!'[78] For this reason, the Arts Council was, and still is, one of the few sources of support for many artists.

Second, the purchase itself as a form of patronage is not only financial, but also symbolic – symbolic, that is to say, in the sense that the manifest effect of Arts Council purchases signifies a stamp of art-world approval. This is clearly reflected in the fact that being included in the Arts Council Collection has become one of the standard entries listed in artists' catalogues or résumés. Its imprimatur is beyond dispute. Institutionally, the Arts Council is the most influential public agency for *contemporary arts* in Britain, and individually those purchasers who have worked for the Collection include some of the best-known luminaries from the contemporary art world, such as Alan Bowness, who later became the director of the Tate in 1980. In short, it is this combination of institutional power with the authority and political influence of individuals that locates the significance of the Collection not only in its size, but also in its symbolic mapping of the national cultural landscape. It is also in this capacity that

corporate art collectors look upon the Collection as one of the most elo-
quent barometers of what to purchase.

To recognise the power that the Collection may have is not to contradict
the earlier point that the Collection is, in fact, relatively unknown if we take
into account its huge size and its history of collecting over half a century.
Writing in 1980, one journalist asked: 'Yet who has heard of the Arts
Council Collection?'[79] The same question was asked again ten years later.[80]
The answer to this apparent paradox lies in the fact that for most of its his-
tory the Collection's impact has been on the regions rather than on London.
Its budget was also so limited that it was impossible to have many high-
profile star artists in its stable. And above all, its ambitious lending policy to
'[reach] the parts most other collections cannot reach' resulted in exceptional
mobility.[81] For such a centralised country as Britain, to bypass the metropolis
is to forgo a lot of critical attention. The Collection would have remained
known only outside London, or accessible to only a very small circle of met-
ropolitan art cognoscenti, had it not been for the free market forces released
in the 1980s that challenged the social ownership of such a collection, and
forced it to be run more like a business enterprise with all the publicity-
seeking strategies that this implies.

But does the Collection, for all that, achieve its proclaimed aim of *art for
everyone*, or is it merely 'an archive of good intentions'?[82] The commitment
to public access may be a genuine one; the rub is, however, that the con-
struction of 'art' in the neatly phrased motto 'art for everyone' collapses too
many different positions of social and cultural power within a capitalist soci-
ety, and this makes it unlikely to be workable either in theory or in practice.
To speak of art as if it were a universal category requires a persistent nega-
tion of the representational needs of the non-gallery-going public, who are
consistently fed by 'museumified high culture' as if they have no culture of
their own.

Only occasionally is this sense of cultural dislocation and exclusivity able
to surface in the now all too familiar debates over what constitutes contem-
porary art. The furore over the Collection's 'fish-tin-in-wash-tub' sculpture
by Richard Wentworth, exhibited at the Serpentine Gallery in 1984, for
example, is not atypical.[83] But, here, after all, it is because of the public pro-
file of a *public* collection that a forum for opposition has been made available,
or at least tolerated, however limited this opposition may actually be. Or put

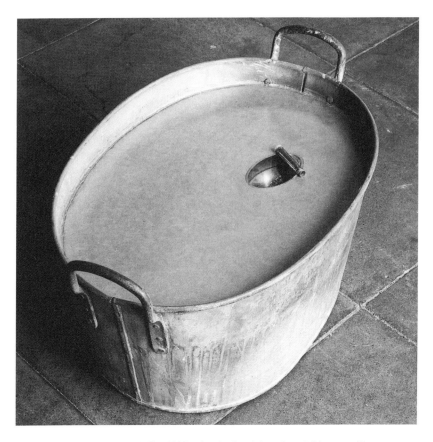

Figure I Richard Wentworth, *Toy*, 1983, galvanised and tinned steel, 31 cms × 41 cms × 62.5 cms, Arts Council Collection, Hayward Gallery, London.

it another way, if the Collection only partially succeeds in achieving its ostensible goal, this has nothing to do with its ownership, but rather is to do with the broader structure of different modes of social power within a capitalist democracy that largely shapes and constrains its practices. It is the public ownership of the Collection, on the other hand, that might possibly bring about a redefinition of what 'art' actually is.

THE NATIONAL ENDOWMENT FOR THE
ARTS AND ALTERNATIVE SPACES

To begin with, the umbrella term 'alternative spaces' requires clarification. Unlike the inclusive expression 'artist-managed exposure', which encompasses the whole range of methods employed by artists themselves to bypass the mediation of dealers, the alternative space movement here refers to a historically specific category.[84] It arose in America in the late sixties and early to mid-seventies in direct response to the support system of museums and commercial galleries, to which access was deemed to be very limited by many artists, at a time when neither was willing to accommodate the range and diversity of new experimental work, in particular performance art and conceptual art.[85]

Like artists' co-operatives in the fifties, the alternative space movement was a direct result of a desire on the part of artists to take control over the dissemination and distribution of their artistic production. But, unlike the co-operatives, whose main concern was not dissimilar to that of commercial galleries, namely to sell, these spaces were not primarily interested in selling. To quote Jock Reynolds, director of the Washington Project for the Arts in Washington, DC: 'We're not in the business of managing careers.'[86] On the contrary, in some cases these spaces, by exhibiting unsaleable works, challenged the very assumption of art as commodity promulgated by the commercial market. It is this sense of ideological allegiance and social awareness of being outside the mainstream, and on the oppositional periphery, that underpinned the movement and imbued it with the idealism of the sixties' counter-culture.

The relationship between the establishment and the practices of alternative spaces and the NEA, in particular its Visual Arts Program, is a direct and close one. Most of the first generation of alternative spaces were created at a time when the federal art budgets rose meteorically, examples including the Kitchen and Artists Space in New York, in 1971 and 1973 respectively.[87] Under the influence of the directors of the Visual Arts Program, including artists Brian O'Doherty and Jim Melchert, alternative spaces received a substantial amount of their annual budgets from the NEA as well as from state arts councils.[88] Brian O'Doherty was even credited with coining the expression 'alternative space'.[89]

As early as 1971, the Visual Arts Program gave five grants of $22,600 in total to support these embryonic artists' experiments. The following year a specific category, 'Workshops', was established to designate this area of funding. With a budget of $203,478, it represented 21.6% of the Program's budget as a whole, and received 42 applications in that year. A decade later, the category was renamed 'Artists' Spaces', had a budget of $919,550, and received 170 applications.[90] The statistics themselves, of course, give no indication of how much public subsidy these organisations received in their earlier days, and with what impact, and unfortunately no systematic data are available to help us clarify this.[91]

But the importance of public funding for these artist-run galleries was beyond reasonable doubt. Not only was the Program the only public program within the federal structure devoted to contemporary art, but the timing of its support was particularly decisive. Most spaces were started on a shoestring; for instance, the Kitchen was literally begun in the kitchen of the Broadway Central Hotel. The renowned alternative P.S.1 in New York was once a dilapidated school building, refurbished in the early seventies under the auspices of the New York Institute for Art and Urban Resources, with funds from the NEA and the New York State Council for the Arts, in addition to a Chemical Bank loan.[92] It cost a mere $150,000, in stark contrast to the City estimate of $1.5 million. The P.S.1 opened in 1976, housing some 35 low-rent working studios for artists, as well as spaces for exhibitions and other activities.[93] The resources that the government channelled into these artistic practices in their growing phase were thus of critical importance for their survival. Even after some years, the public input was still paramount. According to Phil Patton, the Kitchen's annual budget for 1977 was $200,000, of which 45% came from the federal and state governments, with the rest paid by the private sector and 500 to 600 paid-up members.[94] The Institute for Art and Urban Resources, which began in 1972 as a 'social and aesthetic welfare organization for artists', remained heavily dependent on public funding.[95]

The staunch support that the NEA gave to this movement had, as O'Doherty put it, 'the benefit of a favorable historical moment'.[96] The NEA guidelines described the 'Workshops' category in terms of the significance of 'artists' self-determination', and of 'non-commercial, bare-walled, ripped-out, "alternative space", run by artists for artists . . .'.[97] The image of

alternative spaces thus envisaged by the NEA was one of the avant-garde organisations that, fed by the 'radical energies of the sixties', expressed themselves in terms of counter-cultural values and practices.

The integral role that the NEA assigned to the artists in this area of funding cannot be overemphasised. Unlike art museums throughout the United States, whose boards of trustees usually read like a list of *Who's Who* in corporate America, the artists' organisations have a 'significant portion' of artists serving on their boards and making overall programming decisions.[98] This is sometimes written into their bylaws, as was the case with the Washington Project for the Arts, for instance, whose bylaws stipulated that half of the board members must be artists. More often, this is particularly advocated by the Visual Arts Program through its policy of giving priority to the 'integral role' played by artists in funding decisions. It is in this organisational arrangement that the NEA in general, and the Visual Arts Program in particular, nurtured a fundamentally new, and in many respects radical, framework for artistic production and distribution in the country. In short, before the arrival of the Reagan administration in 1981, the NEA 'effectively enfranchised' a nationwide network of multi-disciplinary organizations, which made available exhibition, service or work space and were 'devoted to "alternative", non-market oriented artists and art works'.[99]

Unlike the Arts Council Collection, which was intended to cater for the public (this, at least, was the theory), the NEA defined the primary purpose of alternative spaces as 'to serve the needs of, and enhance opportunities for, visual artists'. The actual relationship between alternative spaces and their audience is therefore left to individual organisations to elaborate. This often entails a complicated, and sometimes even conflicting, interaction. Since artists' spaces were established to support work that, to quote two longtime figures on the scene, 'challenges established sociological, political, and ethnic assumptions, work that takes risks and allows the artist to fail, work by new artists with new unvalidated approaches', there may well exist, at the very least, some kind of artistic camaraderie between the artists/administrators of these spaces and their fellow artists.[100] But the relation between these spaces and 'the public' is more problematic. As the previous quotation suggests, alternative spaces existed to support those works and artists who were outside the dominant structure of the contemporary art world, that is

to say, it existed to 'empower' disenfranchised artists. This aspiration to counter what was perceived as a progressive political, as well as artistic, marginalisation was in fact identified by Renny Pritikin, the director of New Langton Arts, an alternative space in San Francisco, as the origin of the alternative movement:

> The objective [of the artists' space movement] was self-determination. Artists took this rhetoric, originally intended to address disenfranchisement from political decision-making process, and applied it to the microcosm of an art world that has effectively placed artists in a passive and victimized role[101]

It is in this sense that alternative space speaks of itself as a representative of the disenfranchised (under)class of society, their 'imaginary public', so to speak. Their intention may be genuine, if naïve. As one alternative space administrator enthusiastically put it: 'The egalitarian in me wants to show all points of view, with a leaning toward the underdog and the unrecognized.'[102] Leaving aside the fact that most of the artists who started alternative spaces were white middle-class Americans, the problem is that there is a difference between an artistic career that is *chosen* and requires long years of training and cultivation, and a *choiceless* condition of life of being at the bottom of society.

Without questioning its own practice in terms of its connection with power, both in the art world and within society as a whole, the alternative space movement ironically helped to redefine and gentrify the derelict urban ghettoes where these spaces were located in the first place.[103] Art and artists were not, of course, the only forces in gentrifying the downtown areas of many American cities by making loft living, for instance, so fashionable.[104] But, as Anne Bowler and Blaine McBurney observed, when 'the avant garde and its "spirit of revolt" itself have become a commodity for consumption in the constant search for the ever-new and latest thing' within late capitalism in general,[105] these artists' spaces in fact participate, willingly or unwillingly, in an arena of profound social change where the haves and have-nots are in direct conflict and struggle, with the latter often being ruthlessly evicted and displaced.

The failure rigorously to engage the question of power, in particular their own power and their connection with power in the art world after a

decade of existence, meant that these spaces, collectively, were not able to produce an alternative audience or a radically different context for artistic careers. Paradoxically, some of them reproduced the very system of institutions and values that they had set out to challenge. They became rather museum-like, or like 'the establishment of the anti-art establishment', while others functioned as feeders for the commercial market, with some of the founders of the movement moving on to open their own commercial galleries, and artists similarly leapfrogging from the alternative to the commercial. The move of Barbara Kruger, for example, who showed at alternative galleries as early as 1974, to the high-powered Mary Boone Gallery, 'an apogee of commercialism', in 1987 ironically exemplifies the inherent contradictions of alternative spaces and their 'radical' artists.[106]

To recognise the dilemmas and ambiguities of alternative space is not to minimise the significant role that it might fulfil in the discourse of contemporary culture in American society. On the contrary, to lay bare its intricate power relationships is to provide a pointer as to where genuine revolt against the patronage system of late capitalism may hopefully take place. Nor is this to deny that within the 'decadent bohemian avant-garde' often associated with the subculture of the alternative there were those who continued to express genuine concern for the underprivileged, and sustain an 'alternative' force to the dominant order, where cultural production and consumption do not succumb to the forces of the marketplace. Examples included ABC No Rio, Political Art Documentation and Distribution in the East Village in New York, and the Washington Project for the Arts.

ABC No Rio, set up in 1980, originated in the exhibition *The Real Estate Show*, mounted by a group of about 35 young artists when the East Village was being rapidly gentrified. The purpose of the show was unequivocal: 'The intention of this action is to show that artists are willing and able to place themselves and their work squarely in a context that shows solidarity with oppressed people'[107] Although it is impossible to discuss their activities in detail, suffice it to say, as Rosalyn Deutsche and Cara Gendel Ryan pointed out, that ABC No Rio was the only group in the art world, including established alternative spaces, to show their awareness of their own cultural and economic privilege:

We fall into that area of implication because we've got the best deal in town. We've got a low rent and minimal pressure. And the reason that we're here is because we're attractive, because we represent an art organization. Whether or not that's a save-face for the city, allowing it to say it's not involved is gross speculation. 'Look we gave the building to ABC No Rio' . . . it's really complex and for that reason I don't want to project an image of purity.[108]

Alternative spaces as such may not necessarily be very much in the public eye, but they are nonetheless of considerable significance, in potential if not in fact, in maintaining a critical edge of oppositional vanguard alternatives. Paul DiMaggio, a sociologist at Princeton University with an abiding interest in the arts, has pointed out that government is in a potentially strong position to 'take fuller responsibility for the pursuit of those purposes that neither the market nor private philanthropy can be expected to support'.[109] It is this position that makes public arts funding ever more important, despite its limits and its internal contradictions, within a capitalist society. However, the privatising policies of the Reagan and Thatcher governments during the 1980s transformed these public and semi-public institutions on both sides of the Atlantic. For the American art museums that had already ventured into the complex territory where the private and the public overlap, the coming of age of unfettered market forces was in some ways simply a step forward. However, for British museums and galleries and public arts institutions alike (and to a lesser extent for federal arts agencies in America), the New Right's promotion of an enterprise culture has been both ethically problematical and irreversibly damaging. While the changes undergone by museums will be the subject of Chapters 4 and 5, it is to the eighties-style public arts agencies that we now turn.

THE CHANGING ROLE OF GOVERNMENT IN THE ARTS

CHANGES IN PUBLIC POLICY UNDER REAGAN AND THATCHER

> In this present crisis, government is not the solution to our problem; government is the problem.
>
> Ronald Reagan, inaugural address, 1981[1]

After Ronald Reagan and Margaret Thatcher came to power in 1981 and 1979 respectively, they conducted their terms of office under the dual banners of reducing public spending and expanding the private sector. The policy of privatisation on their political agendas not only redefined the role of the state in every aspect of economic and social life in contemporary USA and Britain, but also extended into the cultural landscape of both countries. The previous social-democratic/liberal assumption – that access to the arts, like that to any other public service provided by the state, is a fundamental right of every citizen – was profoundly challenged. This is especially true with regard to the arts in Britain, since the British government had directly provided arts organisations with their operating costs since the establishment of the Arts Council of Great Britain in 1945.

In the Thatcher years public-funded arts institutions, whether they liked it or not, were forced to expose themselves to market forces and adopt the competitive spirit of free enterprise. To move the arts world into line with the

enterprise culture, both the Reagan administration and Thatcher government cut the budget for direct arts subsidies, which were perceived not only to have weakened initiative and created a culture of craven dependency among the subsidised bodies, but also to have discouraged or driven out potential supporters from the private sector.[2]

While one can well argue that budget cuts were being exercised across the board rather than being specifically targeted at the arts, both Reagan and Thatcher made persistent efforts to ensure that sufficient incentives were implemented to lure private money into this area. Their efforts can best be illustrated by changes in public policy related to the arts, especially tax policy, during their terms of office, and by the associated use of political influence and symbolic power that they both commanded as heads of state or government. If the former seems to be black-and-white and thus self-explanatory, the latter is more than mere speculation. Exclusive government receptions given in the name of the arts provided business people with unique occasions to meet leading politicians (and the royal family in Britain) in a seemingly non-political ambience and thus, it was hoped, open up a pathway to the corridors of power for them. This was both tacitly understood and explicitly stated by government and business.

THE ARTS UNDER THE REAGAN ADMINISTRATION

When he was still Governor of California, Ronald Reagan already preached the gospel of less government interference and poured scorn on intellectuals and liberals. He was once quoted as saying that he was not 'in the business of subsidizing intellectual curiosity'.[3] In response to *American Arts* magazine's questions to presidential candidates in 1980, Reagan criticised the 'populism' of the Carter administration. While stating that federal arts funding might have a steady annual increase under his administration, his allegiance to private arts support was unequivocal: 'Support of the arts by the private sector is very uneven. I would take a personal interest in encouraging individuals and corporations to provide support.'[4] No sooner had he assumed the presidency of the United States in 1981 than his avowed intention to increase federal support evaporated. Instead the administration, with unabashed candour, carried out its agenda of corporate soliciting.

What the Reagan administration first proposed for the National Endowment for the Arts, along with its sister agency the National Endowment for the Humanities (NEH), was a 50% cut in the fiscal year 1982 budget of $175 million, as had been requested by the Carter administration, and from the fiscal year 1984 onwards the Endowment's budget would be held at $100 million. The Reagan White House also requested the abolition of the Institute of Museum Services. There was even widespread suspicion that the administration intended to abolish the two Endowments altogether.[5] This drastic budget cut represented a sharp reversal of federal policy on public funding for the arts, which had been expanding since the Nixon administration. The sum involved, compared to an overall federal budget of $700 billion, was minuscule, and even abolishing the entire agency would in no way have substantially reduced a projected deficit of $40 billion.

The meaning of these draconian cuts has thus to be understood in relation to the administration's own particular ideology. Firstly, Reagan's political allies claimed that the Endowment programmes had been 'politicalised' under the Carter administration and redirected towards developing arts for social rather than for artistic purposes. In response, the right-wing think tank the Heritage Foundation came up with a 'new' arts policy: 'The arts that NEA funds must support belong primarily to the area of high culture. Such culture is more than mere entertainment'[6]

Secondly, the public ownership of the arts provided by the Endowment was deemed to be a disincentive to private support, and thus contrary to the free-market-driven policies of the Reagan administration. As the Office of Management and Budget (OMB) put it: 'This policy [of the NEA and the NEH] has resulted in a reduction in the historic role of private individual and corporate philanthropic support in these key areas. The reductions would be a first step toward reversing this trend.'[7] Declaring federal cultural support to be a 'low-priority item', the OMB thus decreed that the NEA programmes had to suffer the largest single cut, proportionately speaking, in any government agency.

Thanks, however, to the concerted efforts of the arts lobby, the President did not finally carry out his threat to cut the Endowment's 1982 budgets by 50%. Yet this did not result in the administration abandoning its ideological battle lines over arts funding. In February 1982, the OMB proposed a

30% budget cut for the Arts Endowment, a 27% cut for the Humanities Endowment, and, again, the termination of the Institute of Museum Services for the fiscal year 1983. The administration stated its message in no uncertain terms: 'These reduced levels of funding reflect the Administration's intent to encourage direct beneficiaries and the private sector to make larger contributions to cultural activities.'[8] The attempts of the Reagan White House to reduce the federal arts budgets, despite opposition from significant elements in Congress, did not abate throughout Reagan's two terms in office.

The Presidential Task Force on the Arts and Humanities

In the wake of the proposed 50% cutback of the two Endowments, Reagan established a Presidential Task Force on the Arts and Humanities in May 1981. The President charged this Task Force with studying the possibility of restructuring the two agencies and recommending ways to 'increase the support for the arts and humanities by the private sector'.[9] As a result of the Task Force's report, a President's Committee on the Arts and the Humanities was set up with a similar mandate in the following year. The Committee, described as 'the President's troubleshooting team for the arts and humanities', had a limited role in the public arts funding debate, however.[10] It had a small staff and a modest budget. Yet its underlying meaning and political potency are not to be found in its formal structure, but in the very fact that, being a President's committee, it had, as its deputy director Malcolm Richardson pointed out, 'direct access to the political players over in the White House' and was not just 'a small outlying appendage of the government'.[11]

This access to the highest office in the land no doubt has its political appeal. On the one hand the Committee's memberships read like a *Who's Who* of the American corporate community, and included the chairmen or chief executive officers from blue-chip companies such as the Mobil Corporation and the Times-Mirror Corporation, in addition to celebrities from the arts world.[12] On the other hand, the Committee was a 'delightful place' for the President to reward his political supporters and give presidential recognition to the private sector contributors.

The significance of presidential recognition was indeed emphasised by the

Presidential Task Force's report in 1981.[13] Both as the head of state and as a celebrity at the heart of high society, Ronald Reagan commanded enormous political influence and symbolic power. The appearance of the President or First Lady could therefore confer kudos on any arts event, and provide its participants with a kind of quasi-national stamp of approval.

A symbolic gesture

This exercise of symbolic presidential power had come to be considered by the administration as an effective way of raising money privately, and to give the same sort of artistic imprimatur as a NEA grant used formerly to confer. To quote Frank Hodsoll, chairman of the Arts Endowment appointed by Reagan: 'I think you will see this Administration – the White House, the First Lady, and occasionally the President – getting into the act to encourage people, whether individuals, corporations, or foundations, to give more.'[14]

Soon after the proposed cut for the Endowments was announced, for example, the Reagan White House hosted a mammoth fund-raising gala for Ford's Theater in March 1981. The President was reported to have seized every opportunity to plead for corporate dollars as he urged on the audience: 'We need this private support for the arts to continue in years to come.'[15] These presidential festivities entertained not only an impressive list of performers and political movers and shakers, but also nearly 100 major companies, ranging from Alcoa to Xerox, with some of them having reportedly paid up to $5,000 for a seat.

Not surprisingly, when the corporate giant Philip Morris had an art show opening in Washington in June 1981, Reagan also gave a reception in the White House to boost morale.[16] The incessant fanfares at the White House not only deflected criticism of his ideological stand against public arts funding, but inevitably helped to legitimise corporate intervention in the contemporary culture of American society.

The fact is that the role of government *vis-à-vis* the arts had been redefined by the Reagan ideology. The government was acting as fund-raiser rather than simply as funder, and the federal agency, the Arts Endowment responsible for the arts, had effectively been replaced by the personal aura of the President, and removed from the arena of open democratic debate.

The grandest of these presidential gestures came when 12 artists and art

patrons were honoured at a White House luncheon in May 1983, and given the Presidential Award for Service to the Arts, a new honour devised by the administration.[17] The Texaco Philanthropic Foundation, the Dayton Hudson Foundation and Philip Morris were among those honoured as art patrons. The inclusion of three companies (or their foundations) underlined the prominent role that the business sector was expected to play in the administration. Unsurprisingly, it was Philip Morris – the company whose slogan for its arts projects is 'It takes art to make a company great' – that was honoured first by the President.[18]

To further consolidate presidential endorsement for artists and art patrons (which, as Frank Hodsoll put it: 'the President is rather good at . . .'), Reagan then proposed to transform this original series of one-off awards into a National Medal of Arts. This was approved by Congress and enacted into law in 1984.[19] The significance of these Medals was succinctly and tartly summed up by one of their recipients, the photographer and film director Gordon Parks, in 1988: 'We need more medals and less [sc. public] money'[20]

Tax reforms

To elicit higher levels of corporate donation, the Economic Recovery Tax Act of 1981 raised the deduction ceiling for charitable contributions for companies, either cash or benefit-in-kind, from 5 to 10% of a firm's taxable income. This statutory limitation, moreover, was not as binding as it appeared to be, since any excess contribution of more than 10% in a given year could be carried over to each of the following five years.[21]

Nor, without reference to the historical context, can these figures in themselves demonstrate the full extent of the administration's determination to encourage private donations. At the time of the legislative amendment in 1981, forty-five years had elapsed since the Federal Revenue Act of 1935 first allowed the 5% deduction for corporate donations to charitable causes. However, the evidence is that corporate donors had always been giving much less than the limits would allow, and that their contributions had remained stable at about 1% or less for the previous decades (see Table 3.1).[22]

There was a modest rise in corporate contributions as a percentage of pre-tax income from 1% to 2% in the 1980s. Yet, Michael Useem, Professor of Management at Wharton School, University of Pensylvania, pointed out

Table 3.1
Total corporate contributions, and contributions to the arts, 1975–86

Year	Total contributions ($ billion)	Contributions as percentage of pre-tax net income	Percentage of total contributions given to the arts	Estimated amount given to the arts ($ million)
1975	1.20	0.91	7.5	90
1976	1.49	0.89	8.2	122
1977	1.79	0.89	9.0	161
1978	2.08	0.89	10.1	211
1979	2.29	0.89	9.9	227
1980	2.36	0.99	10.9	257
1981	2.51	1.11	11.9	299
1982	2.91	1.71	11.4	331
1983	3.63	1.75	11.4	413
1984	4.06	1.69	10.7	434
1985	4.40	1.96	11.1	488
1986	4.50	1.94	11.9	536

Source: Conference Board, *Annual Survey of Corporate Contributions*, New York, 1987, p. 27, and *Survey of Corporate Contributions*, New York, 1988, p. 35; cited in Michael Useem, 'Corporate Support for Culture and the Arts', in Margaret Jane Wyszomirski and Pat Clubb, eds, *The Cost of Culture: Patterns and Prospects of Private Art Patronage* (New York: American Council for the Arts, 1989), p. 47.

that 'changes in the deductibility elements of federal law may or may not alter giving patterns'.[23] The extent to which the growth that occurred is directly attributable to the change in the law is unclear. This is because there are several different factors that affect corporate giving, and the tax law in question is only one of them.[24] Thus, when the administration amended the tax law relating to corporate contributions in 1981, on the assumption that higher corporate giving would ensue from favourable tax write-offs, it was actually indulging in wishful thinking.

MARGARET THATCHER AND HER ARTS MINISTERS

Some months before the 1979 election, Margaret Thatcher assured Kenneth Robinson, the then Chairman of the Arts Council, that her government

would continue to support the arts, since she did not believe that 'it will make sense for any government to look for candle-end economies which will yield a very small saving, whilst causing upset out of all proportion to the economies achieved.'[25] Despite her pledge, arts expenditure for the year 1979–80 was reduced by almost £5 million in an overall budget of some £63 million.

To dispel accusations that she would become one of the most philistine Prime Ministers of the century, Thatcher pledged her approval of state subsidies in her first speech on the arts after she became Prime Minister at a Royal Academy banquet in May 1980. But her view of state patronage was categorically clear: 'You cannot achieve a renaissance by simply substituting state patronage for private patronage.'[26]

Thatcher's view was further articulated and trumpeted through her Ministers for the Arts, who changed six times during her eleven and a half years at Downing Street. Given that one of her famous adages was 'one of us', it was no surprise that her Arts Ministers toed her ideological line. Her third Arts Minister, Lord Gowrie, for example, admitted that he was 'an orthodox member of this government in terms of economic thinking'.[27]

In an interview with Frances Gibb of the *Daily Telegraph*, Norman St John-Stevas, the first of Thatcher's Arts Ministers, made his stand for commercial sponsorship without reservation:

> State-side expansion has come to an end. While the public support policy will continue, in this economic and political climate it will be totally unrealistic to look to the public sector for large sums. We must look to the private sector for new sources of money. That's where the possibilities for the future lie.[28]

The 'private sector' referred to here by the Minister includes, of course, both wealthy individuals and businesses. But it is to business that the government primarily looked by introducing substantial measures to stimulate their support.

The Arts Minister soon launched an aggressive campaign to persuade the business sector to invest in the arts. As he explained: 'Our task will be to explain and clarify, by means of leaflets, conferences, seminars, advertisements, newspaper articles, research projects, consultancy sessions, and various other devices.'[29] The crusade was intended to boost arts sponsorship,

estimated at around £4 million to £5 million in 1979, to double that figure for the coming year.[30]

In its drive to propagate the message, the government awarded a special grant of £25,000 to the Association for Business Sponsorship of the Arts (ABSA), a 'private' enterprise designed to promote arts sponsorship, which we shall consider in more detail later. The Arts Minister revealed that this was only the first step in his campaign and promised the association 'all possible support'.[31] As Kenneth Gosling, *The Times'* correspondent pointed out, it was paradoxical that the ABSA, whose aim it was to extract money from non-governmental sources, should 'procure a cheque from the Government in order to maintain itself'.[32] The paradox, however, did no more than reveal the fragile base of corporate arts sponsorship in the early days of the Thatcher era, in sharp contrast to the dominant position that business had come to occupy by the end of her period of office.

To raise the profile and recruit captains of business to join the race, a 14-strong unpaid sponsorship committee was established and chaired by the Arts Minister. The advisory group, like Reagan's Arts Committee, was a 'Committee of Honour' and served an essentially symbolic function. What really counts is not what a committee does, but who is on the committee. It is thus no surprise that such big names in commerce as Sir Nevil Macready, managing director of Mobil Oil, Sir Charles Forte, executive chairman of Trusthouse Forte, and Colin Knowles, former head of public affairs at Imperial Tobacco, were included.[33]

At the same time, as part of the Minister's campaign, the Office of Arts and Libraries (OAL) produced 25,000 copies of a booklet entitled *The Arts Are Your Business*, extolling the benefits of business sponsorship, and these were widely distributed to industry and commerce. The government did not lose sight of the bottom-line concern of the business sector, and the booklet spoke in business terms, since the Minister did not wish to suggest that 'all support of the arts from the private sector is or should be provided on a wholly disinterested basis'.[34] Among the many 'real and quantifiable commercial' benefits listed in the booklet, perhaps the most significant was the tax relief for businesses that supported the arts. The government stressed in no uncertain terms that it was now making covenanted payments 'more generous in order to encourage private giving'.

St John-Stevas's initiatives arguably provided the blueprint of the Tory

programme of arts privatisation. However, his immediate successor, Paul Channon, had a rather low profile, and Lord Gowrie, given his 'mysterious resignation' in 1985, did not stay in office long enough to implement any significant change, although it was during his tenure that the Business Sponsorship Incentive Scheme (BSIS) was launched in 1984.

Lord Gowrie's successor, Richard Luce, who came into office in 1985 and 'knew nothing about the job', ironically turned out to be the longest serving of Thatcher's Arts Ministers.[35] At the time when he was beginning to grasp his job, he shocked the arts world in a 1987 speech outlining the government's arts policy for the next five years with a quintessential dose of Thatcherism: 'There are still too many in the arts world who are yet to be weaned from the welfare state mentality.'[36] Describing his plan as 'a new departure in arts funding', the Minister introduced so-called 'incentive funding', or 'challenge funding', alongside a three-year funding system for the Arts Council.[37] The scheme, which earmarked £5 million from the Arts Council's budget, was directly related to his call for an end to the 'mentality of the 1960s and 1970s'.

What the 'new climate' required, according to the published plan, was that arts organisations become more 'financially enterprising' and 'improve their commercial management skills', thereby developing 'a sustained and reliable income from the private sector'.[38] The incentive funding scheme, which was to be administered by the Arts Council through two types of funds, the Enterprise Fund and the Progress Fund, was to match 'one Enterprise pound' for every two pounds raised from private sources.

Although the scheme was hailed as a 'new' arts policy, it was neither 'new' nor an arts policy, since it was designed to put the arts as far as possible at the mercy of the marketplace. The concept of 'challenge grant' had been in place in the United States for years, with the National Endowment for the Arts setting up a specific challenge grant program in 1976.[39] Moreover, for all the emphasis the scheme placed on income generation, it was the most financially successful companies that would be rewarded generously by public money. The whole plan had more to do with economics than with the arts.

Some account needs also to be taken of the ways in which the Thatcher government exercised political power in order to create the impetus for private arts funding. In the United States Reagan was the head both of the state

and of the administration, but in Britain, although Margaret Thatcher was the head of government, the Queen is the official head of state. Whereas Ronald Reagan raised funds for the arts by hosting extravagant galas at the White House, the corresponding role in Britain would be divided between the royal family, the Prime Minster and, to a lesser extent, her Arts Ministers. A combination of the presence of the Prime Minister and the Prince of Wales, the future king, is the highest symbolic acclaim that any business could hope for in Britain.

In 1986, for example, Mrs Thatcher invited the chairmen of 53 of Britain's leading companies to 10 Downing Street to launch a Per Cent Club, an imported American practice of corporate giving, in which companies commit themselves to contributing at least half of 1% of their pre-tax profits to the community, including the arts.[40] The approach of the club was very much in line with government thinking, and by the very action of issuing invitations herself the Prime Minister gave it her full support. Not surprisingly Prince Charles was invited to give a lecture in the following year to boost morale.

As in the United States, this (prime) ministerial symbolic support, coupled with the dark art of media manipulation, was exploited by the Conservatives to cultivate arts sponsorship. Speculative as this claim may seem to be, it is actually confirmed by a government publication on the BSIS that was intended to woo business: 'Sponsors are presented with commemorative certificates and are photographed with the Minister, MPs and the national media are invited to these prestigious events.'[41] The ceremonial function performed by the Minister was shown in its true colours by the former Arts Minister, Timothy Renton, when he said, albeit in a bitter moment: 'In a way you did your damnedest to fight for all the money you could get with the Treasury . . . for the rest of the year you were rather like minor royalty. You were asked to open things, bless statues. There are plaques all over the country that have been unveiled by Ministers of the Arts'[42]

Such political symbolism reached its peak towards the end of Mrs Thatcher's term of office when she attended the festivities accompanying *British Days in the USSR* in Kiev in 1990, a £7 million mammoth trade show combined with cultural celebrations such as an English National Opera tour, funded by the Conservative government and topped up by

corporations like Rank Xerox.[43] The meaning of the presence of Margaret
Thatcher and the Princess Royal, and indeed the essence of the whole spon-
sorship deal, was vividly summed up by Thatcher's appointee, Peter
Palumbo, the then chairman of the Arts Council: 'Rank Xerox realizes that
with the Prime Minister there to open this month of festivities, with the
Princess Royal there, and with very few photocopying machines in the
Soviet Union, they stand an extremely good chance of getting to a market
that is virtually limitless.'[44]

Relaxing tax regimes

While specific tax and legal provisions will be dealt with in detail later, the
general issue of tax policies with respect to the arts must be considered
here, in particular those tax provisions that affect charitable giving: charit-
able contributions in America, and deeds of covenant and the Gift Aid
scheme in Britain.[45] It is not only because, in translating the Republican and
Tory policies into law, these fiscal measures, more than anything else, were
central to both governments' commitment to privatisation, but also because
using tax-based mechanisms to encourage private support for the arts, or
charities in general, has far-reaching implications.

First of all, any donation to charities eligible for tax relief is a form of
disguised public subsidy, since the government actually contributes part
of the donated money by allowing the donor (individuals/corporations) to
write off the contribution when computing their income for tax purposes.
In the American system of contribution deductions, for instance, the
donor channels the entire donation, say $100, to the charity in one pay-
ment, including the taxes ($50, if the donor's tax rate is 50%) that would
otherwise be payable to the Internal Revenue Service (IRS) and the
donor's (net of tax) private contribution ($50). The donor then deducts
$100 from his chargeable income when submitting his tax return to the
IRS (see Example 3.1). The government's contribution to charity is thus
obscured.

These hidden subsidies, or, as Alvin Toffler calls it, 'patronage via the
backdoor', are by no means insignificant.[46] According to a Twentieth-
Century Fund report, tax expenditure, or in other words revenue lost through
various arts-related tax incentives or exemptions, provides more than twice

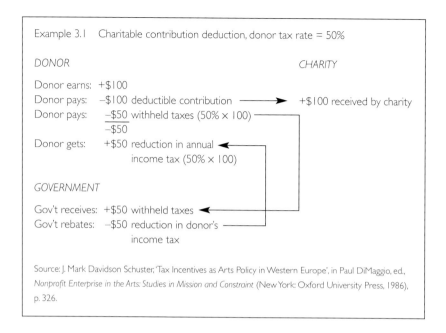

Example 3.1 Charitable contribution deduction, donor tax rate = 50%

DONOR *CHARITY*

Donor earns: +$100
Donor pays: −$100 deductible contribution ⟶ +$100 received by charity
Donor pays: −$50 withheld taxes (50% × 100)
 ─────
 −$50
Donor gets: +$50 reduction in annual ◀
 income tax (50% × 100)

GOVERNMENT

Gov't receives: +$50 withheld taxes ◀
Gov't rebates: −$50 reduction in donor's
 income tax

Source: J. Mark Davidson Schuster, 'Tax Incentives as Arts Policy in Western Europe', in Paul DiMaggio, ed., *Nonprofit Enterprise in the Arts: Studies in Mission and Constraint* (New York: Oxford University Press, 1986), p. 326.

the amount of direct subsidies to the arts from all levels of government in the United States.[47] As a result of the obscurity of these mechanisms, most American art institutions have never been made to recognise the degree of their public subsidies, and the extent to which they are a 'private' enterprise rather than a 'public' one is always confusingly ambiguous.

Secondly, tax forgone is hidden from any public scrutiny and is beyond government control, since it goes to whichever body the donor nominates and endorses. Given the graduated rates in American tax law, rich taxpayers have power over many more government dollars for each dollar of their own in their charitable contribution than do poor taxpayers.[48] Accordingly tax deductibility in America increases the decision-making power that the wealthy already have.

A powerful effect of this, and the most democratically questionable, is the behavioral differences that emerged. About half of all philanthropic gifts are made by poorer people to religious foundations, while the better-off tend to give more to civic, cultural and artistic causes.[49] While the issue of social

fairness involved is a matter of concern in its own right, it is of particular relevance to the discussion here in that it highlights one of the reasons why businesses have attempted to associate themselves with art institutions. In the same way as the upper-middle class have chosen and favoured arts institutions, whether they appear as their trustees, donors or visitors, so has business. It is this spectrum of people who count in the business mind.

This tax incentive regime, with its private outlook, underpins the bulk of philanthropic giving in the United States, distinguishing it from the rest of Western European countries in arts funding.[50] It was precisely this model of pseudo-private support that the Thatcher government and its supporters looked to with envy when struggling to raise private money. It stands in stark contrast to what the Conservatives explicitly opposed in the 1960s:

> We are not in favour of this country following the American example of allowing individual citizens to set against their income tax liabilities the money spent on buying works of art [for eventual donation]. . . . It enables very rich people to buy works of art for their personal enjoyment during their lifetime more or less at the taxpayer's expense. The national collections should be added to by curators, not by business tycoons.[51]

Before Mrs Thatcher came to power, the major tax incentive device in Britain was the deed of covenant, through which companies could give donations to charities, and most British arts institutions, including museums and art galleries, were, and still are, legally registered as charities. A deed of covenant bound a covenantor to make donations to a charity over seven years since the 1922 Finance Act introduced this form of legal agreement for the first time.[52] This distinctive feature of long-term commitment (instead of one-off donation) has provided arts organisations, and charities in general, with an assured source of income over several years.

In contrast to the American charitable contribution deduction, in the British deed of covenant the donor makes a payment to the charity net of the basic-rate income tax and pays the tax to the Inland Revenue, which the charity concerned can then reclaim from the Inland Revenue (see Example 3.2). The British system thus has the advantage of clarity as regards the origin of the funds in that it separates the flow of money into

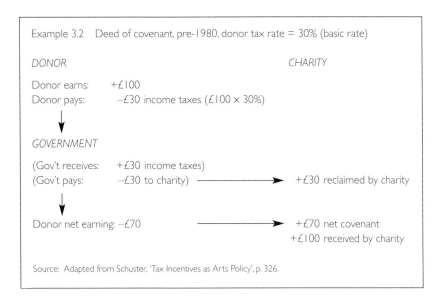

Example 3.2 Deed of covenant, pre-1980, donor tax rate = 30% (basic rate)

DONOR *CHARITY*

Donor earns: +£100
Donor pays: −£30 income taxes (£100 × 30%)

GOVERNMENT

(Gov't receives: +£30 income taxes)
(Gov't pays: −£30 to charity) ⟶ +£30 reclaimed by charity

Donor net earning: −£70 ⟶ +£70 net covenant
 +£100 received by charity

Source: Adapted from Schuster, 'Tax Incentives as Arts Policy', p. 326.

two streams: the private contribution flowing from the donor to the charity, and the tax forgone flowing into government and reclaimed by the charity.[53] Despite its bureaucratic cost, this distinction is significant not only in that the government contribution is unmistakable, but also because the charity has control over the taxes that it claims back from the Inland Revenue, with none of the donor restrictions that often obtain in America.

However, these distinguishing characteristics were eroded by successive tax changes under the Thatcher government, which single-mindedly devoted itself to 'liberalising' the tax regime for private giving. The first Finance Act, introduced in 1980, substantially shortened the minimum covenant period from seven to no less than three years. The amendment was designed to make the scheme more attractive to the donor, since in a world of economic uncertainty, it is reasonable to assume that one does not want to be tied down by financial commitment for a long period.[54] The 1980 Finance Act was a watershed for British charities, since it also reintroduced relief for the higher rate taxpayer, which had been withdrawn in 1946, with

the same effect as the graduated tax rates in America, where it costs richer people much less than poorer people to give to charities.

Under the 1986 Finance Act the companies (other than close companies) were further allowed to deduct charitable contributions up to a limit of 3% of dividends paid.[55] This significant measure, providing an easier alternative to charitable giving than the more onerous contractual agreement through deeds of covenant, brought the British system into line with American contribution deductions. Given such a historic departure, subsequent Finance Acts only served to relax tax law still further.

The Finance Act of 1987 introduced a completely new method of tax-effective giving to charity in the workplace, known as the Payroll Giving scheme (or Give As You Earn). Taking advantage of the workplace as a convenient collecting point, the scheme allowed donations to be deducted from the employee's income by the employer and passed on to a charity of the employee's choice.[56] This change deserves note here insofar as corporate giving does not operate in isolation, and one cannot understand the full significance of the Thatcher government's resolution in pursuing private money without understanding how its tax reforms related to individuals.

The advent of the 1990s witnessed one further Conservative tax reform as the Gift Aid scheme came into effect on 1 October 1990. This scheme, which designated tax relief for non-close companies, already introduced in the 1986 Finance Act as Gift Aid, was far from being simply an exercise in semantics. By extending relief to close companies and individuals, the scheme sought to lure all private sector businesses with a bait of tax redemptions. The statutory limitations, according to which each single cash gift had to be at least £600 and the total of gifts in any tax year did not exceed £5 million, was soon to be considerably relaxed.[57] The 1991 Finance Act furthermore abolished the upper limit of £5 million altogether, an unusually generous tax incentive and virtually unprecedented in other European and North American countries.[58]

CASH HANDOUTS

As if it were too impatient to wait for the results of tax relaxation to come through, the Thatcher government set up a Business Sponsorship Incentive

Scheme to hand out cash inducements for business sponsors in 1984. The scheme, run by the ABSA on behalf of the OAL and the Department of National Heritage (now the Department of Culture), matches sponsors' money at different ratios, in particular favouring first-time sponsors. The maximum sum for any single sponsorship could be up to £35,000.

The position of the government was crystal clear: one of the criteria for assessing applications was that the BSIS award should be of some significance in attracting sponsors, since the scheme was intended not as a reward for arts groups, but rather to provide greater value for corporate money. The proposed use of the award money should therefore provide 'greater benefits for the sponsor'.[59] The benefits in question included such things as an extra event, extra advertising of the sponsored event, or the extension of a tour to further venues to 'ensure that businesses receive a better value sponsorship'. For instance, the TI Group, the engineering conglomerate, was rewarded with £20,000 for its sponsorship endeavour at the Royal College of Art in 1992. The company in turn used the money to mount two annual exhibitions at the College and credited itself as sponsor.

Unlike the American matching grant model, on which it was patterned, and in which public sources lead, the scheme virtually entrusted business with the power of using taxpayers' money. In other words, the government was putting public money into the corporate purse, and companies could then avail themselves of this for their advertising campaigns. What made the scheme all the more intriguing was its manifest contradiction with the Thatcherite logic of the free market. For all its ideology of non-interference, government did in fact intervene in ways that massively benefited the corporate order.

The willingness of the Thatcher government to follow the American style of arts patronage has, I hope, been clearly demonstrated. Its ideological commitment even led to its outstripping the model it sought to emulate. In any case, it is clear that corporate power, which is primarily based on financial capital, was substantially strengthened by public policies under both the Reagan administration and the Thatcher government. To map out the effect of such changes in policy on public art institutions, we must now turn to an examination of the Arts Council of Great Britain and the National Endowment for the Arts in the United States.

THE ARTS COUNCIL OF GREAT BRITAIN AND THE
NATIONAL ENDOWMENT FOR THE ARTS

The predilection for privatisation in the cultural sphere that Reagan and Thatcher shared is nowhere more evident than in their policies toward the NEA and the ACGB respectively. The transformation of these public arts agencies into paragons of arts privatisation was to take place at every level, from the organisational to the ideological. Nonetheless any radical changes in public arts funding were likely to run up against vigorous resistance, as evidenced by the abortive attempt of Reagan's administration to abolish the NEA. Both the Reagan and the Thatcher administrations therefore decided not to opt for major structural reorganisation, but to use existing organisations as instruments for their policies.

As the priorities and policies of both agencies are largely shaped by the chairman/secretary-general and the senior staff that he or she hires, Reagan and Thatcher had only, in order to alter their direction, to install political placemen in the two agencies, who would in turn hire staff that reflected their political orientation. Thus, although the formal structure of the agencies remained the same on the surface throughout the eighties, their inner mechanisms and aspirations were undergoing a radical change. Apparently in both cases the agencies witnessed an increase in the chairmen's power. The potential for this was already present within the organisational structure, but it had not been used in such a blatant way for political reasons before.

During the eighties the two institutions had taken, or, more precisely, had been forced to take, active steps to advocate private support, especially business sponsorship, both for themselves and for the arts bodies they funded. The thrust of this ideological commitment was not just a matter of extracting more arts money from the private sector. Unwavering faith in the marketplace, shared by both the Reagan and Thatcher administrations, compelled both agencies to run their affairs in a more business-oriented manner. Agency bureaucrats in the eighties patently spoke in a totally different language. Gone were the arguments of money for value, instead came monetarist talk of value for money. To quote from the Arts Council's own statement: 'The arts are not different; they are competing with everybody

else for the consumer's time, interest or money, and an effective marketing programme must be at the core.'[60] The catchphrases of the new order of Thatcherism and Reaganism were therefore entrepreneurial skill and business acumen. The signal of this transformation of the public arts agencies could hardly have been clearer: one of the Arts Council's publications in 1987, announcing the £5 million incentive fund, is succinctly entitled *Rewarding Enterprise*.

THATCHERISING THE ARTS COUNCIL

The intention of the Thatcher government to impose its ideological template on the Arts Council is unmistakably evidenced by the chairmen it appointed: firstly, the replacement of Kenneth Robinson with Sir (now Lord) William Rees-Mogg in 1982, and secondly the selection of Peter (now Lord) Palumbo in 1989. These appointments were decisive. By statutory provision, the Council is composed of unpaid members and is the governing body of the Arts Council despite its non-executive role. As the head of the Council, the chairman thus has the ultimate authority of overseeing the institution. To the extent that the chairman thinks fit to exercise it, his power can determine the direction of the Arts Council and the way in which it works.

Accordingly, without changing its actual structure, the government was able to shape the Council, regardless of the notoriously ambiguous principle of 'arm's length'. William Rees-Mogg, an outspoken supporter of Thatcher's economic policies, and Peter Palumbo, a successful developer well connected in both the art and business worlds, were both appointees perfectly attuned to the Thatcherite ethos. To quote Raymond Williams, the true social process of British quangos such as the Arts Council is one of 'administered consensus by co-option'.[61]

It was therefore only logical that Rees-Mogg in turn appointed Luke Rittner as the secretary-general in 1983. Until his appointment to the Arts Council, Luke Rittner was director of ABSA, a position he had held since its formation in 1976. The promotion of Rittner from the head of the then obscure corporate sponsorship organisation to that of a national public arts agency with a staff of over 300, remarkable not least because of his youth,

signalled the persistent efforts of the government to instil the principle of sponsorship in arts funding.[62] Rittner, as the founding director of ABSA, was just the right young man with the necessary business contacts to promote the enterprise ethos in the arts.

The energy of this entrepreneurial duo in the earlier days was, however, absorbed by the imminent problem of devolution. This was highlighted in 1984 in their publication *The Glory of the Garden*, and the take-over of the South Bank Centre from the Greater London Council, following its abolition by the Conservative government in 1986. The result of the pair's efforts in promoting business sponsorship therefore only became clear in the later years of the 1980s, in the operation both of the Arts Council as a whole and of the visual arts department.

In order to establish a systematic approach to enterprise culture, a new Department of Marketing and Resources was set up in 1987 to help clients' organisations as well as the Arts Council itself to improve their marketing and fund-raising skills. Little wonder that the new department was to be a 'promoter of enterprise, partnership and efficiency'.[63] The organisational change signified an important step in the Arts Council's long crusade for corporate money. The Arts Council, for all its class-bound tradition, was used as a public resource, but since that time it allowed itself to become a marketing arm of the corporations. Not only did the Arts Council and the business world coalesce in the name of advancing the arts, but as the national arts funding agency, the Arts Council urged the subsidised arts organisations in the country to follow suit.

The Arts Council pursued commercial sponsorship in two ways: firstly through publicising and openly endorsing the practice, and secondly by collaborating closely with business itself. In its 1987/88 annual report the Arts Council addressed itself directly to business people for the first time in its more than forty-year history. Subsequently business sponsorship regularly featured in its various publications. For instance, Ian Rushton, the group chief executive of Royal Insurance, was invited to voice his opinions on business and the arts in the Arts Council 1988/89 annual report.[64] This space, which used to record the activities of the public arts agency, thus became 'corporatised', a forum for business people to advocate enterprise ideology.

Meanwhile the Arts Council began by practising what it preached – to attract commercial sponsorship for its projects alongside public money.[65]

Within the first two years of the existence of the Marketing Department, the Arts Council had successfully attracted sponsorship for its own programmes from a broad spectrum of the business world, including companies such as Coopers and Lybrand, the National Westminster Bank and ICI. That it was able to do so is, of course, not surprising as the Arts Council is one of the principal state institutions of contemporary culture in Britain.

When Peter Palumbo arrived as chairman in 1989, he reiterated the need for a concerted effort to pursue sponsorship in his first statement in the Arts Council's annual report: 'I am convinced that the way forward for the arts in this country must be by means of a partnership between public and private sector funding.'[66] A specific Sponsorship Unit was thus created within the Marketing Department in 1989 'to develop fruitful long-term relationships between the Arts Council and businessmen'.[67] Such was the momentum of sponsorship that within a few years the Arts Council had launched several projects financed by companies, such as the Arts Council/Midland Bank Artscard in 1989, the Arts Council Award presented in association with Prudential Arts Awards in 1989, and the Arts Council/British Gas Awards – Working for Cities in 1991.

A closer look at the specific role that the Arts Council played in this so-called 'partnership' is relevant here. For instance, when every Midland Artscard holder used the card for the first time, the bank contributed £5 to the arts. After that, every time a cardholder spent £100 with the card, the bank donated 25 pence to the arts.[68] For all its talk of supporting the arts in the press, the Artscard was just an ingenious marketing strategy designed to enable the bank to break into the oversaturated credit card market by attracting an arts audience, which happened, by and large, to be the affluent upper-middle class, the most welcome customers of any financial institution. To quote its spokeswoman: 'At the time we were looking for a new product to appeal to new cardholders and . . . hopefully end up with a profitable card scheme.'[69]

Homogeneous as it is, the arts audience is perceived to be much more easily targeted than general consumers. The most reliable way to reach this group is through the arts organisations that such people favour and in which they participate as members. Yet to ask arts organisations to 'sell' their membership lists is too nakedly commercial and ethically dubious to be successful. This is where the intermediary role of the Arts Council

comes in. When the Arts Council was asked by the bank to write to arts organisations on its behalf to promote the scheme,[70] the 'own label' marketing device of the big corporations not only looked less commercial and ostensibly disinterested, but also was legitimised with 'state approval'. The power relation between the granter (the Arts Council) and its grantees (the arts organisations) was cleverly and successfully exploited by the bank.

It is precisely because publicly funded arts organisations such as the Arts Council function as a branch of the state, in however disguised a way, that business seeks to capture it so as to claim for their arts intervention the legitimacy associated with public institutions. Without the varnish of public credibility provided by association with the Arts Council, this brand marketing could not function so effectively.

Ironically the chairman of the Arts Council actually took pride in this sort of co-operation. To quote Peter Palumbo: 'I applaud Prudential's generous and far-sighted commitment to the arts especially through the Prudential Awards. . . . We are proud to be associated with the Prudential Awards through the Arts Council Award.'[71] What should concern us in partnerships of this kind is the extent to which the Arts Council has allowed itself to become the tool of business. More than rhetoric is at stake here. Not only have the concepts of sponsorship as a marketing exercise and 'altruistic' commitment to the arts become blurred, but also the symbolic power of state institutions such as the Arts Council has been mobilised to validate corporate power.

Within the Arts Council, the Visual Arts Department was inevitably infused with the new spirit of enterprise. Unlike other departments at the Arts Council, the Department was heavily involved in generating its own exhibition programmes instead of responding to the initiatives of other organisations through its grant-making mechanisms. Half of its budget had been spent on its own activities. In the changed era of the 1980s, the Arts Council Collection and the galleries that it organised had now to go out and find private sponsorship.

For years the Department had directly operated two exhibition spaces in Central London: the Serpentine Gallery in Hyde Park, and the Hayward Gallery at the South Bank Centre arts complex, the latter being at the top of the Arts Council's gallery pecking order. In the mid-eighties, Julia Peyton-

Jones, now director of the Serpentine Gallery, was recruited on a part-time basis to raise funds for exhibitions at the Hayward Gallery. Subsequently the Serpentine Gallery 'went independent' in August 1987, and the Hayward Gallery was handed over to the management of the South Bank Centre in April 1988, which had also taken over responsibility for the Arts Council Collection and National Touring Exhibitions.[72] These structural changes indicate quite clearly that the Arts Council decided to be consistent with its policy of not being a provider of arts events but a grant-making agency. More importantly, these two galleries had now the 'complete freedom' to find commercial sponsors. To quote Antony Thorncroft, *The Financial Times'* arts correspondent: 'There may be no reason why the South Bank should not prove one of the more conspicuous successes of privatisation.'[73]

In the meantime, before the Arts Council Collection was handed over to the South Bank Centre, the Department was also busily engaged in raising sponsorship for purchases for the Collection. In 1987 the Department successfully secured sponsorship from English Estates for the exhibition organised by the regional touring service, *Introducing with Pleasure*. Although English Estates is strictly speaking a public agency rather than a commercial company, it nevertheless markets itself as if it were a commercial one.[74] Precisely because it is that peculiar creature of Thatcherism, a public institution in the private sector, its sponsorship is all the more illuminating for the purposes of this study.

In addition to exhibition sponsorship, English Estates also donated £15,000 to purchase paintings by Paula Rego and Thérèse Oulton for the Arts Council's collection. For the first time in its more than forty-year life, the Department occupied itself with securing 'corporate' money to fund purchases for the national collection of contemporary art. For the financial difficulties facing the collection, whose budget had been slashed from £102,000 in the early eighties to £70,000 in 1987/88, commercial sponsorship seemed to be the only way forward. The message was publicly advertised in a leaflet promoting the collection and English Estates' sponsorship: 'Private patrons and public company sponsors are now actively sought for such purchases. Sponsors are credited wherever and whenever acquisitions made with their funds are on view.'[75]

Ironically, while its curator had been seeking funds from the commercial sector to maintain the Collection, the Chairman of the Arts Council, Peter

Palumbo, ventured to cash in on the Collection. The developer-chairman did not lose sight of the market value of the Collection, with its works by star artists such as Francis Bacon, Henry Moore and David Hockney; a Bacon could have fetched £3.5 million at the time. He decided either to sell it or set it up as collateral against the loan for the Opera House, regardless of his earlier praise of the collection: 'the Council values its Collection for the enormous pleasure the works bring to thousands of people each year.'[76] Lord Gowrie, then chairman of Sotheby's, was invited to start a valuation.[77] In the event the sale was terminated not because the public ownership of a contemporary British art collection mattered to the entrepreneurs of the eighties, or because it was an insult to a forty-year commitment to public collecting, but simply because Palumbo learned that he could not sell the Collection legally, or even if he could, that the proceeds would have gone to the Treasury.

Perhaps the most illuminating example of the commercialisation of public sector arts in the eighties is an internal document from the Visual Arts Department. Writing in 1990, the Department was looking for a development consultant: 'to develop new retail and marketing opportunities, to seek corporate, business and trust fund support for programmes of funding and collaborate in new enterprises initiated by the Visual Arts department'. The ethos of the enterprise era under the Thatcher government could hardly be stated more clearly.

THE NATIONAL ENDOWMENT FOR THE ARTS UNDER FRANK HODSOLL

In America, the extent of co-operation between the NEA and the business sector in the 1980s is not as pathbreaking as that between the ACGB and corporate enterprise. This is primarily because the NEA does not provide operating expenses for arts organisations, and its enabling legislation also mandates that it can only provide up to 50% of the cost of any project that it funds.[78] Implicit in this matching grant is the fact that the NEA has always had some sort of partnership with other funding resources, either state arts agencies or the private sector. Indeed, Nancy Hanks, who presided over the Endowment in the seventies, was herself an advocate of private

initiatives, perhaps partly because of her long-standing association with the Rockefeller family and the Rockefeller Foundation.[79] As a result, the pursuit of corporate dollars in the NEA's policy during the 1980s was not such a dramatic departure as it was in the case of the Arts Council, but more a matter of intensification of established policy. Nevertheless, there were definite changes in the Reagan-era NEA.

The administration exercised control over the Endowment by choosing a political ally of the President to chair it.[80] Frank Hodsoll, who under the Reagan administration would lead the Endowment for eight years from November 1981 to February 1989, came directly from the White House, the first lawyer and the first career government official to assume the chairmanship. He was a former Foreign Service officer for 16 years, had held many positions at the Department of State, and was, before his appointment as NEA chairman, deputy to White House Chief of Staff James Baker.[81]

While denying that he was a 'political apparatchik', Hodsoll did not conceal his political loyalty when he testified before the Senate Committee on his nomination: 'Needless to say, I would not be here if I did not fully sympathize with what the President is trying to do with regard to that [budget cuts].'[82] His reservations about the record of public arts funding were also revealed in an interview: 'It's not entirely clear to me that there is anything vital that's going to be lost because of the cuts.'[83]

Despite insisting that the White House had no political agenda for the arts, Hodsoll brought significant changes to the Endowment. Both Reagan and Hodsoll appointed conservatives to the key positions at the Endowment, people who had a proven track record in their political ideology rather than arts expertise.[84] For example, Reagan named Samuel Lipman, the publisher of the conservative magazine *The New Criterion*, to the National Council on the Arts, an influential advisory committee to the Endowment, and Ruth Berenson, whom Hodsoll appointed as the associate deputy chairman for programs, was an art critic for the conservative *National Review* and described herself as a 'Reagan conservative'.[85]

The chairman's power

Once in office, Hodsoll was quick to put his personal stamp on the Endowment, centralising the authority within the chairman's office. By

statutory provision the chairman had the ultimate authority to make the final decision on all grants, on the recommendation of specialised panels and the National Council on the Arts. In practice, those who had chaired the agency previously had viewed their role as nearly automatic in relation to the panel-Council's recommendations and almost never used their power to overturn them. Livingston Biddle, Hodsoll's predecessor, once commented: 'I would never think of myself as reversing panel-Council decisions', and he did not remember one instance of his overruling either a panel or Council recommendation during his entire four-year tenure.[86]

Hodsoll did not hesitate to interfere directly in the grant-making process. He took an active role in overseeing and questioning the peer review panels, and his deputy, Berenson, was said to have read 'almost all' grant applications before they went to the chairman for approval. In the first year of his tenure at the Endowment, Hodsoll exercised a 'chairman's veto' on 20 out of a total 5,727 panel-endorsed applications.[87] Not even a small grant could escape his scrutiny. For instance, small publication grants for New York's Heresies Collective and Political Art Documentation Distribution, to support a series of public forums at which prominent radical artists and critics such as Hans Haacke, Martha Rosler and Lucy Lippard would participate, was rejected by the chair despite the endorsement both by the peer review panel and by the National Council.[88] Responding to charges of 'political censorship', Hodsoll was quick to deny that his veto had been in any way politically motivated.

In other instances the peer panel's recommendations did not even reach the National Council meeting, because they were 'hijacked' by the chairman's office, despite the fact that this was contrary to the legal provisions governing the Endowment. According to Michael Faubion, deputy director at the Visual Arts Program, Hodsoll 'usually would not intercede unless he felt there would be a political problem there'.[89]

Shortly after he became chairman, Hodsoll established an Office for Private Partnership in 1982 'as a way of bringing together the arts and businesses in partnership ventures'.[90] The fact that the deputy chairman for private partnership was given the same ranking as the deputy for programs and public partnership demonstrates the seriousness of Hodsoll's aim to strengthen the ties between the Endowment and business. The project unexpectedly failed because, according to an insider, the deputy chair

appointed was a 'political appointee' whom Hodsoll did not appreciate, and as a result the office lost the high profile it enjoyed at the beginning.[91]

Art in the marketplace

To translate his conservative ideology into the administration of various programs at the Endowment, in particular the Visual Arts Program, Frank Hodsoll brought with him a sturdy faith in the marketplace. Speaking at the Conference for the Media Arts in 1983, Hodsoll summed up the NEA's position: 'Commercial films are as much art as non-commercial ones. . . . We've got to bring the two together.'[92] He thus urged his audience to look to the film and television industries for support.

Interviewed earlier in the same year, he articulated the same agenda for the Visual Arts Program. Stating that there was a natural relationship between the Endowment and the commercial film and theatre industries, he expressed the view that he would like to see a similar relationship established between the visual arts and commercial gallery system:

> We need more input at the Endowment from the galleries. In my view, most artists would like to have a commercial gallery. We need to help artists get gallery representation. For younger artists, peer support . . . remains the most important element. But in the end, over time, an artist's reputation is made in the market.[93]

To implement his ideas, Hodsoll appointed the artist Benny Andrews as the new director of the Visual Arts Program in the summer of 1982. Andrews was a firm believer in the market system, and Hodsoll reportedly remarked of him: 'Benny is a professional painter with gallery affiliation.'[94] It was no surprise that Andrews echoed Hodsoll's sentiment by saying: 'The people who set up the alternative spaces, they kept a certain attitude, an anti-commercial attitude. But most artists don't see anything wrong with selling. And it's the job of the Endowment to respond to artists' needs.'[95]

Other changes within the program soon followed. The program's Policy Advisory Panel, which makes policy recommendations, changed its name to the Overview Panel, and as a result of the consolidation of the power within the Endowment, its panellists now served at the discretion of the program

director.[96] The panel, which had formerly consisted entirely of artists, critics and alternative space directors, for the first time included an art dealer, Ronald Feldman, who was appointed in 1983 to be a voice for the private sector.

Within the program, alternative spaces, later categorised as Visual Artists Organisations by the Endowment, came under close scrutiny.[97] The movement to create alternative spaces, initially generated by artists in the late sixties, was conceived as an alternative to mainstream art museums and commercial galleries, which at the time were either unwilling to take on emerging art forms such as performance art, or were rejected by artists on ideological grounds. But for the conservatives, alternative spaces were, to quote Hilton Kramer, 'licensed rebels at the taxpayers' expense', a sort of 'negative cultural luxury' and 'the permanent wards of the government patronage system'.[98]

With the arrival of Hodsoll and Andrews, there was an attempt to force a market orientation on these galleries. Andrews reportedly first sought to provide these organisations with mechanisms for selling the works they showed, only to be greeted with indifference from the directors of these spaces. He then drew up plans to help these organisations to pursue private sector money. The idea of commercialising these spaces, which were founded in the first place to confront the commercialism of the art world, is paradoxical to say the least.

But during Benny Andrews' two-year term as director of the Visual Arts Program, the most controversial initiative was the suspension of the funding category of Art Critics Fellowship Program by Hodsoll.[99] The fellowships, initiated in 1972 and suspended for three years from 1981 to 1983, were meant to be reinstated in 1984 on the Overview Panel's recommendation. As the Hodsoll-initiated 'agency-wide exploration of fellowships' got underway, John Beardsley, an outside writer, was commissioned to research into the critic fellowships.[100]

Basing himself on the market-oriented approach of Hodsoll, Beardsley emphasised the importance of 'promoting a criticism that, while intelligent, is also intelligible to the layman', and concluded that the 'daily newspapers and mass market periodicals . . . offer the best hope of an *independent criticism* [italics added]'.[101] By quoting Beardsley's report, Hilton Kramer launched a fierce attack on the program in the *New Criterion*, which Samuel Lipman, who, as mentioned earlier, served at the National Council, in turn

used as evidence in his attempt to end critics' funding.[102] Siding with Lipman and Kramer, Hodsoll overturned the panel recommendations and put the critics' fellowships on hold indefinitely. Whatever the 'merits' of abolishing the critics' fellowships might be, this time Hodsoll overturned not just an individual grant or two, but the entire fellowships program, a testimony to the power of the chairman and of the 'well-placed' conservatives on the National Council.

The business of prize-giving

The first priority of the Visual Arts Program were the fellowships. But the prospect of finding corporate sponsors to match the fellowship money was considered not only difficult but ethically questionable, as the predecessor of Benny Andrews, Jim Melchert, once admitted: 'The idea of Exxon–NEA fellowships makes me very uneasy. Many artists would just turn them down.'[103] The only exception to this rule within the program proved to be the model example. Along with the Rockefeller Foundation and the Equitable Life Assurance Society in New York, the Visual Arts Program co-funded the project Awards in the Visual Arts (AVA) from 1982 to 1992. Although conceived before Hodsoll's arrival at the NEA, the AVA was operative under his chairmanship for the greater part of its existence. The combination of private and public support for the arts could not have been closer to his ideal.

The AVA, organised by the Southeastern Center for Contemporary Art (SECCA) in Winston-Salem, North Carolina, was a national annual program to award ten $15,000 fellowships to artists of 'significant artistic achievement' in ten designated regional areas encompassing the whole country.[104] The awards were unique in concept. Apart from the money, AVA also provided a tour of seven to ten works by each of the winning artists to three museums across the country, with a well-illustrated catalogue and purchase funds of $5,000 available to the participating venues to acquire works from the exhibitions for their permanent collections.

Largely because of the former NEA chairwoman Nancy Hanks, who, at the time, sat on the boards of both the Equitable and the Rockefeller Foundations, Equitable joined in supporting AVA.[105] According to Miranda McClintic's report in 1985, AVA was one of the Equitable's major programs

of arts sponsorship and 'the only instance of its support going beyond just giving money'.[106] To say that Equitable sponsored AVA for the sake of public relations is to state the obvious. Nor did Equitable's executive, David Harris, who was one of the original founders of AVA, deny this: he expressly stated that Equitable would like more visibility for the program without affecting its artistic integrity.[107] Many AVA exhibitions toured various parts of the country where there were Equitable offices. The company sponsored the receptions at each museum opening of the exhibitions, and these were, according to an insider, 'a tremendous cost' on top of the sponsorship money already committed.[108]

More significantly, according to a spokesperson at the Endowment, one of the motivations of its involvement was that Equitable used AVA 'as an iden-tification mechanism, to identify artists around the country' whose reputation perhaps was not widespread, but, 'through the panel and nomi-nation system of AVA, would be identified'. Equitable then bought their works to add to its corporate art collection. Understandably Equitable's spokesperson defended Equitable's involvement by saying that it was 'not quite as self-serving as that'. But the fact remains that between 1979 and December 1984 (the only years for which data are available) when SECCA advised and helped develop its collection, Equitable bought a total of 164 works from 74 artists, which included 13 works by 7 AVA winners and 32 pieces by 15 AVA nominees.[109]

As further proof of the seriousness of Equitable's involvement in AVA, the company was also reported to have provided SECCA with additional money to purchase a computer system and software, along with consultants, to set up a database to keep track of all the nominated artists. Given the sharp eye it kept on the market as a financial house, it is not too far-fetched to suggest that Equitable was anticipating that those artists whose works they bought from AVA would be tomorrow's blue chips. The combination of the two highly regarded institutions, one an established art gallery, SECCA, and the other the federal art agency, gave AVA an unprecedented credibility that Equitable would not have secured in any other way. The fact that almost none of those AVA-related works in the Equitable collection emerged to be 'a great investment', in Ms Stave's words, the then curator of the Equitable, by no means undermines the hypothesis advanced here concerning the motives behind Equitable's sponsorship.

While admitting to McClintic in 1985 that the AVA had not been particularly effective for the company in terms of public relations, Equitable received considerable 'adverse publicity' in 1989. One of works in the 7th AVA exhibition, *Piss Christ*, by the award artist Andres Serrano, sparked a series of robust attacks from conservatives such as Donald Wildmon, a United Methodist minister and executive director of the American Family Association, which drew the attention of the national media.[110] *Piss Christ*, a photograph of a plastic crucifix submerged in a jar of Serrano's own urine, was seen by its critics as 'morally reprehensible trash' and 'blasphemy paid for by government'. Facing the outcry, Equitable withdrew its support from the museum.[111] As a touch of irony to the drama surrounding Serrano's work, we may note that conservatives such as Representative Dick Armey (Rep.–Texas), when assailing the Arts Endowment in Congress, proclaimed: 'The arts do serve a role of probing the frontiers, but I would say let that be funded from the private sector.'[112]

With the withdrawal of Equitable's sponsorship from AVA, BMW of North America took over its funding role in 1989. In the heyday of corporate intervention in the late eighties, BMW's agenda for AVA was not a small one. As part of the sponsorship deal, the AVA touring exhibitions stopped over at the so-called 'BMW Gallery' on Park Avenue in New York every year, in addition to travelling to the three museums it used to tour across the United States.[113] This, of course, put the 'BMW Gallery' on a par with the well-established public art museums in the tour, such as the High Museum of American Art in Atlanta, Georgia, and the Hirshhorn Museum in Washington, DC, while, in reality, the 'BMW Gallery' was a showroom of luxury cars in disguise.[114] It is little wonder that only selections of the AVA tours were shown at the 'BMW Gallery'. Any works not compatible with car selling were unlikely to be shown in such a commercial space.

As the Arts Council of Great Britain and the National Endowment for the Arts are among the most important arbiters of contemporary culture in their respective nations, their active promotion of business intervention in the arts, endorsed and prompted by Reagan and Thatcher's cultural policies, had a spiralling effect on the national cultural scenes on both sides of the Atlantic. They set the model for other arts groups to follow and became examples of enterprise. While corporate intervention in the contemporary art world will be the subject of the next chapter and beyond, it is necessary

first to look at the trade associations of the business art sponsors in both countries, since these provided business people with the forum from which to trumpet their causes.

THE BUSINESS COMMITTEE FOR THE ARTS AND THE ASSOCIATION FOR BUSINESS SPONSORSHIP OF THE ARTS

As the Arts Council of Great Britain is to the National Endowment for the Arts, so the Association for Business Sponsorship of the Arts (ABSA) in Britain is to the Business Committee for the Arts (BCA) in America. But while the NEA had to model itself on its British precedent, ABSA followed its American counterpart.[115] This contrast is of significance in that it highlights the differences in the traditions of funding of the arts in both countries as they are generally perceived. In the case of ABSA, seed money had to be injected from the government to get the organisation off the ground.

As the trade associations of corporate patrons of the arts, the BCA and ABSA serve basically similar functions: both exist to encourage and develop business support for the arts and to increase the visibility of corporate arts intervention in British and American society. This certainly does not imply that they are in the same rank as the ACGB and the NEA, but it is no co-incidence that most of the people in the arts world whom I interviewed almost automatically referred to them as the ultimate sources of information on business sponsorship.

It is no easy task, however, to gain access to these essentially for-members-only clubs for either research purposes or to have first-hand information. Despite the fact that the BCA is registered as a non-profit organisation and ABSA as a charity (with the implication that both serve the public interest), both claim to be 'private' and access to their records is very difficult, if not impossible.[116] Why they see fit to operate under such cloaks of secrecy is difficult to ascertain. Those tempted by conjecture might assume that they must have something to hide. Moreover, because of the fact that neither association is a grant-making agency and hence not news-worthy, there is a dearth of secondary material on them, except what they

themselves or their associates choose to publish. What is presented below must necessarily be considered with this limitation in mind.

The origin of the BCA is significant both in its timing and in its inspiration. Immediately following the establishment of the NEA in 1965, it was David Rockefeller who first entertained the idea of setting up a businessmen's council on the arts. As he stated in an address at the National Industrial Conference Board in 1966: 'I would like to propose that we seriously consider the establishment of a comparable organization for the arts – a Council on Business and the Arts.'[117] It came as a surprise to no one that the two Rockefeller brothers each provided $50,000 of the initial seed money for the Business Committee for the Arts, which officially opened its doors in January 1968.

In essence, the Committee was, and remains, an exclusive club for the higher echelons of business. This exclusiveness is embedded in the structure of the organisation, since membership is by invitation only. Not every chief executive officer of a company with an arts program can join in, but only the heads of the largest organisations.[118] It is no wonder that by 1990 the BCA had only about 130 members nationwide.[119] Neither is an organisation of this kind intended to open a genuine dialogue between the arts and business, since no arts representatives are included. As G. A. McLellan, its first executive president, remarked: 'We will never be able to get a group like the BCA to sit down with comparable arts organizations for the type of dialogue that we would all like to see happen.'[120]

The main purpose of the BCA is 'to bring information about business support of the arts to businessmen, and to induce them to become actively involved in the arts'.[121] It represents a conscious and organised effort on the part of blue-chip companies to enhance the visibility of business support for the arts, both in order to convince the unconvinced of its value to business, and to champion the benefactor face of business to the general public. Business concerns are their alpha and omega. One of a series of leaflets published by the BCA in 1986 with the revealing title *Involving the Arts in Advertising* proclaimed:

> Many companies go beyond underwriting arts programs and shows; they also advertise them. . . . By promoting and advertising arts programs, your company not only makes them available to a broader audience . . . you also make sure your

company is not hiding its light under the bushel. . . . If they appreciate your efforts, it may help them decide to do business with you.[122]

Following its American cousin, ABSA was founded by a group of six companies in 1976 to promote and encourage the concept and practice of business sponsorship of the arts in Britain. The leadership, this time, was provided by Tony Garrett, at the time chairman of Imperial Tobacco, with a start-up grant of £15,000 from the then Labour government.[123] The role of Imperial Tobacco in initiating ABSA is of course highly significant, since tobacco advertising is not only a contentious issue but also severely restricted by law. As a prominent arts sponsor of the seventies, Imperial Tobacco was keen to ensure that its image as a public benefactor was fully acknowledged. As its spokesman candidly commented: 'We are in the business of generating publicity.'[124] It is little wonder that Antony Thorncroft, *The Financial Times*' correspondent, pointed out that 'ABSA sees itself as a propagandising unit.'[125]

However, unlike the BCA's closed clubbiness, ABSA's membership is open to all industrial, commercial or business organisations based or operating in Britain, and by 1994 the ABSA had over 300 members, which provided the majority of its finance. Basically modelled on the activities of the BCA, ABSA advises its business members on sponsorship opportunities, produces publications to champion the practice, lobbies on behalf of members for increased tax incentives, improved sponsorship credits in the media and other related issues.

And above all from 1978, ABSA presented corporate sponsors with 'prestigious' annual awards, in emulation of American practice. The so-called ABSA/*Daily Telegraph* Awards started with ten awards in four categories and gradually expanded to ten categories.[126] Despite their self-congratulatory nature, the Awards had always been presented with considerable panache. Not only were the Awards themselves specially commissioned works of art or crafts to ensure the uniqueness of the occasion, but they were also presented by a member of the royal family at a dinner at a prestigious venue such as the Savoy, the Banqueting House or the Tate Gallery. To maximise publicity, the Awards were always associated with a media sponsor, *The Daily Telegraph* for the thirteen years after their inception, *The Times* from 1991 to 1995, and *The Financial Times* since 1996.[127]

Newspaper reporting of these events amply testifies to the 'glory and glamour' that are associated with these public manifestations of the marriage of art and commerce, as the media are wont to describe them. For example, to celebrate the tenth anniversary of the ABSA/*Daily Telegraph* Awards in 1987, a mammoth party was held at the Victoria & Albert Museum. Of this *The Financial Times*' correspondent wrote: 'Over eight hundred tongues will be slaked. Business tycoons will be there; artists will be there, some performing in *tableaux vivants* around the museum; the Prince and Princess of Wales will be there. The grand occasion will celebrate the coming of age of arts sponsorship in the UK.'[128]

One may simply dismiss these awards as self-congratulatory and not worthy of serious consideration, but they work for the people for whom they are intended. For smaller companies and sponsorship novices, they function as a stamp of approval and crown their efforts. Edwin Shirley, for example, who put £15,000 into the Battersea Arts Centre's production of the Marquis de Sade's *120 Days of Sodom*, expressed his changed attitude towards sponsorship after he was rewarded with an ABSA Award: 'Two minutes into the first night I thought "What have I done?", but I'm proud of it now.'[129] For some business people in particular this is the only opportunity which they get to meet government ministers or members of the royal family.

Ever since the Thatcher government actively drummed up arts sponsorship in the 1980s, the importance of ABSA has risen considerably. Not only did the government inject cash into the organisation, but its own Business Sponsorship Incentive Scheme had also been run by ABSA since 1984.[130] This co-operation, for lack of a better term, between the Tory government and ABSA helped promote the ever more mixed message of Conservatism. The old distinctions between public and private were broken down and this left ABSA's position even more ambiguous. As J. Mark Davidson Schuster pointed out, it was clearly the government's policy that no new programme such as BSIS, that could be managed in the private sector, would be allowed to be administered in the public sector.[131] But the assumption that ABSA, being a charity, is a private institution is open to question. For ABSA to run the BSIS on behalf of government, the government had to provide a sizeable grant to ABSA in addition to the award money. The BSIS therefore not only inflated the importance of the association, but also gave it the flavour of a public institution, which, paradoxically, ABSA was quick to deny.

So successful was the propaganda machine of ABSA and BCA that they became part of the 'Establishment' in the 1990s. For instance, in an Arts Council publication entitled *The Arts Funding System Pack*, ABSA was listed alongside public institutions such as the Arts Council, the Crafts Council and the Museums and Galleries Commission as part of the UK arts funding system.[132] This accreditation surely elevates ABSA, a blatant instrument for commercial public relations, to a position that not only disguises its ultimate purpose, but also directly helps businesses to advance their private interests. How corporate art intervention helped the commercial sector to advance its own cause will be the subject of the next five chapters.

4

GUARDIANS OF THE ENTERPRISE CULTURE: ART TRUSTEES

Individualism being one of the cornerstones of the enterprise culture, it should come as no surprise to find a particular group of individuals transferring to the art world the same sort of entrepreneurial initiatives that they used in business. Members of this group, the corporate elite, sought to establish themselves in places of influence on museum and gallery boards of trustees, and the individuals in question came in turn to be much sought after by, in Britain, the Thatcher government, and, in the US, by trustees already in place in positions of power and influence. This chapter sets out to analyse how and in what ways high-profile corporate businessmen came to serve on the boards of art museums in the 1980s in the two countries, and to examine in particular the trustee boards of the Whitney Museum of American Art in America, and the Tate Gallery in Britain.

By placing their favourite Tory businessmen on the boards of trustees, the Thatcher government injected its entrepreneurial vision and practices into these art institutions, while at the same time cutting their public subsidies and pushing them willy-nilly into the open marketplace. The situation in the United States was less obvious since, historically speaking, American boards of trustees were already peopled by rich businessmen and their families. The 1980s, nevertheless, saw a different type of corporate elite sitting on the boards in the US, namely those 'wheeler-dealers' who had made their fortunes by speculating in the deregulated market. These people, unlike their predecessors, had their gazes firmly fixed on both

personal and corporate advantage. It was here, at these unaccountable centres of local power in both countries, that corporate influence began to consolidate and increase.

In America, as in Britain, there have been few, if any, published statistical data on trustees of art museums compiled from a sociological perspective. In the two otherwise fairly comprehensive collections of statistical data on the arts and on museums in America, for example, the absence of any specific information on trustees and their backgrounds is conspicuous.[1] The very few publications on museum trustees have, unfortunately, provided a normative description of what an ideal trusteeship should be, rather than what it actually was in the 1980s and is at present.[2] Except in some notorious scandals where trustees were involved in underhand dealings, the role of trustees, whether in term of their social composition or the power they exercise, is an area that has been significantly passed over in silence.

My attempt to find any statistically valid means of comparing the boards of art museums in both countries over time, along with their changes in the 1980s, met with outright suspicion. Indeed, I was advised by a source in the Museum Trustee Association that directors of museums are 'very touchy' about the question and that it is almost an 'impossible task' to pursue the issue. In America, the biographies of people who occupy similar roles as trustees in public agencies, such as the National Council on the Arts, the organisation that oversees the National Endowment for the Arts, are available to the public. In stark contrast, the thousands of men and women (who usually qualify as the wives or daughters of the socio-economic male elite) who serve as trustees of art museums and control invaluable works of art and buildings for the nation are far removed from the gaze of the public, whose interests they, presumably, represent.

In Britain, while the names of trustees of museums and art galleries, either national or with charitable status, are available as public information, their biographies or occupations are not always so. The discrepancy, rationalised as being in the interest of confidentiality, cannot be more paradoxical. Are those trustees not presumed, on behalf of the public, to bring the perspectives gained from their individual (working) experience to bear on the operation of the institution they serve? On what grounds, then, is the public not entitled to know the background from which they come? Hans Haacke's

1974 piece, *Solomon R. Guggenheim Museum Board of Trustees*, by spelling out in elaborate detail the family and corporate connections the Museum trustees had among themselves, is a rare attempt to combat the information blackout on museum trustees imposed by the museum world in general.[3]

BOARDS OF TRUSTEES IN AMERICA

In contrast to the number and variety of art museums in America, the demographic composition of their boards proves to be surprisingly homogeneous. In a rare cross-country survey of 156 board members by the Century Foundation in 1969 (*unpublished*, of course), 60% were at least 60 years old and had graduated from Ivy League or Little Ivy League schools; on average they held three trusteeships in different cultural or educational institutions, and 38% listed Episcopalianism as their religion. Nearly a third were in banking and finance (with many holding law degrees) and another fifth worked in law firms.[4] A similar profile was reported a few years later. Sixty-three per cent of art museum trustees are male, 44% are more than 50 years old, and 85% are white, with 3% for other ethnic minorities (12% were not reported). The business community was by far the single most dominant background from which the trustees were drawn: more than one third were business executives (24%), bankers, accountants or other financial experts (7%).[5]

These figures, however, say nothing of the close relationship between people on the board, who are very often intimately connected to each other. This should come as no surprise since most art museums in America were built as memorials to their donors and benefactors. By tradition also board membership is not only self-perpetuating, but also based on lineage and wealth, in which money and power are the prerequisites to entry. As explained by Grace Glueck, no fewer than 10 out of the 16 trustees at Cleveland Museum of Art were related to the Museum's founders, past trustees or benefactors either through blood or marriage. A similar pattern can be found in museums elsewhere, if less extreme than in the case of the Cleveland board.[6]

Moreover, these trustee elites, just as they do in business, sometimes serve on more than one museum board, and are related by family or business

connections to the trustees of other museums. In the early 1970s, for example, at the Museum of Modern Art, trustee Mrs C. Douglas Dillon was the wife of the president of the Metropolitan Museum; trustee Mary Lasker was the stepmother of Mrs Leigh B. Block, a trustee of the Chicago Art Institute, and of Mrs Sidney Brody, wife of the president of the board of the Los Angeles County Museum. Trustee John de Menil was a trustee of the Museum of Fine Arts in Houston, the Amon Carter Museum in Fort Worth and the Museum of Primitive Art in New York, to name but a few.[7]

Serving on museum boards is quintessentially a 'mandatory accoutrement' of an elite social life. As one insider observed: 'In our culture, in our way of doing things, that is the role of the wealthy. . . . And poor people go to the local church or temple, right? Make suppers, cake sales.'[8] Not unlike joining a private social club, whose exclusivity signifies ultimate social status and power, board membership is part of the jigsaw of the upper class's networks of relationships, friendships and acquaintanceships. But art museums, after all, are *not* private clubs; they operate and function in the public sphere, thereby commanding significant public authority and respect. For anyone with the status of trustee, it provides an institutional means of wielding considerable power within society; it is an avenue of consequence in a capitalist democracy.

Of course, museum trustees will not see themselves as running an exclusive social club, or, at least, not in public. To quote George C. Seybolt, president of the board of trustees at the Museum of Fine Arts in Boston: 'In essence the trustees represent *the public*. . . . Since a substantial part of every museum's collections and endowments is derived from *our method of tax deductions*, they are also responsible to the *smallest taxpayer*, and by extension, to *every citizen* [italics added].'[9] It would be very difficult to see how these trustees can actually achieve the democratic claim they make, with such undemocratic representation on essentially white-dominated, if not WASP-oriented, boards.

This is not to say that all art trustees are necessarily businessmen or their associates. To seek a charter for non-profit status or financial support from the city, the founders/trustees of the museum are usually obliged to include some *ex officio* members or people from the major educational institutions in the city. The Metropolitan Museum, for example, has five *ex officio* members on its board, including the mayor, in exchange for their land in Central Park

and all the maintenance expenses provided by the City of New York taxpayers.

Further, in response to public criticism, and in particular the need to apply for public funding in the 1970s, American museum boards elected some trustees from the minorities (blacks or other ethnic groups), or people outside the upper echelons of American society. The Museum of Modern Art, for example, elected a black trustee, Dr Mamie Clark, a psychologist, to its board in 1970, for the first time in its more than forty-year history. All the same, whether they are *ex officio* members or minority representatives, they are token members of the board, and seldom exert real power. As Karl Meyer pointed out, 'this democratization rarely extends to the key decision-making committees, whose recommendations the full board normally ratifies.'[10]

By the 1980s, the American museum boards were already filled with powerful businessmen and their spouses/daughters. Optimistically, in 1971, Grace Glueck, art critic of *The New York Times*, took the view that: 'Even Old Guard trustees can see the handwriting on the wall – that the cozy, clubby era of museums as private fiefs is over. Trustees in the future will have to earn their places on the boards by more than money and the magic of family name.'[11] Two decades later, Anthony Sampson recalled the situation in the 1980s when 'the Met began to look more like a playground and cat-walk for the rich – the "Club Met" or "Rent-a-Palace"'[12] This telling juxtaposition is not contradictory in itself. As money and power remain the *sine qua non* for American trusteeship, the museum boards of the 1980s were simply colonised, alongside the old family names, increasingly by the new rich, a generation of businessmen (and few businesswomen) whose entrepreneurial ambition was enormously boosted by the deregulated market under the Reagan administration. This money-determined ethos is made unequivocal by the famous Three *G*s, 'Give, get, or get off', or, as spelt out by Joseph V. Noble, director emeritus of the Museum of New York:

> A trustee is expected to *give* money. A trustee, by using political and social muscle, is expected to *get* money. If a trustee can't do one or the other, then it's time to *get off* the board and let someone else sit.[13]

THE WHITNEY BOARD

Given constraints of space, I shall limit discussion to the trustees of the Whitney Museum of American Art in New York. There are several reasons for this choice: first, although the Whitney was officially established by Gertrude Vanderbilt Whitney in 1931, it remained strictly a family affair until its move to the present Marcel Breuer fortress in 1961.[14] Its expansion and growth in subsequent decades, therefore, have more in common with other art museums in America, half of them established in the 1960s and 1970s.[15] Secondly, given the difficulty of finding information on trustees and the limits of my study, I had no choice but to rely, along with the standard biographical sources such as *Who's Who in America*, on the brief notes about the trustees provided by the Whitney Museum's own bulletins published since 1978. This is of course very limiting, as it is not always possible to work out the relationships created by marriage or business.

The growth of the Whitney board was noticeably concomitant with the rapid expansion of the Museum's activities in the 1970s and 1980s, in particular its increased financial needs. When it 'went public' in 1961, at a time when the Whitney family could no longer single-handedly support the institution they had founded, it added 9 non-family trustees to its board, bringing the total up to 16. The next great expansion came when Thomas H. Armstrong took over its directorship in September 1974. Within the following four years, he appointed 14 new trustees, bringing the total to an all-time high of 29.[16] At the end of the 1980s, the number of the trustees had risen again to a total of 38, including the director and three honorary trustees.

An analysis of the Whitney trustees between the late 1970s and late 1980s can demonstrate some of the changes in question, although this approach is substantially circumscribed by the fact that once a trustee is elected, he or she is likely to be on the board for about a decade or more, and the shift in the 1980s was therefore not as drastic as it otherwise might have been. According to the Museum's bulletin, on 30 June 1978 there were 27 trustees.[17] The Whitney family were represented by four members: the president of the board and granddaughter of the Museum founder, Flora Miller Irving; her mother (F. Whitney Miller as honorary chairman) and her husband, Michael H. Irving; and Sandra Payson, a cousin of Flora Miller

Irving. There were seven trustees from the world of high finance, and another five trustees were top corporate executives, the very people allied to big money and corporate power. These included Arthur G. Altschul, a partner in the investment banking firm of Goldman Sachs; Howard Lipman, a senior partner in the brokerage house of Neuberger & Berman; Leonard A. Lauder, president and CEO of the cosmetic conglomerate Estée Lauder; and Laurence A. Tisch, chairman and co-CEO of the Loews Corporation. With the inclusion of two lawyers on the board (Joel Stanley Ehrenkranz and David M. Solinger, a lawyer who had married into the Gimbel department-store family), approximately 52% of the trustees came primarily from the business world.

Ceremonial consumers

This number, however, is deceptive, for the six women on the Whitney board are either the wives of rich businessmen or wealthy heiresses of big business money. This relationship is partly indicated by the fact that these affluent businessmen's wives were often listed in their husband's names as Mrs so and so, rather than in their own names, a trend that, however, was in decline during the eighties. Barbara B. Millhouse, for example, is heiress to the huge R. J. Reynolds tobacco fortune in North Carolina, while Mrs Charles Gilman was the wife of the president of the Gilman Paper Company in New York. Although it partially reflected the trend of the growing number of women trustees since the 1970s,[18] their presence is inseparable from the men who make the money and allow the female members of their family the leisure of not having to work, but to be a 'career trustee' or as 'an alternative to "doing nothing"'.[19] Or to put it politely, they belong to the category of 'civic workers', that is to say, the woman is what G. William Domhoff described as 'a long-time volunteer worker or official in one of the many welfare and civic organizations', a blue-blood tradition historically associated with upper-class women in America.[20] The brief biographical details provided by the museum's own bulletin on Elizabeth Petrie, wife of Donald A. Petrie (then chairman and CEO of *Harper's Magazine* and chairman of the Monitor Publishing Co.), is typical. Joining the Whitney board in 1980/81, she served at the same time as a trustee for the Philadelphia Museum of Art, the Corcoran Gallery of Art in Washington, DC, and the

American Federation of Arts, and as an overseer for the Faculty of Arts and Sciences at the University of Pennsylvania.

In this sense such women are not unlike 'ceremonial consumers', a term that Thorstein Veblen used to describe the wives of the rich in the nineteenth century.[21] Their conspicuous consumption lies not only in the *haute couture* in which they dress themselves while participating in museum functions, but also in the very fact that a seat on the board may well have cost a six-figure sum per year in the 1980s.[22] Being a trustee of art museums, therefore, is a way of advertising one's opulence, a way of gaining social status with automatic publicity. Although this is generally true for both male and female trustees, it is particularly common for the leisured and moneyed type of female trustees to adopt this assocation in their social identity. Excluding the heiresses, the female trustees represent, in essence, the social category of 'executive's wife', whose role of participating in social and civic affairs is significantly related to their husband's position in the world of business. Yet, regardless of whether these women inherit or marry into wealth, it is precisely because the source of their wealth is ultimately the male elite that they can be seen as an extension of the economic power of these businessmen.

Corporate executive trustees

Of the 34 trustees on the Whitney board at the end of the 1980s, the Whitney family were represented only by its chairman, Flora Miller Biddle.[23] While the high financiers retained their control of seven seats, a substantial proportion of corporate executives were now recruited to serve on the board, rising from 5 to 13. The combination of these two groups, along with the two lawyers, gave them a majority of nearly 65% on the board, 13% more than that in the late 1970s. And there were, still, no blacks or Hispanics represented.

A close look at these corporate executives reveals some quintessentially eighties phenomena. It was the first time that entrepreneurs who had made their fortune primarily in real estate (an area of business that produced the highest percentage of people listed in the *Forbes 400* in 1988) had made it to the Whitney board. During the decade three of the new trustees were from real estate, most noticeably the billionaire Adolph Alfred Taubman.[24]

Taubman, who set up his construction firm in the 1950s, represents the 1980s generation of the rich who made enormous sums of money simply by speculating during the frantic spree of raids and takeovers that took place during that time. They were the chief beneficiaries of the American boom during the Reagan decade. For instance, Taubman led the Irvine ranch buyout in 1977 and made a profit of $150 million when it was resold to D. Bren in 1983. In the same year he bought Sotheby's, pocketing $47 million, and keeping 56% of it by taking it public in 1988.[25] In the 1984 *Forbes 400* he was listed as a millionaire in the ranks of $500 million. Within the short span of three years, he jumped into the big league of billionaires in 1987. In this respect Taubman is not just an isolated case. The fortune of Leslie Herbert Wexner, a trustee introduced by Taubman to the board from 1983/84 to 1988/89 and a part-owner of Sotheby's, similarly skyrocketed through playing the stock market. In the 1984 list, his net worth was just over $500 million, but in the following year he was in the billionaire class as his stock rose over 100%.

Another important occurrence is the entry of 'corporate trustees' to the Whitney board – the kind of businessmen whose trusteeship is unequivocally a *quid pro quo* for their brokerage of an unique deal between the museum and their respective companies. George Weissman, chairman of the board of Philip Morris Inc. and Benjamin D. Holloway, executive vice president of the Equitable Life Assurance Society and chairman and CEO of the Equitable Real Estate Group, joined the Whitney board in 1980 and 1984 respectively. Not only did both companies contribute handsomely to the museum, but, more specifically, both men were instrumental in establishing a Whitney branch within the headquarters of their respective companies.[26] It was these corporate trustees who helped create in the 1980s the phenomenon of the proliferation of Whitney branches that so notoriously earned the museum the nickname of the 'McDonald's of the museum world'.[27]

Being in a position of corporate power, both Weissman and Holloway struck the branch deal in order to gain substantial benefits from the presence of the museum in their headquarters. Both men represent the category of 'cultural managerial capitalists', to paraphrase the American sociologist Paul DiMaggio's description of cultural capitalists.[28] They are not traditional capitalists in the sense that the majority of them did not make their wealth

from industrial enterprises as those of the nineteenth century had. Unlike those earlier capitalists and their inheritors, these chairmen/chief executives are professional managers who emerge through the so-called 'managerial revolution'.[29] Their power within the corporation is thus achieved through their corporate position rather than family lineage. They are unlike their nineteenth-century predecessors in one further crucial aspect: however hypocritically, the nineteenth-century capitalists and their early twentieth-century successors claimed the status of philanthropists and took pride in serving the public interest. As Mrs J. D. Rockefeller III reflected on her involvement with the board at the Museum of Modern Art in New York over many years: 'I'm not a violent women's lib person . . . but I was brought up to believe you should be of service to your community.'[30]

By contrast, the eighties corporate trustees displayed their ambition quite nakedly. Neither Weissman nor Holloway hid the motivation of their involvement in the Whitney as part and parcel of a corporate strategy. To quote Weissman:

> Our basic decision as a corporation was not in the development of art; our basic decision as a corporation was that we had to be unique and have a personality and an identity that was different from the rest of the tradition-bound [tobacco] industry.[31]

The fact that they were able to be so frank and had no need for pretence only indicates the extent to which they were confident in exercising their political and social influence to secure their own commercial interests. Unlike the more tangible effects of the sponsorship of exhibitions by corporations, the influence exerted by corporate executives on any museum generally operates below the surface as an undercurrent. This is therefore a real pointer to the qualitatively different types of influx of corporate power into museums in the eighties.

The expansion of the board, however, is not the only means by which corporate executives exert influence on the governance of art museums. Although a full investigation is not possible here, it is worth noting that, while there are limitations on the number of trustees that can be appointed, more trustee committees, such as the Corporate Committee of the Whitney, were formed in the 1980s, while those in existence had added new members.

By these means more corporate executives were recruited to the Museum than the main board could otherwise accommodate. As with board members who have to contribute a significant sum of money annually, these people are very often recruited for their financial 'clout'. Even if they may not be individually as rich as the trustees (which is why they are not on the main board in the first place), their top position in a corporation often ensures unique networking opportunities and access to other corporate coffers. According to a source at the Whitney, a corporate benefit night at the Museum raised over a million dollars in 1994 and between $500,000 and $600,000 in 1995. Not uncharacteristically, it was the chairmen or the CEOs of the big corporations sitting on the museum's Corporate Council who, by writing to their business associates or contacts, helped sell the tables, some of which cost as much as $10,000.

But where are we to locate the rewards for a trusteeship? Very often the trustee–museum relationship is characterised as 'a two-way street'. Or as Agnes Gund, president of the board of trustees of the Museum of Modern Art in New York, bluntly put it some years ago: 'Why should they [the trustees] give something, and get one day of parties and a champagne toast and that's it?'[32] Social prestige and status are the obvious trophies conferred by membership of an exclusive museum board. But the reality of the situation is more significant and delicate: most American boards are full of collectors, businessmen included, who are buying (contemporary) art. This is not, of course, for a moment to imply that trustees, either individually or collectively, are ever involved in anything illegal or unethical. Yet the fact is that being a trustee allows them inside advantages and benefits, say, over non-trustee collectors, that potentially can result in substantial financial gain for themselves. For instance, they know in advance which artists' works will be acquired or exhibited by the museum, thus affecting the reputation of the artists and their market. If the trustee-collectors purchase or collect for themselves the works by the same artists, the value or prestige of their collection will be automatically enhanced after the museum exhibition, regardless of whether or not any works from their collections are exhibited.[33]

At this juncture, however, it must be emphasised that trustees, according to the common law trust standard, should act solely for the benefit of the beneficiaries, that is, the public. They should also have a duty of undivided loyalty to place the interest of the museum first and to avoid self-dealing and

conflict of interest (see footnote below), and not to use their board position for personal gain.[34] The standard of conduct required of a trustee has been summarised in the oft-quoted words of Benjamin Cardozo, in the case of *Meinhard* v. *Salmon*, as follows:

> Many forms of conduct permissible in a workaday world for those acting at arm's length are forbidden to those bound by fiduciary ties. A trustee is held to *something stricter than the morals of the market place* . . . [italics added].[35]

Conflicts of interest*

In the light of this conception, the reality of the behaviour of museum trustees in America is far from uncompromising. Not only have the issues of conflict of interest and public accountability never been rigorously observed, but even when they arise, they are easily dismissed by the parties involved. For example, when Alfred Taubman bought Sotheby's in 1983, he was not only on the Whitney board, but also on the Museum's Painting and Sculpture Committee (as was Leslie H. Wexner, part-owner of the auction house). Do not the acquisitions and exhibitions at the museum affect the reputation of the artists whose works, if subsequently auctioned, will fetch a higher price? To what extent did Taubman influence the choice of exhibitions and acquisitions made by the museum? Questions like these, however, are rarely posed. Taubman was reported to have informed his fellow trustees about his business interests in Sotheby's, and they apparently decided that 'it was not a conflict of interest' and that he should remain on the board.[36] In a somewhat contradictory vein, Flora Biddle, chairman of the board, apologetically defended Taubman's position:

* I use the phrase 'conflict of interest' throughout this book to mean a step or decision that might link a person's duties as a trustee with another business, professional or personal relationship. I call this a conflict of interest not because there is an actual conflict or because anyone might have done anything improper; I call it a conflict of interest because the trustee might not, if later challenged, be able to prove whether the step or decision had been taken in the best interests of the organisation of which he or she is a trustee or in the best interests of another person or organisation.

I've thought a lot about it. *It's almost impossible to be a trustee and not have conflicts of interest.* The board is full of collectors who are buying contemporary art. The problem the Whitney has generally is that as soon as we have a show or buy a piece, the artist's dealer raises his prices by 30%. What do we do about that? [italics added][37]

She went on to praise Taubman's strong values and ethics and to stress that he would not become involved in a conflict of interest. But the rub remains that most *informal* transactions between the trustees and the museum take place behind closed doors, and there has, therefore, never been an effective critique of their roles. When personal integrity and self-policing fail, few practical means exist either to expose or correct this abuse. Theoretically, it is open to the ordinary citizen to challenge in the law courts any trustees who have violated their fiduciary duties. In reality, only the state attorney-general has the necessary means and expertise to effectively bring the charges. Surprisingly, despite the pervasive and compromising situation in American art museums, as evidenced by Flora Biddle's remarks, very few legal actions have been registered.[38] This has less to do with self-regulation on the museums' part and more to do with the fact that trustees are very often so-called 'blue-ribbon citizens', both economically privileged and socially prominent. Rigorously to enforce trustee obligations becomes thereby a highly charged political issue. With the exception of extreme cases, the state attorney-general is understandably reluctant to investigate the dark underside of museum operations, nor does he have the staff to undertake such action.

How far these businessmen trustees can influence the operation of museums is difficult to determine. The precise mechanisms through which they exercise their power are not the kind of knowledge that is for public consumption. But their 'mogul power' is a fact attested to by an incident reported by Grace Glueck. Leonard A Lauder, then vice chairman of the Whitney Museum and the CEO of Estée Lauder Inc., was quoted as saying, as he recalled a glittering acquisition in 1980: 'Let's get a million-dollar painting! If we're going to buy paintings, we have to make a splash.' It is not the particular painting in question but its price that dominates the thinking of these magnates. Three Whitney trustees, along with an anonymous donor, gave a total of $825,000, with the rest to be met from the museum's

general fund. The painting then suggested by the director, Tom Armstrong, was Jasper Johns' *Three Flags*, and this realised a record sum for the work of a living American artist. Lauder was further reported as saying: 'since then, people have taken our collecting efforts seriously.'[39]

The extent to which this instance is representative of the power of businessmen on museum boards in general needs further exploration, but the signs are obvious: flashy pretension had come to be interpreted as substance and seriousness, while the social and personal *éclat* associated with the extravagant life style of the rich was played out by these corporate executives at an inflated level in the 1980s. It was also these corporate executives who had finally ended the Whitney family's 60-year hold on the Whitney Museum. The self-made millionnaire Leonard Lauder took over the chairmanship of the board in the mid-nineties, at around the same time as his family cosmetics empire was reported to have successfully avoided paying capital-gains tax estimated at as much as $95 million by exploiting certain tax loopholes.[40] Leonard Lauder's chairmanship at the Whitney Museum has, of course, to be seen within a wider context, that of his brother Ronald Lauder also being chairman of the board of the Museum of Modern Art. Two of the most prominent art institutions in New York are thus brought under the control of a single family, a phenomenon that makes trusteeship in America an extremely potent instrument.

BOARDS OF TRUSTEES IN BRITAIN

In Britain the intricate network of museums and art galleries can be basically divided into three types, according to their funding sources. First, at the top tier are the national museums and galleries, such as the National Gallery and the Tate Gallery, which were, and primarily still are, funded by central government but run by 'independent' boards of trustees. Second, there are the dozen or so so-called 'independent galleries', such as the Whitechapel Art Gallery in London and the Arnolfini Gallery in Bristol, which were heavily reliant on grants from the Arts Council of Great Britain (now Arts Council of England), supplemented by local authorities and other public sources, such as the London Arts Board. Third, local authorities have funded a series of museums and art galleries throughout the country, such as the Leeds Art

Gallery and Museum. These are run directly by the civil administration, and have no relevance to this study. The discussion that follows will focus, accordingly, on the first category of galleries, with occasional reference only to the second type of galleries.

The American example of museum trustees is instructive in showing what would have been in store for Britain if the Conservative government's predilection for the free market had ever been realised with full force in the museum world. Unlike American trustees, whose role has always been directly related to the museum's financial stability, British trustees had, up until the Thatcher decade, virtually no need to pay special attention to the financial aspect of the institution they were responsible for, and they had generally played a merely advisory role. This is not to say that they were not in a position of power to affect the direction of the museum. As a matter of fact, according to the convention of English common law, they were the 'collective owners at law of the national treasures entrusted to their charge' on behalf of the nation as a whole.[41]

This is not to suggest that the British boards in the pre-Thatcher period did not consist of people of wealth and social standing. Indeed, the board very often comprised a star-studded cast of the great and good of the land, such as minor royals, members of the aristocratic class and knighted captains of industry. These trustee museums, like other quangos such as the Arts Council of Great Britain, are a distinct brand of British institution, the kind of establishment that operates, in the words of Martin Kemp, a former trustee at the Victoria and Albert Museum, 'through unwritten rules of consensus and personal constraint'.[42] Or as Sir Norman Reid, the former director at the Tate Gallery, put it: 'All this works on a fairly informal basis, but there is a clear understanding of what are the duties and rights of the Trustees and what of the Director and the staff.'[43] Because of their birth and breeding, which often means, at the very least, a 'public' school and Oxbridge education (of which more later), and a career or otherwise amateur commitment in public service, these trustees share certain common values and beliefs. This mutual understanding, which does not need to be *openly* expressed, is precisely what Raymond Williams so succinctly described as 'administered consensus by co-option'.[44] One feature that British and American boards share is that in both countries boards of trustees are far from being representative of the population at large, but are dominated by

a very small and self-selected segment of society, which is uncompromisingly and unashamedly undemocratic.

It is within this traditional establishment mentality that the role of trustees had always been vaguely perceived as 'trustees for the nation'. Through the metaphor of trust, the trusteeship is frequently couched in paternalistic terms; trustees are, to use a ubiquitous term of the eighties, guardians of 'national heritage'. In contrast to what Martin Kemp rightly described as the 'more active, partisan, and managerially-minded' trustees of the eighties, what is implied in effect in the cosy rhetoric of guardianship are the so-called 'traditional ideals of public service', a kind of patrician *noblesse oblige*.[45] Apparently the assumption, which Kemp himself is also guilty of making, is that trustees of the older generation were 'men of quality and spirit', who took up trusteeship on behalf of the public, and mediated 'non-partisan representation of diverse interests'.[46] It is, however, open to question whether personal integrity and ethics are necessarily inherent in people with social standing, although until the 1980s British trustees were never *publicly* involved in the endless cases of conflict of interest and abuse of board positions experienced by their American cousins. Or at least so I believe, for I have no means of accurately assessing the quality of British trusteeship before the 1980s, given the lack of research on the topic and the limits of this study.

What definitely sets British boards far apart from American ones is that a comparatively high percentage of trustees on British boards was, and still is, composed of people professionally involved in the visual arts, including artists, art critics, art historians and, to a lesser extent, architects.[47] This is not to suggest that being arts professionals necessarily absolves them from being part of the British establishment, or automatically disconnects them from positions of power and privilege, despite the fact that some artists take on the role of representing marginalised communities. Some artist trustees indeed went to the so-called 'Clarendon schools',[48] as their fellow business trustees did (Anthony Caro went to Charterhouse, while Victor Passmore went to Harrow; both were former trustees at the Tate Gallery), although their artistic training would take them away from the well-trodden educational pattern reserved for British elites. These arts trustees can certainly have an impact on the way in which galleries operate, and they can be politically influential too, but the form of their leverage is at best fragmented and unorganised, and of

an entirely different order from, say, the institutional power and influence exercised by the chairman or chief executive of multinationals, who occupy crucial positions in the structure of the economy and can mobilise organised capital on a global scale.

The arrival of the Thatcher regime, along with the ideology of privatisation, meant that grants-in-aid to national museums and art galleries were severely cut. Consequently publicly funded art institutions, already on strained budgets, were forced to engage in an endless chase after corporate money and other alternative sources of income. For instance, the Serpentine Gallery in London, which was largely funded by the Arts Council until 1987, is now dependent on other sources for more than 50% of its operating expenses.[49] As far as trustees were concerned, it was these financial circumstances that made it increasingly imperative to recruit more businessmen (and still predominantly men) to join boards throughout the Thatcher decade: they themselves became highly 'collectible' and were expected to exercise their financial 'clout' to raise money from the corporate sector on behalf of the art institution.

For national museums and art galleries, the overwhelming majority of whose trustees were appointed by the Prime Minister, the rise of businessmen on the boards was even more conspicuous. Although it is not possible to explore here in detail the change in other institutions, it is essential to point out that the trend was so predominant as to extend to appointments of virtually all boards in other public arts organisations, such as, for example, the Royal Opera House.[50] The board of the Victoria and Albert Museum, for instance, which acquired its trustee status only in 1983 and whose members were thus all appointed by the Prime Minister, is the most illuminating example of the workings of Margaret Thatcher's policies and ideology. While Robert (now Lord) Armstrong, Mrs Thatcher's favourite civil servant, was appointed chairman of the museum, more than half of the board members came from the background of private enterprise, including the then chairman of the Wimpey construction group, Sir Clifford Chetwood; the former managing director of the Mobil Oil company, Sir Nevil Macready; City grandees Ian Hay Davison and Sir Michael Butler (a former diplomat); and Maurice (now Lord) Saatchi, then chairman of the Saatchi & Saatchi empire, the world's largest advertising agency in the mid-eighties.

The subsequent introduction of admission charges and the 'Laura Ashley of the Eighties'-style museum shop were part and parcel of the money-spinning strategies that these businessmen brought to the museum.[51] The V & A was to be further restructured in 1989, in the face of international protest and furore, to remove any remaining obstacle to entrepreneurial dynamism, an approach guided not insignificantly by men from Saatchi and Saatchi, the same agency that had run Margaret Thatcher's election campaigns.[52] According to Martin Kemp,

> The nadir of this approach was reached when one of the smart young men from Saatchi and Saatchi was introduced . . . to present a series of propositions on virtually every aspect of the museum's operations. Each proposition was written on a single sheet of paper in large letters, and the Trustees were taken through these like a primary-school reading class. Needless to say, the selling of assets and compulsory admission charges featured prominently in the presentation.[53]

What concerns us most in this specific context, however, is the potentially contradictory nature of Maurice Saatchi's interests. As a trustee of the Museum, his company was apparently at the same time selling services to the Museum, a practice that ran through the eighties and to which we shall return shortly. To gauge the profound change that the Conservative government brought to the museum boards in Britain, we will have to turn to a detailed analysis of the case of the Tate Gallery.[54] This is, in size and status, comparable to the Whitney Museum, which we have already analysed above.

THE TATE GALLERY

Unlike American art museums with their ambiguous public/private status, the Tate Gallery is a public institution, funded by central government. Like other national museums and art galleries in Britain, the Tate is thus subject to government control, not only in terms of its finance, but also to the extent that its essential organisational structure is determined by various Treasury minutes and Acts of Parliament. This is despite the claim often made for so-called 'independent' boards of trustees, which ostensibly function according

to the 'arm's-length principle' from government, and are presumably free from direct political intervention.

Direct intervention, however, was not something that the Thatcher government hesitated to indulge in. A definite sign of the fundamental change in how the Tate operated during Mrs Thatcher's tenure was the way in which the terms of the appointment of trustees were altered. It was more than thirty years since a Treasury Minute of 1955 had established the convention that the Gallery had ten trustees, of which four were to be practising artists. The Thatcher government's new policy with regard to 'the problem of the Tate', to quote its Treasury Minute of 7 November 1987, was to reduce the artist trustees from four to three, and to increase the total number of trustees to eleven. Ten of these were to be appointed by the Prime Minister and one by the trustees of the National Gallery from amongst their own board members (who, of course, were appointed by Mrs Thatcher as well).[55] The term of the trusteeship was also reduced from seven to five years, and, again according to the Minute, the five-year term might be extended for a further five years or more, which in fact resulted in certain trustees remaining on the board for more than a decade, a phenomenon unheard of in the previous two decades. This significant change not only weakened the representation of artists in the running of the gallery, but also, by making the terms of appointment more elastic, permitted the government, or, to be more precise, the Prime Minister, to take even tighter personal control of board appointments.

The most signal example of Mrs Thatcher's intervention was the appointment of Dennis (now Lord) Stevenson as the chairman of the Tate Gallery in 1988, to replace the retiring Richard (now Lord) Rogers.[56] The fact that Richard Rogers was serving an eight-year term instead of seven before he retired already broke with established convention. But the more intriguing development was that the chairman of the Tate used to be elected from among the trustees themselves, at least according to the previous convention, whereas the decision on Stevenson's chairmanship was, in fact, parachuted in from Downing Street just four weeks after he was appointed as a trustee.[57]

According to Bernard Levin, the Tate Gallery actually invited Sir John Burgh, ex-director-general of the British Council, to become a trustee with the intention of succeeding Rogers.[58] Sir John was, of course, a career civil

servant, 'precisely the sort of timber from which the old-style Great and Good had been hewn'. This being the case, his outspoken criticism of the budget cuts suffered by the British Council since the 1979 election could not have pleased Downing Street.[59] Whereas previous Prime Ministers usually rubber-stamped the choice of the boards of national museums,[60] Downing Street, after three weeks' silence, instructed the Tate to find a substitute for Sir John because he was not acceptable to the government. 'Are we', asked Bernard Levin, 'at the court of Henry VIII? Or of Stalin?'[61]

Whether or not Sir John Burgh would have been an excellent chairman is not the point. What this act of outright political placement meant was that appointments to these high-level public positions within an ostensibly democratic state were to be made with less and less public accountability. Compared with American museums, whose boards are self-perpetuating and answer to nobody, the public nature of British galleries had been to some extent preserved by virtue of its constitutional framework. Yet, public appointments under Mrs Thatcher were dominated by one specific ideological criterion, which is encapsulated in her infamous catchphrase 'one of us'. By overturning convention, whether written or otherwise, when it saw fit for its own political purposes and bypassing public consultation, the Conservative government was further weakening the bourgeois state's already weak claim to democracy.

Direct intervention, of course, was not the sole means of shaping the new look of the Tate during the Thatcher years. A more profound change still lies in the trustees actually appointed, in whom ultimate authority over the institution is after all vested. Precisely how the list of potential trustees is drawn up by the incumbent trustees and the director before it is delivered to Downing Street is a well-kept secret and never subject to public debate or investigation. An episode such as that of Sir John Burgh lifting the veil of 'discretion' is a rarity. Yet, even without overt pressure from above, the political sensitivity of certain arts bureaucrats would surely guarantee a carefully considered list that would not go against the grain. As Nicholas Serota, director of the Tate, was quoted as saying in 1989:

> I have the feeling that if I wanted to have Professor Richard Wolheim – who is, after all, an outstanding philosopher and art theorist – on the Board of Trustees, I think the chances of Number Ten choosing him would be quite slight.[62]

The fact that Serota was appointed by the trustees in 1988 to replace that firm supporter of state funding, Sir Alan Bowness, made his position particularly delicate.[63] This is not to suggest that Serota was in any sense a Thatcherite placeman. He was, nevertheless, by inclination or by passive acquiescence, congenial to the political order of the day. Back in 1980, when he was still the director of the Whitechapel Art Gallery, what he had to say about the appointment of trustees perfectly epitomised the transformations in trusteeship that would characterise the Thatcher decade:

> The most immediate need is for those authorities who appoint trustees to recognise that one of the best services of any trustee would be to make contacts for the gallery and assist in fund raising, and not just be a guardian of local authority money.[64]

Before looking at the Tate trustees specifically, we need to draw attention to another important development related to the new fund-raising role of trustees. Whereas in America the number of trustees on a board can be increased to some 30 to 50 members, constraints imposed by public law make this impossible in British museums and art galleries. To circumvent this, trustees in Britain have, willingly or unwillingly, created their own version of American-style boards. Instead of adding more corporate executives to their boards, which is not always permissible by law or their charters, British galleries established separate foundations for fund-raising purposes, such as the Tate Gallery Foundation, established in 1986, and the Whitechapel Art Gallery Foundation, set up in 1984.

Patrons of New Art

Within the structure of the Tate, there are also the Patrons of British Art and Patrons of New Art, established in 1986 and 1982 respectively, to assist with acquisitions for the gallery's collection, following the freezing of the government purchase grant at a level of about £1.8 million in 1979.[65] These two groups, structurally speaking, are, however, more in the category of museum friends' organisations since their membership is by subscription; nor do they command the same degree of authority and influence as the trustees of the Gallery. There are several reasons, on the other hand, why they are to

be regarded as significant in the context of the present discussion, in partic-
ular as far as the Patrons of New Art status is concerned. First, although the
subscription fee to join these groups is relatively small, and their member-
ship, at least in theory, is open to everyone, the people who do join are not
ordinary members of the public. They tend to be 'dealers, collectors and
business or City types' and those connected with a network of people in posi-
tions of power and influence, such as the wife and daughter of the former
deputy Prime Minister, Michael Heseltine.[66] These members thus can
mobilise, collectively or individually, substantial resources, whether corporate
or private. For example, Mrs Jill Ritblat was on various committees of the
Patrons of New Art. The company that her husband John Ritblat (who in
turn was a member of Patrons of British Art) chaired, the British Land
Company plc, was one of the principal corporate sponsors.[67]

Second, the Patrons work with the director and curators of the gallery in
purchasing works of art for the gallery through subscription fees. Such inner
workings would be much less problematic if the members on the Executive
Committee or Acquisitions Sub-Committee were not already professionally
involved in commercial art dealing. Apparently there has been little if any
public discussion of the issues of inside advantage that such involvement
inevitably generates, except in the *cause célèbre* of Charles Saatchi (of which
more later). To the extent that their subscription fees are tax-deductible, and
because these groups indirectly contribute to public art collections, there is
little doubt that they are in fact acting within the public, not just the pri-
vate, sector. In this respect, their status is not dissimilar to that of a 'public
trust'.

Third, and more importantly in the present context, some of the mem-
bers active on these groups are closely related to the Tate trustees, such as
Penelope Govett, events organiser for Patrons of New Art, whose husband
William Govett was a Gallery trustee from 1988 to 1993. The absolutely
central strategic position that such a group of so-called 'art lovers' occupies
in relation to the board of the gallery or Gallery Foundation makes its other-
wise diffuse and fragmented membership worthy of closer scrutiny here. In
this respect, such people can, without exaggeration, be described as consti-
tuting unofficial miniature trustee boards of one sort or another.

Although my original intention had been to explore the Tate Gallery
Foundation Board along with the main board, this proved in reality to be

almost impossible. While some trustees of the Gallery Foundation over-
lapped with the main board, the two women on the Foundation board were
not listed in *Who's Who*, nor was the American-born financier, John Botts.[68]
Personal approaches to the Tate invariably ended in my being shunted,
without success, from spokesperson to spokesperson. Typical of the sorts of
answers I received was: 'Yes, the public have their right to know a lot of
things. But we still think they are private citizens. I can't give you informa-
tion like that.' One source, however, did agree to provide some information,
but this turned out to be, in her own words, 'rather sketchy'.[69] When I fur-
ther inquired if she could indicate who the trustee Mrs Sandra Morrison was,
I was told: 'I hope you will really appreciate that you have to do your own
research; I can't do that for you.'[70] The discussion that follows will therefore
concentrate on the Gallery's main board, with some, alas, only incidental ref-
erence to the Foundation Board.

Demographic characteristics

In order to map out the changes that have taken place, I have examined sta-
tistically the demographic make-up of trustees since the 1960s in terms of
gender, education (schooling and universities) and occupations. I exclude
artist trustees from the data as their representation on the board is fixed by
public act, and any longitudinal comparison would accordingly not be mean-
ingful. I include data on the trustees appointed under the Conservative
government during the nineties, because they provide some insight into
the survival of the Thatcher legacy.

It is unequivocal that in the sixties and seventies, the Tate board was
quintessentially a male club.[71] The addition of three women to the board in
the eighties is largely consistent with other changes occurring within society
at large (see Table 4.1), although the board still consisted predominantly of
men (72.7% male and 27.3% female). Nor is this factor, of itself, to be taken
as proof of a broader representation on the Tate board. The transatlantic par-
allel is that some of these female trustees are on the board not because they
are representative of the female population at large, but because they them-
selves are part of, or have intimate access to, networks of people of money
and power. The most illuminating example is the Countess of Airlie, one of
the few trustees to remain on the board for more than a decade.[72] Brought

Table 4.1

Gender of Tate trustees by decade of appointment

Gender	1960s		1970s		1980s		1990s	
	Number of trustees	Per cent of total	Number of trustees	Per cent of total	Number of trustees	Per cent of total	Number of trustees	Per cent of total
Female	—	—	—	—	3	27.3	2	25.0
Male	13	100.0	10	100.0	8	72.7	6	75.0
Total	13	100.0	10	100.0	11	100.0	8	100.0

Notes:

No missing cases.

The data for the 1990s' trustees refer to those appointed under the Conservative government.

up in the United States, she is the granddaughter of the financier and philanthropist Otto Kahn. Married to Lord Ogilvy (who succeeded Lord Maclean as Lord Chamberlain in 1984), she has been Lady of the Queen's Bedchamber since 1973. Her aristocratic connections are a classic example of the intermarrying of inherited wealth and power, and hardly make her a meaningfully representative female figure.

The second distinctive characteristic of the Tate trustees is the overwhelmingly similar educational background they share. This, of course, is not a surprise, given that historically a whole range of British national life has been, and still is, dominated by men who have been to 'public schools' and then to Oxford and Cambridge Universities, sometimes derogatorily referred to as the 'Oxbridge mafia'. A unique, and indeed peculiar, feature of class distinction in Britain is how admittance into the elite circle is determined at such an early age by public school entry, and into such a tiny number of schools, and especially Eton. As an effective signifying system of upper- to upper-middle-class upbringing (whatever these terms might mean), the inclusion of schooling in this analysis proves to be anything but arbitrary.

In the sixties, 90.9% of the trustees had gone to 'public schools', with 45.5% attending the so-called 'Clarendon schools', while in the seventies, the proportion was 70%, with 40% having passed through Eton. Although the proportion fell to 45.5% during the eighties, this was partly

Table 4.2
Schooling of Tate trustees by decade of appointment

| Schooling | 1960s | | 1970s | | 1980s | | 1990s | |
	Number of trustees	Per cent of total	Number of trustees	Per cent of total	Number of trustees	Per cent of total	Number of trustees	Per cent of total
Foreign-educated	—	—	1	10.0	3	27.3	—	—
Public schools	10	90.9	7	70.0	5	45.5	8	100.0
State-educated	1	9.1	2	20.0	3	27.3	—	—
Total	11*	100.0	10†	100.0	11‡	100.0	8§	100.0

Notes:

* Missing cases: 2 † Missing case: 0 ‡ Missing case: 0 § Missing case: 0

The data for the 1990s' trustees refer to those appointed under the Conservative government. Rounding results in column 7 not totalling 100%.

because of three trustees having been educated overseas, and partly because another three had come from state-funded schools (see Table 4.2). This percentage decrease is impressive, but by no means conclusive. Statistically speaking, the number of trustees appointed in a decade is fairly small; a change in one or two individuals is likely to show an exaggerated percentage reaction. In particular the nineties' trustees appointed under the Conservative government were all educated at public schools, with as many as 50% of them having gone to Eton. There is little sign of any loosening of control over public appointments in the ranks of ex-public school boys.

Similarly, the same dominant position of Oxford and Cambridge in the makeup of trustees' higher education can still be discerned. Within the time period covered here, the percentage of Oxbridge graduates among the trustees remained at its highest in the sixties (66.7%) and seventies (70%), with a decline to 36.4% in the eighties, before a resurgence to 75% during the nineties (see Table 4.3). While the spread of backgrounds might be wider in the eighties than it had been in the previous two decades, this does not suggest that any broader representation had been achieved. As with the question of gender, education cannot, in and of itself, be an

Table 4.3

University education of Tate trustees by decade of appointment

University education	1960s		1970s		1980s		1990s	
	Number of trustees	Per cent of total	Number of trustees	Per cent of total	Number of trustees	Per cent of total	Number of trustees	Per cent of total
Foreign	—	—	1	10.0	2	18.2	—	—
Oxbridge	8	66.7	7	70.0	4	36.4	6	75.0
Non-Oxbridge	2	16.7	—	—	1	9.1	—	—
Not known	1	8.3	1	10.0	3	27.3	1	12.5
Arts training	1	8.3	1	10.0	1	9.1	—	—
Profess. training*	—	—	—	—	—	—	1	12.5
Total	12†	100.0	10‡	100.0	11§	100.0	8‖	100.0

Notes:

* Professional training includes lawyers, surveyors, etc. † Missing case: 1 ‡ Missing Case: 0 § Missing case: 0 ‖ Missing case: 0
The data for the 1990s' trustees refer to those appointed under the Conservative government. Rounding results in column 7 not totalling 100%.

absolute indicator. This point is tellingly summed up by one anonymous Tate source when speaking of a particular trustee who had no known university education: 'It doesn't make any difference. He is a man who comes from a very wealthy family.'

What distinguishes eighties' trustees from those of the previous decades is ultimately their occupations. In the sixties, 38.5% of trustees were from academia and the arts world (including writers, critics and art historians), 46.2% from business and 15.4% from the civil service. The comparable percentage for the seventies are 30, 40 and 30% (see Table 4.4). In the eighties, virtually all the trustees were from the business sector, with the exception of the two women, Countess of Airlie and Caryl Hubbard.[73] In particular three out of eleven trustees were from the financial sector, clearly signifying the increasingly important role given to these high financiers in the operation of the Gallery. It goes without saying that these *men* of free enterprise are no ordinary businessmen but hold high-level positions within the economic structure of British society. To quote one Downing Street source explaining

Table 4.4
Occupation of Tate trustees by decade of appointment

	1960s		1970s		1980s		1990s	
Occupation	Number of trustees	Per cent of total	Number of trustees	Per cent of total	Number of trustees	Per cent of total	Number of trustees	Per cent of total
Arts/ academia	5	38.5	3	30.0	1	9.1	2	25.0
Business sector	6	46.2	4	40.0	9	81.8	4	50.0
Civil service	2	15.4	3	30.0	—	—	—	—
Not full-time	—	—	—	—	1	9.1	1	12.5
Landed gentry	—	—	—	—	—	—	1	12.5
Total	13	100.0	10	100.0	11	100.0	8	100.0

Notes:

No missing cases. Rounding results in column 3 not totalling 100%.

The data for the 1990s' trustees refer to those appointed under the Conservative government.

'Architects' are included in the category of 'business sector'. The way in which architects conduct their business has more in common with the business sector than with the arts world. In any case, there was only one architect appointed in the 1960s and one in the 1980s.

Mrs Thatcher's public appointments policy: 'She goes for the millionaire of the moment.'[74]

But such statistical data do not tell the whole story. They say nothing about the extensive ties that these trustees have with people in positions of political power in Britain, nothing about the labyrinthine nature of the corporate and social networks they create among themselves, and, above all, nothing about the resultant concentration of power revolving around a coterie of trustees in a democratic state (with 'democratic' the critical qualifier). First, most, if not all, of them are Tory sympathisers, and some are even major financial backers of the Conservative party through the companies they chair. For example, David Verey, chairman and chief executive of the merchant bank Lazard Brothers, was reported in 1994 to have given £180,000 to the Conservative party since 1986. He was appointed by Mrs Thatcher as a trustee of the Tate Gallery Foundation in 1989 and as a

trustee of the Gallery by John Major in 1992.[75] In *Who's Who* Verey's hobbies are listed as 'stalking [animals, one hopes . . .], bridge, gardening and travel' – art is nowhere in sight, of course.

This is not, of course, to suggest that Verey had been 'buying' his trusteeship in secret. Whereas it is impossible to substantiate the connection, as information of this kind is either classified as confidential or *simply off the record*, it does indicate the significant link between the trustees and the Thatcher government, or the Conservative party. It also begs the question of what role, if any, trustees of public art galleries should play. Are the interests served those of public service, or is it a question of creating personal fiefdoms, or of the ruling party repaying ideological or financial debts to leading business tycoons?

Second, considerable importance was attached in media reporting to the 'entrepreneurial spirit' of these trustees. David Puttnam, Britain's best-known film producer, was not only one of the selected guests at Mrs Thatcher's Boxing Day Luncheon at Chequers in 1983, but he was also perceived to represent the kind of 'adventurous high-risk enterprise man much favoured and admired by Mrs Thatcher'.[76] Similarly, Dennis Stevenson was said, in his new role as chairman of the Tate, 'to inject entrepreneurial know-how into the gallery's funding and management'.[77] By promoting these 'enterprise men' to formal positions within public museums and galleries, the Conservative government was not only manoeuvring to take over the running of the country's cultural institutions, but also furthering its advocacy of the 'enterprise culture' in a strident and ideological way, a process that was inevitably to transform the identity of Britain's art institutions.

The extent of this metamorphosis in identity is plainly seen in the language used in the media when dealing with the trustees and the Tate Gallery. Business jargon, which would otherwise have been reserved for the commercial world, has over time come to infiltrate intellectual discourse, as if a public art gallery such as the Tate could itself be considered as a corporate enterprise. When Richard Rogers was elected chairman of the board in 1984, for example, the headline was: 'Another Tate *Takeover*'.[78] And, more significantly, in the numerous reports on the activities of Dennis Stevenson when he was the Gallery's chairman, the name of the Tate was unobtrusively slipped in among a long list of chairmanships and directorships that he

held. In a revealing description, he was simply referred to as 'a *director* of the Tate Gallery as well as Pearson'.[79] This shift in language that serves to equate a national institution with a multinational company speaks for itself. To justify why '*some* [*sic?*] business people' are selected as trustees, the gallery claims: 'the Tate Gallery now runs and administers shops, restaurants, and *is in itself a business* [italics added].'[80]

Third, what makes these trustees powerful is not only that the majority of them are individually very wealthy, but also that they hold high positions in the corporate world. At the time of his appointment in 1988, William Govett held 23 concurrent UK and overseas directorships, including those of the Govett Atlantic Investment Trust plc, John Govett Investment Management Inc., and Berkeley Govett and Co. Ltd (Overseas). Equally, trustee Gilbert de Botton (1985–92) held a similarly impressive list of UK and overseas directorships, such as J. Rothschild & Co., Global Asset Management UK Ltd and the Banque Privée SA (Switzerland).[81]

The combination of personal wealth and positions of economic power within institutions allows them privileged access to a wide variety of boards and committees of quangos, charities, hospitals and schools. This means that their power, which derives primarily from capital, permeated widely into national life. For example, Mark (now Sir Mark) Weinberg, 'a super-salesman of life insurance', who joined the Tate board in 1985, was chairman of Allied Dunbar, Britain's largest unit-linked life assurer.[82] His other public appointments included the chairmanship of the Organising Committee of the Marketing of Investments Board (1985–86) and deputy Chairman of the Securities and Investment Board (1986–90), the main political body for policing security firms and investment companies. At the same time, he was the co-founder and joint chairman of the Per Cent Club, deputy chairman of Business in the Community, and honorary treasurer of the National Society for the Prevention of Cruelty to Children.[83]

Business associates

But what makes the Tate Trustee Board so eminently clubbable in business world terms is the fact that certain of the trustees are intimately related to each other either by business association or by marriage. At the centre of a web of interlocking directorships among these businessmen is their association

with Jacob (now Lord) Rothschild, 'well known as the most ruthless member of the banking dynasty'.[84] While Rothschild was chairing the National Gallery, his business allies were sitting on the board of, and running, the Tate.[85] The close-knit group included Mark Weinberg, a long-time ally of Rothschild; Gilbert de Botton, who left Switzerland to work for him in London in 1981 and in 1983 set up his own investment house, Global Asset Management, which was 29% owned by Rothschild's company;[86] and Dennis Stevenson, who was reported to be 'a protégé of Weinberg'.[87] Their relationship culminated in the summer of 1991 when Rothschild and Weinberg joined forces to launch another life assurance company, J. Rothschild Assurance, which Stevenson joined as a non-executive director some two months later.[88]

Nor did the business links of trustees end there. A similar connection between Dennis Stevenson, chairman of the Tate board (from 1988 to 1998), David Verey and David Gordon extended the network well into the 1990s, with at its centre, this time, the media and entertainment conglomerate Pearson plc. While Stevenson had been a non-executive director of Pearson since 1986 and became chairman in May 1997, the merchant bank Lazard Brothers, which David Verey has chaired, was 50% owned by Pearson, whose board Verey joined as a non-executive director in 1995.[89] Before being appointed as a trustee in 1993, David Gordon had been working for the *Economist* since the late sixties, and gradually climbed the corporate ladder until he became the group's chief executive from 1981 to 1993, and then director of *The Financial Times* from 1983 to 1993. Both publications are owned by Pearson plc. Pearson was, of course, one of the companies that had made donations to Britain's two major political parties from 1994 until the recent curtailment of the practice, while Stevenson personally worked for the Conservative party in the past and for the Labour party thereafter.[90] Perhaps unsurprisingly, when Stevenson retired from the Tate board, David Verey succeeded him as chairman of the Tate.

Wife and husband

But a more incestuous side to this association is revealed by the Tate Gallery's trustee couple, Gilbert de Botton and the Hon. Mrs Janet Green (now Janet de Botton), which brings the Tate closer to the American-style

board than at any time previously. While Gilbert de Botton first joined the Tate board in 1985, he also became a trustee of the Foundation when it was established in 1986, and he subsequently became its chairman in November 1987. In the same month the Hon. Janet Green joined the Foundation Board. Both de Botton and Janet Green were also representatives on the International Council of the Tate Gallery Foundation. They, of course, knew each other before they were appointed to the Foundation Board. The couple were married in 1990.[91]

While trustees' personal lives are, of course, their own affairs, their situation does raise wider questions of representation and public perception. The fact that Janet de Botton is the daughter of Lord Wolfson connects her to one of the greatest business fortunes ever accumulated in Britain. Lord Wolfson was, until his retirement in 1996, chairman of the Great Universal Stores empire, and he and his family of course had close connections with the Conservative party, in particular Margaret Thatcher.[92] Through family connections, Janet de Botton is a trustee of the Wolfson Family Trust and the Wolfson Foundation, which was reported to be one of Britain's biggest private benefactors since Nuffield. This undoubtedly qualifies her as one of the most sought after trustees of the eighties and, as a matter of fact, she has been deeply involved with the Tate, following an uninterrupted upward path from the Tate Gallery Foundation (1987–92) to membership of the Tate Gallery Liverpool Advisory Council (1988–92) to the highest honour of a Tate board place since 1992. Her association with the Tate culminated in 'an extraordinary gift' of 60 contemporary art works donated to the Gallery from her personal collection in 1996. These were the object of a special exhibition at the Tate in 1998, one of the effects of which was to establish her as the leading woman patron of contemporary art in Britain.[93] To date, in the list of donors and benefactors for the new Tate Modern at Bankside, she stands alone as the Gallery's sole collections-benefactor.

There is also a parallel between Janet de Botton and the case of Alfred Taubman in America, which we have already discussed. Like Taubman, de Botton occupied an extremely sensitive position straddling the worlds of public trusteeship and closely related private business interests insofar as she was a non-executive director of Christie's at the same time as being a Tate trustee. Her appointment to the Tate dates back, as we have seen, to 1992, and it was in November of the following year that she accepted the Christie's

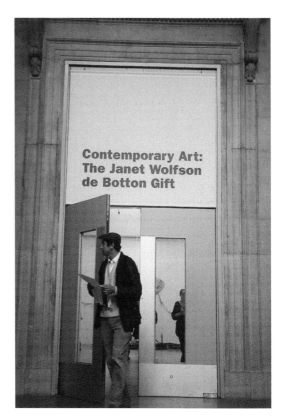

Contemporary Art: The Janet Wolfson de Botton Gift

Figure 2 Exhibition at the Tate Gallery, London, 1998, in honour of Janet de Botton's donation.

appointment. It is difficult to see how she could have passed from the status of a public trustee to that of a commercial appointee in precisely the same sphere of activity without weighing up the obvious charges to which she could be exposing herself. Clearly the public interest and the likely public perception of her ambivalent position were not her highest priorities when she took the decision she did.

One should, of course, be wary of constructing any sort of conspiracy theory, but the fact remains that the curious emergence of powerful individuals at virtually the same moment and at the same institution is a strong coincidence. Their overlapping trusteeships on the various boards of the

Tate Gallery, and their prolonged tenures of office, inevitably raise questions of public interest. The issue at stake is, of course, not whether these people are competent to serve the institution in their trust, given the time they can afford to devote to such public service; it is rather that undemocratic appointments to such positions and the concentration of power in a tightly knit group are simply not an acceptable way to run public institutions in a modern democracy.

This picture of self-electing and self-perpetuating power is even more alarming if we take into account the broader context of museum boards in Britain. Here trusteeship is run, in essence, like musical chairs, with the same coterie of people who retire from one board only to assume the trusteeship of another. After serving at the Tate for twelve years, for example, the Countess of Airlie retired from the board in December 1994 and, from April 1995, became a trustee for the National Galleries of Scotland and subsequently became its chairwoman in 1997. Christopher Le Brun retired from the Tate board in January 1995 and went on to become a trustee of the National Gallery in London. Both the Countess of Airlie and Le Brun, however, continued their involvement with the Tate when they joined the Tate Gallery of British Art (now Tate Britain) Consultative Committee founded in 1995 to raise awareness of its Centenary Development.

Such occurrences bring clearly to the surface the same range of underlying problems that arise in circumstances that we have already discussed above in relation to American boards. Trusteeship is, of course, not simply 'toiling long hours for no financial reward'.[94] The reward lies first and foremost in the social prestige and status that come with it, and it goes without saying that the Tate board is probably *the* most prestigious contemporary art board on which to serve in Britain. To quote Dennis Stevenson:

> I have begun to realise that Tate is *the most powerful brand name*. It wasn't so long ago that the Tates were sugar, yet now Tate has a magical ring because millions have come to this rather extraordinary building on the water [italics added].[95]

It is no surprise in the scheme of things that these words should come from a past master in the professional art of image management and 'dream[ing] up ideas for big business', such as advising Stanhope Properties to commission a Richard Serra sculpture for its Broadgate development in

the City of London, or advising Dunhill 'how to tap the Japanese lust for luxury goods'.[96] Dennis Stevenson was often described in the media as 'chairman of the SRU Group and the Tate Gallery' as if his chairmanship of a non-profit-making national institution carried the same weight as his private sector money-making venture.[97]

Buying a seat?

Moreover, once the needs and the logic of private capital enter and permeate a public institution, secretiveness enters also, and turns potential conflict of interest into reality. Back in 1985 when the Tate was preparing for a Francis Bacon retrospective, it was well known that the Gallery had difficulties in finding sponsorship because sponsors did not want to be associated with 'that mad flaying Baconesque vision'.[98] At the very last minute, when the catalogue had already been printed and no other sponsorship material prepared, Global Asset Management, the international financial house chaired by Jacob Rothschild and run by Gilbert de Botton, came to the rescue.

The timing of the sponsorship deal and the appointment of de Botton as a Tate trustee is too close to suggest a mere intriguing coincidence. According to de Botton himself, it was 'early in 1985' that, 'shocked to learn' that no sponsors had come forward for the exhibition, he himself decided to sponsor the retrospective, partly because he is 'a fan of Bacon'.[99] De Botton was appointed as a trustee in the middle of April 1985, the exhibition was held from 22 May to 18 August 1985.[100] According to Alan Bowness, the then director of the Gallery, the trustees accepted the sponsorship of Global Asset Management Ltd *just before* de Botton's appointment.[101] What is unusual about the appointment of de Botton is also that he (a Swiss national) was the first non-British citizen, or non-Commonwealth national, to be appointed to the trustee board of a British national museum or art gallery.

I have no means of assessing the accuracy of the timing and the connection (if any) between the two events, since the way in which such appointments are made is always firmly hidden from view under the veil of 'discretion'. But the fact remains that the exhibition would have gone ahead as planned even without the intercession of de Botton, because when the sponsorship was offered, the catalogue had already been printed, and other

printed material capable of carrying sponsorship acknowledgement had not been planned.[102] Second, the real sequence of the events remains unclear because such appointments take many months to come to completion, as the case of Sir John Burgh illustrates. No one would, of course, suggest that anything improper took place (like buying a place on the board), but many might see here a potential contradiction in trustees' constitutional powers, and this would naturally be a matter of public interest.

The question of conflict of interest (see footnote on p. 94), insofar as de Botton as a trustee of the Gallery was also running the company that was sponsoring the show, was indeed posed to de Botton during the conference *Sponsorship of the Arts*, coincidentally held at the Tate during the exhibition. 'The thought had crossed our cautious mind,' he explained, 'but it had been dismissed.'[103] But he did not mention the fact that he is himself a collector of Bacon, and that three Bacon oils from his own collection (catalogue numbers 79, 89 and 95) were on display in the retrospective.[104] What we see here finds a parallel in our earlier discussion relative to American boards and their business trustee-collectors. By virtue of these Bacon works having been shown at the Tate, the value of de Botton's own collection must have increased, resulting, potentially at least, in financial gain for him personally.

In a similar instance of the possible use of privileged information, de Botton, acting through Global Asset Management, sponsored a second exhibition, *Late Picasso*, in 1988. Peculiarly enough, there was barely a voice of criticism raised. Unlike Francis Bacon, Picasso is one of the most exhibitable and sponsorable artists of the twentieth century.[105] Global Asset Management's sponsorship therefore was unlikely to reap the same sort of kudos as that reserved for those who promote art – to use de Botton's own terms – out of the sense of adventure, or 'to stir spirits' or to support 'comfortably unpopular' artists such as Bacon.[106] While three Picassos from de Botton's own collection were again on display (catalogue numbers 28, 49 and 63), his ownership was openly acknowledged in the catalogue as ('Gilbert de Botton, Switzerland'), thus producing an effect of distance and disconnection.[107] Although these extremely rich individuals often have several residences across the globe, the fact is that Global Asset Management is actually registered in London, and de Botton indeed moved to London in the early 1980s, according to several accounts.[108] At the time of the Picasso exhibition, he was still sitting on the board of the Tate.[109]

Clash of interest is, of course, often a delicate matter, and this is why cautious individuals may prefer to avoid rather than to 'dismiss' it. When advantage is immediate, charges are more easy to substantiate, but long-term gain is difficult to estimate, and in such cases one has to fall back on hypotheses. If de Botton had had a precise estimation of the worth of his Bacons and his Picassos, and if he had then sold them on the open market after the two exhibitions in question, it might have been possible to quantify the extent of any advantage that his position as a Tate trustee could have given him.

The two brothers

The notorious case of Charles Saatchi provides a further, and perhaps clearer, illustration of this sort of inside advantage. Despite Saatchi never having served on the Tate board, he was once on the Committee of the Patrons of New Art, a committee of which he was the driving force when it was first established in 1982, and whose membership in those days included many collectors and nearly all the London art dealers.[110] In the same year, the Tate Gallery organised the first exhibition of Julian Schnabel's work in collaboration with the Patrons; nine out of the eleven paintings in the show were owned by Charles Saatchi and his then wife Doris.

While this and other similar manoeuvres by Charles Saatchi in the early eighties do not readily lend themselves to investigation, his activities at around the same time at the Whitechapel Art Gallery, of which he was a trustee, provide clearer evidence of how he was able to take advantage of the various interlocking positions of power that he held. During his trusteeship, his advertising company was actually making donations of several thousands of pounds to the Whitechapel to supplement their public funding. Shortly *after* the Gallery decided to mount an exhibition of Francesco Clemente's paintings, but before the exhibition went on show, Saatchi bought up 12 Clementes for his private collection. There is, this time, no doubt about the timing, since the sequence of events was explicitly confirmed by the Whitechapel's then director, Nicholas Serota.[111]

A similar instance of Saatchi apparently benefiting from inside information is provided by the case of Malcolm Morley. After learning at a trustees' meeting that the Whitechapel intended to mount a Morley exhibition,

Saatchi and his wife were reported to have added several Morleys to their personal collection. It was only in 1984 that Saatchi saw fit to resign his Whitechapel trusteeship. As an art collector, Saatchi was said in 1983 to have had an annual turnover of some £3 million, which invites the speculation that his purchasing activities may well have included some selling also.[112] Although not strictly speaking an art dealer, his approach to art collecting was little different from a dealer's: he bought not only to keep but also to sell. He not only bought in bulk, but sold in bulk also, which might well have led the artist Sean Scully to refer to Saatchi in a television interview as a 'commodities broker' in art.[113] It is inevitable that a businessman of his experience was not going to sell at a loss, and it can therefore be assumed that some profits must have come his way following his initial purchases. Some at least of these must have been the direct result of inside information. In any event, his company is reported to have made at least £15 million profit in selling art.[114]

The case of Charles Saatchi and the issue of inside advantage have, of course, a wider context in that during the eighties his brother Maurice was also on the board of the V & A. A more cautious man than he might have refrained from mixing business with such an appointment in order to avoid any charge of conflict of interest, but Saatchi and Saatchi, the company that he chaired, was also responsible for running the advertising campaign for the V & A, 'An ace caff with quite a nice museum attached'.

The Saatchi brothers provide an excellent illustration of the interchangeability of various forms of capital and of the resultant problems of concentrated power facilitated, if not actually encouraged, by the Conservative government. Not only was Saatchi & Saatchi the world's biggest advertising agency in the mid-eighties, but also, and closer to home, it was they who ran Margaret Thatcher's election campaigns, thus giving them a powerful base for political power. Their connections with the Thatcher government won their company various accounts for public bodies as well as arts institutions, thus allowing them to transform their recently won political power back to serve their own economic interests. On a personal level, the powerful positions they occupied within public institutions further consolidated and extended the two brothers' power and ambition from the economic into the cultural domain. The fact that Charles and (probably also) Maurice Saatchi benefited economically from their public

offices exemplifies the process of transformation of cultural capital into economic capital.

Art, the business world and politics have entered into a clandestine symbiotic relationship in which the unelected and the nominated join forces with those entrusted to manage public institutions and those elected to govern. Using their many different power bases, people like the Saatchis are in a privileged position to transform part of their economic capital into cultural capital, which they do, for example, when their personal fortunes and influence allow them access to trusteeships of art galleries and museums. This cultural capital they then transfer back into economic capital by using art as a commodity. What makes this circle a vicious one is that it functions free of public scrutiny even though it operates through public institutions. Personal fortunes are created, sustained and increased by a small number of self-selecting individuals purporting to be acting out of selfless public-service motives, and endowed with the enviable gift of being able to turn Nelson's eye to any trace of conflict of interest looming on the horizon.

The existence of interlocking family relationships of the type illustrated by the Saatchi brothers and the de Bottons is one of the features that the British trustee system has come to share with its American counterpart. But whereas in the latter it is an open secret that trusteeships can, to all intents and purposes, be bought, in Britain exploitation of personal wealth takes a less blatant, some might say a more hypocritical, form when it comes to gaining admittance to the powerful inner circles of trusteeship. A glance at the acknowledgements list in the Tate Gallery exhibition catalogues reveals an implicit additional qualification for membership, namely the status of benefactor or donor that is applied to individual trustee's names. Behind these philanthropic-sounding terms lurks the fact that some trustees earn their place, so to speak, by virtue of their personally supplementing the income that the gallery continues to derive from the public purse.

It is at this juncture that one may recall what Alan Bowness had to say about the nature of American trusteeships and the gap between them and their British equivalents: 'At one museum of modern art in California a sufficiently large donation guarantees a place on the board. At least we haven't reached that stage.'[115] Behind the veil of enterprise culture and the rhetoric of public interest, the Thatcher government succeeded not only in closing this gap, but also in taking steps to legitimise and protect the interests of the

business elite. Rather than broadening representation in the public interest as befits a public institution, it acted to channel ostensibly private capital into public institutions, a political process that contributed actively to concentrating more and more power into smaller and smaller groups of people. Although a substantial part of 'private donations' by trustees is actually indirect public subsidy raised through tax mechanisms, the Tate can confidently deny any public accountability in the name of protecting the 'private' confidentiality of the individual donors. When asked by me what the different levels of donation were between a benefactor and a donor, the Gallery replied that it felt under no obligation to answer such enquiries from the public.

Although under the Thatcher government British trustees moved closer to the American model, institutions such as the Tate have remained very much in the public domain, with the result that developments here have been more cautious. Standards in public life have, in the meantime, become an issue, and under the influence of the Nolan Committee of Inquiry, codes of best practice began to be drawn up in which certain basic ground rules were set out. In the code issued in early 1996 by the Board of Trustees of the National Galleries of Scotland, for example, individual board members are reminded explicitly of their responsibilities and it is clearly stated that 'they should not use information gained in the course of their public service for personal gain, nor seek to use the opportunity of public service to promote their private interests.'[116] In view of the past activities of certain trustees of certain prominent institutions, this may look very much like a case of closing the stable door once the horse has bolted. 'Trusting the trustees' has not in the recent past proved to be a very successful way of ensuring accountability and safeguarding the public interest,[117] so one can only look forward with optimism to the new era of openness and honesty by which Lord Nolan attempted to replace the discredited deregulation frenzy of the Thatcher decade. New Labour's commitment to more transparency in public life also holds out hope for the future. But as yet, this new age shows little sign of having dawned.

EMBRACING THE ENTERPRISE CULTURE:
ART INSTITUTIONS SINCE THE 1980s

> With the Government giving less to art and education, somebody's
> got to give more. And that somebody is America's corporations.
>
> Chase Manhattan Bank, NA[1]

Statements such as the above, presenting business to the public conscious-
ness at large as an enlightened patron of the arts, were a common feature of
the Reagan years. They form part of a wider phenomenon that was also char-
acteristic of the 1980s under successive Reagan and Thatcher governments,
that of the intervention of business into contemporary culture. Such an
intervention was unprecedented in the sense that never before had the cor-
porate sector in both America and Britain mobilised its resources so
forcefully in order to extend its sphere of influence and effect an *entrée* into
the world of culture.

Compared with the United States, there was a great deal less corporate
engagement in art museums in Britain, at least before the Conservatives
came to power in 1979. Then the government at both local and national
levels was still directly and adequately funding art galleries. Thus it was still
possible in 1980 to speak of visual arts sponsorship in Britain as a 'new
game', with its territory yet to be 'firmly demarcated'.[2] Yet throughout the
1980s the Conservative government was highly successful in emulating
American-style enterprise culture, transforming the cultural scene in Britain.
By the end of the 1980s, whether in Britain or America, art museums had
become just another public-relations outpost for corporations, and we live
with the consequences to this day. Across the Atlantic, Lexus sedans were
regularly displayed outside museums and concert halls, such as the Los
Angeles County Museum of Art and the Lincoln Center in New York, while

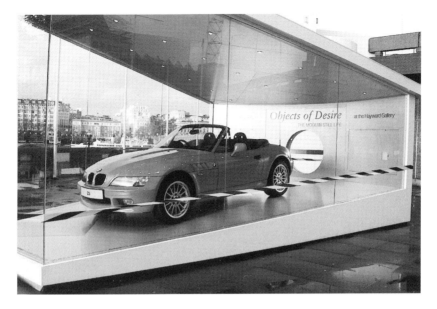

Figure 3 BMW's Z3 displayed at London's South Bank during the *Objects of Desire* exhibition, sponsored by BMW at the Hayward Gallery, 1997–98.

in Britain both the Royal Academy and Royal Festival Hall converted their courtyards into car showrooms for corporate sponsors. The transformation of art museums in the 1980s from purveyors of a particular elite culture to fun palaces for an increasing number of middle-class arts consumers has thus to be seen within the dual perspective of government policies and business initiatives.

THE PRINCIPLES OF ART SPONSORSHIP

But why are companies or corporate executives attracted to arts sponsorship in the first place? Notwithstanding the considerable endeavours to foster private support for the arts under the Reagan and Thatcher regimes, corporations were doing much more than simply responding to government

pressure. It was rather a question of the unashamedly pro-business ambience created by both governments significantly helping companies in their efforts to advance their agendas. At an ideological level, business has always perceived any government regulation as a potential threat to the free market system. Closely following the setting up of the National Endowment for the Arts by the US federal government in 1965, the business community responded in 1967 by establishing an arts support system of its own, the Business Committee for the Arts. Like other business associations such as the Business Roundtable in America, the BCA assumed, and has maintained, an undisputed role as the principal spokesman for business views on arts issues. It defends and champions its arts intervention through regular publications of the speeches of top corporate executives. Here is part of one of them by Winton Blount, the chief executive officer of Blount Inc. and a former chairman of the BCA, at its annual meeting in 1984:

> That environment [of freedom] is being persistently eroded everywhere by ill-advised and ill-conceived regulation, taxation, and other forms of government control. So we are engaged in an important work in furthering the arts. We are not merely meeting a civic obligation which we can accept or reject as we wish. We are helping to keep open those avenues of freedom along which art and commerce both travel.[3]

But freedom of artistic expression, in which an individual asserts his or her right to advance his or her art at a personal level, is of an entirely different order from the freedom that businesses with vast amounts of private capital have to follow their altogether more earthly pursuits.

The significance of this pro-business offensive can only be fully understood against the background of an even larger corporate strategy; that is, to quote Willard C. Butcher (successor to David Rockefeller as president and chief executive of Chase Manhattan Bank), to take a 'visible role in communicating the private enterprise perspective on a variety of critical public issues'. During the 1980s, it was not only business executives who made concerted efforts to speak out through media appearances, as Butcher had urged his fellow executives, to 'take our message directly into American homes, to the people. . . . We need nothing less than a major and sustained effort in the marketplace of ideas.'[4] Companies also spent millions of dollars

on issue advertising, not directly to sell products, but to propagate company views on contemporary political and social issues. Although this broader issue cannot be dealt with here, it is essential to bear in mind that corporate arts sponsorship is not an isolated phenomenon. By sponsoring art institutions, corporations present themselves as sharing a humanist value system with museums and galleries, cloaking their particular interests with a universal moral veneer.

While culturally 'playing safe' is generally thought to be the strategy of corporate sponsorship, contemporary art certainly offers more treacherous ground than that of the old masters, which are unlikely to generate controversy. Why, then, does any company choose to tread upon it? The mythological cult of artistic personality and the strong association between avant-garde art and innovation within the paradigms of modernism have provided the business world with a valuable tool for the projection of an image of itself as a liberal and progressive force. When introducing its sponsored exhibition *When Attitudes Become Form*, a survey of conceptual art, John Murphy, then the executive vice-president of Philip Morris Inc., emphasized that

> We at Philip Morris feel it is appropriate that we participate in bringing these works to the attention of the public, for there is a key element in this 'new art' which has its counterpart in the business world. That element is innovation – without which it would be impossible for progress to be made in any segment in society.[5]

By appropriating the concept of innovation, and by mediating and redefining its meaning in corporate terms, business seeks to present its intervention in the arts as a great and legitimate cause.

MANAGING SPONSORSHIP

To venture into arts sponsorship, however, requires more than an imaginative manoeuvre. It is an initiative generally taken not by middle managers, but by the chairman or chief executive, or, in the case of partnerships, the senior partners. At variance with orthodox management theory, according to

which senior management's involvement should increase or decrease in pro-
portion to the relative scale of expenditure, top managers take a
disproportionate interest in arts sponsorship, regardless of the small sums
involved in relation to a company's annual budget. A systematic analysis by
Michael Useem and Stephen I. Kutner in 1984 of corporate contributions
among companies in Massachusetts reported that the CEO of three-fifths of
the firms still reviewed recommendations for specific contributions if they
exceeded a minimum amount, with that amount for half of these firms
being a mere $500.[6]

The important role that senior managers, in particular the chairman and
the CEO, play in corporate arts sponsorship is confirmed by the results of my
own survey into the subject.[7] When it comes to initiating any programme,
the single most pivotal figure is the chairman or CEO, followed by other
senior managers. Nearly three-quarters of US companies and well over half
of British ones reported such senior involvement in their arts programmes.

This suggests that senior corporate executives play a very significant role
in arts sponsorship, and indeed corporate arts intervention in general. Such
people, an elite within an elite, occupying the uppermost echelon of corpo-
rations, are in a position of great power and influence. Despite the pressing
demands of their jobs (and frequently of other directorships), they also
manage to serve on a bewildering list of charities and non-profit-making cul-
tural institutions. These men (for they are mostly men), to paraphrase the
American sociologist Paul DiMaggio's description of cultural capitalists, are
the 'cultural managerial capitalists', the sort who climb to the top of the cor-
porate ladder through a managerial career, and for whom involvement in the
arts is a locus of social distinction to which their elite status and class
aspirations are anchored.[8]

DISTINCTION

The engagement of this business elite in the arts can thus be interpreted
both on the individual and corporate levels. Despite all the media attention
given to self-made entrepreneurs during the Thatcher and Reagan years, top
corporate management was, and still is, dominated by an economically priv-
ileged, and thereby socially and educationally prominent, class in both

countries. By virtue of their social background and corporate positions, they are participants in an intricate and complicated web of economic and social networks of acquaintance, friendship and inter-marriage. However, inherited wealth or a high-status occupation, as Thorstein Veblen argued in the nineteenth century, does not of itself constitute a sufficient credential for membership of the dominant section of the class.[9] It also depends upon the adoption and display of a particular set of values and life styles. To be seen as a patron of the arts is part and parcel of a distinct *style of life* required and sanctioned within this 'sophisticated' stratum of society. The exercise of high culture has become an increasingly important social activity: it is above all at exclusive events in arts venues that the business and political elite meet and recognize one another. It is no surprise that the names of executives often crop up in arts sponsorship in media reporting. To put it bluntly, there is more than a grain of truth in Thomas Hoving's cynical comment: 'Art is sexy! Art is money-sexy! Art is money-sexy-social-climbing-fantastic!'[10]

It is appropriate at this juncture to recall Pierre Bourdieu's theory of 'cultural capital'.[11] By participating in arts sponsorship, these elites are using their corporate positions to advance their personal interest and social status. Slightly modifying Bourdieu's theory, one could argue that these business elites are transforming the economical capital of the corporations that they oversee into cultural capital for their own personal ends, while simultaneously acting in the corporate interest. It is sufficient, for our present purposes, to point out, following DiMaggio's elaboration of Bourdieu's concept, that cultural capital can in turn be transformed into the social capital of acquaintances and connections, and that this in turn can be put to use for the accumulation of economic capital.[12] It is the fluidity and flexibility of private capital that has made the confluence of its variants conceptually conceivable and in reality attainable in the very locale of these top businessmen. The interchangeability of these different forms of capital is likewise intelligible on the corporate level, something that will become evident over the course of the following discussion.

If the essence of the top executives' involvement in arts sponsorship requires further refinement, the importance of arts sponsorship as a public relations tool does not. It used to be an open secret but now it is openly discussed on both sides of the Atlantic. The true nature of this marketing exercise can best be seen in the tax concessions granted in both countries.

While tax advantages are rarely mentioned by American arts sponsors, they have long been a prime item on ABSA's campaign agenda for tax reform in Britain. The difference lies partly in the fact that the sums involved are minuscule in relation to any company's budget, but it is also because in America sponsorship is in any case already tax-deductible, whether the sponsorship dollars come from the marketing/public relations department (as the majority of them do) or from the so-called 'corporate philanthropic budget'.[13]

In Britain, however, sponsorship and patronage are differentiated for tax purposes, though in the perception of the general public the two terms are interchangeable. To encourage arts sponsorship and side-step what is seen as the cumbersome process of qualifying for tax deductions by making covenanted payments, both the Thatcher government and ABSA advocated a specific definition of sponsorship: 'a commercial undertaking, *i.e.* a payment by a business to an arts organization for the purpose of promoting the business name, products or services. This is a commercial deal between the parties concerned, rather than a philanthropic gift.'[14] By contrast, patronage via the tax route of deeds of covenant is deemed a 'philanthropic gift' or 'pure' donation, however arbitrary the distinction between the two categories. Accordingly, the bias in the tax structure is geared toward the self-interest of sponsors; presumably by locating sponsorship within the gamut of public relations campaigns, more corporate money would be forthcoming. This is, of course, not just a matter of shift in corporate priority. It meant, in effect, that the Thatcher government, along with organizations with substantial vested interest in sponsorship such as ABSA, openly defined sponsorship as a form of commercial promotion, with arts organizations acting as PR agencies for corporate sponsors. Ironically, only 9.7% of British respondents to my survey, compared to 39.6% of American companies, considered the tax incentives of any importance at all.

Unsurprisingly, the primacy of public relations elements in sponsorship was confirmed by my own survey. Both British and American companies gave paramount importance to this aspect of sponsorship. When asked their reasons for launching arts sponsorship, 92.7% of British companies (78.2% of American companies) considered it a means of improving corporate image, and 90.6% (78.2% for American) saw it as a public relations exercise, compared with only 35.1% (52.5% for American companies) who maintained

that they undertook sponsorship for employee benefits. The highest percentage by far was recorded when it came to measuring their perception of the success of their sponsorship as a PR exercise. Among British companies, 90.5% (90.0% for American companies) were satisfied that it constituted a successful and effective public relations exercise, and 97.2% of British companies (88% for American companies) reported improved corporate image, while only 52.5% (75.0% for American companies) thought that it successfully advanced employee benefits.[15]

BURNISHING THE CORPORATE IMAGE

The concept of the publicity campaign is, therefore, essential to arts sponsorship. The need for publicity varies according to the products or service that the companies are marketing, but arts sponsorship is particularly effective for those companies, such as petroleum, tobacco and weapons industries, whose image is in need of some polishing. It is therefore no coincidence that oil companies such as Exxon and Mobil provide the largest amount of money for arts and culture in America.[16] Likewise, in Britain, British Petroleum (BP), fully privatised in 1987, is one of the biggest arts sponsors in the country, on a par with British Telecom. Since 1990, the regular rehanging of the Tate Gallery collection, of which only a fifth is on display at any one time, has been sponsored by BP. For around £150,000 a year, a sum which can buy only two-and-a-half minutes' commercial advertising on prime-time television in 1990, the BP logo appears all year round on the Tate's large banners advertising the New Displays and on the front cover of the gallery's publications.

This publicity machine is run even more cost-effectively by the tobacco industries. Although it is not appropriate to discuss tobacco sports sponsorship in detail here, it is essential to understand that sports and arts sponsorship are interrelated, and have to do with the fact that tobacco advertising is severely restricted by law. Sports sponsorship gets the tobacco companies' brands considerable television exposure in a medium in which they are not permitted to advertise. While there is some, albeit ineffective, form of regulation for sports sponsorship, there are no restrictions whatsoever for arts sponsorship. For arts sponsorship, however, tobacco companies

are buying not television coverage, but a different kind of publicity associated with public prestige, status and access to people of influence. In America, the Philip Morris Companies, including household brands such as Marlboro, Benson & Hedges and Virginia Slims, are the world's largest tobacco conglomerate. Since the 1960s, the company has also become one of the leading specialists in capitalizing on arts sponsorship, especially in the visual arts. It gave an estimated $15 million to arts organisations throughout the country in 1990.

In contrast to its political contributions, which it would prefer to protect from the public gaze, the company is proud of its arts support and from time to time produces glossy publications to champion its high-minded achievement. To celebrate its 35 years of arts sponsorship, for example, Philip Morris published a 130-page catalogue listing each and every contribution it has made since 1958. It covered virtually every artistic discipline and mentioned almost every major arts institution throughout the United States and across the globe.[17] Despite all the grand talk of commitment to the arts, its real motive is abundantly clear. To quote George Weissman, its then vice-chairman: 'We are in an unpopular industry. [While] our support of the arts is not directed toward that [problem], it has given us a better image in the financial and general community than had we not done this.'[18] This carefully crafted image of a unique corporate personality has won the company eulogistic comments from the media. The well-known art critic Barbara Rose paid Philip Morris this compliment: 'One can only be grateful to a corporation farsighted enough to deflect PR budgets into public service rather than pouring it down the Madison Avenue drain.'[19] J. Carter Brown, director emeritus of the National Gallery of Art, also praises the company for providing a 'bedrock of support to cultural organizations around the world' and for its 'unwavering support' and 'enlightened and far-reaching vision'.[20]

The concentrated strength of Philip Morris in arts sponsorship finds no equivalent in Britain, where the greater part of corporate money has gone to supporting music. Even so, in Britain the tobacco companies remain one of the pioneers in this area. Although it is now defunct, it is worth mentioning that the Peter Stuyvesant Foundation, funded by Carreras Rothman, began to fund New Generation shows at the Whitechapel Gallery in the 1960s. The most prominent tobacco industry player in visual arts sponsorship in the 1980s was Imperial Tobacco. In 1980 Imperial launched its annual Portrait

Award at the National Portrait Gallery, significantly at a time when the company's sales of cigarettes had dropped to 120 billion from a peak of over 137 billion in 1973. Of its arts sponsorship, Peter Sanguinetti, its then external affairs executive, emphasized, in a *Sunday Times* interview, that 'We want the arts people we pick to work hard to give us publicity. We don't talk about "giving" money on sponsorship – the recipient gets the money, we get the publicity.'[21]

Although it lies beyond the scope of our present study, it has to be pointed out that the magnitude of tobacco sponsorship in Britain was such that in the early 1980s three of London's main orchestras were supported by tobacco largesse, with the London Philharmonic being dubbed 'the du Maurier Band'. While British businessmen have preferred classical music and opera, museums in America have always been the favoured beneficiaries of corporate money. According to the Conference Board, nearly 20% of corporate arts support in America goes to museums of all kinds every year, far ahead of the 12% given to music.[22] In Britain, the comparable figures for music, opera and museums are 18.9%, 17.76% and 11.96% respectively.[23]

THE ART-GOING PUBLIC

If art museums find it easier to get corporate support than museums of other types, the reasons are not hard to find. While the attendance figures of museums of other types, be it in America or Britain, are by and large higher than those of art museums, art museum visitors rank higher in socio-economic terms than those visiting other museums. Statistically speaking, despite all the claims made for the democratization of both the production and appreciation of the arts since the Second World War, art museum audiences are far more educated, have more prestigious jobs, and are more affluent than visitors to other museums, even though museum audiences in general are already disproportionately privileged in socio-economic terms compared to the population as a whole. For instance, in the US 48% of art museum visitors had at least undergraduate education, compared with 34.4% of visitors to other museums, whereas only 13.9% of the population had such educational qualifications in 1975. A similar disproportion can be seen in occupation and income levels.[24]

So it is the demographic features of these consumers that largely explain why art museums are particularly appealing to corporate America and Britain. This is despite the fact that companies often claim that 'the general public' are their target audience, as if this public were a homogeneous group. Companies often advertise their benevolent attitude in such terms; to take one example: 'Manufacturers Hanover is pleased to carry on the tradition of private sponsorship of the arts for the benefit of the public.' Consistently negating the underlying socio-economic inequalities in arts participation, corporate rhetoric such as this serves to mask the capital interests of sponsors, and to create a false image of what is referred to as 'corporate philanthropy'.

There are two main considerations behind corporate sponsorship: first, for companies whose products or service can make a 'right' connection with the sponsored show or the institution, the sponsored event is a sales promotion, however well disguised it may be; second, for companies whose products lack a direct link to exploit the sponsored event, association with the arts is more geared toward advertising their so-called 'enlightened' corporate image.

In the first instance, it is people within the ABC1 groups who are directly targeted. Over the last ten years the imported German beer Beck's has been the favourite tipple of the official British avant-garde. It made its début conventionally enough sponsoring the exhibition *German Art in the Twentieth Century* at the Royal Academy in 1985, at a time when its British distributor, Scottish and Newcastle Breweries (S&N), were about to launch a nationwide marketing offensive, aimed at the under-30, style-conscious generation in an already over-crowded lager market.

Beck's programme soon made a splash when it sponsored the retrospective of the newly garlanded Turner Prize winners Gilbert and George at the Hayward Gallery in 1987, with the brewers producing a 'limited edition' of 2,000 bottles carrying a label designed by the artists. The success of this 'innovative art sponsorship' is obvious: not only did it capture media attention, but the bottle itself became a collector's item, with one of them actually being admitted to the Tate Gallery's collection. To date, special edition bottles have included labels by Tim Head, Richard Long, George Wyllie, Bruce McLean and the 1993 Turner Prize winner, Rachel Whiteread. Compared with 20,000 barrels in 1984, S&N were importing 350,000 barrels ten years later. This spectacular sales growth is underscored by an equally

impressive sponsorship budget of more than £350,000 in 1994, compared with £20,000 in 1985. This is, of course, nowhere near the big league of arts sponsors such as British Telecom (£1.8 million in 1994) or BP (£1.25 million in 1991), or even S&N's competitors such as Guinness. But the potential of its relationship with the arts is abundantly clear; as James Odling-Smee pointed out, 'bear in mind that Beck's is just one beer, just one brand.'[25]

In the second case, where it is corporate image rather than indirect sales that are the concern, politicians, senior civil servants and opinion-formers figure among the most frequently mentioned target audience in my interviews. To quote from one of the top brewers in Britain: 'Our target audience is very easy and very simple, and it's probably no more than a thousand people. It would be the MPs . . . broker analysts, relevant journalists . . . and civil servants. Again these are all people relevant to our business.' The same company is even more specific when it comes to defining its actual criteria. As far as geographical location is concerned, the spokesperson specified: 'We would tend to sponsor things within a one-mile radius of the Houses of Parliament because we want to reach MPs.' The significance of this corporate 'schmoozing' cannot be overestimated in a political climate where it was clear – at least under the previous administration – that influence could simply be bought. In attempting to dismiss charges of political lobbying, the company secretary of one manufacturing multinational in London candidly revealed its real motive:

> It's not just the City, but you want a long-term relationship with Government. . . . I stress 'a long-term relationship' because we certainly do not use sponsorship or any other external affairs activity to try and specifically influence such people because we've got some issue at the time, which it would be helpful if we changed their views about. . . . If you can invite to events the senior politicians, not necessarily just the ones in Government but the ones in Opposition as well, because you know, in so many years' time they might change, so you can meet them socially, so they get to know you a bit more than just a name or a face in a formal situation. Yes, it just means [that] if some issue does come up, they won't dismiss something out of hand

This is political lobbying, no matter how informal and sophisticated. Similarly, the public affairs manager for an unnamed brewery pointed out

that it already knew its target audience so well that it sponsored not only art exhibitions, but also concerts and theatres to appeal to the specific interests of influential individuals.

After all, arts sponsorship, with its attraction of tax relief and with the British government's handout of public money to endorse it, is more than mere advertising for an 'enlightened' corporate image. Ultimately, the significance of this corporate intervention has to be understood in political terms. By virtue of their being within the public sector or, in the case of American museums, in the domain of public prestige and authority, art museums have such a privileged position that association with them is a conspicuous signal of social prestige and power. This is further reinforced by the claim, widely made in the name of 'art for art's sake' in bourgeois culture, that art, by its very nature, resides above the sordid world of politics and commerce; in the words of a senior officer in one prominent museum in New York, 'We are non-political.' Precisely because the ambience of art museums ostensibly absolves them from participating ideologically in the political process, they paradoxically provide the most discreet of venues where top politicians or government officials are invited to rub shoulders with equally prominent business leaders.

THE INSTITUTIONS OF ART

To gauge the influence that corporate capital has on the practice of contemporary art, we must now turn to examine art museums. This is not to say that contemporary art exists only inside art museums and galleries, but rather that their institutional structure provides the most visible site for any attempt at corporate influence.

As we have already seen, affluent museum visitors constitute a niche market of substantial purchasing power for business to capture. As one of the visual arts sponsors pointed out, sponsoring art exhibitions with carefully vetted invitation lists is more practical than sponsoring, say, the performing arts; exhibition openings, with their attendant champagne and canapés, provide an unrivalled context for sponsors to entertain their clients and to communicate with them. This is especially so in Britain, where in both my surveys and in the interviews I have conducted, corporate hospitality has

been reported to be very important. In addition, it has been standard practice since the late 1980s for the benevolence of the sponsor to be permanently documented in the chairman's statement in exhibition catalogues, and widely distributed thereafter.

Nowhere is the transformed role that art museums came to play in the 1980s more clearly visible than in the immense popularity of 'blockbuster' exhibitions. According to Victoria Alexander, who studied the impact of public and corporate funding on art museums in America, the most significant effect of the shift in funding from public to corporate is the new emphasis being placed on 'blockbuster shows'.[26] These exhibitions, designed to attract the largest number of people possible to the museum, have become a yardstick whereby to judge its success, or otherwise. As J. Carter Brown, director emeritus of the National Gallery of Art in Washington, DC, stated: 'it got into the corporate mentality that there's no point in spending money on a show unless you can guarantee that it's going to be another Tut.'[27]

The popularity of blockbuster exhibitions, however, signified a more profound change in museum operations brought about by corporate capital in the 1980s, namely its over-expansion. The extent to which this also had its origins in a conscious policy on the part of the institution is a complicated question that lies beyond the scope of this study. But the most important link between the world of art and that of commerce is the museum's director. Museum expansion policy is thus closely bound up with the ambition of the director. In this respect, the directorship of Thomas Hoving at the Metropolitan Museum from 1966 to 1977 gave a foretaste of the ethos that would come to dominate the art world of the 1980s. With a 'big business background' as well as a training in medieval art, Hoving deliberately ventured into costly undertakings – new wings, blockbuster exhibitions and expensive acquisitions – thus forcing the museum into a desperate search for new sources of income. Hoving's regime at the Met successfully transformed the traditional operation of the art museum from a warehouse of art artefacts into that of an entrepreneurial undertaking. The Met was marketed as a magnificent mansion providing a never-ending succession of blockbuster shows. As the conservative critic Hilton Kramer put it, Hoving made 'the Museum bigger in almost every respect', on a scale that can only be described as 'imperial'.[28] Arguably the most influential

museum in the United States, the Met left a far-reaching and lasting imprint on art museums elsewhere.

The 1980s' equivalent of Hoving's showmanship would be Tom Armstrong of the Whitney Museum of American Art. When he became the museum director in 1974, Armstrong claimed that the Whitney could no longer afford to mount major exhibitions without corporate or government funding, despite the fact that, until Marcia Tucker was dismissed in 1976, none of her exhibitions actually had outside funding. The 17-year director-ship of Armstrong at the Whitney witnessed a succession of blockbuster exhibitions, of which the earliest was the Jasper Johns show in 1977. Within one decade, attendance figures at the museum more than doubled from 231,654 in 1974–75 to 532,333 in 1983–84.

It was Armstrong who, with breathtaking audacity, was responsible for opening four Whitney branches at the headquarters of multinationals in the 1980s. This brand of maverick commercialism became even more overt with the appointment of Margery Rubin Cohen as the museum's public relations officer in 1988, with her 'extensive background in marketing and publicity for the fashion and cosmetics industries', including being the mar-keting director of the exclusive department store Bloomingdale's. The cult of limitless expansion with escalating costs forced the Whitney, and American art museums in general, to rely more and more on corporate money, and on commercial marketing and promotion skills to generate income and draw under their roofs the ever-increasing crowds that are pre-sumed to befit grand art institutions.

SEROTA AT THE TATE

In Thatcherite Britain there emerged a new breed of museum director, what Antony Thorncroft referred to as 'scholarly business managers'.[29] They included Neil Cossons at the Science Museum, with a background of run-ning a commercial museum (Ironbridge), and, especially important for our purposes, Nicholas Serota at the Tate Gallery. They are, like their American counterparts, entrepreneurial, if somewhat less ruthless. This is not to say that they are necessarily Thatcherite in a political sense, but they are nonetheless ready to market aggressively the institution in their care. Belated

as it was in terms of the broader change described here, the change at the Tate Gallery, with Serota replacing Sir Alan Bowness in 1988, was clearly a sign of the times. Although he played his part in courting sponsors, Bowness openly declared that 'to think the American system is the panacea' is 'sheer nonsense'. 'My colleagues in the United States often envied me – even in these straitened times,' says Bowness. 'I believe in state funding. I don't think it's possible – I don't think it's desirable, for the arts to be left to the private sector.'[30] This is hardly an attitude that Number Ten would have been prepared to countenance forever.

While Bowness's Tate, which Lord Gowrie once described as 'a bit of a maiden aunt', was not seen as 'a hit', Serota's task at the Tate was to make it 'the biggest art fun-palace in Europe'.[31] Prior to becoming director of the Tate, Serota, as has been noted above, was director of the Whitechapel Art Gallery from 1976 to 1988. Young and enthusiastic, he was known as an adventurous exhibition organizer. But equally impressive was his skill in establishing a portfolio of corporate sponsors for the Whitechapel. Serota was quoted as complaining in 1980 that 'the amount of my time spent on fund-raising certainly affects the quality of our exhibitions, because I can spend far less time on the actual show, on ideas, on artists. One works very hard for peanuts . . .', but by the time he left the Whitechapel, he had already acquired substantial sums from over eighty companies.[32] In particular, his track record of fund-raising and political manoeuvring was brilliantly demonstrated in his negotiating the Whitechapel's £2.2 million renovation in 1985. He was also, of course, responsible for establishing outposts of the Tate at Liverpool and St Ives, as ambitious an expansionist as his American counterparts Thomas Hoving at the Met and Tom Armstrong at the Whitney.

Serota's Tate in the 1990s is particularly revealing in this context because it elucidates how far corporate capital, along with its particular brand of commercialism, have affected British art galleries. Interviewed just after he arrived at the Tate, Serota indicated his fear that the primary museum activities of scholarship, conservation, and education, as well as 'academic shows', might be 'squeezed out' in circumstances of cash crisis.[33] Occasional blockbusters, on the other hand, are regarded as essential since they generate high income.

LUNCH WITH CÉZANNE

The new vision of the Tate produced a series of blockbuster shows, each bigger than the last: *John Constable* in 1991 (169,412 visitors), *Picasso: Sculptor/Painter* in 1994 (313,659 visitors) and the 1996 *Cézanne* extravaganza (408,688 visitors). Not only was a ticket to the Cézanne exhibition the 'hottest' in town, with its ticket agency taking some 5,250 bookings a day (admission cost £8.60), but the Tate also mounted an extensive merchandising campaign, with its shop stocking everything from vases, tea towels and CD-ROMs to £45 Cézanne scarves, not forgetting the 'Cézannewich' offered at the London branches of Prêt à Manger and a specially bottled 'Cuvée Cézanne at the Tate' wine. Back in 1989, it was Serota who was quoted as saying: 'I don't want the Tate to be a shopping mall. But if people want to buy something, they should be able to.'[34]

Nowhere is the 'expansionist' ambition of the Gallery more clearly shown than in the grand scheme for Tate Modern, which opened in May 2000 at the disused Bankside Power Station on the Thames. To realize the plan, which cost some £134 million, the Tate launched a mammoth fund-raising campaign to raise private money to match the £68.2 million already awarded by the Millennium Commission and other public bodies. In exchange for a generous benefaction of anything between £1 million and £10 million, individuals can buy 'immortality' by having galleries at Tate Modern named after them.

In this ambitious enterprise, Serota was backed by an impressive team of professional fund-raisers. While there was no Development Office at the Tate in the 1980s, soon after Serota took over the directorship, one was established with six staff in 1990, 'development' being the vague but impressive sounding term for such transatlantic notions as fund-raising and networking. The Office is so well organized as to be able to cover virtually every conceivable aspect of private sector funding, such as the Charitable Giving Programme, the Corporate Sponsorship Programme, the Events Section and the Friends of the Tate Gallery. By 1991 a specific post for Corporate Sponsorship Manager was in place, concomitant with the launching of a Corporate Membership Programme. When the new Tate was still in process, the Development Office had an army of some 50 staff members, outnumbering those at the far larger Metropolitan Museum,

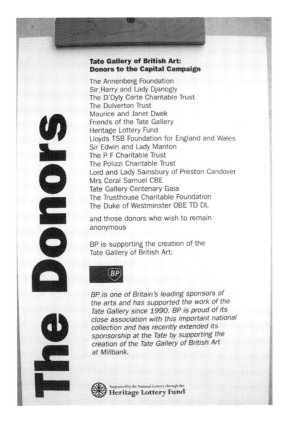

Tate Gallery of British Art:
Donors to the Capital Campaign

The Annenberg Foundation
Sir Harry and Lady Djanogly
The D'Oyly Carte Charitable Trust
The Dulverton Trust
Maurice and Janet Dwek
Friends of the Tate Gallery
Heritage Lottery Fund
Lloyds TSB Foundation for England and Wales
Sir Edwin and Lady Manton
The P F Charitable Trust
The Polizzi Charitable Trust
Lord and Lady Sainsbury of Preston Candover
Mrs Coral Samuel CBE
Tate Gallery Centenary Gala
The Trusthouse Charitable Foundation
The Duke of Westminster OBE TD DL

and those donors who wish to remain
anonymous

BP is supporting the creation of the
Tate Gallery of British Art:

BP is one of Britain's leading sponsors of
the arts and has supported the work of the
Tate Gallery since 1990. BP is proud of its
close association with this important national
collection and has recently extended its
sponsorship at the Tate by supporting the
creation of the Tate Gallery of British Art
at Millbank.

Supported by the National Lottery through the
Heritage Lottery Fund

Figure 4 Display list of donors to Tate Gallery's Capital Campaign, during refurbishment, 1998–99.

and closer perhaps to the number labouring at similar activities in the Museum of Modern Art in New York.

For our purposes, the Corporate Membership Programme offers a glimpse of the business culture mentality. Imitating similar American schemes before it, the Programme offers its corporate members conventional benefits such as private views or tours for employees and the hire of the gallery space for corporate entertainment. While American museums generally have a broad-church approach to their corporate membership (and much lower subscription fees), the Tate plays the exclusivity card by charging a subscription of £10,000 per year for Associate Members and £25,000 for

Partner status, and, above all, by limiting its memberships to under fifty people. The reason why the Gallery is able to market itself effectively is because it is placed at the top of the pecking order of contemporary public art galleries in Britain, and enjoys, as we have seen, an artistic aura of authority and acceptability in the public consciousness. This is why Antony Thorncroft remarked: 'Companies feel safe at the Tate.'[35]

MUSEUMS FOR RENT

The meaning of this exclusive membership restriction (and the Tate is probably the only gallery in the Western world to have it) may not be immediately clear, not least because it is ultimately in contradiction with its professed claim to raise as much money as it can. Certainly, its intention is not to price the Gallery out of the market, but rather to place itself into a specific niche market. As the Tate spokesperson put it, the membership allows corporate members 'to "belong" to an exclusive "club" which primarily gives them the exclusive opportunity to entertain in the Gallery'. Restricted access is thus designed to ensure that the Gallery can 'deliver real and exclusive benefits'. As an anonymous Tate source put it, 'There are only so many entertaining opportunities available in the year!'

The operative word in all this is 'exclusive'. But exclusive from whom, and for whom? Although 'employee benefits' is one of the categories listed among the benefits of membership, most of the exclusive access and services are reserved for a very small number of people, with some benefits being exclusively earmarked for the chairman and the chief executive and a guest of their choice, such as attending the annual Tate Gallery Foundation Reception, the Annual Partners' Dinner, and the most sought-after event of the contemporary art calendar, the Turner Prize Dinner, to name but a few. Restricted corporate membership is thus intended to make the Tate another powerful high-society club.

More specifically, in exchange for £500,000 from the accountancy firm Ernst & Young for the Cézanne blockbuster, the Tate hosted more than forty evening receptions for the purposes of entertaining its clients and potential clients, which, along with other sponsorship promotions, reportedly cost the firm another £500,000. Likewise, Frank Saunders, the

vice-president of Philip Morris, admitted, in a conference on business and the arts, that one of the benefits of sponsoring exhibitions was that, 'If we have an opening in Washington, for example, we go to the White House, we will have the leaders of Congress to a black-tie opening.'[36] It is ironic to recall the words of Thomas M. Messer, the former director of Solomon R. Guggenheim Museum in New York, in 1980: 'We would never rent out the museum.'[37]

The 'PR-ization of art museums' by corporate capital is clearly articulated in the language they now speak. The Metropolitan Museum in its brochure to lure corporate sponsorship tells it all: 'Many public relations opportunities are available through the sponsorship of programs, special exhibitions and services. These can often provide a creative and cost-effective answer to a specific marketing objective, particularly where international, governmental or consumer relations may be a fundamental concern.'[38] The Tate markets itself in a similar indirect and low-key fashion:

> The Tate Gallery's central location, on the Thames close to Westminster, makes it especially attractive to businesses located in London, or seeking a central London venue in which to entertain. . . . The Tate Gallery's fine buildings offer a range of unique settings in which to entertain clients, shareholders and other business guests. These facilities are available exclusively to corporate members and current sponsors; the Tate Gallery does not hire its buildings to other commercial organizations.[39]

The appeal of being 'close to Westminster' is obvious enough. In one publication, the Tate even boasts that it has 'a reputation for developing imaginative fund-raising initiatives', and that it works 'closely with sponsors to ensure that their business interests are well served'.[40]

The mercenary mentality, of course, is not only compartmentalized within the Development Office; it moves by osmosis into other aspects of the museum operations. For instance, at a conference on its purchasing policy, ironically captured in the title 'New Directions for a National Collection', Jeremy Lewison, deputy keeper of the Modern Collection at the Tate, not only referred to art dealers as 'allies' ('We collaborate with the dealers'), but also remarked: 'You can look for packages – buy two works and receive one as a gift, for example.'[41] It is difficult not to see this as a variation of well-tried supermarket gimmicks. To the extent that identity is based in the

structure of language, the mercenary transformation of the Tate, and art museums in general, cannot be more spectacularly expressed. How, then, is the Tate to prove that it is still a public gallery, belonging to the whole nation, and not simply an agent for big business bent on advancing its capital interests?

REPEAT AFTER ME . . .

Flooding the grand halls of art museums with PR budgets does not bring about any chemical change in the nature of public relations. The struggle over the acknowledgement of sponsorship in the media, especially in Britain, amply proves the point, with those on the sponsors' side coming perilously close to blackmail. Because public relations is the primary goal for sponsors, to have their names credited in the press is of paramount importance. However, the media, the BBC and the so-called 'quality papers' in particular, which have long seen themselves as the custodians of 'good taste' in British culture, have resisted naming sponsors in editorial columns; to do so is to give business sponsors what amounts to free advertising, and to run the risk of making newspapers advertising broadsheets.

Naturally ABSA has fought a consistent battle on this issue over the last 15 years, and, from time to time proudly announces 'success at last'. More surprisingly, both Arts Ministers and the Arts Council join forces to 'cook up' ways and means for sponsors. In the early 1980s, through the personal intervention of Norman St John-Stevas, then Arts Minister, the BBC made the concession of announcing the sponsors' names on broadcasts of concerts and operas. According to Waldemar Januszczak, the *Guardian*'s arts correspondent, the Arts Council was becoming 'increasingly aggressive in demanding the complicity of critics', by distributing special notices informing them, at the Renoir exhibition held at the Hayward Gallery in 1985, that 'they were expected to thank the sponsors in their copy'.[42] No one could miss the irony that, in the early 1980s, the Arts Council had been complaining seriously about the arts bodies it subsidized, maintaining that companies obtained unjustified publicity, whereas it was, and still is, the primary supporter of the arts in Britain.[43] The shift, of course, was due to the fact that, whatever reservations one may have about his Council tenure, Roy

Shaw was in charge of the Arts Council in the early 1980s, whereas since 1983 the Council was in the hands of Luke Rittner, the sponsorship-broker turned secretary-general.

Taking offence at the 'lack of co-operation' by some arts journalists, the sponsors threatened to withdraw their support. 'If those writers in newspapers purporting to support the arts cannot come to terms with nourishing new arts sponsorship through valid editorial references,' says Brian Angel, one of the sponsors' supporters, 'they should not be surprised if such sponsors go back to the football terraces, and Britain's arts projects become even more penurious.'[44]

Penurious or not, arts organizations, be it in America or Britain, have adopted the same tactic of promoting the causes of their sponsors and monitoring the 'mileage' obtained in the press. One of the development officers in a prominent New York museum revealed that there was resistance from journalists, but that they 'lobby hard for it', which, in effect, means 'We call them all the time. All our press officers will talk to the journalists and say please remember that such and such companies sponsor the exhibition.' A similar view was expressed by a development officer in a London art gallery:

> We monitor it [press coverage]. We send sponsors every bit of the press. . . . We work very hard; I spend a lot of time on telephone to critics and art editors that I know are covering the show. On the whole, as long as I get through to them, they do it; sometimes it's a bit of an argument we have on the telephone, each time. . . . And until recently the newspapers took the line that, you know, if BP wants to have their names on our newspapers, they can buy an advert. We have to persuade the journalists and editors . . . if the newspapers don't help us to provide the kind of benefit which is available potentially to the sponsors, then they are not helping us in gaining sponsorship, and they are not helping to ensure that art activities continue in the way they can.

The development officer commented upon one or two journalists who said 'absolutely no' to her: 'they're just stubborn about it, because that doesn't do them any harm to put the name of the sponsor at the end of the review at all.' If some journalists or art critics tried to take a firm stand against corporate power, after decades of concerted action by business sponsors, arts

administrators and governments dedicated to market principles, such opposition is being voiced less and less.

What has made corporate power so significant, however, is the fact that, even if corporations cannot succeed on the battleground of print media, they certainly can buy their way through one means or another. Built in to sponsorship money to art museums is, therefore, an equally large promotional budget to publicise art exhibitions, a development that has become even more pronounced in Britain since the 1990s. For an annual arts budget of £1.8 million in 1995, for example, BT spent another £800,000 in back-up costs. By offering the 'impoverished' art museum a gift of publicity that it otherwise cannot afford, sponsors utilize the opportunity to trumpet their generosity and high-minded 'corporate citizenship'. As a result, they maintain control over both the promotional dollars and eventual outcome because, as the arms manufacturer United Technologies Corporation declared, they wanted 'to be guaranteed that the final products have a unified look and meet their standard of quality'.[45]

THE LAW OF LOGOS

More significant still is the metamorphosis in identity that arts organizations have undergone, partly as their sponsors' need, among other requirements, to gain access to the editorial pages of 'quality' papers has intensified. By incorporating the sponsor's name into the title of the event or organization it sponsors, thereby making them inseparable, the sponsors are certain to wring as much publicity as possible from their act of 'good will'. In the 1980s, this kind of 'title sponsorship', though popular, was largely confined to events such as BT New Contemporaries or Barclays Young Artist Awards. In the 1990s the practice was extended to labelling institutions. With its huge £1.8 million arts budget (not forgetting, however, that this equalled a mere five hours of BT profits, at a rate of £100 a second), BT now demanded that its name be incorporated into any sponsorship deal. So instead of having a 'Scottish Ensemble', we had the 'BT Scottish Ensemble'. Rodger Broad, the company's head of sponsorship and advertising, was reported as saying that arts organizations never objected to this contractual obligation.[46]

In the field of visual arts, the most notorious title sponsorship deal was that between the Institute of Contemporary Arts (ICA) and Toshiba Information Systems, which was set up in April 1994. Although it was not exactly called 'Toshiba ICA', but more discreetly, 'ICA/Toshiba', with the added phrase 'sponsored by', the new sponsorship logo was so designed that the Toshiba presence was conspicuous and unmistakable. Toshiba paid some £300,000 for the status of 'Primary Sponsor' for three years, with another £75,000 cash handout from the Conservative government through its Pairing Scheme (the National Heritage Arts Sponsorship Scheme) to pay for publicising and marketing the sponsorship, as well as contributing to the 'Innovation Commission', which was itself designed to raise the profile of the sponsor.[47]

But what made the deal a 'new departure' was more than the ubiquitous appearance of the sponsor's logo, which amounted to upwards of one million Toshiba logos in the first year. Not only did the ICA bulletins and catalogues now carry an editorial statement from the sponsor, sometimes called the 'Toshiba Mission Statement', at other times, stressing its slogan, 'Toshiba – In Touch with Tomorrow', but the premises of the ICA were turned into a commercial showroom for the company. A purpose-built showcase of Toshiba products, entitled 'Toshiba Centre of Excellence', was prominently on display in the entrance hall, and the company's televisions and videos were extensively used in its exhibitions. Such changes (and there were many), according to its then director, Mik Flood, were due ultimately to the shortage of money, which 'can make you become a tick-over organization with programming that's dull and bland because you have nothing to finance your ambitions with'.[48]

It was only fitting, then, that Flood should applaud the largesse of Toshiba's money, writing in the biannual report for 1993–95: 'we are particularly grateful for Toshiba's involvement in the ICA.' The dilemma is this: how can the ICA reconcile the bold position of proclaiming its mission to 'stimulate, educate and astonish', and 'challenge orthodoxy in the arts', while pandering to a corporate giant that wields enormous power and influence both in the British Isles and globally?

In fact, given the permanent presence that Toshiba already occupies at the Victoria and Albert Museum, 'immortalised' in the Toshiba Gallery of Japanese Art, Toshiba is the very embodiment of cultural domination exercised by the multinationals. Its ambitions are so great that it is entirely appropriate to

describe its financial activities in the cultural sphere with the buzzwords of the 1980s – raids and take-overs, aimed at capturing one institution after another. What, then, does Flood mean precisely when he so proudly announces that the ICA 'continually challenges its own assumptions'? That image is, perhaps, always something of an illusion, or at most, simply not concrete enough, for the Institute cannot afford to question its own practice of serving corporate interests, and assess what impact that association might have.

ALTERING THE CULTURAL CLIMATE

Given the earlier discussion and the survey results, it is very difficult to imagine what point Richard Luce, the longest-serving Arts Minister under Mrs Thatcher, might have been attempting to make when he maintained that there was 'no artistic interference' from sponsors: 'Lord Goodman, who is president of the Association of Business Sponsorship Awards [*sic*], has been involved in the arts for 17 years and has never once come across a firm wishing to take over the *artistic side* of a venture [italics added].'[49] This and other similar contentions are, however, predicated on the assumption that there is a clear distinction to be made between the so-called 'artistic side' and 'anything else', such as its financial sources or ideological profile.

Assertions like this are simply unsustainable, not least because of the way in which contemporary art has developed to the point where its very identity and reception depend, to a large extent, on works of art being framed within a specific context. For example, *House*, Rachel Whiteread's notorious creation that won her the £20,000 Turner Prize in 1993 (and, notoriously, £40,000 from the K Foundation for the worst body of art produced in the previous year), was 'brewed' by Artangel, and subsidized by Beck's beer. *House*, which, before its demolition, was situated in a derelict part of East London, involved casting the interior of an entire terraced house, and then removing the exterior to reveal the shape of the rooms. *House* was original, and even radical, in its approach to sculptural space and in the way in which it explored our notions of domestic space, but its sister product, the *House* label on Beck's beer bottles, also designed by Whiteread, is not. On the contrary, the *House* label is what Fredric Jameson referred to as 'pastiche', a 'blank parody . . . that has lost its sense of humour', casting

Figure 5 Rachel Whiteread, *House*, October 1993–January 1994, Bow Road, London, an Artangel/Beck's commission.

ridicule on the original *House*.[50] The irony is that *House* is the house you cannot walk into, and Beck's is 'the beer you buy not to drink . . . when the label is more valuable than the contents'.[51]

THE ART WORLD INHALES

When it comes to the ethical aspect of art museums, and to the question of how, through its mediation, power is transferred and transformed in a capitalist democracy, the problem with sponsorship appears even more acute. Art museums, along with other arts organizations, have been struggling over the years with the ethical implication of accepting money from tobacco industries, and in Britain the blacklist also includes the armaments industry and certain political regimes, such as South Africa under apartheid. The issue remained largely academic until *The New York Times*

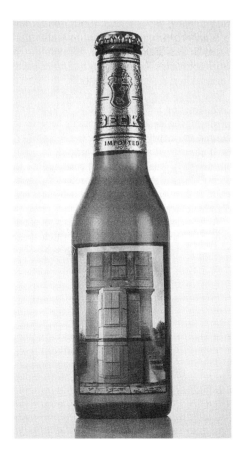

Figure 6 *House* label designed by
Rachel Whiteread for Beck's beer.

ran a front-page story on 5 October 1994 entitled, 'Philip Morris Calls In
IOUs in the Arts', at a time when the New York City Council was consid-
ering a bill that would ban smoking in virtually all public places in the
city.[52] Fighting back, the world's largest tobacco company blackmailed the
City, threatening to move its headquarters elsewhere if the bill passed,
taking with them some 2,000 employees, and, by implication, all its arts
support. 'If the level of such corporate support, for whatever reason, were
to decline', the statement of the company declared intimidatingly on 28

September, 'the quality and quantity of the dance, theatre, music and art exhibitions offered here might be diminished.'[53]

In desperation at the proposed bill, Philip Morris further urged arts organizations that they had funded to 'put a good word with Peter F. Vallone, the City Council Speaker', the main sponsor of the bill. Stephanie French, the vice-president in charge of the company's cultural programme, personally visited Vallone to appeal against the bill, apparently spelling out its implications for Philip Morris's funding of the arts.[54] Despite the multi-million dollar advertising campaign from the tobacco industry, the City Council and Mayor Rudolph Giuliani managed finally to turn the bill into a law that came into effect on 1 January 1995.

Philip Morris is a very powerful presence in the art world, and none of the museum people whom I interviewed in May 1995 would dare to speak about the company's actions. By dispensing money as widely as Philip Morris had been doing, the tobacco companies were buying the critical silence of arts bureaucrats and their institutions. Ironically, it was the interviewee from Philip Morris who admitted that there was some 'conversation' between the company and the major art museums in New York. Their version of the story was, however, different from that reported in the media: it was Karen Hopkins from the Brooklyn Academy of Music, 'crazy, wonderful fund-raiser, but wacky', who first came up with the idea of calling up the City Council and suggested it to the company:

> Yes, Stephanie [French] went to, maybe, the Guggenheim, the Met, four or five of our friends, called them and said: 'This is what's happening. If you want to call the City Council and we are important to you, do it.' That's it, you know, very low key, with four or five major institutions we are on the board of, or have funded it for many years. And it was all really in reaction to what was initiated by arts organizations themselves. And you know, that was it. . . . But there's never no pressure [*sic*]. . . . I don't think it's pressure tactics. I think it's a fair way to say: this is what's happening. If you want to say something, you can

This is the moment, I would argue, at which the 'cultural capital' accumulated by the corporation is transformed, in the most naked manner, into political power, at the service of corporate economic interests – even though on this occasion Philip Morris was unsuccessful in its efforts. Nor is the

power of Philip Morris in the arts world so easily circumscribed. Although cigarette smoking as such is prohibited in museums, the Metropolitan Museum permitted the company to hand out cigarettes at the opening night of *Origins of Impressionism*, to which Philip Morris donated $1 million. Even after the new law took effect in 1995, a sign at the reception of the company's headquarters announced, symbolizing its ultimate power, 'Smokers and Non-Smokers are Welcome'. Indeed, for the size of the company and the power it wields, the building is exempt from the law; the spokesperson stressed that 'we never do anything illegal', but just that 'we are exempt from the law'.

Although art museums are hardly places where radical politics are played out, they have always portrayed themselves, at least in the bourgeois culture of late capitalism, as the custodians of humanistic values, and have advocated a spiritual enrichment role for the art works housed under their roof. Their current managers, however, feel no need in the present climate even to appear to be above private interests; it is no longer, as it was in the past, politically expedient for them to do so. By accepting tobacco money, by not speaking out against the dangers of smoking, and, on the contrary, by lobbying for the tobacco cause, the museums and their managers are selling out their mission, which they always paradoxically proclaim as 'life enhancing'. The unmistakable signal is that even the largest museum in the US cannot afford to indulge in ethical judgements of any kind when it comes to issues of money. As one of its senior officers apologetically remarked: 'When you are a charitable institution, you can't say, certainly you could, but we are not lucky enough to have the money to say, "No, we can't take your money because of what you do." We don't do that; we don't do that with anyone.'

By comparison, Britain's public museums and art galleries still maintain, to some extent, a sense of public accountability for the public funds they receive every year. For instance, the Tate Gallery does have a formal policy regarding sponsorship, according to the gallery:

> It does not accept sponsorship from tobacco companies or companies dealing in armaments. Sponsorship from drinks companies is not accepted for youth projects. In the past, the gallery did not allow association with companies involved with South Africa, but this was revoked in 1994 after the constitutional changes there.

To what extent such principles are strictly adhered to, however, is open to question. After all, the nature of corporate capital in the late twentieth century was so internationally mobile, and business interests so diversified after the frenetic spree of take-overs, mergers and demergers over the 1980s and 1990s, that it requires systematic and consistent efforts to examine such changes. Moreover, the policy is so defined as to allow a wide scope of interpretation. Apparently the Tate has in the past been lenient in defining what business association literally meant: was BP not heavily involved in South African oil and coal industries at a time when the gallery was in receipt of its largesse?

ENTRANCE FEES

The problem of sponsorship from multinational companies has disturbing implications for a democratic state. Given their enormous capital, multinationals can easily manoeuvre art exhibitions or indeed arts organizations across national frontiers to wherever their markets dictate. Further, the origins and backgrounds of gift-givers may not always be immediately clear. The case of the Nomura Room at the Tate and Nomura Securities, the world's largest stockbroking company, is a case in point. Through the International Council of the Tate Gallery, and the Council's chairman and the Gallery's trustee, Gilbert de Botton, Nomura Securities donated £1.5 million to the Tate to refurbish one of its rooms, named the Nomura Room in honour of the company.[55]

News of this rare munificence reached the ears of the Prime Minister, Margaret Thatcher, who praised the company: 'I am delighted that Nomura Securities are giving this money to build a new gallery and I hope that other firms will follow their lead.'[56] While the Nomura Room was scheduled to open in the early months of 1990, Nomura International, its new European headquarters, 'the largest façade-retention scheme in Europe', occupying an entire City block, was opened on 31 December 1990 by John Major on his last day as Chancellor of the Exchequer. The timing of the two events was hardly mere coincidence. Furthermore, the European tour of the Royal National Theatre productions of *Richard III* and *King Lear*, sponsored by Nomura in early 1991 to mark the opening of

its Prague and Budapest offices in the new free enterprise zone of Eastern Europe, showed that Nomura donations were not unconnected with wider corporate strategy. At a seminar held at Nomura headquarters in February 1992, Keith Clarke, then director of Corporate Communications at Nomura, noted that his company's entry into Czechoslovakia was helped by their meeting with its playwright-president, Václav Havel, at a dinner, which was only made possible by sponsorship of the tour to Prague. As a result, Nomura Securities won important commissions from the Czech and Hungarian governments.[57] The coup was succinctly summed up by Colin Tweedy, director-general of ABSA: 'If you are a Japanese business trying to break into Europe, you want to do everything as "unJapanese" as you can. What could fit the bill better than staging Shakespearean English theatre?'[58]

Since no 'public' record exists, it is impossible to say for sure what access the Nomura donation to the Tate was meant to 'buy'. But it is fair to say that, as in the case of the National Theatre's European tour and other sim- ilar multinational arts ventures, it revolved around similar influence-buying activities and the gaining of access to overseas (in this case British) politicians and business contacts.

The Nomura case also illustrates one of the most remarkable and ques- tionable aspects of sponsorship development since the 1990s, that is, the veil of secrecy that is drawn over so many deals. Along with the great influx of private capital, particularly foreign, into British public museums and art gal- leries since the Thatcher days, the receiving institutions are obliged to be ever more discreet. Nomura's very large donation was hardly reported in the media, in sharp contrast to the attention given to, say, the three-year £300,000 ICA/Toshiba deal, or Beck's gift of £350,000. The spokesperson at the company would answer none of my inquiries, except to say that the donation was a one-off matter, decided in Japan, and that Gilbert de Botton was, in their words, 'related' to the deal (de Botton's own multinational finance company, Global Asset Management, is one of Nomura's clients). Nor was the Tate much more forthcoming, saying that any arrangements between the Gallery and Nomura were 'confidential information'. Moreover, I was 'requested' to send them 'any part of [my] thesis referring to the Tate before submitting it, so that it can be approved or corrected if necessary'. This, of course, I did not do.

Now, this is a matter not of the traditionally secretive ethos of the Japanese business world being imported into Britain – the British are quite capable of manufacturing their own secrecy – but rather of the implications for national democracy of multinational companies' cultural operations. In a different but relevant context, Raymond Williams eloquently commented on the rise of advertising in a capitalist economy:

> It is the result of allowing control of the means of production and distribution to remain in minority hands, and one might add, for it is of increasing importance in the British economy, into foreign hands, so that some of the minority decisions are not even taken inside the society which they affect.[59]

At the same time that the Nomura Room at the Tate was about to be opened, it was revealed, in late June 1990, that Nomura Securities in Japan – along with the other three biggest securities houses – was involved in one of the largest financial scandals since the war. The extent of the scandal was such that it eventually led to the resignation of Japan's Finance Minister, Ryutaro Hashimoto, in October, with the American and British regulators investigating the company's practices in each of their countries. The malpractice for which Nomura was convicted included illicit compensation for favoured clients, tax evasion and, above all, extensive secret dealing with Japan's second largest organized crime syndicate, Inagawa-Kai. Public consternation in Japan may not be a concern in Britain, except, perhaps, in financial circles, but the question inevitably arises: when is tainted money not tainted? And what greater irony could there be than that the Nomura Room, originally designed to elevate the company on the global stage into the corporate pantheon, should now turn out to be a permanent memorial of embarrassing indiscretion for the Tate?

ART AND ADVERTISING

In Britain, as in the United States, the 1980s wrought a profound change in art museums, a change whose impact is only now becoming visible. Crucially, British art galleries were, and of course still are, exposed to a climate of chronic financial insecurity without the support that used to be

provided by government. As Fay Ballard, head of development at the Tate, put it, 'The Tate is like a hungry animal. It needs continuous feeding.'[60] Straitened financial circumstances and the rise of arts sponsorship go hand in hand. But it is a fundamental mistake to view the dominant corporate presence in art museums (and in the art world in general) as an issue that is only financial. That dominance, a logical consequence of companies' economic power, has had a profound impact on the cultural landscape of both British and American society.

One of the manifest effects of this corporate-processed message is on the public perception of the art museum. Emblazoned all over exhibition leaflets and banners is always the epigraph of gratitude: 'The exhibition is made possible by a generous grant from Corporation X.' Or as BP's aggressive advertising campaign has it: 'Thanks to BP, throughout the year the Tate is able to re-hang each of its galleries with New Displays and so bring you more of its masterpieces.' These messages, linked with blockbuster shows, help to create in the visitor's mind the illusion of today's art museums being sites of a series of megashows sustained by corporate largesse. However, while there are no precise figures available for American art museums showing a distinction between public and corporate money, at least in Britain the fact is that the public sector still provides the majority of funding for art museums and galleries.

It is also at this juncture that one has to ask how corporate sponsorship has affected the artists and their artistic careers, an issue that Victoria Alexander tried to measure statistically, but without success.[61] No artist's career has been more closely linked with corporate sponsorship than that of the art-world star Damien Hirst. As Robert Hewison pointed out, Hirst's career has from the beginning prospered thanks to sponsorship, from Olympia & York and the London Docklands Development Corporation, who supported his banal student show *Freeze*, to the BT New Contemporaries in 1989, Häagen-Dazs at the Serpentine Gallery in 1994, and the commission of designing the sets for the contemporary opera *Agongo*, sponsored by Beck's in 1995.[62] This glittering career reached a crescendo when Hirst won the Turner Prize in 1995. Hirst, whose manipulation of sheep, cows and sharks preserved in formaldehyde once put him at the centre of controversy in London avant-garde circles, is perhaps most qualified to speak on the topic:

If art is about life, you can't avoid that side of life. At Goldsmiths' College they really encouraged breaking down barriers and finding new ways to do things, and sponsorship is all part of it. Undoubtedly it affects the reception of the work but that is something to work with. I don't see myself approaching the Meat Marketing Board, but you could make a political point by doing something really gruesome with animals, and getting sponsorship from Friends of the Earth.[63]

Hirst's career, which combines the 'shock' value of cutting-edge art with sponsorship from the bourgeois world that the avant-garde once set out to challenge, is very much a paradox. It is precisely the outrage and publicity that cutting-edge art often generates that have made it attractive to sponsors who are looking for a specific market, who wish to ride on the image of the young, the innovative, the cool. As Hewison put it: 'So sponsorship can become just one more piece of artist's material. Yet in the process the artist becomes one more piece of advertising.'[64]

After almost two decades of Conservative governments' promotion of the enterprise culture, entrepreneurial visions and practices in the art world are by now fully home-grown products in Britain. When Janet Minihan made her study of public funding of the arts in Britain in 1977, she chose to entitle it *The Nationalization of Culture*.[65] The Conservatives' successive terms of office certainly succeeded in reversing this process. So much so, in fact, that by the 1990s it had become standard practice to find museums and art galleries in Britain indulging in marketing practices that would have been inconceivable before the advent of Thatcherism.

ABSOLUT ADVERTISING

The zeal with which such institutions embraced the enterprise culture is well exemplified by the Museum of Modern Art (MOMA) in Oxford. Its readiness to jettison its integrity and to transform itself into a public relations agent for its sponsors became clear for all to see in 1996–97. Immodestly labelling itself as 'one of Europe's most influential museums', and taking pride in having been 'Britain's leading alternative space in the 1960s and early 1970s',[66] the Museum held an exhibition with the eye-catching and

'pioneering' title of 'Ab*so*lut Vision' – subtitled 'New British Painting in the 1990s' (Plate 1).[67] Playing on the words 'Absolut' (a ubiquitously advertised brand of vodka), 'absolute', and 'about' and their sounds and visual graphics ('s' and 'l' have a different type-face), the title can be read innocently as 'Absolut Vision' or 'Absolut[e] Vision'. If and when the penny drops, one might or might not (as I myself did not) begin to see that the title of the exhibition could also be read as 'About Vision'.

Not content with being pioneers in intrusive advertising, Absolut Vodka also broke new ground in actively seeking to integrate themselves into the very heart of the exhibition with an audacity hitherto unknown among sponsors in Britain. Included in 'their' exhibition was a Chris Ofili painting featuring their famous vodka bottle, which they specifically commissioned for the purpose (Plate 2). No less subtle as a sponsor's advertising message was the title of the work, *Imported*, which echoes the prominent wording at the base of the vodka bottle. The painting, bearing

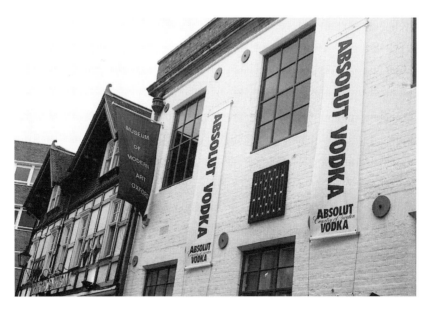

Figure 7 Façade of Museum of Modern Art, Oxford, with sponsor's banners, 1996–97.

Ofili's favoured trademark of oil paint, glitter and elephant dung, was praised by the departing director of the Museum, David Elliott, as an 'exciting new work', which was destined to be added to Absolut's own corporate art collection.

The question that arises is this: if the show truly is a celebration of a vision into the new millennium, whose vision is it? Absolut Vodka's, MOMA's or perhaps that of the multinational owner of the brand, Vin & Sprit in Sweden? As a success story, the intervention into art of the Swedish-born brand Absolut Vodka has a history that is both proud and tainted. Their thrusting commercial ambition to position their brand in the fashionable upmarket reaches of the international advertising world has been pursued alongside a policy of associating itself with experimental and avant-garde art. Starting in 1985 when Absolut Vodka first commissioned Andy Warhol, 'the godfather of pop art', to do a painting of its bottle, over 400 artists have been deployed in the creation of its 'artful ads'.[68] The scale of the operation has been such that the firm can boast that 'Absolut Vodka has become a kind of global art gallery'.[69] By capitalizing on the status of the avant-garde artists responsible for their advertisements, lithographic editions of which were marketed for profit by their former distributors, Carillon Importers of Teaneck, New Jersey, in the late 1980s, the owners and distributors of Absolut Vodka succeeded in transforming the spirit from a consumer commodity into an art form. As they themselves now proudly proclaim: 'Art has become an important medium to express the basic values and magic of Absolut Vodka.'[70] Perhaps, as the company itself suggests, 'When Absolut Vodka is involved in an event, the borders between art, fashion, PR and marketing blur long before the first drink is poured.'[71] Whoever's vision it is, and for whatever audience it is intended, it certainly is a new vision that has radically and irreversibly changed the way in which we look at the world of art and commerce. While the Oxford MOMA is funded on a long-term basis by a distinguished list of public bodies, it is to the private corporate sponsor of this one-off event that the credit goes for defining the present direction that art is taking, and for offering a vision of its likely future.[72]

It has long been argued and advocated by conservatives on both sides of the Atlantic that, to guarantee choice in a democracy, the arts should be funded from a variety of sources. In America, this often means that the role

of federal government should be restricted and indirect, 'lest it become a state-imposed culture at odds with the American pluralist tradition'.[73] A similar rhetoric has often been articulated in Britain in the concept of plural funding, as the former Arts Minister Richard Luce put it: 'This plurality of funding means that arts organizations can spread their risks, and become less dependent on one source of funding. Plural funding adds to the vitality of the arts and acts as a safeguard against any restrictions on artistic expression.'[74] The democratic appeal of such funding, however, simply cannot be substantiated. So-called 'plural funding', as we have shown, was only another piece of privatisation designed to move art museums and galleries from the public domain into corporate hands. It does nothing but reinforce the underlying economic relationships in society. To quote the Trade Union Congress' report: 'It is important to remember that the activities of the private sponsor of the arts, unlike his public counterpart, are not subject to any degree of democratic control.'[75] The increasing take-over of non-economic domains by corporations, one of the most remarkable features of late capitalism, must open our eyes to the fact that the rise of arts sponsorship is a mixed blessing: as much to be lamented as it is to be celebrated.[76]

6

CORPORATE ART AWARDS

The business world's exploitation of the arts in both Britain and America does not stop at the increasing appropriation of art museums and galleries as their public relations agencies. Not content with passively waiting to be solicited to make contributions to art museums, the corporations have been strenuously striving since the 1980s to establish themselves as a legitimate force within the art world.

The enthusiasm with which modern corporations set about emulating art museums was boundless, even to the point of their appointing their own curators and founding their own art departments. They held exhibitions, established new art galleries, and their corporate premises were sometimes even hosts to a branch of a 'public' museum. The move to establish corporate art collections began in earnest in the 1970s, and the impetus has continued more or less undiminished since. To champion the grand image of themselves as art patrons, these corporations also organised and toured their art collections throughout the country and abroad. Last but not least, they actually themselves organised, as well as sponsored, art awards, extending their tentacles right into the heart of the art establishment. Central to these ventures is the assumption that corporations can and should act as if they were part of the cultural life of the country in which they operate. The following three chapters will be devoted to this advanced stage of art involvement in which corporations have been actively engaged ever since the Reagan and Thatcher years.

GLITTERING PRIZES

Corporate art awards, while a relatively infrequent phenomenon in America, have been proliferating in Britain ever since the mid-1980s. So competitive are they, according to *The Independent*'s art critic, Andrew Graham-Dixon, that 'Britain leads the world in the development of art as a competitive sport.'[1] Indeed, on the playing field of the art arena, the participants turn out to be not only the players themselves, but also the punters-cum-sponsors. In their heyday in the late eighties and early nineties, British businesses of all descriptions were embracing arts awards, ranging from service industries such as banking (Barclays Young Artist Award and NatWest Art Prize), insurance (Prudential Arts Awards), accountancy (Arthur Andersen Art Award) and publishing (Athena Art Awards) to manufacturing industries such as tobacco (John Player Portrait Award), engineering (Hunting Art Prizes), construction (Laing Art Competition) and oil (BP Portrait Award and BP New Contemporaries). The list could, of course, be extended. Across the Atlantic, on the other hand, until the launch of the high-profile biennial Hugo Boss Prize by the German clothing manufacturer in 1996, arts awards had not been particularly popular in corporate America. This difference, of course, has little to do with what awards might have to offer various corporations across national boundaries. It has, rather, to do in part with the fact that the British media, as we saw in the previous chapter, have been very reluctant to give such activities the oxygen of publicity and to acquiesce in what they consider to be the provision of free advertising to corporate sponsors. It is also to do with the fact that, for a country as diverse and big as America, it would be very difficult for art awards to function as effective marketing tools on a national scale.

To single out art awards as one of the most influential phenomena of corporate intervention is not to suggest that they are a new form of cultural activity. Nor is the idea of competitiveness in the arts in any sense an innovation of the Reagan–Thatcher decade. Scientific and literary prizes, for example, have a long and distinguished history going back to the early years of the twentieth century. What has marked out corporate-sponsored art awards since the 1980s, however, is the way in which competitiveness has come to involve not only art practitioners themselves, but also the funding companies and their corporate self-images in the wider social and economic

contexts within which the multinationals operate. When awarded by academies, such prizes serve to reflect current establishment tastes and appear to be disinterested – or at least not to have direct vested interests. With the exception of the big prizes such as the Nobel Prize, they also tend not to go beyond national boundaries.

But the imperatives of global capitalism have made borders obsolete. For multinationals in search of national and global market domination, visual arts awards have become a most valuable promotional vehicle by which to cross any boundaries, whether national or cultural. It is for this reason that we find such incongruous phenomena as the Philip Morris Art Award in Japan and the Philip Morris ASEAN Art Awards spreading across all South East Asian countries, as we shall see in more detail below. The irony is, of course, that while contemporary art, especially in its avant-garde manifestations, is generally assumed to be in rebellion against the dominant system, it actually acquires a seductive commercial appeal within it. It should perhaps come as no surprise to find that certain *enfants terribles* of the present generation of artists – Jeff Koons, Damien Hirst and Tracey Emin are obvious examples – who learned their trade, and some of whom even won their initial fame, during the Thatcher and Reagan decade, are so well versed in self-marketing and in image projection.

THE INSTANT ESTABLISHMENT

Insofar as art awards remain a marketing exercise for big corporations, and given the fact that they fulfil this role in such an obvious manner, it might not be prudent to talk of art being subversively subsumed under the corporate marketing banner. Art awards, as a specialised form of arts sponsorship, ultimately enter public consciousness in a way that allows businesses a valuable entry into the Establishment, in this case, the art world establishment. Art awards, being the end-products of competition and peer adjudication, carry with them value judgements and hence contribute to the creation of hierarchies of taste. For the various participants, this implies a special brand of excellence arbitrated in the public arena, and in some way, therefore, sanctioned by public approval. Being the sponsor or organiser of such awards is, accordingly, to situate oneself by association at

the very centre of excellence as well as centre-stage in widely publicised (and sometimes televised) spectacles.

To place this public manifestation of excellence in the spotlight, however, requires a substantial marshalling of the resources of the art establishment and of its personalities. In other words, corporate art awards, like any other sphere of prize-giving, cannot claim legitimacy without the prestige and status that go with their being conferred ultimately by the art establishment itself. Businesses usually achieve such legitimacy in two ways. For smaller prizes, corporations invite established personalities from the art world to sit on the panel of judges and thus ensure that the awards are validated. Bigger players in the field of arts sponsorship enter into alliances with well-established art museums or galleries to launch their awards, as can be illustrated by the pairing of the Hugo Boss Prize with the Guggenheim Museum in New York and the BP Portrait Award with the National Portrait Gallery in London. Given the high public profile that these institutions enjoy, to make them the locus of an award is to exploit at one and the same time their media access and their central position within the arts world. As a result, corporations succeed in placing themselves in the full spotlight of media attention and simultaneously at the very heart of the art world. In short, corporate arts awards are not unlike creating an 'instant establishment'. Instant because their status is achievable overnight, as it were, by means of their enormous corporate capital and equally instantly abandonable once the marketing impetus subsides; establishment because they project themselves as having the authority to set standards of quality and to influence the direction of artistic trends.

CASH PRIZES FOR IMAGE ENHANCEMENT

Yet, art awards, with their particular brand of gaudy, media-oriented prize-giving ceremonies, are first and foremost a sophisticated marketing offensive targeted at a specific market. Whether one terms them 'brand sponsorship'[2] or 'designer sponsorship',[3] art awards are, with the single exception of the Turner Prize, an 'own label' marketing exercise *par excellence*. They provide direct association of the sponsor's name with the particular event, thus making the brand name inseparable from the award. This allows

the business, as we saw in the previous chapter, to sidestep the British media's resistance to naming arts sponsors. It also gives the company a large measure of control over how the award can be run to the maximum bene-fit of itself as sponsor. This is, of course, especially true if the business does its own organising. As a result, corporate sponsored/organised arts awards and competitions, whether large-scale or modest, proliferated in the Thatcher years, and the trend reached an all-time high in the 1990s. At any one time, the list of corporate arts awards in Britain reads like the FTSE Index in miniature. It should therefore come as a surprise to no one to find corporate arts awards operating very much in line with the principles of marketplace: the bigger the company, the bigger the prize money and the bigger the media brouhaha.

For almost a decade, the Prudential Corporation, Britain's largest insur-ance company, ran its own arts awards, the Prudential Awards for the Arts, as if they were part of the fabric of 'Britain's artistic life'. Despite the fact that the company's chief executive, Mick Newmarch, saw fit to draw atten-tion to the Prudential's public spiritedness,[4] sponsorship of this sort is never disinterested. Back in the late 1980s, the company had felt the need to 'revitalise its corporate brand image', and conducted qualitative research to identify its target audience – 'usually the high social-economic group of arts lovers'. In order to reach this group, the Prudential opted for initiating arts awards, something which would provide 'an interest of its own', because traditional methods of arts sponsorship were considered insufficient to create the sort of publicity that the company wished to have.[5] Launched in 1989, the Awards rewarded what the company considered the most desirable artis-tic qualities with which it would like to be associated, 'creativity, innovation, excellence and accessibility' in five categories: Dance, Music, Opera, Theatre and Visual Arts. They were to be given to arts organisations rather than going into the pockets of individual artists.

Considering the size of the company, one would not expect less: from the very beginning the Prudential Awards were the biggest arts prizes in the country, with an initial total of £200,000, which was soon increased to £260,000 in 1992.[6] Its awards ceremony was also transmitted live on tele-vision. Such generous prizes as these, at a time when art organisations in Britain were suffering from the Tories' belt-tightening measures, were embraced with enthusiasm and gratitude. Almost every arts organisation,

well-established or otherwise, found itself in a race to get its share of the Prudential Awards cake. This included such well-known national institutions as the Scottish Ballet, English National Opera and, in the specific context of visual arts, the National Touring Exhibitions Service and the Arts Council Collection, who put in a joint bid. Obliging these national institutions to run a race on terms that the Prudential itself dictated was a supreme piece of manipulation insofar as it involved placing corporate values above the collective public values that these institutions had long embodied in the national consciousness. By exploiting their financial power to reward artistic endeavour, corporations such as the Prudential transformed themselves into leading arbiters of taste in contemporary British culture.

It goes without saying that the Prudential cash did not come without strings attached. To make its corporate logo visible to its target audience, the art-loving public in general, the Prudential requested its award winners, and stipulated as much in the Award rules, to use the logo 'as supplied by the Prudential, in a prominent position on all printed material and in advertisements produced to promote the planned programme'.[7] In other words, by distributing a large amount of money, the Prudential transformed selected arts organisations into its public relations agents in order to promote its corporate image in the most favourable light possible. The award winners could not, of course, make their own decisions on how to use their prize money without the prior approval of the company.

Just as the Prudential Awards represented the sort of glamour that only big corporate money can buy, the Laing Art Competition, organised by the construction company John Laing plc, meets the expectation of more modest or small corporate art awards. The Laing Art Competition, which started somewhat obscurely in the early seventies, had become well established by the late eighties, when the company gave it a central role in its marketing strategy. To quote its spokesperson:

> Because we advertise in the local papers to let artists know about the competition, it gets our name in front of the public by advertising in local papers. It's very difficult to advertise a construction company. You can't say: 'Please buy your next motorway from us.' So it's a way of getting our name known in the nicest possible way because we are helping artists.[8]

Unlike the big money involved in the Prudential awards, the total prize money for the Laing Art Competition was a meagre £15,000. What the prize lacked in cash, however, the company made up for with its administrative expenses in its determination to make the prize serve its marketing purposes. The Competition was composed of 10 regional competitions and accompanying exhibitions in those parts of the country where the company had offices, with a cash prize of £500 for each region. Fifteen works from each regional competition were then selected by regional judges to participate in the national competition. There was then an exhibition held in London, where the final prize winner secured the trophy of £5,000, after which six paintings were selected by Laing's chairman for reproduction in the company calendar.[9]

The Laing Art Competition and its exhibitions have not, of course, caught national media attention in the same way as the Prudential did. It has nevertheless worked for John Laing plc in precisely the ways in which the company had intended. By holding previews for each regional exhibition, the company is able to invite its clients for sessions of corporate 'schmoozing' in an arty environment, an alternative to inviting them, for example, to the usual rugby match or golf tournament. As its spokesperson put it: 'It's a very good public relations exercise. We meet galleries, we meet a lot of people, and in the process of doing the painting competition, we are also able to entertain our clients in all our regions in a way which is unique because they are seeing paintings for our painting competition.'[10] Unlike any other form of arts sponsorship, corporate art awards are a marketing tool whose very flexibility allows any interested company to have its own-label awards tailor-made for its particular market specifications.

Most corporate arts awards, in terms of their size and scope, fall somewhere in between the Prudential Awards and the Laing Competition. While corporate sponsors do not wish to indulge in such lavish art prizes as the Prudential offered, they are not necessarily content with the small amount of national media attention that, for example, the Laing Competition has so far generated. Because an art award is not, in itself, a sufficient guarantee for securing maximum publicity, most corporate sponsors opt to initiate arts awards with high media interest to ensure success. Over the last two decades, award partnerships have thus become the most visible force on the corporate arts sponsorship scene. These include, or have included, the Singer

& Friedlander and *The Sunday Times* Painting Competition, the Hunting and *Observer* Art Prizes, and Adam & Company and the *Spectator* Annual Art Award, to name but a few. And since it is only natural for corporate arts awards to invite art critics to sit on their panels of judges, the chance of such art awards getting reviewed in the media is even higher. *The Financial Times'* art journalist, William Packer, for example, praised the Hunting Prize exhibition as 'London's best mixed show', before declaring that he had acted as the chairman of the Hunting Prize judge panel on several occasions.[11]

SMOKE SCREEN

This marketing strategy is particularly effective for any industry whose name may, for whatever reason, be in need of polishing. The longest-running portrait award in Britain, held at the National Portrait Gallery since 1980, was, for example, first launched and then sponsored for some 10 years by Imperial Tobacco, in which role it was replaced throughout the nineties by BP – two enterprises with particularly tainted images. As we saw in the previous chapter, arts sponsorship by the tobacco industry is to be seen in the context of the restrictions placed on its advertising activities. During the early eighties when the Conservative government was keen to encourage sponsorship of all kinds, almost all the major tobacco companies were heavily committed to arts sponsorship, including Imperial Tobacco's two competitors, BAT (with its Du Maurier brand) and Benson and Hedges (part of Gallaher). Tobacco arts money was, however, spent more lavishly on music than on visual arts sponsorship. The Benson and Hedges Gold Award competition for concert singers, for example, inspired one music critic to comment facetiously: 'try Benson and Hedges to improve your lung power.'[12]

In launching its own-label award (officially known as the Imperial Tobacco Portrait Award), Imperial Tobacco ensured that its name was prominently connected with the award, and it contrived, in its publicity, to relegate its host institution, the National Portrait Gallery, to a secondary position.[13] The then director of the Portrait Gallery naturally felt obliged to extend his gratitude to his sponsors, though one wonders whether John Hayes' tone was entirely free of irony when he said: 'It is, in any case, *very*

healthy that the Gallery should have extensive contacts with the world of finance and business. I greatly welcome the imaginative generosity of Imperial Tobacco and this splendid opportunity to co-operate with one of the major sponsors of the arts [italics added].'[14] In 1983, in order to focus on its John Player brand, Imperial Tobacco changed the award's name to the John Player Portrait Award.

As one of Britain's national galleries, the National Portrait Gallery naturally attracts a great deal of media attention. So did the Portrait Award. Every time the award was mentioned, Imperial Tobacco (or the John Player brand after 1983) was mentioned too. But the effectiveness of the Award also depended to a considerable extent on the way in which it was organised. In addition to the portraits by the prize winners, some fifty of those submitted were selected for a special exhibition held at the National Portrait Gallery. The first prize winner, in addition to receiving a cash prize worth several thousands of pounds, was commissioned to paint the portrait of a notable personality. The announcement of the competition, that of the prize winners and the accompanying exhibition, and the completion of the portrait commission all served to keep the Award and the name of its sponsor in the press and in the public eye for the best part of a year. The announcement of the prize winner and the exhibition, for example, generated a great deal of publicity for the company in local newspapers across the country. When the work of a local artist was selected, the newspaper of the town in which he or she lived often ran the story with eye-catching headlines such as: 'Magical portrait wins £100 for Mick',[15] or 'Local Artists Triumph in National Portrait Competition'.[16] The local-boy-made-good approach gives the award a kind of human touch, while the juxtaposition of the local and the national often serves to promote a sense of civic or regional pride. By implication, the award sponsor comes to be regarded not only as socially responsible but also as a special friend and ally of a particular community – the last thing that a tobacco company in fact is, of course.

The commissioning of portraits, on the other hand, serves a different purpose for Imperial Tobacco. The subject of the portrait is usually a well-known personality who, without the trappings of a national award, already attracts media attention in his or her own right, not only on a local but also on a national level. Paul McCartney in 1982, Cardinal Basil Hume in 1985

and the Queen Mother in 1987 are typical examples. Moreover, because the portrait is destined to be added to the national collection, when the time comes for the presentation ceremony, the press is naturally to be found yet again devoting space to the award. For the relatively insignificant outlay of £10,000 or so, Imperial Tobacco was thus able to keep its name and its John Player brand name in the press for the whole of a year. As *The Financial Times'* art critic succinctly put it: 'Here you have goodwill, national publicity, local connections and low cost.'[17]

The long relationship that Imperial Tobacco enjoyed with the National Portrait Gallery culminated in 1992 in a special exhibition dedicated to its award and entitled, *The Portrait Award 1980–1989: Ten Years of The John Player Portrait Award*. In conjunction with the exhibition, the National Portrait Gallery produced a tobacco-packaging-turned-catalogue prominently featuring the John Player Special logo with its three embossed stripes, printed in its distinctive silver colour on a black background. What is revealing in what proved to be the curtain-call of this particular tobacco sponsorship deal is that, in stark contrast to his earlier enthusiastic praise of Imperial Tobacco, the Gallery director deputed the task of expressing his institution's thanks to the sponsor in the catalogue itself to the critic William Packer.[18] The director's silence eloquently articulated the fact that the heyday of tobacco arts sponsorship was now over, and a recognition that the long and hard campaign against tobacco advertising had finally taken its toll on cigarette companies.

The draft proposals of the Labour government to end tobacco advertising, including tobacco arts and sports sponsorship, by the end of December 1999 was another nail in the coffin of cigarette companies.[19] A bill to this effect was published, but at the start of 2001 it had not yet begun its passage through Parliament. Whether or not this will prove eventually to be the swan-song of tobacco arts sponsorship in Britain, however, remains to be seen; aggressive and resourceful as they are, tobacco companies can be counted on to do everything in their power to sidestep the ban imposed both by the British government and by the European parliament. One thing that is certain is that the disappearance of tobacco arts sponsorship from the European landscape will only push tobacco companies to redirect their arts money into other markets elsewhere in the world – to Asia, for instance, where they have a relatively free hand and, as we shall see, are

already busy perfecting their marketing techniques of arts sponsorship-cum-advertising.

CHANNELING THE PRIZE MONEY

Unlike tobacco sponsorship, which has always been designed to attract as much media attention as possible, the alliance between the Turner Prize and Channel 4 has always given the impression of being what one might term 'noticeably discreet'. Noticeable because most visitors to the Turner Prize exhibition at the Tate Gallery, if they are not aware of Channel 4's involvement beforehand, will certainly not fail to notice the tangible signs of the sponsorship by the time they leave the last room of the exhibition where the Channel 4 profiles of short-listed artists are screened. Discreet because Channel 4's sponsorship has so seamlessly integrated itself into the Turner Prize brand that it has become part and parcel of it without having to advertise its role. The 'win-win' situation of Channel 4 as sponsor has, of course, a lot to do with the fact that it itself is a media operation and has therefore the capacity to present any event that it chooses to sponsor without having to generate specific publicity for it.

The most intriguing question remains: what is it in the Turner Prize that has encouraged Channel 4 to continue its sponsorship for the past nine years or so? The Prize, having been organised by the Tate Gallery since 1984 and enjoying therefore the cachet of that influential institution, has obviously continued to be the most prestigious award for contemporary art in Britain. It found its first sponsor in 1984 in Oliver Prenn (a member of the Patrons of New Art) for three years, and then in the American investment firm Drexel Burnham Lambert International Inc. for a further three years.[20] The bankruptcy of DBL in 1989 brought the Prize to a halt in 1990. It was at this critical juncture that Channel 4 came to the rescue, and in 1991 the Prize was re-established in its present format. But the early nineties were, of course, critical years not only for the Prize, but for Channel 4 also. As a corporation, it had to launch itself into the commercial world, and was obliged for the first time to sell its own advertising. It is a switch that required a substantial flexing of marketing muscle in order to brand its new-found image for the purposes of attracting potential advertisers as

well as audiences – what its director of programmes, Liz Forgan, termed a change in image from that of an 'exclusive place' to one 'offering something for everyone'.[21]

This may, of course, be little more than rhetoric, since such a shift towards populism would sit incongruously with what the remit of Channel 4 is supposed to be: catering for minority interests. It is in fact precisely in the context of serving minority interests that the link between the Turner Prize and Channel 4 can most easily be understood and justified. It is true that the Prize itself, and contemporary art in general, has gained unprecedented popularity in the press over the last few years. Whether in the broadsheets or the tabloids, the Prize attracts publicity and notoriety in equal proportions each time that the shortlist exhibition is staged, and countless inches of media coverage continue to be devoted to the exploits of young British artists. Despite the brouhaha and publicity surrounding the Turner Prize, the actual audience for it is relatively small. The attendance figures for the Prize exhibition have shown a substantial increase over recent years, with those for 1999 reaching 133,000.[22] This figure is, of course, impressive for any contemporary exhibition, but it does not come within striking distance of the high hundreds of thousands that an Impressionist artist such as Monet can attract to an exhibition. Nor can the viewing public for Channel 4's live transmission of the award ceremony be termed in any way popular, at least in the ratings' stakes set by such programmes as *Neighbours* or *Blind Date*.[23]

This is not, of course, to underestimate the popularity of the Prize and the artists who have been associated with it in the recent past. The frequency with which young British artists appear in the newspapers these days would have been unthinkable even some ten years ago. But there is a world of difference between news stories on the public persona of these artists, designed to satisfy society's insatiable thirst for voyeuristic stimulation, and insightful reporting on contemporary art capable of helping to de-mystify, for a wider public, the self-referentiality and theorising in which so much contemporary art practice indulges. It is thus inevitable that the Turner Prize will remain a minority interest, despite the fact one of the Prize's aims is, as the Tate Gallery claims, 'to promote public discussion of new developments in contemporary British art'.[24]

Minority interest it may be, but the Prize's target audience also has some attractive characteristics. Following the pattern of the art-going public as

established in the previous chapter, they tend to belong to the ABC1 social classes, and well over half of them are under 55 – precisely the segment of the general public that most advertisers are anxious to target.[25] This is naturally not lost sight of by its sponsors, who consider the Turner Prize to be exactly the 'right profile event to sponsor'. This is, to quote Janey Walker, Channel 4's former commissioning editor for the arts, 'because advertisers want a young hip audience; anybody can get old people to watch television. That's straightforward. If you are a commercial television channel, you want up-market and younger people watching your programmes.'[26]

One should not, of course, be misled into thinking that the Turner Prize audience is one that could be easily persuaded into becoming consumers of the products whose commercials happen to be sandwiched in between different parts of the ceremony transmission. The marketplace obviously functions in a far more complex way. What Channel 4 is 'buying', metaphorically speaking, through its association with the Tate Gallery is what in marketing jargon is called 'brand identity'. As Janey Walker put it:

> It's not an economic thing. But the benefit to the Channel is more subtle than that. It's more about our brand identity. We do a lot of programmes about modern art. It underlines that, as a channel, we are interested in contemporary art and that kind of British cultural scene. So it has a value beyond the actual advertising revenues it generates. And Channel 4 benefits from people recognising that it is cutting-edge, young, irreverent, outrageous sometimes, interesting, unpredictable – all those things. So all those things associate with the brand of Channel 4. You can see the Turner Prize helps feeding into that. It definitely adds something to the image of Channel 4 as a whole. You can say we are the channel which does Eurotrash, the Turner Prize, and Big Breakfast.[27]

The brand in question is, of course, that of Channel 4 as an arts channel, something that is in line with its remit while at the same time being very attractive and marketable when other broadcasters' arts programmes are continually shrinking. Waldemar Januszczak, former commissioning editor at Channel 4, clearly took pride in declaring that: 'On Channel 4 the arts are not only safe but expanding.'[28] And what better way is there for an art channel to present a cutting-edge image than being associated with the equally cutting-edge Turner Prize and the high-profile Tate Gallery? To secure this

specific brand of corporate identity, Channel 4 has each year to chip in the not insignificant sum of £160,000 for the Prize exhibition and an undisclosed sum for the glamorous Prize dinner party. This makes it by far the most significant cultural sponsorship that the television company has up until now undertaken.[29]

The sum is significant indeed, but more significant still, in Channel 4's sponsorship of the Turner Prize, is the extent to which the sponsors and the Tate Gallery collaborate in presenting the Prize to their respective publics. When it was relaunched in 1991 with Channel 4's money and involvement, for example, the Prize was reorganised in such a way as to make it more suitable for media coverage. The shortlist was curtailed from six to four in order to allow it to fit comfortably into an hour-long television profile of the artists in question.[30] In general, though, Channel 4 seems to be content to take a back seat and maintain a low profile. This 'hands-off' attitude is, of course, a function of the fact that Channel 4 is as much a commercial enterprise as it is a public trust. It therefore has, as it were, only one foot in the marketplace, and does not, by and large, manoeuvre the art events it sponsors to serve its commercial interests to the same extent as other business concerns normally do.

HUGO BOSS: DRESSING UP FOR CONTEMPORARY ART

While the Turner Prize partnership between the Tate Gallery and Channel 4 has always been discreet and low-key, the alliance between the Guggenheim Museum and Hugo Boss is a celebrity marriage of convenience. The $5-million deal includes, among other things, Hugo Boss's sponsorship of two or three exhibitions at the Museum and, in our specific context, the inauguration of the Hugo Boss Prize. To quote Peter Littmann, president and CEO of the firm, the Museum was praised, as 'the world's first truly international museum' and therefore an 'ideal partner for Hugo Boss AG'.[31] The Museum, on the other hand, claimed this relationship as 'unique' in scope and level of commitment, and as Thomas Krens, its director, put it: '[It] surpasses any traditional form of sponsorship the Guggenheim has had in the past.'[32] The question then arises: to what extent is this collaboration creating the very uniqueness to which it lays claim?

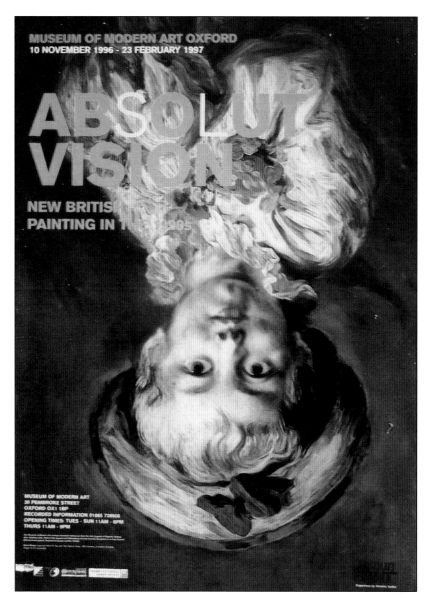

Plate I Poster for *Absolut Vision: New British Painting in the 1990s* exhibition, 1996–97, at Museum of Modern Art, Oxford, featuring Glenn Brown's *Searched Hard for You and Your Special Ways*, 1995, after the painting *Small Boy in the Pierrot Costume* by Jean Honoré Fragonard.

Plate 2 Chris Ofili, *Imported*, 1996, oil paint, glitter, polyester resin, map pins and elephant dung on linen with two elephant dung supports, 121.9 cms × 91.4 cms, now known as 'Absolut Ofili'.

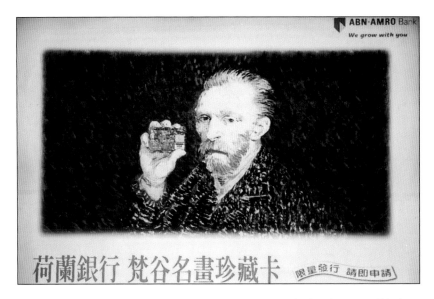

Plate 3 Van Gogh as salesman for the Dutch ABN-AMRO Bank, advertisement at Taipei Airport, 1998.

Plate 4 Old-style décor and art collecting at a London merchant bank, 1992.

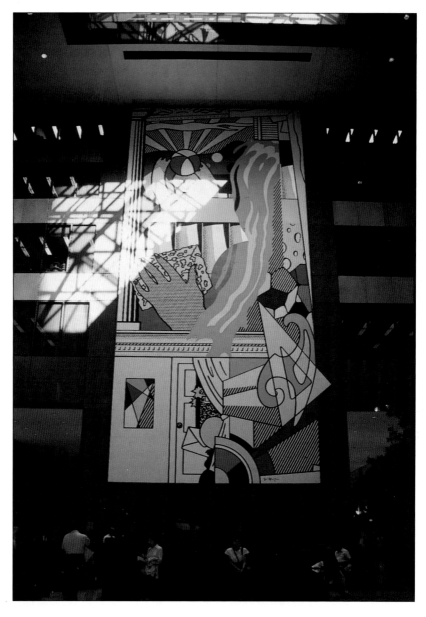

Plate 5 Roy Lichtenstein, *Mural with Blue Brushstroke*, 68′ × 32′, at Equitable, New York.

Plates 6, 7 Gerhard Richter, *Untitled*, c. 1985, triptych, oil on canvas, atrium at The BOC Group, Windlesham, Surrey.

Plate 8 Oliver Carr Building, Washington, DC, featuring Lincoln Perry's *All in the Golden Afternoon*, 1989, oil on canvas.

Plate 9 Sol Lewitt, *Wall Drawing # 580 Tilted Forms*, 1998, double drawing with colour ink washes superimposed and black grid. At Deutsche Bank, London.

Plate 10 Bridget Riley, *Midsummer*, 1989, oil on linen, 164.5 cms × 159 cms, commissioned by 3i (Investors in Industry) and used here for 3i Group's 1989 Annual Report.

To start with, there is nothing new about the association between the fashion and art worlds; the former has long flirted with the latter. The fashion world, whose profits are made precisely by cashing in on contemporary trends, understandably did not fail to leap on this particular bandwagon. Hence in late 1997 the corporate-friendly *Art Newspaper* was able to run a special section, 'Fashion And Art', with a specific focus on the sponsorship of *haute-couture* houses including all the grand names in the trade such as YSL, Giorgio Armani and Chanel.[33] Hugo Boss is, of course, boldly following this well-trodden path. What has marked out its particular sponsorship, however, is the lavish sum of $5 million that it was prepared to pay in order to be able to play the ace card in the game of cutting-edge art.[34]

Nor is the Hugo Boss Prize itself as unique as the sponsors and the Museum would have us believe. It bears a close resemblance to the Turner Prize, even if it is not in fact inspired directly by its British precedent. The parallel with the Turner Prize is in fact frequently made in American media reporting, and the comparison is openly claimed in the official Guggenheim exhibition catalogue for its 1996 short-listed artists.[35] Both prizes feature an international panel of jurors, with Fumio Nanjo, an independent Japanese curator, actually serving on both panels. Both prizes also favour current 'trendy' conceptual artists, and some artists, for example Douglas Gordon (winner of the 1996 Turner Prize and the 1998 Hugo Boss Prize), compete for both awards. Both prizes also mount an exhibition for the finalists in advance of the actual announcement of the winner. Given that the Turner Prize has been in place for many years, it is only reasonable to assume that the current practices of the Hugo Boss Prize are in fact modelled on the Turner Prize, despite what Americans might perceive as the 'parochialism' of the British award.[36]

What is at issue in this question of precedence is not, of course, national pride, but the particular aspects of the Turner Prize that the Americans deem to be worth emulating. The Guggenheim Museum and its sponsor are well aware of the value of the media coverage generated by the notoriety and controversy of the Turner Prize. As two of the Boss jurors, Lisa Dennison and Nancy Spector, point out: 'With the critical participation of Channel 4, the Turner Prize has become a much-debated national event among people who may never enter a museum or gallery.'[37] One of the ambitions of the Boss

Prize organisers is likewise for it to 'eventually attract the attention of a far-reaching public'.[38] It is in the pursuit of this sort of media visibility that the close relationship between the two worlds of art and fashion can most easily be seen.

Indeed, the partnership between the Guggenheim and Hugo Boss, in particular its joint Hugo Boss Prize, was from the very start orchestrated to attract as much attention as possible from the international art and fashion media. The Guggenheim label itself undoubtedly carries with it a global brand of enormous marketing power, but the $5 million transaction between the two partners is equally, if not more, newsworthy. Moreover, the company's decision to fly 25 journalists from Europe to New York to witness its award ceremony hardly suggests that Hugo Boss was not looking to make itself a name in the international arts arena.

It should come as a surprise to no one that the efforts of Hugo Boss in the art world are closely bound up with its commercial ambition to enter the US market.[39] Hugo Boss suits, the quintessential German men's suits, have over the years acquired an image of being 'big, moneyed, expensive and square', a menswear brand that has been imaginatively described as the sartorial equivalent of the BMW.[40] Given its plans to open 20 shops in the early nineties in the US, Hugo Boss was keen to promote and sharpen its prestige image among the other competitors in the market. What better way was there of spicing up the otherwise square image of its suits than by associating itself with 'trendy' cutting-edge art? As Peter Littman, the key Boss broker behind the deal, put it: 'There's no question that this partnership improves our image in the United States.'[41]

WORLD-WIDE BOSS

So how successful has the rebranding of Hugo Boss been with the borrowed clothes of cutting-edge art? In line with its global market ambition, Hugo Boss champions a specific brand of internationalism, one of whose hallmarks seems to be political correctness. The Prize is judged by an international panel of jurors whose task it is to come up with an international shortlist of artists; more precisely, to quote Joachim Vogt, chairman and CEO of Hugo Boss, with a list representing 'five continents'.[42] So the clothing company is

making a political point: despite its German origin, it is not merely a German company (in fact, no German artists have so far featured on the shortlist). The company is proud of having a global vision, and it boasted as much in its announcement of the 1998 Hugo Boss Prize winner: 'The Boss Prize truly represents the international scope of our partnership with the Guggenheim Museum.'[43] This is in line with one of the stated aims of the Prize: to 'foster the global understanding of art and to encourage artists in the exploration of new ideas'.[44]

The operative word is, of course, 'global'. Global in what ways and for what reasons? The first shortlist in 1996 featured two Americans (Laurie Anderson and Matthew Barney), a Canadian (Stan Douglas), an artist from the Bahamas (Janine Antoni), a Japanese (Yasumasa Morimura) and a Chinese (Cai Guo Qiang). The ethnic background of Cai and Morimura undoubtedly makes the shortlist attractively international. But this brand of internationalism inevitably carries with it a Western gaze, albeit an orientalised one, with all its unarticulated colonialist assumptions. The curator told us, when commenting on Morimura's cross-dressing photographs of Western canonic masterpieces: 'it is still provocative to see an Asian male dressed as a Caucasian woman.'[45] If gender and the racial identity of artists themselves have any meaning in art, as the curators seem to suggest they do, then the value of Cindy Sherman's similar self-integration into Western masterpieces (her work pre-dates Morimura's and might have actually inspired him) must be less provocative, given that she is a white female posing in paintings representing other whites. However liberated and politically correct, a Western feminist gaze directed onto an Oriental male implies an exoticism in which the gender roles have been reversed. Instead of the traditionally colonist white male gazing at an Oriental woman, we now have a Western female gazing at an Oriental man.

This sort of internationalism remains, of course, a basically Western construct. The few Oriental and African candidates shortlisted could be seen as token figures, a politically correct gesture representing the multinationals who are embracing globalisation not only in economic terms, but in cultural terms too. The non-Western artists who have been able to gain admittance to mainstream art institutions in the West are in any case those who have, more often than not, spent many years in the West and work with specific artistic media and modes sanctioned by the predominant Western artistic

Figure 8 Yasumasa Morimura,
*Self-Portrait (Actress)/After Red
Marilyn*, 1996.

discourse. Some of them are also adept at adopting a self-exoticising style
to cater for the Western taste for otherness, while at the same time making
sure that it is not too outlandish to the Western palate. The work of the
Chinese artist Huang Yong Ping (shortlisted for the 1998 Hugo Boss Prize),
who repeatedly plays on images of turtles and Chinese characters, is an
obvious example. These images, while they bring with them associations of
Oriental enigmas, are securely presented in the fashionable language of con-
ceptual art, thus producing a combined effect of ancient Eastern exoticism
and contemporary Western familiarity. In other words, these works fit
squarely into the postmodernist obsession with identity, exotic enough for

Western viewers to identify their ethnicity, but not so ethnic as to invite rejection.[46]

Nor should one disregard the economic considerations that have facilitated the rise of Japanese and Chinese artists on to the world stage. The increase in Japanese economic power has undoubtedly helped the exposure of Japanese artists in the West over the last ten years, as a secondary effect of increased commercial ties between the West and Japan. The Japan Festival extravaganza of 1991, for example, was initiated by British business interests in order to foster closer working relationships with this important new partner in the world economy. China, on the other hand, represents for the West an imagined market of enormous potential and thus enjoys a privileged position of being continually courted by the West, particularly its multinationals. The coming of age of Chinese artists (the 1996 and 1998 Hugo Boss Prizes each featured one Chinese artist in their shortlists) has less to do with the intrinsic value of their work than with the special economic position that their country enjoys in the West. Korea had apparently been admitted to the league before the recent collapse of its economy since Lee Bul, a Korean, was shortlisted for the1998 Hugo Boss Prize. How far do these spheres of commercial interest extend? Would it, for example, stretch the bounds of political probability for the Hugo Boss Prize ever to feature an artist from a country such as Indonesia or even China's *bête noire*, Taiwan?

PHILIP MORRIS: LIGHTING UP THE ASIAN CONTINENT

What is unimaginable for Hugo Boss and their Guggenheim partners will not, of course, necessarily be so for other multinationals. Insofar as market principles reign supreme, the bounds of political probability can certainly be stretched far enough to accommodate the requirements of the market. Over the past six years or so, for example, Philip Morris has been sponsoring the Philip Morris ASEAN Art Awards, giving prize money to those South East Asian countries that continue to be more or less marginalised by mainstream Western institutions, be they political or artistic.[47] Neither does Hugo Boss yet have any substantial stake in this particular market, nor has any established Western art institution shown interest in contemporary art

work produced in this region of the world. But for Philip Morris, whose cig-
arettes and other everyday products cater for a much more popular
consumer, South East Asia is, of course, a region on which it, as a multina-
tional, would very much like to capitalise.

The art capital that Philip Morris has invested in its ASEAN Art Awards
is not insubstantial for a region that is in general economically poor. With
prize money totalling $150,000 or so, the Philip Morris Art Awards have
proved to be extremely popular. Needless to say, the Awards, referred to as
'Southeast Asia's most prestigious art competition', are organised with both
style and effectiveness.[48] They operate according to a two-tier system. On
the national level of each ASEAN country, a painting competition under the
Philip Morris name is launched. Some thirty or so semi-finalists are selected,
with their works then being exhibited in the most prominent art institution
of each country. Five finalists from each country are then chosen to partici-
pate in a region-wide exhibition in the city where the ASEAN summit is
scheduled to take place. For example, Vietnam's Deputy Prime Minister
Nguyeān Maïnh Caàm held a high-profile prize ceremony at the Hanoi
Opera House in which the 1998 Award grand prize, worth $10,000, was
presented, just weeks before the opening there of the 6th ASEAN summit.
The exhibition also won the endorsement of the Vietnamese government
when it was officially designated as one of Vietnam's cultural activities
selected to celebrate the summit.[49] Fully exploiting the region's existing eco-
nomic structure and networking, the Philip Morris ASEAN Art Awards
have thus achieved the maximum publicity for the company, both on the
national level of each individual ASEAN country and on that of the whole of
South East Asia.

Given the marginalised status of contemporary art produced in the
region, one could easily dismiss the importance of these Awards. This would,
of course, be to miss the point. From the very start the Awards have existed
to advance the cause not only of the participating artists, but also of their
sponsor. Nevertheless in a region where government support for contempo-
rary art is rare, the Awards, along with their cash prizes, are of considerable
importance for young artists. The Malaysian artist Kow Leong Kiang's win-
ning of the grand prize in 1998 was, for example, heralded as a 'great
psychological watershed' for Malaysian art, and placed it henceforth on a par
with the 'Big Three of ASEAN art' – the Philippines, Indonesia and

Thailand.[50] Media 'hype' in a local newspaper is, of course, by no means the same thing as winning accolades from Western art institutions. But for the 2,400 artists who entered the competition in 1998, the Philip Morris ASEAN Art Awards are as close to an international art competition as they could hope to come – an international competition financed by a US company and therefore associated in some way with much sought-after Western credibility.

Not that Philip Morris actually represents, in the eyes of the West, any particular credibility. But for people in the East, who have lived through a substantial part of the twentieth century under Western colonialism, Philip Morris is quintessentially a Western institution that, for example, cannot sell its Kraft cheese to Asians without first selling an affluent Western life style. The 1998 Philip Morris Art Awards ceremony held at the Hanoi Opera was thus acclaimed by the local newspapers as 'the highest profile international art event ever staged in the country'.[51] Even though a eulogy such as this inevitably involves some degree of exaggeration, it nevertheless points to a collective sense of psychological inferiority among people who long to see themselves as actors on the international stage and look to the West as some sort of arbiter for admission to the inner sanctum. This Eastern chip-on-the-shoulder, for lack of a better term, goes a long way to explaining why a Western art intervention such as the Philip Morris ASEAN Art Awards has been so successful. Would it be thinkable for Philip Morris ever to contemplate undertaking a similar scheme, the Philip Morris EU Art Awards, say, on a European-wide scale?

RUNNING WITH THE HARE AND HUNTING WITH THE HOUNDS

The success of this sort of art intervention is nowhere more contradictory than in a region where government health authorities and other anti-smoking groups have been struggling for years against the pernicious influence of the tobacco industry.[52] The most obvious example is Singapore, well known in the West for the severe social control that it exerts over its citizens' personal life, from chewing gum in public to access to the Internet. Not surprisingly, in Singapore there are numerous regulations forbidding its citizens to smoke in any public building, restaurant or public transport,

and the city-state has, for example, been praised by a journalist from *The Independent* as 'hav[ing] led the way among Asian nations with its anti-smoking laws'.[53] In order to discourage its citizens from smoking, the Singapore government, in a recent anti-smoking television campaign, did not hesitate to use shock tactics by showing gruesome pictures of brain clots, fatty deposits in arteries and cancerous tumours in the lungs.[54]

And yet when it comes to accepting tobacco company sponsorship, the Singapore government proves to be far less squeamish. On the contrary, it seems to find no difficulty in extending a warm welcome to Philip Morris cash. Not only does Singapore regularly participate in its Awards, but its centrally controlled Singapore Art Museum also accepted, with suitable gratitude, a donation of $100,000 from the company in order to purchase works from the competition to establish what it called 'the Philip Morris Group of Companies Collection at the Singapore Art Museum' as part of its permanent collection. Its curator, Bridget Tan, was quoted as saying: 'The company's generosity has assisted greatly in tapping into a pool of emerging talents. It adds a qualitative historical dimension for the future of art in Singapore and at the Museum.'[55] In its drive, since the mid-nineties, to make its affluent city-state an international art centre capable of attracting tourists from all over the world,[56] Singapore has been more than willing to let public health considerations take a back seat. The dual standards it finds itself adopting have their roots in its ambition to claim for itself a place on the world art stage as a suitable venue for major international exhibitions – the sort of standing that only Western institutions, multinational or otherwise, can provide.

The benefit that Philip Morris sees itself acquiring through this sort of sponsorship is, of course, first and foremost commercial. Not that the Philip Morris ASEAN Art Awards are necessarily of any special interest to the potential consumer whom the company is targeting. As we saw in Chapter 5, sponsorship such as that undertaken by Philip Morris is aimed at creating better access for them to people of influence and power in the country, while at the same time building up, as far as possible, some goodwill among the general public. For Philip Morris, this access to the ruling elite of the ASEAN countries is of paramount importance, at a time when it is pressing for its cigarettes to enlarge its market share in developing countries in order to compensate for shrinking sales on the domestic front. This drive is

encapsulated in a headline from *The New York Times*: 'Tobacco Industry: Conciliatory in US, Aggressive in Third World.'[57]

As befits a far-sighted company, Philip Morris is, one can expect, looking into the future and gearing up to 2003, when the ASEAN Free Trade Area is to come into being. At that time, not only will the member countries reduce internal trade tariffs to a maximum of 5% (from a previous high of 50% on some products), but the common market thus created, comprising as many as 500 million people, will open up a whole range of new windows of opportunity for the commercial sector.[58] For all the goodwill that the Awards have generated for the company, the cash that Philip Morris has invested in them is minuscule, a drop in the ocean of its billion-dollar marketing budgets each year.

Nor is this 'generosity' towards South East Asian countries in any way comparable to the liberality that it showers on its own American art institutions – the $1 million sponsorship money, for example, given to the Metropolitan Museum just for their Impressionism exhibition. In other words, Philip Morris is not to be seen as generously helping out worthy causes in the East, even though some participating artists can convince themselves that it is in fact providing some much needed artistic support in the region. Philip Morris is in reality a puppet-master, pulling the strings and staging a cultural show. Deliberately or not, the tobacco conglomerate is exploiting the economic poverty of South East Asian countries, and profiteering from Eastern vulnerability and the need to look to the West for social and artistic validation.

SMOKE OVER MOUNT FUJI

The discriminatory and hierarchical nature of Philip Morris's marketing strategy in sponsoring the arts in the developing countries of South East Asia is most easily seen in their setting up of another of their award schemes, this time in Japan. Since 1995, Philip Morris KK of Tokyo has organised a biennial art award called 'The Philip Morris Art Award', of which the third took place in 2000. This has a substantial amount of prize money attached to it, each of the seven prize winners netting a cool ¥2,000,000 (approximately $15,000), much more than artists in other South East Asian countries can ever hope to win.

Money is not, of course, the only issue. What makes the Japanese Art Award distinct from its counterparts in South East Asia is ultimately the degree of seriousness with which the company takes it, and its ambition to be seen promoting Japanese contemporary art on to a world stage. The Award was designed, in the words of William H. Webb, CEO of Philip Morris, to 'discover, support and bring international recognition to a new generation of contemporary artists from Japan'.[59] To achieve this aim, the international panel of jurors who are to select the final winners are carefully composed of seven art world luminaries. These jurors include, or have included, Richard Koshalek (director of the Los Angeles Museum of Contemporary Art), Lars Nittve (now director of Tate Modern), Suzanne Pagé (director of the Musée d'Art Moderne de la Ville de Paris), Ida Gianelli (director of the Castello di Rivoli Museo d'Arte Contemporanea) and Shuji Takashina (director of the Tokyo National Museum of Western Art), a figure sometimes referred to as 'the emperor of the Japanese art world'. These people can be said, without too much exaggeration, collectively to enjoy a whole range of international connections and networkings within the art world, a fact that would naturally help advance the careers of those young Japanese artists fortunate enough to be singled out by the Award.

In their ambition to launch the careers of young Japanese artists, Philip Morris KK and its US parent company have successfully joined forces to find an outlet to exhibit their award winners' works not only in Tokyo but also in New York. The works by the 100 artists who pass the first screening by the Japanese jurors are shown in a group exhibition in Tokyo. Seven prize winners out of these artists, chosen by the international jurors in a second selection process, then have the honour of participating in an exhibition in New York, *First Steps: Emerging Artists from Japan*, which has been held biennially at the Grey Art Gallery at New York University since 1997.[60] Neither the exhibition venue in Tokyo nor the Grey Art Gallery can be said to be among the mainstream art institutions of Japan or America, but they nevertheless provide an important opportunity for young artists eager to make their artistic début. The whole series of arrangements from the beginning to the end of the process helps, of course, to keep the sponsor's name in the media for the best part of a year.

It hardly needs to be added that patronage on this scale is far less easily available to the poor relations of the Japanese who end up prize winners in

the Philip Morris ASEAN Art Awards. As befits the marketplace where commercial profit reigns supreme, the size and worth of the prizes can be expected to be designed in accordance with market potential. In Japan the tobacco market is dominated by Japan Tobacco (a privatised company of which 80% is owned by the government), while foreign tobacco companies have only some 20% share. But with a tobacco market estimated to be worth ¥4 trillion, even a 20% share can easily make a handsome income of more than $5 billion, not to mention the importing of foreign cigarettes, which is growing at an alarming rate of 10 to 13% every year.[61]

VAN GOGH: CORPORATE ART AMBASSADOR

It is not just East Asian countries with huge commercial potential like Japan that attract Western art sponsorship. A country as modest as Taiwan can also find itself on the receiving end of Western corporate colonialism in the field of art. No visitor to present-day Taiwan will have remained insensitive to the presence there of the Dutch ABN–AMRO Bank. Although the Bank has been active in Taiwan since 1980, its business had been concentrated on institutional clients, Taiwanese business groups as well as foreign companies operating in Taiwan. To secure a niche in the consumer market of individual banking, the Bank has, since 1998, been conducting a massive marketing campaign to attract individual customers. This marketing offensive is centred on promoting the icons of Dutch windmills and Van Gogh, two quintessential images that any average Taiwanese will naturally associate with Holland. (ABN-AMRO does not, of course, mean anything to the locals, and the Bank is known in Chinese simply as the 'Dutch Bank'.) In an omnipresent advertisement, Van Gogh is shown in his own self-portrait, a familiar image to the Taiwanese, but holding in his hand the Bank's credit card, which is adorned with a miniature portrayal of the artist's famous *Irises* (Plate 3). It should come as a surprise to no one that the Bank chose four images of Van Gogh's best-known paintings as designs for its credit cards and cashed in on Van Gogh's popularity in their advertising bylines: 'Collectible cards of Van Gogh's famous paintings: Don't delay – Get them Today!'

This marketing strategy also included a high-profile 'public art' competition for a famous high-rise building that has not been in use for some years,

Figure 9 Reproduction of Van Gogh's *Starry Night over the Rhône*, claimed by ABN-AMRO Bank as 'public art', in Taipei, 1998.

situated on a busy traffic roundabout in an up-market district of Taipei. Prior to the competition, which was actually launched in August 1998, two gigantic reproductions of Van Gogh's paintings, sponsored by the Bank, had already been hung on the site. These canvases, each measuring some 33–35 metres high and 22–27 metres wide, were inaugurated and lauded as an outstanding example of 'public art'. For the opening, in February 1998, of the first 'public art' installation entitled *Starry Night over the Rhône* (one of the Bank's credit card images), the then Mayor of the City (and subsequently Taiwan's President), Chen Shui-pien, was invited to dress up as Van Gogh with the artist's trademark beard and palette. Mayor Chen was a very popular figure and his appearance at the opening won the Bank an enormous amount of free and very positive publicity.

Riding high on the success of its first public show of good will, the Bank proceeded, two months later, to install 30 colourful windmills in the centre

of the roundabout, thus completing its appropriation of the whole site for its massive publicity stunt. The Bank's managing director in Taiwan, Paul J. Scholten, articulated the company's ambitious policy in a press release: 'We hope . . . we are able to continue to bring to Taiwan the concepts of a European artistic lifestyle.'[62] By the time the Bank installed its second reproduction of Van Gogh's painting on the site in June 1998, it had gone so far as to boast: 'by allowing the citizens of Taipei to choose which painting is to be hung, we are introducing into Taiwan the *advanced Western* idea of public participation in public art [italics added].'[63]

It is not difficult, given its taste in publicity, to anticipate exactly what kind of 'public art' competition it was that the ABN-AMRO Bank opted for to 'encourage' and 'help' local Taiwanese artists. The plan was to follow its installation of the Van Goghs by replacing them with the prize winner's work, and such was its audacity, in its self-perception as 'an advanced Western' multinational, that it decided to call the competition 'Who Can Replace Van Gogh?' Is it mere coincidence that the ABN-AMRO top prize eventually went to a work representing springtime and featuring windmills, harvest fields and irises? To crown it all, ABN-AMRO insisted on attaching 12 working models of windmills on to the surface of the winning installation.

The question that remains is, of course: how many new customers did its Van Gogh publicity drive help the Bank to attract? Within six months of first launching into the credit card market in 1998, ABN-AMRO was reported to have issued no fewer than 180,000 cards – at a time when Asia was suffering from a severe fiscal and economic crisis.[64] Taiwan has, of course, emerged from the crisis in better shape than other Asian countries such as South Korea, but the Bank's achievement in issuing 1,000 cards a day is nothing short of a unique commercial success story. Two factors above all others account for this: in the first place the Bank had the wherewithal to bankroll its enormous 'public art'-cum-publicity project; and secondly, it had the audacity to set itself up as the representative of a largely imaginary European culture and lifestyle that could not fail to appeal to the status-conscious Taiwanese.

This cultural posturing, needless to add, brings with it unarticulated colonialist attitudes that exploit what we have already referred to as the 'Eastern-chip-on-the-shoulder' type of inferiority, from which the Taiwanese

are no less exempt than their Asian neighbours. It is one thing for the Bank to pursue its own commercial interest under the guise of providing free 'public art', but it is quite another for the Mayor of Taipei and all the local media to rally so enthusiastically and uncritically to the Bank's supposedly public-spirited art sponsorship. Taiwan is not, of course, in the same league, in economic terms, as the poor countries of South East Asia, but its ambiguous relationship with China has forced it into a political straitjacket that prevents it from having proper diplomatic relationships with other countries in the international political arena. This political vulnerability goes a long way to explaining why Taiwan extends such a warm welcome to any friendly gesture from foreign investors – and even foreign exploiters.

ABN-AMRO was no newcomer to the global scene of corporate art sponsorship, and had already sponsored, for example, a British art award, 'The Discerning Eye', for two years in 1997–98. Their approach in Britain, however, was low-profile and unobtrusive, with nothing like the sort of patronising attitudes they brought to their 'public art' sponsorship in Taiwan. Would it have been possible to imagine the Dutch Bank hanging a reproduction Van Gogh on a building around, say, Trafalgar Square, and proclaiming to Londoners that ABN-AMRO was giving their city a facelift by installing some free 'public art' in their capital?

ABN-AMRO's 'public art' sponsorship in Taiwan has another significant historical dimension, for it is a little-known fact that, during the seventeenth century, Taiwan, under its former name of Formosa, was actually a Dutch colony for 38 years (1624–62), in the heyday of Holland's supremacy as a world sea power. Would it be unfair to suggest that the Bank might today be acting in a way that is reminiscent of its long-forgotten role as a colonial power, seeking to bring European enlightenment to the benighted 'natives'? It would, of course, vehemently deny such a charge.

But capitalism was, and still is, constructed on forms of imperialism, in which the present-day multinational is the equivalent of the empire builder. While the erstwhile imperial powers acquired and accumulated territories and subjects through military conquest, the modern multinationals acquire and accumulate profits by occupying an ever-increasing share of the commercial market. Both forms of domination involve invading other territories, geographically or metaphorically, and superimposing on the dominated the language, tastes and culture of the dominant. The ready acceptance by

today's Asian populations of the same sort of power relationship in the commercial and cultural spheres mirrors their earlier colonial exploitation. It is difficult to see Philip Morris's successful incursion into the Eastern market as anything other than a throwback to the good old days of empire. Hugo Boss's talk of globalism and ABN-AMRO's claim to represent 'advanced Western' taste in art are, in their turn, obvious examples of cultural constructs that have been appropriated and then manipulated by the multinationals in order to advance their own material interests. The missionary spirit of yesteryear has been replaced by the corporate zeal of today's multinationals.

SHOWCASES OF CONTEMPORARY ART WITHIN CORPORATE PREMISES

> We [must] demonstrate . . . that patronage is just another aspect of
> the marketplace, another move you make there to sell your products
> and services and enlarge your share.
>
> Herbert Schmertz, director, Mobil Corporation[1]

BRANCHES OF PUBLIC INSTITUTIONS WITHIN CORPORATE PREMISES

Unlike the sponsorship of exhibitions organised by art institutions, where the sponsors' presence is temporary and their role limited, a corporation gains substantial control of an art institution when the latter becomes a corporate tenant and agrees to one of its branches being established on business premises. Nor does the corporation have to strive for publicity and recognition as it does in other arts ventures. Maximum publicity is automatically generated as the name of the company and that of the institution, for example, 'The Whitney Museum of American Art at Philip Morris', become inseparable.

This phenomenon is, for various reasons, a peculiarly American style of corporate intervention, confined to heavily built-up metropolitan centres such as New York City.[2] Nothing entirely comparable yet exists in Britain except for the Henry Moore Foundation Studio located at the Dean Clough Industrial Park in Halifax, near Leeds. This is primarily because the sheer scale of the financial commitment necessary for this form of arts sponsorship has ruled most players out of the game.[3] Also, the built environment of New York is much more conducive to this sort of corporate adventure than that of London, primarily because of the substantial planning incentives granted

by city authorities to real-estate entrepreneurs, not to mention the considerable tax gains offered by federal and state governments. As the practice of using art as a common currency pushes the alliance of art and commerce to the ultimate level of intimacy, this phenomenon is all the more significant despite its limited application.

THE McDONALD'S OF THE MUSEUM WORLD

No art museum in the 1980s identified itself so thoroughly with corporate America as the Whitney Museum of American Art in New York. The first branch of the Whitney was opened in 1973 in the Wall Street district, and was supported by the Lower Manhattan business community. The rationale was then, according to its education officer David Hupert, 'to reach out to more people with more exhibitions'.[4]

However, the Whitney branches mushroomed so vigorously that by the end of the 1980s it already owned four branches, notoriously nicknamed by *The New York Times* 'the McDonald's of the museum world'.[5] In addition to the one in Lower Manhattan, the Whitney opened a branch in Fairfield County, Connecticut, in 1981, supported by the Champion International Corporation. Then, in 1983 and 1986, it opened another two in Midtown Manhattan, sponsored by Philip Morris and by the Equitable Life Assurance Society respectively. In 1988, the Whitney also relocated its first branch to the Federal Reserve Plaza, where it was hosted by the joint developers of the Plaza, Park Tower Realty and IBM.

This conspicuous and ostensibly disinterested hospitality extended to an art museum by corporate landowners was, of course, nothing short of what corporate jargon terms 'good corporate citizenship' in full public display and in its most favourable light. But the continuous presence of 'high art' institutions within corporate territorial confines brings to the businesses concerned a special kind of social status and kudos that no other form of corporate 'philanthropic' project can ever achieve. What actually underlies this symbiotic relationship between the Whitney and its corporate landlords is, however, a real-estate strategy. Without wishing to digress, one has only to look briefly at how zoning resolutions regulate the construction of skyscrapers in New York City.

Figure 10 Sculptural court at the Whitney Museum of American Art at Philip Morris, New York (with notice of prohibitions in use of space), 1990.

ZONING AND TAX GAINS

The three Whitney branches in New York were located at the base of office towers within special high-density commercial zones, namely Midtown and Downtown Manhattan, areas in which the City planning authorities sought to encourage development through special zoning concessions.[6] One of the 'bonus zoning' concessions was that, as long as the builder agreed to provide 'public amenities' at the site containing the building, the developer was allowed up to 20% extra floor area to increase the height of the building.[7] If the developer set aside 1,000 square feet for 'public space' in a tower, for example, he could add an extra 10,000 square feet or more to his building, depending on the ratios of bonus floor area and the basic floor area allowed.[8] This substantial zoning bonus, more than anything else, helped to shape the elaborate corporate atrium and the lobbies of

Manhattan skyscrapers as we know them today. To quote Paul Goldberger, *The New York Times'* architecture critic: 'So these plazas are not really a gift to the people from the buildings' owners – they are much more a gift from the city itself.'[9]

Should the zoning bonus be an insufficient inducement, companies can gain various tax benefits from federal, state and city governments. A real-estate benefit may be provided indirectly, according to Marisa Lago, General Counsel at the Economic Development Corporation in New York, 'since creating such a public space could reduce the assessed value of the building, thereby resulting in lower real-estate taxes'.[10] And above all, companies can write off the expenses incurred in operating the branches by counting them as corporate contributions when computing tax returns to the Internal Revenue Service for corporation tax purposes.[11] This direct tax benefit from the federal coffers results in a further tax deduction from the New York State government, since the state's entire income is based on taxpayers' federal taxable income.[12]

To incorporate a branch of an art museum within this bonus-yielding public space is arguably a logical development from what these corporatised indoor plazas came to represent in the early eighties. As Suzanne Stephens pointed out, what the arts programme was to Equitable in the 1980s paralleled what up-scale restaurants and cafés were to Citicorp in the 1970s.[13] While the public amenities provided by the shops within the Citicorp tower did indeed attract people, they also drew in a growing number of New York's ever-present homeless. This would be even more problematic for the Equitable headquarters, since it is located on 7th Avenue and intrudes upon a derelict area of the city only a few blocks north of the squalor of Times Square. At the same time as obtaining substantial extra floor area from the City, corporations can best safeguard their so-called 'public space' against undesirable intruders and wayfarers by means of the grand hall of an art museum.

It should come as a surprise to no one to discover that the Equitable atrium that led to the museum branch was from the very start designed and furnished in a sufficiently user-unfriendly way to serve not as a 'public space' but as an elaborate corporate lobby. If the overwhelming presence of Roy Lichtenstein's *Mural with Blue Brushstroke*, which occupies the centre of the atrium, measuring 68 × 32 feet and looming 13 feet into the

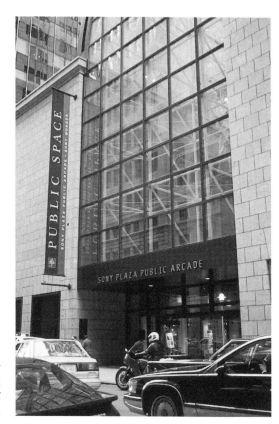

Figure 11 Banner proclaiming 'public space' at the corporate premises of Sony, New York, 1995.

air, is not daunting enough, there is a no less uninviting 40-foot semi-circular settee of verde larisa marble – the so-called 'Atrium Furnishment' by Scott Burton (Plate 5). These works, by their sheer size and their air of opulence, serve, metaphorically speaking, as 'bouncers' to keep unwanted people from wandering around what is ostensibly a 'public space'. Would it not be fair to say that people cannot help but feel uncomfortable, let alone intimidated, sitting on the settee or even lingering for a while in such a space, especially under the eagle eye of the ever-present security guards?

REAL-ESTATE REALITIES

The phenomenon of the Whitney branches in the eighties is illuminating as an indication of the extent to which an art institution can be a comfortable bedfellow with corporate America. The Whitney's courtship with the Equitable was the most glamorous and highly publicised event of its kind, if for no other reason than the Equitable's $7.5 million expenditure on its art enterprise. In addition to establishing the largest of its branches in the Equitable building, the Whitney also seconded its curators to the company as consultants on the commissioning of works for its public spaces and the purchasing of paintings for the exclusive executive dining rooms in its headquarters.

Until the construction of its new headquarters, the Equitable, the nation's third largest life-insurance company with assets at that time of $77 billion, had not been a household name in the art world. Its motivation for venturing into fashionable art patronage in 1986, apart from its being a highroad to the refurbishment of its corporate image, was first and foremost a real-estate investment.

According to Benjamin D. Holloway, the key figure behind the Equitable venture, in order to lease out two-thirds of the space of the Equitable building, the Whitney branch itself and the art works displayed in the building, along with other amenities, were 'a way of attracting the kind of tenant we want, at the rental prices we are asking'.[14] Vividly catching the essential motivation of the Equitable's marketing strategy, *The New York Times* headlined its article 'Equitable Seeking Park Avenue Rents on Seventh Avenue'.[15]

Both sides involved in these deals were fully aware of what they had to sell. As Tom Armstrong, the then director of the Whitney Museum, put it: 'We represent contemporary art', and it is a 'product that most museums don't have'. Conscious of the value of the Whitney card, he revealed in the same interview: 'The prestige that we bring to them [the corporations] is significant, and we want to be compensated for that.'[16] If his corporate patrons had any serious doubts about the value of what was being offered, he was quick to remind them that the prestige of the Whitney can be easily measured in dollar and cent terms by comparing it with commissioning advertisements from Madison Avenue. With the same, or even much less, money, the Whitney puts the corporation in an editorial context that endows

it with a non-commercial and benign image while at the same time disguising its profit-oriented business nature. None of the Madison Avenue super agencies can achieve such a magical effect.

CENSORSHIP: WITHOUT AND WITHIN

Despite all its efforts to sell the prestige of its name, all the Whitney gets in return is money and space. But the ultimate question is: what use can be made of this additional space maintained by corporate funds? And crucially, is curatorial independence up for sale when a museum is willing to let itself be so exploited? The Museum was quick to deny the possibility of censorship being exercised by its corporate patrons. To quote Tom Armstrong: 'Contractually we will not let the corporate sponsor in any way determine our program.'[17] While stating that the Whitney is 'entitled to do whatever they want to do', Mr Holloway does not hesitate to define the Equitable's position: 'I would be the last person in the world to censor them. But I'm responsible for what I do, and they're responsible for what they do, and if they do something irresponsible, they have to take the consequences.'[18]

Censorship, of course, works both from without and from within. This is not to say that the Whitney branches would never mount an exhibition of a controversial nature. On one occasion, for instance, the Whitney branch at Philip Morris held a travelling show featuring the early twentieth-century radical magazine *The Masses*. Within the boundary of the corporate environment, however, curatorial autonomy is very circumscribed, if it has ever existed at all in any meaningful way. Could the Whitney mount an exhibition, say, of Hans Haacke's exposure of the speculation and manipulation of the real-estate market by the Equitable Real Estate Group, similar to the one he created in 1971 on Manhattan real-estate holdings and which was cancelled by the Guggenheim Museum? Or could the Whitney present a show exposing how Philip Morris is exporting life-threatening high-tar cigarettes to the Third World at a time when their domestic sales are declining as a result of the continuing anti-smoking campaign in the United States? Josephine Gear, a former director at the Philip Morris branch, while making clear that Philip Morris did give her a free hand generally, frankly commented: 'Philip Morris wouldn't tour any exhibitions

touching on smoking.'[19] However liberal the corporation would like to project itself as being, exhibitions that confront the host company in any way would be kept out of corporate premises. The exhibition *(un)Making of Nature*, for instance, which was scheduled to tour to the Champion International branch in addition to the Philip Morris and Downtown branches, was cancelled. This was primarily because paper boxes in the work by the artist Michael Paha, *Drawing for Timeline*, a piece concerned to show how technology disrupts natural processes, happened to have been produced by Champion International and bore the company label.[20] Critical comment on the environmental issue in the exhibition offended the corporate sponsor. To suggest that the Museum can, as a corporate tenant, maintain its curatorial independence without sanitising its exhibitions, either politically or socially, is to strain the bounds of probability.

DEAN CLOUGH: PRACTICAL UTOPIA?

The Whitney branches were, of course, the very embodiment of the corporate excesses of the eighties in America, which found virtually no comparable examples outside Manhattan. The closest possible parallel in Britain is, perhaps, Sir Ernest Hall's Dean Clough in Halifax, a business complex-cum-arts centre in Northern England. Occupying some 1.25 million square feet of 16 Victorian buildings, Dean Clough was previously the Crossley's Carpet Mill, once one of the world's largest carpet factories in the heyday of the British Empire, but its fortune, following the industrial decline in Britain, came to a complete halt in 1982. It was bought by the property-tycoon Ernest Hall in 1983, with the aim of creating what the Centre's press release termed a 'practical utopia'. Or as Sir Ernest put it: 'I wanted this derelict building, which has become a symbol of failure and despair in Halifax, to be transformed into something positive.'[21]

What does this grandiose talk of 'practical utopia' actually mean? Alongside 100 or so commercial companies (employing 3,500 people) located on the site, the Dean Clough Industrial Park boasts nine 'galleries' and a theatre. It also takes pride, by offering peppercorn subsidized rents, in hosting a string of selected arts charities, including Northern Broadsides, IOU Theatre and, in our specific context, the Henry Moore Studio operated

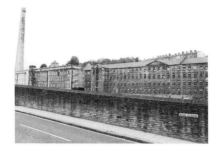

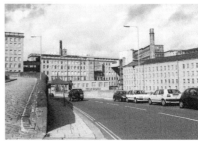

Figure 12 Views of Dean Clough Industrial
Park, Halifax, 1999.

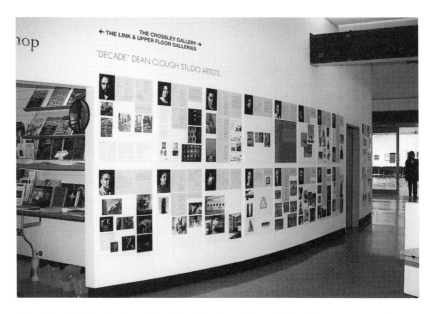

Figure 13 Publicity for Dean Clough Studio artists, the 'goodwill' of the property developer
on full public display, 1999.

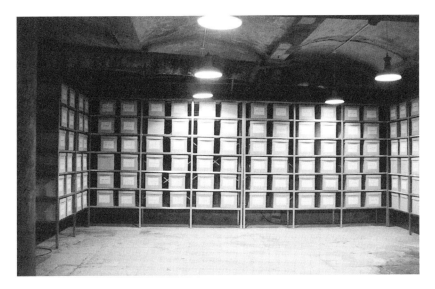

Figure 14 Christian Boltanski, *Lost Workers Archive*, Henry Moore Foundation Studio, May 1994 onwards, a work commemorating blue-collar workers made redundant after the closure of Crossley Mills, and not re-engaged in Dean Clough.

by the Henry Moore Foundation in Leeds. In addition, there are what the Centre refers to as 'Dean Clough artists' – a 20-strong co-operative of visual artists resident in the buildings, with some of them having 'free' working space provided by the Centre. It is not surprising that the Centre also has over 600 works, which they like to term a 'corporate art collection'.[22]

Since its opening in 1984, Dean Clough has been acclaimed as an 'arts emporium', a 'dream factory', and, above all, a shining example of urban regeneration.[23] In particular for the latter reason, it has been a favourite stopping-off point in celebratory tours by royalty or government ministers. In a country that has only gradually come to terms with its imperial past and the continuous decline of its status as a world power, the mills in the heartland of industrial Britain survive as monuments of the golden age of the imperialist past. These mills, often left derelict but listed, therefore represent in some way a collective national complex, a statement of a country's inability to learn to

accept its own past. In other words, the redundancy of mills mirrors the disappearance of empire, while their status as listed buildings, whatever their architectural merit, is in some way a collective expression of nostalgia from a people uncertain as to how best to celebrate its industrial heritage. In this light, what Dean Clough has achieved is little short of a uniquely successful commercial enterprise. It has not only transformed a whole derelict area into a high-tech business centre, but, in so doing, has also gone a long way to restoring an injured sense of pride, not only local but national as well.

While the compelling sense of the past embodied in Dean Clough is important for the national psyche, it is not any sense of history that has kept the name of Dean Clough regularly featured in the strongly London-biased national newspapers. It is when the performances of its resident arts groups come to national media attention that the name of Dean Clough appears in the national media. In the particular case of its high-profile Henry Moore Studio, the artists who have been invited to make works and exhibit there are a cast of internationally known personalities who could not fail to attract media interest. They have included the Italian Giuseppe Penone and Jannis Kounellis, the German Ulrich Rückriem, the American James Turrell, the French Christian Boltanski, as well as Richard Long from Britain, to name but a few. The name of Dean Clough is in fact so intertwined with that of the Henry Moore Studio that one journalist mistakenly believed either that Dean Clough was administered by the Henry Moore Studio or that Dean Clough was simply an alternative name for the Henry Moore Studio.[24] The public institutions that have been invited to become corporate tenants of Dean Clough include the British national Arts Council Collection, but lack of funds has prevented it from taking up this long-standing offer.

As far as using art as a tool for upgrading a site that was previously derelict and unused, what Dean Clough has achieved is not so very different from what its American counterpart, the Equitable, succeeded in doing. Since the eighties it has become ever more popular among developers whose sights are set on acquiring the aura that art generally brings with it, and who seek to use art, as well as top design and architect-signature buildings, to redefine the social character of their enclave developments within an unsatisfactory environment. In this regard, the Equitable and Dean Clough are pursuing similar programmes. But unlike New York, Halifax is not a metropolis where space is the ultimate premium. Dean Clough is therefore

in a much better position to provide 'free' space to its selected arts charities than the Equitable is in New York. And this is indeed what it is willing to give as part of its claim to provide a 'practical utopia' where commerce and art, as they see it, can meet. Dean Clough does not have a policy of providing funds for its arts tenants.

In the case of the Henry Moore Studio, although the Henry Moore Foundation is charged only a peppercorn rent for its 10,000 square feet of studio space, it is a little known fact that the Foundation has in fact to pay a full rent for its storage space (approximately 15,000 square feet) on the site, to the tune of some £10,000 per annum in addition to a monthly service and insurance charge of £1,300. How free, one may ask, is 'free' space with such hidden costs as these? Perhaps this is one of the reasons why George Melly was moved to describe Sir Ernest as 'the bluff Maecenas of Northern Art'.[25] With minimal financial commitment, Dean Clough has in fact managed to achieve, to use the fashionable Thatcherite term, 'value for money' in a most successful way.

ART EXHIBITIONS AND GALLERIES
WITHIN CORPORATE PREMISES

Given the enormous amount of money involved, only big multinationals such as the Equitable, Philip Morris or IBM can afford to play the museum-branch game. For fear of being left behind, more and more firms are, on a smaller scale, devoting part of their precious office space to art exhibitions, or establishing art galleries of their own within their premises. The more adventurous have also made an effort to get themselves listed as art venues alongside gallery listings in the media. The Lothbury Gallery (owned by the NatWest Bank), the Atrium Gallery (owned by PricewaterhouseCoopers) and the Economist Plaza (owned by *The Economist*) are, for example, regularly featured in the bi-monthly listing of galleries in *London New Exhibitions of Contemporary Art*. If corporate names sandwiched between those of art galleries may seem to be out of place and an anomaly, they serve to show how eager companies have become to be identified as patrons of the arts.

These exhibitions are, of course, very different in content from those organised by the so-called 'corporate museums' of earlier decades.[26] A

corporate museum naturally displays exhibits related to the history or operations of the company, such as Harvey's Wine Museum in Bristol in Britain, owned by the wine merchants John Harvey & Sons.[27] Those exhibitions held within commercial space since the eighties, however, are mainly of arts or culture in the broader sociological sense of the terms, and are almost entirely devoid of overt references to the business dealings of the host companies. One might have expected 'corporate galleries' such as the BMW Gallery, transformed from its Park Avenue showroom in New York, to belong to the former category and to organise, for example, exhibitions around motorcar memorabilia. In actual fact, it deliberately avoided linking its shows to its products, and chose instead to display art paintings, giving the impression that its exhibitions were designed purely for aesthetic purposes.[28] In this sense the BMW Gallery, by following the trend of the eighties, succeeded in differentiating itself from the general run of corporate museums.

Most of the corporate exhibitions or 'galleries' in New York and Washington, DC, were established in the eighties, and London firms began to jump on the bandwagon in the nineties. A casual walk through mid-Manhattan in the late eighties would reveal, for instance, art exhibitions of various descriptions at the PaineWebber Art Gallery, the IBM Gallery of Science and Art, the Fourth-Floor Gallery at the Seagram Building, the Chemical Bank Gallery, the Lobby Gallery at Deutsche Bank. The list could, of course, be extended if one included those elsewhere in Manhattan. The same, though on a smaller scale, could be said about Washington, DC; law firms such as Arnold & Porter and Covington & Burling were also keen to provide corporate space for changing exhibitions. In the eighties, the heyday of corporate activity, corporate art ventures were in full swing in America. When the Deustche Bank in New York set out to justify why it had what it termed a 'Lobby Gallery' in its building, its explanation was both familiar and unusual: 'The Gallery reflects a commitment of the occupants of 31 West 52nd Street to support and encourage a deeper understanding and appreciation of the arts.'[29] Familiar because it seemed to be saying that it was imperative for any self-respecting company to host an exhibition within its premises; unusual because, as well as wheeling and dealing as only a bank is qualified to do, it also appeared to be claiming what it considered to be its fair share in the marketplace of art patronage.

SIZE MATTERS

If we use as a guide the way in which the exhibition space is organised, these companies can be divided into three groups. Those best qualified for the 'gallery' title are the IBM Gallery of Science and Art, the PaineWebber Art Gallery and the Equitable Gallery in New York, which, after the departure of the Whitney Museum branch in 1992, was renamed and is now organised by the Equitable in-house curator. What these galleries have in common is not only their properly designated and well-maintained space, but also their generous size compared with other similar operations. The PaineWebber Gallery, which consists of 4,000 square feet, occupies almost the entire ground floor of the PaineWebber Group headquarters on the Avenue of the Americas, while the IBM Gallery, before its closure in August 1994, was an 11,000 square foot exhibition space on the lower level of what was then the IBM 42-storey skyscraper in New York.[30] Given the limited space in central London, in particular the crowded 'square mile' of the City of London, not many British companies could ever have rivalled these American-style corporate projects. Nor were there any tax incentives provided by the local authorities in London for developers following the American example. The single exception was the NatWest's Lothbury Gallery, transformed from the Bank's previous banking hall, to which we shall return.

As we have seen, the sub-text of the New York-headquartered companies' agenda is that, in order to gain extra floor space from the New York City government, the ground floor of the buildings has to be kept open to the public at any cost. Both the PaineWebber and the Equitable Galleries were established as a direct result of the zoning regulations of New York City.[31] Moreover, the expenses incurred by these galleries are tax-deductible either as business expenses or as charitable contributions. Built into this corporate engagement, again, is the ambiguous relationship between corporate and public interest. By keeping the galleries open to 'the public', the corporations not only obtain substantial financial benefits from the public sector as a hidden public subsidy, but also retain the ownership of the gallery space. But 'corporatised public space' itself is ultimately an oxymoronic concept that cannot be equally true for both parties involved.

Important as these galleries may be, their exhibition programmes are too catholic and diverse to merit attention from the art world. But from the very

Figure 15 View of photography exhibition, *Washington: Project of a City*, by Steve Gottlieb, held at law firm in Washington, DC, 1990.

start corporate galleries were meant to put company's goodwill on full public display. Exhibitions at the PaineWebber Gallery, for instance, have ranged from *Gertrude Jekyll: A Vision of Garden and Wood* and *Living Maya: The Art of Ancient Dreams*, to contemporary art works drawn from its own art collection.[32] The fact that none of these galleries is exclusively committed to exhibitions of contemporary art, or art in general, does not place them outside the scope of our study. With their strategic location in Midtown Manhattan, these galleries offer cultural institutions a much sought-after opportunity to showcase their collections or activities, while at the same time installing the company name as a significant focal point on the cultural map of contemporary American society. In the case of the IBM Gallery, with a staff of seven in its heyday, the ambition was a global one. Its exhibitions were drawn from different continents, making it one of the itinerary stops on the international cultural circuit.

OFFICE EXHIBITIONS

The majority of art-oriented companies, such as Arnold & Porter, Covington & Burling in Washington, DC, or Freshfields, PriceWaterhouseCoopers, and The Economist in London, fall within a second category. They hold rotating exhibitions in their office building without necessarily publicising the space as a 'gallery' *per se*. The spaces thus allocated are smaller than those in our first category and range from a full-scale atrium to a simple hallway on the premises. For example, the so-called Atrium Gallery at the mega-accountancy firm of PricewaterhouseCoopers is, as its name indicates, literally located in the atrium of one of the firm's buildings.

Within this group professional organisations such as law firms seem to be among the most active organisers of changing exhibitions in office space, given their specific business needs of direct contact with clients.[33] In addition to having an art collection, the law firm Arnold & Porter in Washington, DC, for example, was also the first firm in the state to start hosting rotating

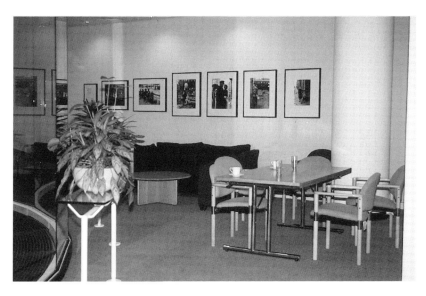

Figure 16 Photography exhibition held at law firm Freshfields in London, 1992.

exhibitions in office space in the early eighties. It was intended, according to Jim Dobkin, chair of the firm's art committee, to 'complement our permanent collection by adding a certain freshness to it'.[34] In London, one law firm found an extra advantage from its photography exhibitions. In addition to showing its sophistication in art matters, it also used the exhibits as a way of lightening up office space and at the same time enlightening its less 'sophisticated' office workers. To quote the lawyer who was in charge of mounting the exhibitions:

> Another area which is quite important to us is we do have regular exhibitions of photographs by British photographers. There from time to time we buy some of the pictures we exhibit and hang those in certain areas of the firm. The reason for that is a lot of the areas downstairs are narrow corridors and so on. They are not suitable for pictures. Photographs go well there. They are quite stimulating. The area is highly popular. A lot of people go back and forth. It is a way of making that part of the environment interesting, we think, for them, without patronising them.[35]

This kind of operation is understandably very modest, much smaller than that in the previous category. But what this group of exhibitions shares is the fact that the space devoted to rotating exhibitions is generally separated from the working office, and set apart from the traffic of everyday office life. The distinction is of significance in that these exhibitions are potentially more accessible to the 'public' than the next group of exhibitions, which are actually held within the office space. Companies can thereby lay a legitimate claim to benefiting the artistic community by holding their exhibitions.

ART AS WALL DECORATION

A third group of companies comprises those that hold exhibitions within their working space. As a result, art works are mingled with the hurly-burly of office life, inseparable from the interior décor. This group of companies is the most difficult to generalise about, as the rationale for holding exhibitions in this way is very varied. For some, exhibitions of this kind are a way of decorating the office, with the added advantage that the

'decoration', so to speak, can be changed regularly without making any substantial financial commitment. Companies that choose this option therefore mount the exhibition or discontinue it whenever they see fit.

The advertising agency Lintas Worldwide in New York provides a case in point. The company placed exhibits along the side corridors of its 42nd-floor executive offices at its headquarters in the late eighties. The motivation, according to its curator, Margaret Mathews-Berenson, was 'to live with the works for a while before deciding to make purchases for the collection'. This happened at a time when the company had decided to replace its nineteenth-century paintings and antiques with contemporary art, which it considered to be more appropriate for its image.[36]

This was the case also with Arthur Andersen in London. As one of the top accountancy firms in the City, Arthur Andersen was, from the late eighties, very keen to promote its image through art. It not only had a part-time curator for its corporate collection of works on paper, but also launched an art award in its name, the Arthur Andersen Art Award in the early nineties. For a period, it held four exhibitions a year in the staff restaurant, two drawing on works in the collection and the others from outside loans.[37] Exhibitions of this sort did not last long and had no function other than decorating the corporate walls.

FUNCTIONS OF CORPORATE EXHIBITIONS

Because of the number of firms involved, the organisation of exhibitions, whether they are in a 'gallery' setting or within the working office, varies from company to company. Nevertheless they operate in a broadly similar way. Typically companies mount several exhibitions a year, curated either by in-house curators or by outside art consultants on a contractual basis. The exhibits are sometimes drawn from the company's own collection, or more often are on loan from artists, museums or commercial galleries. What characterises these exhibitions above all is their emulation of the practices of art institutions. Companies are not only organising exhibitions, but complementing them with press releases, opening receptions and sometimes even providing exhibition leaflets or catalogues to give the show an aura of permanence and scholarship. What for art museums and galleries is an

established practice has become for businesses, firstly, a way of marketing their products and services; secondly, the source of corporate entertainment; and, above all, a device for validating their intervention in the art world.

Nowhere was this sort of changing exhibit made to serve its corporate interest more nakedly than that at BMW's showroom on Park Avenue in New York in the late eighties. The showroom, called the 'BMW Gallery', was, of course, open to the public, or, more precisely, to its potential car buyers. But in doing so, the company also attempted to add a psycho-linguistic twist to its marketing strategy, energetically using the art works as hidden persuaders to enhance the emotional overtones and social status of their products. In the leaflet for the exhibition *Drive!*, for instance, the company announced: 'Here, changing exhibits of the products, technology and heritage of Bavarian Motor Works will be displayed in the atmosphere of an art gallery beside equally stimulating exhibits from various artistic disciplines.'[38] Central to the successful switch from a gallery of art to one of automobiles is the fact that BMW does not just sell over-priced expensive vehicles; more importantly, it sells distinctiveness and style, which art has always suggested and been associated with. It thus blurs the distinction

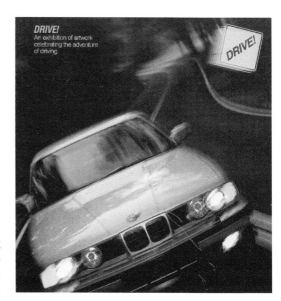

Figure 17 Leaflet advertising the *Drive!* exhibition at the so-called BMW Gallery in New York.

between art and consumer durables, between what is supposed to be above commodification and that which is first and foremost commodity.

Despite these companies habitually publicising rotating exhibitions as part of their portfolio as patrons of art, access to such shows is highly restricted. It is true that corporate galleries like the IBM Gallery or the PaineWebber Art Gallery in New York and the display at The Economist building in London are open to the public. It is not, however, expected that outsiders will, under normal conditions, be allowed to wander freely around a working office. The majority of exhibitions held within corporate premises thus are not readily accessible, and some are seen only by employees and clients of the firms. This is because these exhibitions are operated for the purposes of exploiting the status and social function of contemporary art, as places of social gathering for the firm to entertain its cherished clients in a setting of 'high art' instead of inviting them to a chic restaurant. When asked whether there were outside visitors to the corporate gallery, one of the administrators in a Washington, DC, law firm admitted: 'I would say no. We don't have a lot of people who just walk up from the street. It's not that kind of thing. It's more a type of targeted group, invitations we send out and certain invitations for each artist.'[39]

Moreover, to promote the image of being an enlightened art patron to their target audience in a suitably lavish way, companies very often invite artists on show to give a talk on their exhibits at the private opening reception, where clients are invited as well as employees. As a matter of fact, the attention paid to the exhibition itself is often brief, at most half an hour before a dinner party. One of the administrators interviewed commented that some of the employees came for the dinner, not for the opening view.[40] Exhibitions of this kind are never intended to provide an aesthetic experience for the people involved, and do so only incidentally. Nor are they meant to be an experimental space or one for articulating any dissenting voice.

The game is pushed to its extremes by the Chase Manhattan Bank, whose hegemonic position in the art world over the past decades has unquestionably been built on its financial power. In order to woo its local artistic community following a period of low profits, Chase utilised the facilities at its SoHo branch in New York as an art gallery, reopening with a wide, whitewashed look in March 1985. It was reported that the branch's profit

ranking jumped from 185th to fourth. At the opening of the refurbished branch, one attendee was overheard asking: 'Is this a bank having a show called "Art Gallery" or an art gallery having a show called "Bank"?'[41]

The confusion over the bank-as-gallery or vice versa is not just a question of ideological purity. It is precisely the degree of ambiguity that is at issue here, be it in America or Britain. By emulating the practices of an art museum, business redefines the boundaries between cultural and commercial institutions and thereby the values that they each stand for. By appropriating art in order to distinguish themselves from the otherwise mundane profit-making concerns of the business world, companies are recontextualising the works of art housed under their roof and making them their own. No wonder that one of the insiders, William B. Renner, president of Alcoa, could say: 'Business could hold art exhibitions to tell its own story.'[42]

A similar mindset and manipulation also characterised one of the 'big four' high-street banks, the NatWest Bank, in Britain. NatWest was, of course, no newcomer to the arena of arts sponsorship. On the contrary, over the 1990s it had gone out of its way to set itself up at the forefront of the contemporary art scene – a success story for the Bank, if measured by how many free column inches it was able to obtain in the media. It is indeed, by British standards, a unique story of corporate art intervention in that, step by step, it embraced virtually all the major kinds of corporate art venture, transforming itself from obscurity into a situation in which any show it put on in the late 1990s was certain to secure media attention. And it was not only business-hugging newspapers such as *The Financial Times* that were keen to write about NatWest shows, but the liberal press also; the *Guardian*, for example, found itself reviewing them. Such an achievement is a real pointer as to how far British companies can and do go in art intervention, and what would be in store for us if other companies were to jump on the same artistic bandwagon as NatWest.

But back in the early nineties, NatWest's art efforts, such as the launching of the 'NatWest 90s Prize for Art' and the 'NatWest Art 90s Collection' in 1990, remained little known and hardly ever caught media attention.[43] In order to gear up its efforts and relaunch itself, the Bank resorted to establishing a full-time in-house curator in 1995, probably the first ever corporate curator of its kind in Britain. In its advertisement for the post, the Bank

prided itself on having an 'impressive collection of Works of Art' (*sic*), for which the prospective curator was required to 'acquire new works and organise publicity opportunities and exhibitions'. He or she was at the same time expected to 'establish a network of contacts in the art world' in order to 'keep abreast of the art market'.[44]

The detailed requirements were, of course, no triviality. Corporate art intervention cannot and will not lay claim to legitimacy without ultimate sanction by the art world's own expertise and approval. It was no surprise that NatWest eventually chose Rosemary Harris as its first curator, someone who had previously worked at the Tate Gallery for nine years. Once the curator was in place, the Bank's art ventures soon took off in an impressive way. In the short span of a few years, NatWest seemed to be approaching the apotheosis of its art involvement. The Bank had not only more than 1,500 works of twentieth-century British art armed with their own curator, but also its own art prize, the NatWest Art Prize, worth a cool £36,000 in total, the biggest ever art prize in Britain. To bring all its endeavours into focus, the Bank transformed its previous main banking hall in the heart of the City of London and turned it into what was known as the Lothbury Gallery, opened to the public in 1997.

The Gallery occupied, of course, a strategic position within the Bank's art intervention strategy not only because its presence placed the Bank's beneficence on permanent public display, but also because the Bank could utilise the space as it saw fit. Since its opening, the corporate Lothbury Gallery had been strenuously emulating what had formerly been the prerogative of a public art gallery. It not only showcased the Bank's own collection, but also put on exhibitions with loans from other public collections. In late 1998, for example, it mounted an exhibition called *Fifty Years of British Sculpture: Works from the Arts Council Collection*. The grand title belies the self-inflating nature of the undertaking: how would it be possible to present 'fifty years of British sculpture' in a space of what the *Guardian*'s art critic Adrian Searle called 'a corral of free-standing screens in a sombre City banking hall'?[45] The orchestration of conspicuous artistic collaboration with other public art institutions was, of course, part of a process of association that was meant to help legitimise and validate the Bank's endeavours in the art world.

So much so that the Bank also made a video to champion its Prize and finalists and had it continuously playing at one corner of the Gallery in its

exhibition of the 1999 NatWest Art Prize finalists, a publicity stunt in pure imitation of the Turner Prize presentation at the Tate Gallery. What is even more astonishing is that Tim Marlow from the *Tate Magazine* actually made an appearance in the video, cheerfully testifying to and praising the prize: 'It's great time, I think, for painting in Britain. If you want to look into the future, look at the works of eleven young artists in this year's NatWest Art Prize. That is the future of young British painting.' No one in his or her right mind would have believed, as Tim Marlow suggested to us, that the future of British painting would or should lie in the NatWest Prize, but no amount of criticism can adequately explain the strange 'hype' that ran through the whole operation, the uncritical remarks of a public art bureaucrat risking his own reputation on a publicity-seeking exercise-cum-art-prize, and, above all, the keenness of a commercial enterprise to position itself in the forefront of contemporary art.

Nothing can be more ironic than Marlow's remarks about the NatWest Art Prize; within the short span of a few months after his touching expression of faith in the NatWest Art Prize, the NatWest was taken over by the Royal Bank of Scotland in late 1999. Commercial premises are no safe havens for art, and the cut-and-thrust of the business world is such that, following its financial defeat, the NatWest's expensive intervention into the art world was, at a stroke, to slip into oblivion (the Lothbury Gallery and the NatWest Art Prize included). The case of NatWest is, of course, not isolated. Across the Atlantic, during the recession of the early 1990s, the world's largest computer manufacturer, IBM, suffered the worst financial losses in its history. Like other companies across the US, IBM undertook a large-scale down-sizing, or, to use the current euphemism, 'right-sizing'. As part of their cost-cutting efforts, IBM not only closed its Gallery of Science and Art in its New York headquarters in August 1994, but, more significantly, sold off a substantial part of its art collection (estimated at 90% of its total value) through a series of auctions at Sotheby's in New York in 1995.

The IBM collection, started by the firm's founder Thomas Watson in the late 1930s and since heralded as 'one of the most important American corporate collections', had, from its very beginning, fulfilled a major public relations function. In the new climate of financial stringency, however, the collection along with the IBM Gallery came to be considered as an 'unnecessary asset' and the decision was taken to dispose of it. To quote the

company spokesman: 'We are not in the art business; we're in the informa-tion technology business.'[46] This is in stark and ironic contrast to what IBM described, in its exhibition catalogue of 1989, *50 Years of Collecting: Art At IBM*, as 'the solid commitment of the IBM Corporation world-wide to sup-port art . . .'. Since its heyday in the 1980s, corporate intervention has been pursued with a zeal and a pace that can be seen, from our present vantage point, to have been both over-ambitious and over-confident. Like Icarus rising on the wings of his own economic power, its steep climb brought it perilously close to the sun. The plumes that it borrowed on the strength of its financial profiteering are already showing signs of drooping, and it could well be that the very power that enabled its rise will eventually bring about its decline.

8

CORPORATE ART COLLECTIONS

The Reagan–Thatcher decade witnessed a burgeoning of corporate art collections in the United States and the United Kingdom. Not only did the number of corporate patrons from across the whole spectrum of business increase over the decade, but also the magnitude of corporate collecting was such that it brought about a sea change in the kind of art works being collected and the way in which they functioned in the business context. Nowhere are the changes more apparent than in the phenomenon of business patrons who collect contemporary art in a deliberate and calculated way hitherto unknown. To quote a lawyer who was actively engaged in collecting for his law firm in Washington, DC:

> We were really looking to create a collection that was very much a contemporary collection, that would reflect the fact that our law firm was not only on the cutting edge of legal development, but also on the cutting edge of the art world itself.[1]

What has the business of contemporary art to do with that of a law firm, and why is a law firm motivated to be 'on the cutting edge of the art world itself'? This uncanny alliance of two unconnected worlds is, however, entirely characteristic of corporate intervention in contemporary art during the Reagan and Thatcher decade. At the end of the Reagan administration,

American corporate collectors were running their own art departments and organising exhibitions from their collections for touring both across the country and around the world, as if they actually rivalled art museums in importance in the contemporary art world. Comparatively speaking, the British counterpart was a more modest operation, no doubt as a result of the disparity between the different sizes of the companies concerned in the two countries and the different economies. Nevertheless, British businesses did play a significant role in their own right in the development of contemporary art.

But in precisely what way is this corporate art intervention related to the broader context of the political, economic and social transformation in American and British society brought about by the conservative governments in the eighties?[2] This is a question to which there is no ready or easy answer, since it is far from clear how a general political ethos can directly affect specific cultural development. The radical programme of economic and institutional reform of both the Reagan and Thatcher governments had been modelled on an ideology of commercial enterprise, in which the overriding principle of the free market takes precedence over any other concerns. A wide range of activities previously conducted on different principles, or protected from competitive market forces by means of public funding, were relocated within the domain of the marketplace, with these goods or services becoming purchasable commodities.

The case of the British legal services best illustrates how the transformation of British society into an enterprising collective relates to the issue in question, since professional firms are among the most vigorous patrons to have emerged since the 1980s. The legal profession, traditionally regarded as the custodian of the law on behalf of the public, is governed by long-established ethical principles; to quote, for instance, the United States Supreme Court: 'Early lawyers in Great Britain viewed the law as a form of public service rather than as a way of earning a living and they looked down on "trade" as unseemly.'[3] Tradition-bound as it is, the profession, with its patrician air and sense of professional *noblesse oblige*, was not able to resist the impact of the Thatcherite revolution. In 1989 the Conservative government in its proposal for the future of the legal profession championed the competitive spirit of the enterprise culture in no uncertain terms:

> The Government believes that free competition between the providers of legal
> services will, through the discipline of the market, ensure that the public is pro-
> vided with the most effective network of legal services at the most economic
> price.[4]

The commodification of legal services brought about during the eighties
resulted in the provision of legal advice and skill being seen 'in terms of its
marketability as opposed to being a device in the negotiation of justice'.[5] In
response to increasing competition in the market, law firms had to adopt the
previously alien practices of marketing and advertising, practices that, even
though they are the mainstay of consumerism in a capitalist economy, are
traditionally closed to certain professions in Britain because of the public
interest involved. In explaining why his law firm embarked on the project
that they named *City Life Art Commissions*, Stephen Whybrow, senior partner
at the solicitors McKenna & Co, commented:

> Increased exposure to market forces and competition during the 1980s have
> resulted in enormous changes for solicitors. . . . Like it or not the practice of law
> is moving from being a profession to a service business. In 1980 any form of pro-
> motion or advertising a solicitor's practice was not only prohibited but considered
> to be 'fundamentally inconsistent with the interests of the public and with the
> honour of the profession'.[6]

The Commissions, in which graduates from London art colleges were
invited to participate in an art competition, were launched by the firm 'to
form a backdrop' to a reception to mark its return to the City of London and
ensure that its clients and others in the City were aware of its presence. The
event, not by any means the most glamorous of its kind, was not untypical
of the way in which art collections, together with arts sponsorship, came to
be appropriated by business as a marketing tool in the eighties. The imper-
ative of marketability in the Thatcherite enterprise culture is such that it
draws almost every sector of business into its gravitational field, and profes-
sional firms, with their traditional practices, are perhaps to be seen as
reluctant latecomers as far as jumping on the bandwagon of art patronage is
concerned.

CORPORATE ART COLLECTIONS AND TAX ISSUES

But more concrete than this generalised encouragement to enterprise are the tax policies under both governments that, by directly helping business, inadvertently make it easier for businesses to collect art too. These issues, however, are among the greyest and most sensitive areas of corporate art buying. Greyest because there are discrepancies between legal definitions and actual practice; most sensitive because of the actual sums of money involved, and what could amount to frauds involving serious legal and tax complications for the companies concerned. For these very reasons, the discussion that follows cannot be as definitive and conclusive as it otherwise might be.

Among the tax breaks available during the course of the Reagan administration, those most readily exploited by companies investing in works of art were accelerated depreciation[7] and investment tax credit.[8] It was reported in the media that both, in fact, 'have provided economic incentives for building company collections'.[9] To what extent this is the case, however, is an open question. From the legal perspective, according to an anonymous accountant from the London office of one of the top American international accountancy firms, in order to qualify for these tax concessions, the taxpayer (corporation) must fulfil the following requirements for the property they purchase:

1. The property is used in a trade or business or for the production of income;
2. The property is subject to wear and tear, or decay or decline from natural causes, to exhaustion, and to obsolescence;
3. The property has a determinable useful life and salvage value.[10]

This position is further clarified by the American Internal Revenue Service (IRS). To quote Michael D. Finley, Chief of the Branch 3 at the IRS in Washington, DC:

Tax benefits such as depreciation, investment tax credit, . . . are generally available only if the taxpayer purchases property that has a limited or determinable useful life. A work of art (as contrasted with a mere wall decoration) would not generally have a limited or determinable useful life.[11]

To what extent these legal definitions are actually applied or enforced in real life is, however, not altogether clear. When further questioned, the accountancy firm mentioned earlier stated that 'although it is generally very difficult to meet the criteria for investment tax credit and depreciation, *it is possible to do so* [italics added].'[12] When asked specifically about the actual or theoretical circumstances under which works of art could be depreciated, the firm refused to provide any further information, and, especially significantly this time, the correspondence had to be 'approved' by a presumably more senior member of staff than the one who first replied to my enquiries.

The evidence both from my interviews with the companies and the questionnaire surveys provide further contradictory evidence as to what can be defined as legal. One accountant who worked for a law firm in Washington, DC, admitted that her firm was in the habit of depreciating its art works for some years in the eighties before she arrived in 1989. However, she was not sure if that was the normal practice at the time or an oversight on the part of the person in charge of accounting at the firm. A different law firm in Washington, DC, also provided the following tax information regarding its art collecting:

> Pieces of art are capitalized if they cost more than $500. Pieces that cost less than $500 are not capitalized and are considered simply yearly expenditures. Some capitalized items are depreciated and some are not. Antique furnishings are not depreciated because they are expected to increase in value, as we hope the art will. There is no investment tax credit since 1986. All depreciation is accelerated (7 years for art work).[13]

In my own survey, none of the 72 valid replies from American companies admitted that tax concessions were important factors for companies when initiating art collecting (see Table 8.1). In reply to questions regarding actual tax benefits, two and three companies respectively out of 72 respondents confirmed that their companies indeed claimed investment tax credit and accelerated depreciation for their art works, while another two of them confirmed that they obtained tax benefits by donating works of art to museums. Another three companies stated that they had included the art purchases as part of business expenses in computing the trading profits for tax purposes. Small as the percentage is, the confirmation of the tax benefits for corporate

Table 8.1
Reasons for initiating art collections (US)

Scale of importance*	Individual with personal interest in art		Relocation/expansion of firm		To keep up with business trends		To enhance working environment		Investment	
	Number of firms	Percentage of firms	Number of firms	Percentage of firms	Number of firms	Percentage of firms	Number of firms	Percentage of firms	Number of firms	Percentage of firms
1	1	1.6	7	11.1	20	42.6	1	1.5	15	30.6
2	1	1.6	—	—	6	12.8	—	—	8	16.3
3	7	11.1	6	9.5	16	34.0	2	2.9	19	38.8
4	16	25.4	10	15.9	4	8.5	15	22.1	5	10.2
5	38	60.3	40	63.5	1	2.1	50	73.5	2	4.1

Scale of importance	To generate good public relations		Part of advertising effort		Tax concessions	
	Number of firms	Percentage of firms	Number of firms	Percentage of firms	Number of firms	Percentage of firms
1	3	5.7	24	48.0	29	60.4
2	4	7.5	6	12.0	5	10.4
3	11	20.8	15	30.0	14	29.2
4	26	49.1	2	4.0	—	—
5	9	17.0	3	6.0	—	—

Notes:

* 1 = very unimportant, 2 = fairly unimportant, 3 = neither important nor unimportant, 4 = fairly important, 5 = very important.

Number of respondents: 72

Missing responses account for discrepancies in some totals.

art collecting in the United States during the eighties is nevertheless illuminating and significant. Respondents are, of course, likely to be more reticent in answering questions that raise complicated legal problems, and to react more readily to suggestions that their art collections might be socially, rather than financially, motivated. Moreover, the nature of the federal system in the United States means that, in the absence of a uniform law code, different states may well have different laws.

The test of these issues, of course, lies ultimately in cases brought before the courts. While providing me with some general information, Michael D. Finley also pointed out that more detailed information could only be provided 'if a particular taxpayer were to request a formal ruling on these issues in connection with a specific transaction'.[14] But court cases involving such issues are understandably rare. In the unusual case of *Associated Obstetricians and Gynaecologists P.C.* v. *Commissioner* in 1983, the commissioner of the IRS determined that the taxpayer, Associated Obstetricians and Gynaecologists P.C. (AOG), was deficient in the payment of its federal corporate income taxes for 1976 and 1977 because the Tax Court determined that the taxpayer, AOG, could not sustain its claim that the works of art displayed in its medical offices were depreciable property and therefore entitled AOG to depreciation deductions and investment tax credits for the tax years in question.[15]

A similar discrepancy exists between the legal position of the Inland Revenue and the actual practice of corporate collectors in Britain. As in the case of the IRS, there is no working definition for works of art in determining tax liabilities in Britain. Rather, works of art collected by companies are considered to have 'the status of an asset in the particular business, rather than with {regard to} its significance as a work of art'.[16] The tax benefits relevant to corporate collectors in Britain are: (a) if the expenditure for art works is revenue in nature, then a deduction may be available when computing the taxable income; and (b) if the expenditure is capital in nature, and incurred on 'plant and machinery', a deduction is allowed against taxable profits over a period of time, that is, through capital allowances.[17]

However, according to two sources at the Inland Revenue, in strict law, art works do not qualify for either revenue expenditure or capital allowances except in the following specific cases.[18] To qualify for the former, the company concerned has to be an art dealer, where works of art are held as

trading stock, which is of course not relevant to the kind of companies with which this study is concerned.[19] Moreover, only in certain instances where art works are used to create an 'atmosphere' in order to attract customers are capital allowances available for companies such as hotels, the restaurant trade or stately homes.[20] None of the companies with valid responses in the present study is in this kind of business.

Although none of the companies in my survey admitted that tax concessions were at all important in their decision to start a corporate art collection (see Table 8.2), five companies out of 38 respondents stated that their works of art qualified as revenue expenditure, one of them admitted to obtaining capital allowances for its art works, and one to claiming capital depreciation. Six of them reclaimed the VAT (value added tax) on their art purchases. Like those in America, these percentages are small, but they nevertheless indicate the same sort of discrepancies between legal requirements and actual practice among British corporate collectors.

To double-check these replies, I interviewed an accountant at the London office of an international bank. There are some 1,300 pieces of art that the bank regards as appreciating assets, and another 1,200 pieces with some worth, but not as valuable. While the Bank does not depreciate the former, it does in the case of the latter as it would with office furniture, and it claims capital allowances for both categories of art works. To quote the accountant concerned, whose comment is confirmed by the staff at the tax department in the Bank:

> For tax purposes, . . . they [works of art] are treated like any other asset. Whatever our accounting treatment is, they are treated as normal asset purchases, and we get capital allowances, 25% written down.[21]

How universal the practice of claiming capital allowances for art purchases is it is not possible to determine, but if companies are allowed to claim capital allowances for art works, the tax benefits accruing to them are without question substantial. If companies choose to sell their art holdings in due course, they are still much better off even if they do it legally and subject their sale to capital-gains tax. What this means is that in a capitalist market system money is worth more today than it is tomorrow, and companies are always better off if they claim any tax benefit first. To quote the same accountant:

Table 8.2

Reasons for initiating art collections (UK)

Scale of importance*	Individual with personal interest in art		Relocation/expansion of firm		To keep up with business trends		To enhance working environment	
	Number of firms	Percentage of firms	Number of firms	Percentage of firms	Number of firms	Percentage of firms	Number of firms	Percentage of firms
1	2	6.5	9	31.0	12	50.0	2	5.7
2	—	—	1	3.4	6	25.0	—	—
3	1	3.2	1	3.4	4	16.7	1	2.9
4	12	38.7	6	20.7	1	4.2	10	28.6
5	16	51.6	12	41.4	1	4.2	22	62.9

Scale of importance	To generate good public relations		Part of advertising effort		Tax concessions		Investment	
	Number of firms	Percentage of firms	Number of firms	Percentage of firms	Number of firms	Percentage of firms	Number of firms	Percentage of firms
1	2	7.1	14	60.9	19	82.6	11	39.3
2	5	17.9	3	13.0	2	8.7	3	10.7
3	10	35.7	4	17.4	2	8.7	11	39.3
4	7	25.0	—	—	—	—	3	10.7
5	4	14.3	2	8.7	—	—	—	—

* 1 = very unimportant, 2 = fairly unimportant, 3 = neither important nor unimportant, 4 = fairly important, 5 = very important.

Number of respondents: 38

Missing responses account for discrepancies in some totals.

If the tax rules allow you a tax benefit in giving you written down allowances, then you would always choose to go the most tax-efficient route, and claim those allowances. Which may in the future year give you an inflated taxable profit, but it is better paying an inflated taxable profit in the year of disposal than not claiming any capital allowances and pay tax on a smaller profit by the time of disposal. If you took the net present value of both scenarios, you'd be better off claiming the tax today and paying a bigger profit in the year of disposal.[22]

At this stage of the research, I have no means of precisely assessing the discrepancies between legal definitions and actual practices when it comes to corporate art collecting, as the issues involved are simply too politically sensitive and complex. Statements from chairmen as frank as the following, from the pen of Robert Hiscox, are rare:

When business started to prosper under the penal tax rates of the 1970s, it seemed a bit daft to pay high salaries and donate up to 83% to the government, or worse still pay dividends and donate up to 98% to be spent by politicians. Leaving hard-earned after-tax profits in the company gave me the perfect opportunity to persuade my fellow directors to let me buy paintings and sculpture[23]

Understandably companies do not buy art on the sole basis of acquiring tax benefits, but under the Reagan and Thatcher administrations their privileged and dominant position in the contemporary art world was unequivocally reinforced by tax policies, whether or not these happened to be specifically geared toward art investment. Though this is a matter of considerable public interest, barely any criticism of prevailing practices has been voiced.

THE NEW ART PATRONS OF THE 1980s[24]

It is by no means untrodden territory for American or British companies to 'collect art'. A history of corporate art collecting, however, depends very much on our notion of what actually constitutes 'a corporate art collection'. For those who have been involved in corporate art patronage, particularly

those with vested interests, there is a tendency to claim a much earlier starting date, as though a particular historical pedigree could endow current practice with some much desired legitimacy. Accordingly, the history of corporate art collecting in America is often dated to the turn of the twentieth century when the Atchison, Topeka and Santa Fe Railway first commissioned paintings for the railroad's advertising calendars and posters.[25] In subsequent decades companies such as the Container Corporation of America[26] and De Beers Consolidated Mines embarked on similar ventures to add polish to their company's publications.

The earliest example of corporate art collecting, in the sense of the term adopted in this study, is, however, that established by International Business Machines (IBM) Corporation in the late thirties and mid-forties, a practice in which a commercial institution attempted to emulate the artistic activities of a public art museum. IBM formed two collections of contemporary art, 'Contemporary Art of 79 Countries', featuring art works by artists from the countries in which IBM did business, and 'Contemporary Art of the United States', featuring American artists with two works from each state and territory.[27] The former was displayed at the New York World's Fair and at the Golden Gate International Exposition in San Francisco in 1939, while the latter toured North and South America between 1941 and 1945. Pioneering as it might be, the historical significance of this isolated undertaking should not be overstated.

Similarly, it has for centuries been the policy, albeit sporadic, of many British banks to 'collect' portraits of their distinguished chairmen or members of the boards, or to commission silver or other precious materials to commemorate specific events. Even when they incidentally ventured into landscape paintings, their tastes were very much confined to those of a much earlier era, or, for example, to traditional views of the Thames or St Paul's.[28] In the case of certain industries such as oil and construction, companies have for years commissioned artists to portray their business operations or design posters for use in advertising. Collections of this type, either self-celebratory or business-related in nature, dominated corporate premises, in particular the interior of the boardroom and executive floor before the seventies in America and eighties in Britain. (Plate 4)

Standing apart from this time-honoured tradition, the new breed of business patrons who emerged since the beginning of the eighties (in Britain the

phenomenon gathered momentum in the second half of the decade) had a very different outlook. Unlike earlier collectors, they collected contemporary art works, works bearing no direct relationship whatsoever to their commercial day-to-day dealings. And in America (to a lesser degree in Britain), they took a more professional attitude to collecting than the earlier collectors, who used to purchase bits and pieces in an *ad hoc* fashion. Still hidden from public gaze, the works in their hands were exploited in various publications and sometimes were even organised into catalogues and exhibitions, in order to generate much needed publicity. The earlier collectors, not wishing to be left out of this trend, invariably had to assume a similar style of art buying. It is this cohort of patrons of a more adventurous type that has constituted a compelling force in the contemporary art world since the eighties.

As the material under consideration here dates only from the eighties and nineties, there is as yet no substantial research in this area except for few isolated cases and some journalistic writing.[29] The primary source for a listing of corporate art collections in both countries is the *International Directory of Corporate Art Collections*.[30] At the end of the eighties, more than 1,000 American and 79 British firms had come to be listed in this publication. While the majority of the firms claim to own contemporary art, unfortunately no reliable statistics are yet available on how significantly contemporary art figures in their collections, as the listing is necessarily incomplete and lacking in detail. Nor is the information in the *Directory* always accurate or appropriate. The approach of the *Directory* is so broad as to include virtually any company even if it had only a few works, such as, for instance, the Alexander Howden Group in London, which boasted no more than six works in its so-called 'collection'. From a historical perspective, an art collection such as this is not significant.

Partly owing to the dearth of secondary sources, and partly in order to exploit the wealth of primary sources, I had to adopt an empirical approach to this topic, both qualitative and quantitative. For American corporate collections, I visited 25 of them and conducted 23 interviews in New York and Washington, DC, in 1990. For the British counterpart, I visited 43 collections and conducted 33 interviews in London between 1992 and 1994. To observe the changes that took place during the nineties, I returned to visit four collections and interviewed seven people in 1995 in New York and Washington, DC.

To determine the extent to which my conclusions can be applied to other cities in the two countries would require further investigation, but I believe that the phenomenon observable in these cities is more or less representative. While New York is a metropolitan city and Washington, DC, has a more intimate character, London, especially the City of London, has the largest concentration of corporate headquarters and thus corporate art collections, given that Britain itself is a very centralised country. To improve the representation, I conducted a questionnaire survey with 289 firms in America and 110 in Britain.

As I have visited almost all the art collections in London except for those few to which access is not available, I am able to refine the definition of what constitutes a 'corporate art collection' for the purpose of my survey in order to make it historically meaningful as a cultural phenomenon. In America, an art collection would qualify as such if the number of art works is not less than 100 pieces or if there is a full-time curator in charge of the collection. The different size of the British economy means that the criteria have to be modified for UK companies; here I lower the limit to 50 works provided that the collection contains a certain number of substantial works. And at the time of my survey, unlike their American cousins, none of the British companies had a full-time curator, with the result that this particular criterion could not be valid for British companies. The discussion that follows will be based on observations from my visits, from (mostly taped) interviews and from the survey.

Visits to corporate art collections afford an archaeological introduction to how the art works actually function within the corporate ambience. Entering a sleek modern corporate office, the observer is likely to be overwhelmed by the grandeur of the magnificent pieces hung on the wall in the reception area, a practice especially favoured by American companies, whose buildings with their enormous (three- or four-floor high) atriums make it possible to display and valorise art on such a grand scale and use it to overawe the impressionable visitor. The concentration of so many economic activities within the 'square mile' of the City of London, and the fact that buildings do not enjoy the same possibilities of vertical extension that the skyscrapers in a metropolis such as New York City confer on corporate headquarters, mean that most British companies have to be satisfied with relatively modest office space and thus correspondingly modest art works in their entrances and reception areas. An exception must, however, be made for those giant multinationals whose operations far transcend national boundaries and geographical limitations. The

practice of up-marketing the look of corporate offices is not limited to art works in the accepted sense of the term. Off the reception-area coffee tables have come trade journals such as *Forbes* or *Fortune*, and on have come the glossy monographs of fashionable blue-chip artists or those in the company's own art collection. This phenomenon was particularly noticeable and popular among the law firms that I visited in Washington, DC, in 1990, though somewhat less so in London.

In New York, the corporate hierarchy is expressed by means of an architectural code. The chief executive is housed in splendour on the very top floor of an impressive tower-block, with wide widows revealing breathtaking views of the Manhattan cityscape and Hudson River. Enveloped within this privileged space, art works, having no more aesthetic presence than wallpaper, are appropriated to the task of reinforcing the ultimate hierarchy of the corporate ladder, displayed in places where they are meant to be glimpsed by busy executives and their wealthy clients who come there to conduct business. Whereas in London the corporate hierarchy is not expressed through physical verticality, it is still the case that the chairman's office and the executive floor have the best, which is to say the most expensive, pieces in their immediate physical environment.

BANKING ON ART

By the 1980s self-styled financial institutions such as banks or insurance brokers were believed to be the most active corporate buyers of art. While financial institutions represented 66.7% of the British companies in my survey that started their collections before 1980, the corresponding percentage for American companies is 41% (see Tables 8.3 and 8.4). However, these percentages, like those presented by others before, are relative. Statistically speaking, we know very little about the real percentage of corporate buyers from financial houses in relation to the strength of their position in the economy as a whole, as compared to other industries, especially since the comparison is often made by collapsing a huge variety of different industries within the single category of manufacturing. Nor do we have any precise measure of the extent of the participation of any specific sector in the art market.

Table 8.3
Percentage of corporate art collections from all business sectors by decade (US)

Business types	By 1960		By 1970		By 1980		By 1990	
	Number of companies	Percent of total	Number of companies	Percent of total	Number of companies	Percent of total	Number of companies	Percent of total
Financial services	5	41.7	8	38.1	16	41.0	24	36.4
Publishing/media/PR	2	16.7	3	14.3	4	10.3	6	9.1
Legal services/accountancy/real estate	1	8.3	4	19.0	5	12.8	13	19.7
Utilities/energy/transportation/freight companies/hotels	—	—	1	4.8	2	5.1	4	6.1
Manufacturing	4	33.3	5	23.8	11	28.2	17	25.8
Hospitals/medical services	—	—	—	—	1	2.6	2	3.0
Total	12*	100.0	21†	100.0	39‡	100.0	66§	100.0

Notes:

* missing case: 0 † missing case: 0 ‡ missing case: 0 § missing case: 0

The total valid responses for this analysis are 67, including one collection started in the 1990s. If this collection is included, the percentage for each business type up to the time of the survey (April 1993) would be: 34%, 8.7%, 23.2%, 5.8%, 24.6% and 2.9%. Rounding results in column 9 not totalling 100%.

Table 8.4

Percentage of corporate art collections from all business sectors by decade (UK)

Business types	By 1960		By 1970		By 1980		By 1990	
	Number of companies	Percent of total	Number of companies	Percent of total	Number of companies	Percent of total	Number of companies	Percent of total
Financial services	4	66.7	9	69.2	14	66.7	16	45.7
Publishing/media/PR	—	—	—	—	1	4.8	1	2.9
Legal services/accountancy/real estate	—	—	—	—	1	4.8	7	20.0
Utilities/energy/transportation/ freight companies/hotels	—	—	—	—	—	—	2	5.7
Manufacturing	2	33.3	4	30.8	5	23.8	9	25.7
Hospitals/medical services	—	—	—	—	—	—	—	—
Total	6*	100.0	13†	100.0	21‡	100.0	35§	100.0

Notes:

* missing case: 0 † missing case: 0 ‡ missing case: 0 § missing case: 0

The total valid responses for this analysis are 38, including another three collections started in the 1990s. If these three collections are included, the percentage for each business type up to the time of the survey (September 1994) would be: 50.0%, 2.6%, 18.4%, 5.3%, 23.7% and 0.0%. Rounding results in column 7 not totalling 100%.

The high percentage of financial firms engaged in art collecting should, however, come as no surprise. Whether we see it in terms of a post-industrial economy or late capitalism, one of the most marked characteristics of Western economies in the post-war period is the rise in importance of the so-called 'service sector', in which financial houses occupy the most central position in the overall economic structure. This can be explained in at least two ways. First, in contrast to the earlier period of capitalism when propertied enterprise families played an important role in the economic structure, accumulating capital either individually or as a family, the dominant trend has been the increased concentration of share ownership in institutional investors, that is, financial houses including insurance companies, pension funds, investment companies and bank trust departments. As of 1979, for instance, about 70% of the stock traded on the New York Stock Exchange was owned by institutional investors.[31] In Britain, the concentration is also marked. These financial intermediaries owned about two-thirds of the shares of British companies in the late eighties.[32]

Figure 18 View of dealing room in an international financial institution featuring Annabel Grey's *Hanging Panels on a Railway Theme for the Dealing Room*, ink on raw silk, acoustic screens, London.

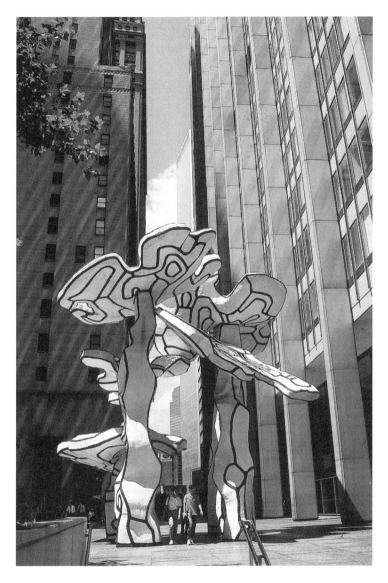

Figure 19 Jean Dubuffet, *Group of Four Trees*, 1972, fibreglass, aluminium and steel, 42′ high, Chase Manhattan headquarters, Wall Street, New York.

Second, by virtue of occupying a central position in the control and cir-
culation of capital, financial firms are the locus of power in the contemporary
British and American economies. Through controlling money and credit in
their lending policies to other businesses, they are in the hegemonic position
of being able to exercise power over other individual firms, industrial sectors
and even national economies.[33] In other words, they are not only the big
creditors of other corporations, but they also own and administer those
companies either through share ownership, or through the business ties
established by interlocking directorships between the financial institutions
and the top management of other industries. By virtue of this position of
centrality, financial firms (and those who lead them) are in a position to make
choices that not only impinge directly on the national economy, but also,
though less visibly, impact on national culture.

But the centrality of financial firms in the British and American
economies cannot of itself explain the important role that they played in art
buying during the eighties. With their sharp eyes on speculation, it is only
reasonable to assume that the financial houses did not lose sight of the
unprecedented and sometimes erratically increasing growth in art prices.
The longest bull market in art for the last three centuries stretched from
1940 until 1986 or so,[34] culminating, as it did, in the astronomical sum of
£24.75 million paid for Van Gogh's *Sunflowers* at Christie's in London in
1987, and the $53.9 million paid for his *Irises* at Sotheby's in New York in
November of the same year. The inflation of prices on the art market was
such that in the late eighties Salomon Brothers placed Old Masters paintings
(with a staggering one-year return of 51%) at the top of their annual com-
pilation of rates of return for 13 different asset categories.[35]

This is not to suggest, however, that the rates of return on art investment
are so uniformly high that financial firms are in fact buying art purely for
investment. In reality, the rate of return on art varies according to a whole
set of variables such as the reputation of the artists or the year in which it is
sold.[36] What sort of return a collection of contemporary art can bring for
financial houses is, however, a difficult issue to determine, especially as the
period under consideration is too close to be representative, and the very few
studies carried out by economists on art investment have not yet been able
to provide any precise analyses. The fact remains that, according to William
N. Goetzmann, there has been a high correlation between art and the stock

and bond markets in the twentieth century, and returns from the sale of paintings have rivalled the stock market in the second half of the century.[37] The extent to which the art collections held by financial firms can be seen as investments will be ultimately put to the test if and when they actually sell off their collections. The chances of this happening, however, are remote, not only because of the high transaction costs that would be involved, but also because it is clear that art in their hands does indeed serve other purposes than straightforward investment, an issue to which we shall return below.

Accordingly, the financial sector remained the main force in corporate collecting in the 1980s, and has continued to be so since. In Britain, this represented 45.7% of companies in my survey, and 36.4% in America, with the percentage remaining fairly constant over the last few decades (see Tables 8.3 and 8.4). Publications on the topic invariably mention this group of buyers. In *The New Patrons*, for instance, a catalogue to commemorate the exhibition on corporate collecting of the same title in Britain in 1992, half of the contributing lenders were from the financial sector.[38] More precisely, almost all of these companies had their headquarters within the square mile of the City of London, the financial heartland of Britain with its enormous wealth and unique financial dominance.

ART IN LEGAL AND ACCOUNTING CIRCLES

These financial 'high-flyers' actually share the stage with three different groups of 'new-style' patrons. Most notable among these are legal and accountancy firms. This group of British patrons represents 20% in my survey and 19.7% for American companies (see Tables 8.3 and 8.4). The seriousness with which these firms took to art collecting was such that one of them in Washington, DC, went as far as to proclaim in its press release announcing an art exhibition at its head office: 'Art at Arnold and Porter is *part of the practice* [italics added].'[39] And the extent of their holding was such that one journalist could pun by interchanging the names of lawyers and artists as if the law firm were indeed an art museum. To quote Nancy Zeldis: 'It is easy to mistake the 23rd through 28th floors at One New York Plaza for the Fried, Frank, Harris, Shriver & Jacobson Museum of Contemporary Art. That title may seem as unlikely as a law firm called Rauschenberg, Motherwell, Lichtenstein

Figure 20 Reception lobby of law firm Fried, Frank, Harris, Shriver and Jacobson, Washington, DC, featuring Martin Puryear's *In Winter Burrows*, 1985, tinted pine, 74″ × 127″ × 1¾″.

& Schnabel.'[40] Similarly, in Britain, it was reported that, for professional firms in the mid-eighties, 'getting into art was as easy as bringing out a new glossy brochure. Every self-respecting firm with a fashionable client list to impress was at it.'[41] It is no wonder that, by the end of the eighties, such household-name accountancy firms in London as Coopers & Lybrand, KPMG Peat Marwick, Ernst & Young, Arthur Andersen and Price Waterhouse had all jumped on the bandwagon of art collecting.[42]

As we have seen, the competitive edge of the deregulated free market unleashed in the eighties altered the practice and the nature of these professions, in particular in Britain. Although one can argue that the degree of competitiveness in this particular sector is probably no more severe than that in others, the fact remains that lawyers and accountants, as producers of services, have a direct and close contact with their clients in a way that, for example, a company producing household goods will never enjoy.

Intimate contact of this kind with clients has made these professions particularly conscious of the image of the firm, especially the physical impression made on clients when they first visit the office. When asked to explain the purpose of the collection, an office services supervisor of a law firm in London stated:

> I would say the purpose is for the public image of the firm. . . . They want to get away from the old-fashioned image of the lawyer. Do you know what I mean? Sitting there in his office, with old prints on his wall, that's finished. Now it's the corporate, big business, big deal. . . . We have a lot a lot of people coming in. . . . It's very important that they come in and they are always very impressed.

Moreover, most law and accountancy firms are owned by partners, as opposed to a corporation's faceless shareholders. Since they have to dig into their own pockets to pay for art purchases, and since their personal fortune is thus more at stake in the appreciation or depreciation of art works, their decision to enter the circle of collectors is all the more impressive and revealing.[43] Two highly publicised collections in London are, for example, those owned by the accountancy firms Arthur Andersen and Coopers & Lybrand, both among the top five accountancy firms in Britain.[44] Although the Andersen collection was started in the late sixties, it was when the firm employed its first curator in 1984 that an aggressive streak was added to its collecting policy and the collection itself took on a new significance. As its then curator Glenn Sujo boasted: 'It is a museum standard collection and is not just there to beautify the building.'[45]

ART AND MANUFACTURING

The second group of art buyers is formed by the manufacturing sector, including retailers, producers of food products and petroleum companies. Unlike the service sector, where companies have direct contact with clients, manufacturing industries face a multitude of 'anonymous' consumers. In some cases they even have captive customers. For instance, the products of the pharmaceuticals giant Glaxo in Britain are mostly available only on prescription.[46] Lack of direct consumer/provider contact also categorises the

Figure 21 Hospitality room of international manufacturing firm, London, featuring William Tillyer's *English Landscape*, 1986.

conglomerates that dominated the corporate landscape in the eighties. This corporate structure, which fed on the eighties deregulated market of mergers and acquisitions, could, as in the case of Pearson in Britain, for example, combine such diverse business interests as publications, the tourist trade and fine china. In America, the Philip Morris Companies, for instance, not only make their huge profits on tobacco, but also own companies that produce a wide range of consumer goods such as Maxwell House coffee, Philadelphia cheese and Milka and Toblerone chocolates. No ordinary customer, either in the UK or America, is likely to be aware of this sort of conglomerate marketing.[47] Nevertheless the need to keep the company's name in the minds of the major markets cannot be underestimated. As consumers grow more sophisticated, so they are able to interpret consumer brands as part of a wider complex of company ownership, and it cannot be long before they become aware of what insiders refer to as the 'meta-brand' of the parent company sheltering behind the multiplicity of different brand names.[48]

Although manufacturing companies as a whole may not be as active on the art market as financial houses, the collections owned by the giants in this sector, such as Joseph E. Seagram & Sons and the Gilman Paper Company in New York, and ICI, BOC and Unilever in Britain, are widely known and acclaimed (Plates 6 and 7). This is of course more a reflection of the financial strength of these companies than anything else. In particular the collections in New York are on a much larger scale and more sophisticated in type than those in other cities in America, and they provide an important role model for latecomers to the art market to emulate. First of all, the corporations headquartered in New York are generally the leading companies in their respective sectors. By virtue of their economic superpower, it was these companies that pioneered art collecting at a time when the price for the artists of the fifties and sixties was relatively low. Today these collections, which often comprise thousands of works, have a more intensive holding of works by 'blue-chip' artists than those formed in the seventies and eighties.

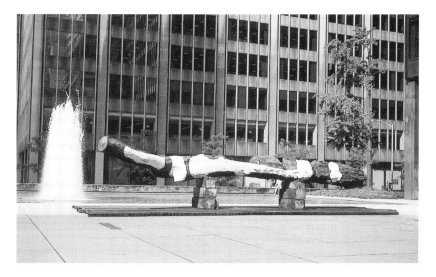

Figure 22 Sculpture display in front of Joseph E. Seagram & Sons, Park Avenue, New York, 1990.

What qualifies them for inclusion in the league of what I refer to as 'the new patrons' is, however, not the sheer size of their collection, but the concerted way in which they utilised their collections to emulate the practice of art museums during the eighties. For instance, Joseph E. Seagram, having started collecting in 1957 and having by the seventies established an art department staffed by full-time curators, organised art exhibitions at what they call the 'Fourth-floor Gallery' at their New York headquarters, and exhibited sculpture on the wide plaza of their landmark building designed by Ludwig Mies van der Rohe. Acting as if it had become a museum in its own right, the company also toured part of its collection to several cities in Canada, completing the exercise by publishing its own catalogue, a theme to which we shall return later.[49]

Similarly, Unilever, ICI and BOC were all industrial blue-chip companies in Britain, and their art collections, while nowhere as big as those of comparable companies in the US, were well located on the exclusive art circuit with their contingents of professional cognoscenti. The collection at Unilever, which had started to purchase contemporary British art in 1980, had over 300 works by 1991,[50] culminating in a catalogue with the grand-sounding historical title of *Unilever House London Contemporary Art Collection: the First Twelve Years*. In the introduction to this catalogue, Unilever was praised for '[keeping] abreast of the changing climate of the 1980s in the development of British art.'[51]

Although the TI Group art collection was not actually initiated in the eighties, it does provide an insight into the ultimate relationship that corporate art collections sometimes have with the Conservative government. 'Recognising the importance of supporting young artists and strengthening the link between industry and the arts,'[52] TI sponsored its own Group Scholarships at the Royal College of Art in late 1992, a scheme that won it a £20,000 cash award from the BSIS, which had originally been established by the Thatcher government. As part and parcel of its association with the Royal College, TI started its own art collection, with the aim of 'selecting paintings by promising young artists, either graduating or past students from the Royal College of Art, and following their work as they develop over the years'.[53] The significance of the BSIS for the Group art collection is explicitly recognised by its inclusion of a reference, on its collection post-card pack, not only to the award as such, but also to the fact that 'The BSIS

is a Government Scheme.' This is in some ways tantamount to claiming political validation for the company's decision to enter the art collecting market.

ART AND PROPERTY

The third group of patrons consists of property developers.[54] As one American writer boldly proclaimed in 1987: 'Art has become a hot commodity in development projects, and many developers now perceive it as a necessity.'[55] While the trend in Britain was not as pervasive as it is in America, where the NEA had been in the forefront of advocating 'art in public places' since the 1960s, there are many reasons for making developers into a special category of art consumers in both countries. First of all, whether it be in America or in Britain, the motivation of developers to enter the field of art patronage is first and foremost for sales purposes, a motivation that the title of a *New York Times* article tellingly spells out: 'Marketing real estate with art.'[56] This is despite the fact that, as a recent empirical study has pointed out, art provision in property development does not actually add short-term value to the buildings in terms of an immediate increase in rental income. It is, however, perceived to be connected to the incremental marketability of a development, the rewards from which are seen in terms of 'ease of promotion, and a greater speed of letting or disposal'.[57] Unlike other social facilities, such as health clubs, shopping centres or restaurants, which have a measurably functional impact on a development, art displays are part of a wider strategy of what could be termed 'quality' enhancement for a development. By displaying what seem to be functionless objects in an apparently disinterested way, real-estate entrepreneurs are actually capitalising on the high social status that comes with the possession of 'art'. The value of the art objects that they are exploiting comes from a socially constructed perception in which judgements of utility play no part. (Plate 8)

This is particularly true of the two outstanding speculative office developments launched in the 1980s on each side of the Atlantic, that is, the Equitable headquarters in New York and the 29-acre Broadgate Development near Liverpool Street Station in London. The construction of

the latter, described by Margaret Thatcher when she inaugurated the Broadgate complex in 1985 as the largest development in the City of London since the Great Fire of 1666,[58] was only made possible for the developers, Rosehaugh and Stanhope, by the easing of planning restrictions in the City of London in the mid-1980s. This coincided with the prospect of a large increase in tenant demand following the deregulation of the financial markets, and with the easy availability of credit to finance new building projects. Despite differences in scale, Equitable and Broadgate share many common features, one of which is their both being situated in socially diverse areas of the metropolis where affluence and poverty are only a few streets apart. To rescue their properties from the undesirable associations of their environments and to raise the status of the neighbourhood, the developers had to do everything in their power to present a new up-market image, and here art works naturally had an important role to play. (Plate 9) The success of Broadgate invites parallels with the Rockefeller Center in New York.[59]

Figure 23 Ludgate Development, London, featuring sculpture by Steven Cox, 1994.

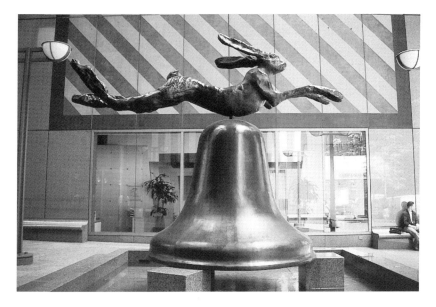

Figure 24 Barry Flanagan, *Hare on Bell*, 1983, bronze, at Equitable, New York.

The majority of works invested in by developers for siting in commercial and industrial developments are sculptures, an art form not favoured by most business collectors. Despite the fact that the number of works owned by these developer patrons is much smaller than those in company collections, their monetary value is immense. The dozen or so sculptures in the Broadgate Development, for instance, are reported to have cost the developers £1 million, far exceeding the initial budget that any British company had spent on art purchases.[60] Similarly, as we have already seen, the art commission at the Equitable Life Assurance Society in New York was reported to have cost the company $7.5 million.

'Big money' is not, of course, the only point that matters here. It is the visual impact that these sculptures, along with their architectural settings, make on the fabric of the urban landscape that constitutes their true and lasting value. As a function of the need to make a 'quality' statement on the

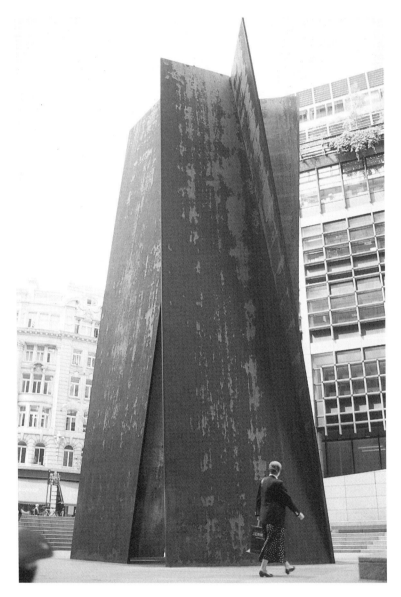

Figure 25 Richard Serra, *Fulcrum*, 1987, off Eldon Street, Broadgate Development, London.

location where they are sited, these sculptures are, more often than not, striking above all by their scale, by their sheer physicality and high visibility in such an unlikely setting as an urban centre. Their vast physical presence holds office commuters as captive spectators. For instance, one cannot possibly pass Richard Serra's overwhelming *Fulcrum* without being forcibly struck by its five huge rusty sheets of steel, each 60 feet high, straddling one of the exits from Liverpool Street Station.

Last but not least, the art objects purchased by developers, unlike those in corporate collections where works are privately displayed in offices, are on 'public' display. But, unlike the sort of public art advocated by public art agencies, art works in real-estate developments are not 'public' in the true sense of the word. Despite the claim made for them that they are 'accessible for public viewing', not everyone has equal access to them. In some instances only privileged individuals prove to have access, as in the case of Howard Hodgkin's *Wave* mural displayed in the Broadgate Club at the Broadgate Development. Moreover, public access is often illusory insofar as the objects are actually displayed on 'corporatised public' space where round-the-clock surveillance operates through hidden electronic systems and the constant presence of security guards throughout the complex.

Beyond these three groups of patrons, there is another phenomenon that is worthy of passing note in the present context. As metropolitan cities, London and New York have a large number of resident foreign companies. These subsidiaries or branches very often possess an art collection if their parent companies back home are themselves active in art collecting. The way in which they operate is a function not of their locus but of their origin. This is especially true in the case of American firms with branches in London. Their collections are determined less by any British context than by policies originating from their parent companies, all the more so in the case of American multinationals, which first started the trend of art buying in the United States. As American multinationals globalise the world market, so they export their concept of corporate art collecting. Collections of overseas companies originating from America will reflect above all their own country of origin, with the result that such art collections take on an additional cultural dimension, that of expressing and displaying national pride and identity in foreign environments. Business art, though often self-serving, can also find itself playing an ambassadorial role.

WHY DO COMPANIES BUY CONTEMPORARY ART?

THE ROLE OF THE CORPORATE ELITE

Among the companies that I personally visited, the chief executive or chairman, or, in the case of professional firms, the senior partner(s), was the pivotal figure when it came to the initiation of art collections. In my survey, the personal interest of these top management executives in launching a corporate art collection is confirmed by the exceptionally high ranking given to executive personal initiatives: 85.7% of American companies and 89.3% of their British counterparts grading this particular consideration as 'fairly/very important' (see Tables 8.1 and 8.2). The significant role that the corporate elite plays in corporate collections is further confirmed by the fact that it is also they who are often the decision-makers when it comes to actually purchasing the works. A total 62.3% of American companies in the survey and 65.7% of British companies reported to this effect. These individuals in the top echelons of the company are often reported, both in the press and in the interviews that I conducted with the company staff, as having a great personal passion for art. Despite the many demands and pressures of their administrative timetables, they find time to visit galleries, artists' studios and the principal auction houses, where they sometimes personally make their company's purchases. To quote two of them:

> I say 'we' started to buy works of art; I mean that I did, since I was appointed to a one-man committee to do it.[61]

> I do enjoy contemporary art and have great fun with it. It's rather pleasant relief from the other activities one gets up to here.[62]

Similarly, a managing partner of a law firm in Washington, DC, who is enthusiastic about his own efforts at creating the firm's art collection, described his involvement as being due not only to his position, but also to his 'love of art':

> If I don't enjoy doing it, I probably will delegate someone else to do it. You have to put yourself into it. I enjoyed meeting Ms X [their art consultant] and talking to her.[63]

It may seem surprising, at least on the surface, that a senior manager should be so personally involved in collecting, especially if we compare his five-figure art budget with his duties of overseeing a business venture worth, in some cases, billions on the stock market.

The advocacy of these high-powered men in a company's foray into art collecting has, however, to be considered within a wider context, that of the way in which, as capitalism develops, high culture functions in society. The 'alliance between class and culture', as Paul DiMaggio described it, still, of course, continues,[64] with the modification that, in recent decades, especially the 1980s, this alliance has increasingly become one between business and culture, with the spending power of corporations replacing the wealth of members of the upper classes as high culture's leading patrons.[65] The new company patrons of the 1980s occupy a curiously intermediate position within the development and transformation of family capitalism into institutional capitalism, and find a somewhat anomalous place in the uneasy coexistence of the two within the business community today.[66]

No better example of the transitional phase of this transformation can be found than in individuals such as David Rockefeller. Being in charge of the Chase Manhattan Bank for almost three decades until he retired in 1981, he was at the centre of the financial arm of the Rockefeller empire, a family fortune made by his grandfather John D. Rockefeller in the Standard Oil Company in the nineteenth century, which by the 1880s controlled nearly 90% of the nation's oil production. While David Rockefeller epitomises the great entrepreneurs of the past, he was, at the same time, able to initiate a corporate art collection for the bank in 1959 by virtue of his position at the apex of the Chase Manhattan Bank. Many critics see this as a decisive turning point in the history of corporate art.

The majority of the chairmen/chief executives who figure in this study are, however, essentially different from Rockefeller in not having the benefit of enormous inherited wealth behind them. They are professional managers, or what John Kenneth Galbraith calls 'industrial bureaucrats', the product of what is commonly referred to as the 'managerial revolution', and their aspirations for the companies under their control to become art patrons are therefore realised more through their corporate position than through family lineage. This is not necessarily to suggest that they are not the dominant class in British or American society, or that their interests are always distinct

from those of the capitalists, as the theory of managerialism posits.[67] The upper managerial echelons are, and have continued to be, peopled by an economically privileged class whose wealth gives them also social and educational prominence in both countries. A classic example of this is Sir Nicholas Goodison, who single-handedly started an art collection at the former TSB, the sixth largest UK bank, when he became its chairman in 1989.[68] Sir Nicholas is not an up-from-nowhere achiever, of course. Born into a banking family, he had worked at the family firm, Quilter Goodison, between 1958 and 1988[69] while at the same time holding several directorships of other prominent concerns, including the top prize of the chairmanship of the London Stock Exchange (1976–88) before he joined the Bank.

What makes the case of Nicholas Goodison particularly interesting are the several other hats he wore in the art world, showing a rare versatility that the arts correspondent Antony Thorncroft encapsulated when he described him as 'an unregenerate arts committee man'.[70] His other hats included the chairmanship of the Courtauld Institute of Art (from 1982), that of the National Art Collections Fund (from 1986), and the directorship of the English National Opera (from 1977 to 1998). Writing about his company's art collection, he chose to entitle his article 'Art is Life'.[71] Such grandiloquence may well, of course, accurately reflect Sir Nicholas's personal philosophy of life, but it succeeds at the same time in masking a remarkable conflation of the private and the corporate, an appropriation by an individual of the sort of high-sounding rhetoric that no collective corporate body would dare to use to justify its ambitions in the art world.

On the institutional level, a corporate art collection represents a desire on the part of a company to claim an active part, as a distinct and recognisable entity, in the cultural life of contemporary society. Alex Bernstein, chairman of the Granada Group in Britain, acknowledged as much when he said: 'I believe that companies have some obligation to take over the role of private patronage.'[72] Just as importantly, if more subtly, these chairmen/chief executives, being on an individual level the guiding hands behind their company collections, have also been able to appropriate the social status and value that come with being the head of a company that invests seriously in art, what Pierre Bourdieu refers to as 'cultural capital'. Elaborating the concept extensively in his *Distinction*, Bourdieu held not only that cultural capital is

freely interchangeable with economic wealth, but also that the accumulation of cultural capital serves specifically to reproduce and consolidate the position of the dominant class. The parallel relationship between a corporate art collection and its company, and between the collection and its chairman, makes it clear that the launching of a corporate collection entails much more than satisfying the personal whim of the chairman, since what is created is also a specific social statement, an attitude to be seen by the public and operating in full public gaze. The cultural edge that their corporate position earns them means that, in some cases, as these highly mobile and powerful chief executives move from company to company, they start collecting art wherever they preside.

RELOCATION OF FIRMS

Despite the often profound personal involvement of the chairman or chief executive in them, corporate art collections are presented as collective activities of the company as a whole. The most determining factor that induces companies to venture into art collecting is the relocation or renovation of their headquarters. In my survey, 79.4% of American companies and 62.1% of British firms cited this as a 'fairly/very important' reason for their launching their art collections (see Tables 8.1 and 8.2). The building spree of the 1980s' property boom, especially in Britain at the end of the decade when there was an over-supply of offices, saw more and more companies moving into new purpose-built office developments. In terms of physical space, there is a fundamental difference between New York and London. London has the highest concentration of company headquarters or head offices of foreign firms, despite the fact that space in London, unlike the rational rectangular sites of New York or Washington, DC, is determined and limited by historical accident, and can expand neither horizontally, for physical reasons, nor vertically, because of the constraints imposed by planning requirements. The lack of space is particularly severe within the square mile of the City of London, which boasts by far the largest number of domestic and foreign banks of any city of the world. What this means is that whereas the New York collections can afford to go in for exceptionally large canvases, in keeping with the trend of contemporary art, the scale of

works bought by their British counterparts tends to be considerably smaller. Only high-profile office buildings, such as the Broadgate complex, built during the eighties' property boom, have the sort of large atrium and office spaces that lend themselves particularly well to the display of impressive, large-scale art.

Moving office is an infrequent but significant decision for any company and provides a fitting opportunity to refurbish the firm's corporate image, which can only be enhanced by its choice of a prestigious building. Relocation always entails a huge budget for the purposes of decorating the new offices, and here art is considered as an essential component of space furbishment. Out go the fusty architectural prints and legal cartoons; in come the large bright paintings. As Harry Anderson, the partner responsible for the art collection at the London law firm Herbert Smith when it moved to Broadgate, was reported to have observed: 'We were trying to produce an uplifting environment. It sounds a bit pompous, but that's what we were trying to do.'[73]

ENHANCING THE WORKING ENVIRONMENT

The most often cited purpose of art collections is to enhance the working environment, for the benefit of the staff as well as of the clients. To quote different companies' own words:

> Windlesham houses an art collection to enhance the visual quality of the building for those who work in it.[74]

> Give staff, customers and visitors an opportunity to experience art in a business environment[75]

> . . . by displaying work from our collection, we bring enjoyment to our clients and employees, and we enrich our corporate life.[76]

However, these statements of objectives, often made with public consumption in mind, say nothing about how the staff really perceive the collection. Nor did any real evidence to support these claims come to light during my

65 or so visits to company premises in the two countries. The casual conversations that I had with employees lower down the corporate hierarchy more often than not showed the contrary, despite the fact that senior managers who initiated the collections were more than enthusiastic to show me around. The staff, buried beneath piles of papers, were much surprised to see an outside visitor busy taking notes and photographs of art works to which, despite their daily contact, they themselves felt indifferent. Uninhibited by the presence of a tape-recorder, they expressed their opinions more freely than they would have done in structured interviews.

The fact that contemporary art has been removed from the white and blank walls of art museums and placed in the more 'congenial' surroundings of corporate space does not necessarily make it any the less difficult to appreciate, or even demystify it, for people who are not at home in the art world. One secretary commented that she could put up with the work in front of her only because she could see her boss approaching from his reflection in the painting's glass. Another, commenting on a series of minimalistic works in front of her, ventured the opinion that she could have done just as well herself. In some cases the view of the works is actually obscured by filing boxes. Lack of appreciation is not limited, of course, to secretaries. A London banker, whom one might not have expected to have had such outspoken views, gave the following appreciation of his firm's collection:

> The money which we have spent on our many pictures has been largely wasted for the tastes of the more conservative employees (myself included). Modern art abounds and it does not really say anything to us and certainly does not cheer us up! Many of us have taken to pinning up our own pictures which we like, to give us something aesthetically pleasing.[77]

As a matter of fact, art in offices can be said only to reinforce the corporate hierarchy; the higher one is on the corporate ladder, the more expensive pieces one gets in one's office, except for more public areas such as the reception lobby where the choicest pictures are naturally hung. Not every company will rehang paintings elsewhere if an employee happens to dislike them. One office manager observed: 'If they don't like it, tough!', while the chief executive of a financial firm stated: 'The painting's where it looks best. No. It stays there.' From an employee's point of view, art works in the office

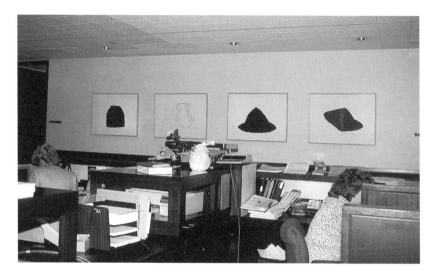

Figure 26 Office at law firm Fried, Frank, Harris, Shriver and Jacobson, Washington, DC, featuring four lithographs by Joel Shapiro, *Untitled # 6, 7, 10, 11*, 1979–80, 22″ × 30″ each, edition of 30.

serve at best as 'conversation pieces' for casual chats. Works by Georg Baselitz in one London bank, for example, always invite comments from visitors such as, 'Oh, your pictures are hung upside down.'

ART AS INVESTMENT

Considering that financial houses with their keen eyes on speculation are the predominant buyers on the corporate art market, it seems surprising that so few companies actually agree that investment is an important factor in launching an art collection. In the survey, only 14.3% of American companies and 10.7% of British companies admitted that investment is a 'fairly/very important' factor (see Tables 8.1 and 8.2). It is, however, paradoxical in a world of profit-making that firms should be so keen to disassociate their collecting from the money-making process to which they are professionally devoted. One of the firms in Washington, DC, was ready

to deny that its collecting had any investment incentive behind it: 'We've never purchased art as an investment, but rather for the beauty and interest it adds to our workplace.'[78] Half of the firms visited in Washington, DC, admitted investment as being one of the purposes of their collections. But they were quick to qualify it as one factor, and not the only or the primary reason for their collecting art works.

However, inflated prices in the art markets of the eighties were certainly not lost on corporate art buyers. An article in *Fortune* succinctly entitled 'The Big Payoff in Corporate Art' quotes the example of a Gilbert and George photo-collage bought by the First Bank System in Minneapolis for $10,000 in the early eighties and which had appreciated in value to an estimated $35,000 a few years later.[79] It is true that dealing in contemporary art is a much more risky undertaking than trading in old masters, and the British Rail Pension Fund's collection, the only collection in Britain set up purely for investment, has not been willing to take the risk of buying contemporary works.[80] But the other side of the coin is that when rates of inflation are running high, art does indeed provide 'reasonable prospects for long-term capital appreciation, at least equal to inflation'.[81] In fact senior managers often express their views on art as investment in somewhat defensive terms:

> They [works of art] were not intended as an investment, although they have turned out to be rather a good one.[82]

> If you ask me personally whether or not I think in ten years it [the collection] will be worth more money than we paid for it, I think it will. But if you start thinking of paintings as an investment, well, I don't.[83]

The utility of art as investment is also underscored by the fact that, while the sort of 'decorative' prints that businesses such as hotels or motels used to purchase will not retain their purchase value, a collection of fine art certainly will. As Frank Carioti, curator of Standard Oil of Indiana's collection, put it when explaining why its collection turned out to be a 'wise investment':

> So-called 'decorator' art is virtually worthless from the moment it's hung on the wall. Fine art has immediate resale value and will probably appreciate in value in time.[84]

IMAGE MAKING

Even if art were ever to underperform on the market, its attraction as a status-conferring object is perennial. The connection between art, power and social status has been consistent since the Renaissance, and it would be naïve to suppose that the role of art in commercial and business environments could be anything other than status-enhancing. As Paul DiMaggio explains: '[Cultural goods] are consumed for what they say about their consumers to themselves and to others, as inputs into the production of social relations and identities.'[85] The title of an article on corporate art in *The New York Times* makes the point even more clearly: 'Projecting an Image – You Are What You Buy.'[86] When ICI, the world chemical giant, completed the renovation of its London headquarters in 1988, it proudly drew attention to its art collection, and the company's glossy brochure boasted:

> We might have chosen safe traditional paintings for this purpose, but we decided instead to capture some of the diversity, challenge and vitality of contemporary British painting, so as to parallel ICI's approach to modern business life.[87]

Marketing the image of an art patron is clearly not the same as a conventional product promotion, which comprises straightforward selling strategies. In a global market of sharp competition where products and services are becoming less and less distinguishable, for a company the only effective means of differentiating itself from other competitors is to have an 'enlightened' corporate image. And art, or the arts in general, is something that is ultimately promotable. As John Hoole states in *Capital Painting*, the catalogue for an exhibition devoted to the City's art-buying companies, in a message directed at corporate non-collectors:

> To those other companies that are not represented here the gallery would like to append a note both of reprobation and encouragement. Some of your competitors have had the insight and flair to recognise the importance of art in the creation of their business image. As Max Bialystock said, 'You've got to have style.'[88]

Even if art collecting can elevate companies above the shabby cut-and-thrust of the business world, collecting contemporary art is no automatic

choice. Not every company is willing to take a risk with contemporary art. Contemporary art does, however, have undeniable appeal insofar as it gives access to the fashionable cult of artistic personality as well as enabling a company to project an image of itself as progressive and innovative. As Roy Chapman, managing partner of the Arthur Andersen London office, commented: 'We have pictures to enhance and enliven the working environment. We are attempting to convey an image that is *contemporary* and *progressive* [italics added].'[89] In London the overall picture is a mixed one. There is, however, a strong bias towards contemporary art, with contemporary art works taking over the boardroom, which used to feature antique furniture and décor. Some established merchant banks, of course, inevitably resist the change, seeing it no doubt as creeping Americanism. In particular in the City of London the old style of business was, and in some quarters still is, conducted on the principle of a relaxed milieu within the old-boy network and the world of gentlemen's agreements.

The essence of this 'brand differentiation', so to speak, is similarly observable in American companies, although by and large they are less concerned with traditions and historical associations than their British cousins. While in some instances long-established (which is to say, more than a century old) law firms continue to display antiques and old prints either to reinforce, or project an image of, their sense of history and stability, collecting contemporary art works is more generally perceived as progressive and forward-looking. To quote a lawyer in Washington, DC:

> We want to have art that is in some way consistent with our vision of the time we are living and the future. We did not want nineteenth-century art; we did not want old prints from England. . . . Many Washington law firms have old prints of horses in England on their walls. Well, my own view is that's boring. No one in our firms, to my knowledge, wants to do that. I think it's a mistake for us to do that.[90]

Nowhere are these 'bankable images' realised more effectively than in the case of First Bank System in Minneapolis, whose contemporary art collection, started in 1980, generated more media attention than any collection of comparable size.[91] For example, it made the headlines when it overrode the objections of the American Legion and the local police and refused to remove

an Andy Warhol print of Mao Tse-tung which it was exhibiting.[92] The master patron of the programme was Dennis Evans, known as a bond-market 'whiz-kid' (he was former president and chief operating officer of First Bank and had also served on the board of Minneapolis's Walker Art Center),[93] and it was he who declared that the programme was started as one of 'several ways to help the ship to deregulate', and 'as symbolic of the bank's aggressive leadership in the newly deregulated banking industry'.[94] Over the decade, the Bank launched a series of art programmes such as *TalkBack*, *Controversy Corridor* and *You Be the Curator* to 'flatten and democratize the power dynamics of people's relationship to art and to each other in the corporate context'.[95] According to the Bank's own Visual Arts Program Manifesto, the Program is

> . . . an organizational transformation tool, an agent of change which acts as a catalyst for the ongoing examination of this corporate culture. . . . We are involved with some of the most provocative artists working today because we believe that only through active engagement with innovative, critical cultural practices can we progress as an organization and a community in the flux of a changing world. . . . We are committed to forging new, more democratic relationships between people and the art of our time.[96]

In the absence of any first-hand knowledge of the bank, it is difficult to judge what this might really have meant for the bank's employees, for example. The fact remains that the bank thrived on an image of being 'controversial' and 'progressive', as a company 'deeply involved in social change'. This policy of espousing the avant-garde no doubt had a certain shock value, but only as long as the phenomenon itself could be contained and was not allowed to offend prevailing susceptibilities. This danger is well illustrated by what happened to the bank's scheduled exhibition *Artside Out*, which it held in conjunction with Film in the Cities, a Minneapolis/St Paul arts organisation. Though the information was censored out of the bank's own publications, the second of the two billboard art shows that it sponsored was turned into a *juried* competition, because the bank balked at being associated with three of the artists, whose works it considered to be 'too controversial'.[97]

Part and parcel of image making is the need to impress the public and to

cultivate some sort of perception of business aspiring to provide Renaissance-type patronage, and it is within this perspective that most companies claim to buy art in order to support living American and British artists. It is true in a sense that most British companies have a British-only buying policy, with companies based in Scotland purchasing only Scottish art or works representing Scottish subjects. The high-profile Robert Fleming collection, for example, is reportedly the largest collection of Scottish art in private hands: 'Our real idea is not just to build up a collection but in some way to foster Scottish art and to try to help some of the younger artists,' remarked Bill Smith, a retired director acting as the keeper of the collection.[98]

Similarly in America, because of the federal system, companies were anxious to demonstrate not only national, but also civic, pride. The 14 collections that I visited in Washington, DC, afforded a typical insight into the situation. With only two exceptions, they were formed in the eighties. Most of the works included were not only contemporary American, but they also had a large percentage of works by local artists, with between 50 to 80% of works originating from the eighties. F. David Fowler, managing partner of the Washington office of the accountancy firm KPMG Peat Marwick, and the driving force behind its art collection, made it clear why one of its purchasing criteria had to be that of the artists concerned working in the greater Washington area:

> For over 80 years, Peat Marwick has been an active partner in the Greater Washington business community. . . . Now we are partners in the arts, as well. Our collection honors the creativity and vitality of the Greater Washington arts community and demonstrates our commitment to the community we serve.[99]

By supporting local artists, businesses are also able to appropriate to themselves historical precedents, claiming, for example, that they are emulating Renaissance patrons and casting themselves thereby as present-day Medicis. While British businessmen are, because of different national sensitivities, somewhat more modest, American businessmen do not hesitate to make use of this sort of historical precedent, not only in the case of top managers, but also as regards the corporation as a whole. The frequency of such historical references in the media is extraordinary: 'Business Brief: Medicis of the Corporate World', 'The Medici and the Multinationals',

'The Modern-Day Medicis', and 'Modern Medicis', to name but a few of many similar eye-catching article titles.[100] Carrying this grand idea to the extreme, the Equitable in New York named its 14 private dining rooms after artists such as Alex Katz, Lee Krasner and Milton Avery, to whose work each room is individually devoted.[101]

This is, of course, so because the significance and achievement of the Renaissance in Western civilisation as a historico-cultural phenomenon have always been somewhat mysteriously canonised in public perception. More obviously exploitable is the Medicis' joint role as bankers and art patrons, with which modern business indulging in the art market can so easily and facilely identify. To persuade other CEOs to emulate the grand style of the Medicis, Herbert Schmertz, director and vice president of the Mobil Oil Corporation, not only drew the parallel but even updated it:

> The Medici were continually under competitive and sometimes military pressure from four other superpowers in Italy itself. Our situation is different only in that it's on a broader worldwide scale. The Medici were in a tough business – cloth-trading and banking – something like Wall Street and the New York Garment District combined. And that sort of commerce was so novel they had to make up the rules as they went along.[102]

Yet, unless we bear in mind the fact that the economic conditions of the artist and his or her artistic production are not necessarily in a cause-and-effect relationship, and unless we take into account the extent to which the economic and political ambitions of present-day corporations differ so fundamentally from those that characterised the Italian Renaissance, we might be liable to mistake corporate rhetoric for aspirational truth. American business, according to Jerry C. Welsh, an executive of American Express, is 'a logical inheritor of America's social and cultural conscience. . . . With our size and power comes the responsibility to seek new avenues to unleash the power of American business in ways which contribute to the general welfare of our country.'[103]

To give preference to local and younger artists is, nevertheless, not just a matter of social altruism, but one of pragmatism also. It is not because American or British executives do not wish to play lavishly on the international art market in the same way as the Japanese, for example, do. The

exorbitant prices for blue-chip artists are such that only very few companies have the resources to play with such high stakes. When asked why his company decided to collect contemporary British art, William Backhouse, chief operating officer at Baring Asset Management, explained: 'Old masters were out of our price bracket, very modern would not have appealed to my colleagues, so we narrowed the field to contemporary British.'[104] By buying the works of young artists, businesses can aim to get 'quality art at reasonable prices while demonstrating civic pride',[105] and at the same time hope that the artists they have in stock may become tomorrow's Van Goghs or Picassos.

The dynamics of this image-making machinery are certainly not limited to merely displaying art works on company premises. Not only has the conventional method of producing a catalogue been exploited to give an aura of permanence and scholarship to the collection, but increasingly art works have been reproduced to enliven the look and enhance the appearance of annual reports and other company brochures. Those dull monochrome annual reports, full of photographs of dark-suited male directors, have been replaced by ones, still of course portraying predominantly men, decorated with splashes of bright colour and abstract shapes (Plate 10). And in the case of Arthur Andersen in London, a full page in a recruitment brochure was devoted to explaining the 10 art works that were lavishly reproduced in it.[106]

LEGITIMISING CORPORATE ART

Yet the mere ownership of art, however much it may contribute to an 'enlightened' corporate image, is not automatically an indication of any particular cultural sensitivity. However lucrative the art market may be seen as being, few companies venture into art buying without taking the precaution of enlisting the guidance of art consultants of some kind. The increase in business buyers during the eighties (in America, since the seventies) has spawned an equal surge of consultants of varied calibre catering for this specific market, what a *New York Times* journalist called 'a cottage industry of art counsellors'.[107] These range from one-man/woman enterprises to companies like Art for Offices in London, whose large warehouse showroom in Wapping displayed works from a collective stable of some 600 artists. In

America, the scale of the phenomenon was even larger and more institutionalised, with trade associations such as the Association of Corporate Art Curators, and the National Association for Corporate Art Management established in the early eighties.[108] Both in America and in Britain, the intensity of corporate collecting is such that the subject has received the accolade of academia and came to form part of some university courses of the nineties.

The members of this art-advice industry who work professionally within the corporate sector are of great significance in that, whether they act as in-house curators or outside art consultants for corporations, they function as gatekeepers, as it were, for business buyers, or what Jack Boulton, former art purchaser for Chase Manhattan Bank, called 'art traffic controllers'.[109] It is a position for which Frances Chaves, curator of the Reader's Digest's collection, claims a privileged status: 'A museum curator has to stand back and wait for the die to be cast. A corporate curator can go out and make art history.'[110] While day-to-day administrative structures vary from firm to firm, the backgrounds of these curators or consultants are surprisingly homogeneous. Like museum curators, they share both academic credentials in art history, very often with advanced degrees, along with equally impressive museum experience. In a report from the mid-eighties, for example, one discovers four corporate curators in Manhattan who received master's degrees from the Institute of Fine Arts at New York University.[111] While academic credentials may not of themselves be a professional qualification, additional on-the-job museum experience certainly is. Jack Boulton, for example, who has a master's degree in Media Studies, not only boasted five years' museum experience as director of Cincinnati's Contemporary Art Center, but he was also a founding trustee of New York's pioneering New Museum, and an adviser to the NEA.

These arbiters of taste, in particular those who have held prominent positions in public art museums, have, by virtue of moving freely between the museum and corporate sectors, transferred to corporate collections the authenticating prestige that they had enjoyed in their positions in public institutions, thereby legitimising corporate collections and giving corporate America a passport to participation in the art world. The original Chase Manhattan art committee, for example, was filled with luminaries from the art world such as Alfred Barr and Dorothy Miller from the Museum of

Modern Art in New York, James Sweeney from the Museum of Fine Arts in Houston, and Robert Hale from the Metropolitan Museum.

Carefully distinguishing itself from other 'up-market wallpaper salesmen or saleswomen', the Contemporary Art Society (CAS) in Britain played a similarly special role in mediating between business and artists, though this was a somewhat peculiar British phenomenon. For a commission fee, the CAS, in addition to its other functions, advised companies on their art purchases in the same way as other consultancies. The CAS's Corporate Art Advisory Service was offered by the Tate Gallery as one of the 'exclusive accesses and services' provided as part of their corporate Partner package, and the Gallery, in its *Corporate Membership Programme* brochure, praised it as giving 'impartial and objective advice on the acquisition, commissioning, installation and maintenance of works of art for the office environment'.[112] But unlike other consultancies, the CAS ran as a non-profit charity, where all the profits from advising companies went back into the organisation to purchase contemporary art for public museums and art galleries in Britain, a position of which its former honorary treasurer, Nancy Balfour, boasted by saying that the CAS had 'a reputation for choosing first-class work for museums'.[113] This semi-public character, as well as the fact of its working in collaboration with the Tate Gallery, gave the CAS political 'clout' and clear advantages over other commercial consultancies, or, as Balfour put it, it 'gives prestige to a business collection'.[114]

This position of privilege, even if unarticulated, is ethically problematic. But it is not exclusively a matter of individuals; American art museums, whose boards of trustees consist predominantly of corporate figures, rarely deny corporate America the opportunity of showcasing their collections under the museum's roof, something that has not happened with any frequency in Britain except for such charities as the CAS or the National Art Collections Fund. As early as 1960, the Whitney Museum mounted a show called *Business Buys American Art*, and similar types of exhibitions followed regularly over the subsequent decades.

What distinguished the eighties-style venture was, however, the active participation of the corporation in the actual organisation of the exhibitions, and an equally uncritical acceptance and willingness on the part of art museums to dance to the corporate tune. Some museums even went as far as presenting wall plaques developed by their host companies for employee

education as part of the shows. The strapline of a *New York Times* article sums up what is really at stake here: 'Seeking exposure, companies take their shows on the road.'[115] In January 1988, the Laguna Gloria Art Museum in Texas (a museum funded in part by the City of Austin and the Texas Commission on the Arts), for example, mounted a corporate show called *Collecting on the Cutting Edge: The Frito-Lay, Inc.*, and boasted in the press release that the exhibition was 'a fine example of what a progressive and enlightened corporate collector can accomplish'.[116]

The Frito-Lay collection, started in 1985, and including by the time of the exhibition some 900 objects, was, according to the company's own publication, a 'provocative collection' centring on the theme 'Contemporary International Humanism'.[117] Not only was the exhibition drawn exclusively from the company's own collection, but many of the wall plaques and other explanatory material developed by the corporation were used at the Museum. The curator of the show, Monica Kindraka, was quoted as saying: 'We wanted to do an exhibition of exciting and difficult contemporary art, something that would be large in impact as well as in size.'[118] Can an art museum possibly achieve the aim of being 'large in impact and in size' with an exhibition of 39 pieces by 21 artists, even if size were in fact a virtue and even if the collection did, as the Museum's overinflated press release maintained, 'read as a veritable "who's who" of the masters of contemporary art'?[119] It is problematic when art museums present corporate collections as possessing a coherent theme, since to do so inevitably involves compromising scholarship and giving a stamp of authenticating approval to works in collections whose commercial value is thereby increased. More problematic still is the fact that museums are increasingly abandoning their traditional role of 'neutral' interpretation and presenting instead corporate collections packaged in the corporations' own terms. These practices, in which art circulates as a common currency for the benefit of museum and corporate capital, have brought the convergence of art and commerce to a new level of intimacy.

THE IMPACT OF CORPORATE PATRONS

By winning consent from museums and taste-makers in the art world, corporations have found it that much easier to gain entrance to the space of

contemporary art, where their presence appears both legitimate and natural. Its legitimation can be demonstrated by the curricula vitae of artists, who will not omit to list their works in corporate collections, and it seems that being collected by a prominent corporation is equally as prestigious as being shown in a public art museum. The power of corporate patronage derives from the simple fact that corporate America has become such a major buyer in the art market since the seventies, and to a lesser extent in the case of British companies, in the eighties. While no systematically collected data on corporate shares on the art market have yet become available, according to Rosanne Martorella's study *Corporate Art* in 1990, its share was well over 50% of the market outside New York, and about 20 to 30% of that in New York.[120] No equivalent figure is available for British companies.

What sort of contemporary art, then, has this new breed of corporate patrons been collecting? At the time of writing, there are no statistics available on the content of the collections themselves. The questions incorporated into my own survey aimed at trying to establish which styles of works were actually preferred seemed to be too demanding for men and women engaged in the hectic world of business. Given the scarce information to hand, the following discussion is based primarily on my own visits to corporate art collections.

In terms of medium, sculptures or other three-dimensional works are the least collectable among corporate buyers, both because of their cost and because of the space required to display them. This is suggested by the remark of Jim Dobkin, a lawyer with the firm Arnold and Porter in Washington, DC: 'contemporary sculpture requires airiness and spaciality, which makes sculpture inconsistent with office efficiency.'[121] Similarly, when asked why their companies do not purchase sculpture, a British chief executive remarked: 'We don't, no, partially because of financial reasons. . . . Secondly, these rooms don't lend themselves to sculpture.'[122] This is not an untypical response. A high percentage of British collections are concentrated in the South East of the country. In the City of London in particular, where space is at such a premium, few companies can afford the American-style atrium and spacious corridors, except in the case of outdoor sculptures owned by the property companies mentioned earlier and those who happen to own outdoor grounds or grand stairways. The issue is further complicated

by security concerns in the City. As one director noted, sculptures were impractical, getting in people's way at times when thousands of people may have to be evacuated from the building.[123]

Sculpture apart, there are some subjects of art that are consciously excluded from the corporate pantheon for reasons of so-called 'taste'. There is nothing new in referring to the conservatism of corporate taste. Except for a few companies that specifically exploit the image of collecting at the cutting edge of art, such as First Bank System in Minneapolis, not all works are deemed acceptable for corporate display. As many as 70% of American companies and 40% of British companies in the survey acknowledged this. When asked to specify what kind of works they considered inappropriate, the range of answers was surprisingly unanimous, in particular those from American companies. In a society as sexually prim, and perhaps, alas, as politically correct, as America, 'naked images' (as one respondent put it) of ladies or gentlemen are definitely denied the privilege of entering the sacred walls of corporate America. Except for a few general statements such as 'anything that does not meet the goals of the specific corporation', in 34 out of the 39 American companies that specified what was inappropriate, nudity was listed as objectionable.

Among the American companies visited, the only collection that had any sort of images representing some hint of female breasts and buttocks was, tellingly, a European bank, and they had been selected by its European president, despite the fact that female staff found them offensive. To quote some companies' written responses:

> We are first in the business of banking so there are not any works which are controversial such as nudes. (From an American bank)

> . . . morbid, extremely depressing, and overly erotic artworks, especially any depicting male or female genitalia or incorporating slanderous images or texts. (From an American manufacturing company)

But any works that may be politically, socially, and in America racially and religiously, controversial are considered inappropriate for display in corporate environments. In the words of some American respondents such works include 'paintings by artist with a "cause"' or 'anything that might "offend

customers"', and it is for this reason that 'decorative works are preferred'. To elaborate further on this, one American manufacturing company remarked:

> The corporation prefer to avoid explicit nudity or works which take an exclusive stance on social or political issues, although this is not a written or iron-clad rule.

British patrons, unlike their American counterparts, seem to be able to endure nudes as long as there is no 'explicit nudity' or providing they are not 'overly sexual', as they put it. Even when some nudes cause controversy, senior managers are able to justify their choice by referring to the precedents of public art collections. To quote one senior executive:

> I believe that most good galleries in this world have paintings of nudes. . . . To say you are not going to have nudes is just as stupid as saying you are not going to have seascapes or landscapes or still lifes.[124]

And perhaps not surprisingly, female nudes are perceived and treated differently from male ones, not least in the City of London, where the whole ambience is aggressively masculine. The company referred to above decided not to purchase a drawing of male nudes by Elizabeth Frink because one of its executives 'absolutely refused to have male nudes'.

Nudity is, however, certainly not a focus of controversy in British corporate collections. There is a higher degree of sentiment, and occasionally resentment, against abstract paintings than against those representing nudity. This is not to say that British businessmen do not buy abstract works at all; a few of them do. Indeed, in one instance, the reason for opting for abstraction was to avoid stepping into any politically controversial areas, as if abstract works were in some way ideologically value-free.[125]

The fact remains, however, that while American companies can be said to show signs of being more tolerant of abstract works, British companies tend to buy figurative works. The profound feeling of unease towards, and sometimes even of being threatened by, abstraction in people who do not possess what Pierre Bourdieu calls 'the code' to decipher splashes of colours and lines is pervasive.[126] During my visits to corporate premises, one accountant in a bank referred to William Scott's works as 'pots and pans', which, he said, could not hang as paintings anywhere but in the staff

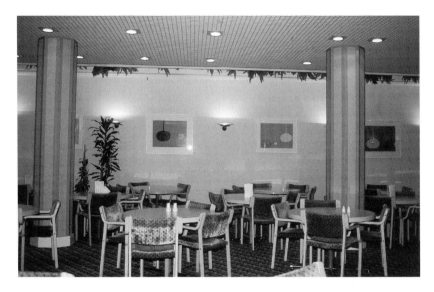

Figure 27 View of staff canteen at international bank, London, featuring works by William Scott referred to as 'Pots and Pans' by staff.

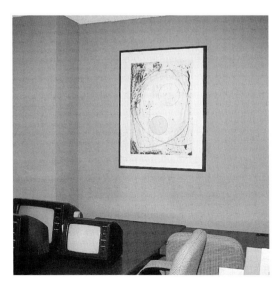

Figure 28 Office at international bank, London, featuring work by Barbara Hepworth referred to by staff as 'Fried Eggs'.

restaurant.[127] Another member of staff in the same bank, a security person, called a set of Barbara Hepworth's prints 'fried eggs, lemon and the moon', and did not consider them to be pictures at all. And even a banker, whom one might expect to have more sophisticated tastes, had this to say about his company's collection:

> . . . facing my desk, I have four differently coloured pictures – part of a series – which consist of vertical lines. This fits the modern style of the building along with the computers, but is overly simple with no overt message. Perhaps they have been chosen to keep us concentrating on our work![128]

Corporate collections, as we have already seen, are primarily shaped by senior managers. The collecting patterns that I am describing inevitably result from the 'tastes' of such people. Thus Edward Adeane, the director responsible for assembling the art collection at Hambros Bank, observed:

> By and large the Hambros collection is representational. I'm not particularly keen on abstract work myself. Also, I suspect that everybody tends to come along and say, 'Why did you buy that?'[129]

But the red tape of corporations can censor anything that fails to perform its public-relations function. For example, when *Cola Wall*, a commissioned collage of metal signage by William Christenberry, was delivered to the law firm Arnold and Porter in Washington, DC, the content of the work caused serious concern to its corporate patron.[130] While there are Coca Cola and Pepsi signs on the work, those of the rival brand 7-Up are not represented, and 7-Up happened to be one of the clients of the firm. The firm was so anxious that it even thought of 'pulling a drape' to cover the painting if its 7-Up client came. Trivial indeed, but, if pushed to its extreme, this attitude shows how corporate custom-made art can inevitably become part of the corporate ethos. A Washington, DC, law firm, for example, commissioned a watercolour, *Table with Correspondence*. It features the dishes, pencils and headed notepaper used in the firm itself, six postcards depicting images of cities where the firm has offices, and a book showing Daumier images of lawyers. In another instance, while not a commissioned piece, a painting called *Portrait of Two Accountants* was hung in the corridor of an accountancy

Figure 29 Office at international accountancy firm in Washington, DC, featuring Leslie Kuter's *Portrait of Two Accountants*, 1998, wool.

firm in Washington, DC. This, of course, does not exemplify the best of corporate art or even what is typical of it. What it does, however, show is that such art, whether specifically commissioned or not, can be not only self-serving but ultimately subversive of values hitherto taken for granted by the majority of art critics.

Can art itself suffer or be depleted within the corporate environment? With the great expansion of corporate art collecting in the United States in the 1980s, minimal art, for example, such as Donald Judd's sculpture, has become, somewhat surprisingly, highly collectable. The reception and identity of minimal art, more than any other kind of art, depends to a large extent on the objects being framed within a specific context. Without the highly controlled space of the modernist gallery – the 'white cube',[131] so to speak, from which the outside world is rigorously sealed off – minimal art, once installed on corporate premises and lost in the hurly-burly of everyday business life, cannot be easily identified as art at all, and the 'aesthetic experience' that it offers as an object 'in a situation'[132] confronting the spectator cannot be realised.

Above all, what minimal art loses most in this corporate setting is its 'objecthood', the appearance of being non-art.[133] Gallery space transforms objects that resemble utility objects into vehicles of expression; corporate space has ironically reversed this process. Thus one of Donald Judd's wall sculptures of wall-bound rows of boxes could almost be seen by uninformed business people as a piece of furniture on which to rest glasses of wine at reception parties. 'When we had cocktail parties, people used to leave their glasses on it,' admitted Laura Perrotti, director of marketing at Fried, Frank, Harris, Shriver & Jacobson in New York, a law firm that stands apart from other corporate collectors for its 'cutting-edge' taste in minimalist and abstract art.[134]

The most far-reaching threat that corporate collecting poses to the production of contemporary art is its neutralizing and sanitizing power. Avant-garde art, whose aim is allegedly to confront and challenge the dominant culture and the status quo, once it has been recruited into the corporate camp, can soon become nothing more than expensive wall decoration; it loses its critical capacity and is assimilated to reinforce the prevailing business ethos and its values. This has to do with the fact that corporate buyers capitalise not on the aesthetic quality of their art works but on

Figure 30 Reception lobby of law firm Fried, Frank, Harris, Shriver and Jacobson, New York, featuring Donald Judd's *Untitled*, 1977, anodised aluminium and galvanised steel, 61″ × 110¾″ × 6″.

the fame and status of their artists. Even when they purchase works by the most critical artists, the works bought will be those that do not, or do not appear to, confront and offend their employees or clients. The highly charged sexual, racial, social and political tensions and overtones characteristic of Bruce Nauman's art are prominent in such works as his neon piece *Welcome Shaking Hands*, and his installation *Room With My Soul Left/Room That Does Not Care*. They are, on the other hand, visibly downplayed in his *Double Poke in the Eye II*, a neon work that one was surprised to find owned by a Washington, DC, law firm that boasted that its art collection was 'controversial' in the context of an otherwise conservative and stuffy legal profession. The work is described in the firm's collection catalogue as follows: 'Nauman likes to expose the extremes of our human natures, those potent impulses we try hard to conceal. In *Double Poke*, two figures . . . seem poised to shake hands, but in one blink, civility fades, hostility rises, and the two go

at it once again.' The work, in which the blinking images actually do perform what the title describes within a second, invites a very different reading once it is realised that the context is that of two men poised to shake hands as lights go on, and that the piece is hung in the firm's litigation department. *Double Poke* is, as the staff member who showed me around explained, an ironic visual pun on the life of the legal profession, in which the time-lapse between shaking hands and, metaphorically speaking, 'poking eyes' is, according to legal mythology, no more than a split second.

An even greater irony for critical artists and their work is, however, to be seen in the case of Hans Haacke. Since the early seventies, Haacke has been the quintessential critical voice against the power of business not only in the art world, but in contemporary society also. One of his works, *On Social Grease*, was, surprisingly, part of the collection of the Gilman Paper Company in New York. The work, whose title ironically equates social grace and vacuous PR business 'grease', consists of six plaques of commentaries from business spokespersons and politicians on corporate involvement in the arts. Robert Kingsley, spokesman at the Exxon Corporation, for example, was quoted in the work as saying (apparently without any humorous intention): 'Exxon's support of the arts serves the arts as a social lubricant. And if business is to continue in big cities, it needs a more lubricated environment.'[135]

How does corporate ownership affect the reception and interpretation of Haacke's works, and how, in turn, does the critical edge in his work serve the owner's interests? Sam Hunter, professor emeritus of art history at Princeton University, provides the following interpretation:

> . . . the very presence of the work [*On Social Grease*] in a well-known corporate collection can be viewed as a promising sign of the concern of at least one member of the corporate community to examine its own motives. Such enlightened gestures do much to ventilate an important social issue, and to deflect criticism of the corporate tendency to aggrandize and flaunt charitable acts[136]

Apparently, therefore, the Gilman Paper's ownership of Haacke's work has not only minimised the critique that the artist was attempting to make in his works, but has actually, and radically, redefined the very meaning of the piece: a work that set out to criticise the corporation has ironically ended up standing for the so-called liberal and 'enlightened' face of business. But is

this enormous corporate purchasing power as liberal and as purely beneficial to artists as Sam Hunter would have us believe? Or is it rather how the media tycoon Malcolm S. Forbes describes it: 'They [businessmen] don't determine the direction of the arts, they only determine which artists mak[e] a living'?[137]

Unlike American buyers, who tend to be flamboyant in their collecting, British businessmen are largely unwilling to talk about their influence on contemporary art. When Sir Nicholas Goodison, for example, spoke out, he did so more in order to boost the egos of other business patrons:

> I believe that being bought by a corporate patron can make a difference to self-confidence and therefore to the development of a younger artist's career. That sounds a bit patronising, which, in the true sense of the word, it is.[138]

The corporate ownership of contemporary art has thus not only affected the reception and interpretation of art works, but actually contributed to redefining and altering the relation between patrons and artists. As artist Jon Kessler put it: 'The role of the artist used to be as outsider. You didn't want to meet your collectors – and you dressed that way. Now, we all eat at the same restaurants, [and] have our apartments photographed for the same magazines.'[139] It would seem that artists are unwilling to bite the hand that feeds them. It is not just corporate art that was coming of age, but also a new and apparently uncomplicated relationship between corporate patrons and those artists who were happy to create objects congenial to the corporate ethos. One such was Bruce McLean, a particular favourite among corporate buyers. Among other corporate pieces, he created *Pestle and Mortar* for the Glaxo House atrium, the centrepiece for its British art collection. The artist said of this work: 'It is a reflection of the company. Glaxo make things that make you feel better and healthier.'[140] The question is: is this incontrovertibly true of this giant drugs multinational? A £7 million settlement between Glaxo and over 400 users of its drug Myodil in 1995 showed that McLean's confident view was not necessarily widely shared.[141]

Cindy Sherman, the avant-garde artist who has been such a popular star for feminist art historians, not only dresses herself up and poses to create her famous artistic film stills, but also does precisely the same thing for Calvin Klein houndstooth sweaters, for Shamask shirts and for Mizrahi evening

wear.[142] And when she appeared on the BBC2 television programme *Relative Values* in 1991, she cheerfully admitted that it was 'just great' to have her works collected by the Chase Manhattan Bank. But have the full consequences of this seemingly natural development been fully and critically understood by the art world or British and American publics? Corporate America provides an answer for us through its magazine *Across the Board*: 'To those who still worry about the power of the corporate purse . . . there is one simple response: If not the corporation, who else?'[143]

The issue at stake in relation to corporate patronage is not that of the use of art by powerful individuals or in order to advance commercial interests; there is nothing new in that.[144] It is rather that of the different meanings that art takes on in the social milieu of commercial space. And here lies a fundamental contradiction. Since the eighteenth century it has been widely claimed in bourgeois culture that art is, by its very nature, above the sordid world of individual interests, as represented, quintessentially, by commerce. Indeed its very capacity to confer status on corporate patrons depends on this. Yet as Bruce McLean's comment illustrates, corporate collecting is anything but disinterested. So the question is: can art bought by corporate capital and housed in commercial spaces be anything more than self-promotion and high-style decoration?

The exercise of economic power in art can, as we see, be converted ultimately into status and legitimacy, or into what Bourdieu terms 'cultural capital'. Conversely, the control of cultural capital can be converted back into monetary capital. Here lies the most attractive quality of corporate art collecting, both as a valuable investment in itself and as a PR tool. As a corporate art 'guru', Manuel Gonzalez, head of the Chase Art Program, once put it with alarming frankness:

> A corporation's obligation is to its community. Art is the cheapest – by that I mean most reasonably priced – decorative element available, with a larger margin of profitability than any other commodity in history. It gives you a great cachet among the sophisticated individuals with a high net worth who are usually targeted by most businesses.[145]

The art critic Robert Hughes brings an even wider perspective to the problem and its attendant dangers:

> The idea of an American public culture wholly dependent on corporate promotion budgets of white CEOs, reflecting the concerted interests of one class, one race, one mentality, is unthinkable – if you think about it.[146]

By virtue of the position it occupies in the world of production, the commercial sector is able to take on, in artistic matters, the role of the dominant group and can come to enjoy the prestige and confidence associated with economic predominance. It needs only the tacit consent of the public at large to this new power group, and public acceptance of the new parameters that it imposes on social and artistic life, to create a set of circumstances that correspond to Gramsci's concept of cultural hegemony.[147] By institutionalising itself, corporate art assumes moral authority, appropriates legitimising symbols to itself and is able to set artistic trends. In this sense one social group acquires power over one of the few sectors of society supposedly above the profit and loss principle, and art becomes thereby the unwitting accomplice of a new cultural hegemony. The origins of this new power, whether it is a potential or a real power, lie in the purchasing power to which corporate capital gives its owners privileged access.

9

CONCLUSION: FROM CONSERVATISM TO NEO-CONSERVATISM

The 1980s witnessed the unprecedented phenomenon of business in America and Britain making art its business, not only at the individual level of the corporate executive (businessmen are as much entitled to taste in art as anyone else) but, more surprisingly and significantly, at the level of the corporations themselves. While corporate involvement in arts and culture obviously pre-dated the 1980s, it was this decade more than any other that witnessed the utilisation of the power of corporate money for active participation in the cultural arena. What was also new was the deliberate pursuit of art not only as financial investment, but also as an image-enhancing tool, within a sector of society that had previously been regarded as, if not philistine, then at least largely ignorant of and indifferent to art. The entry of the private corporate sector into what had hitherto been, especially in Britain, an almost exclusively public domain was the hallmark of the new artistic consciousness of the eighties.

This study set out to plot a small but important part of a trajectory whose impetus lay in the free market policies and ethos of the Reagan and Thatcher decade, and which saw the displacement of public art provision in Britain (and to a lesser degree in America) from its former position of privilege into the open marketplace. Neither Thatcherism nor Reaganism is, of course, simply a political or economic project, but a mixture of what Mrs Thatcher's former Chancellor of the Exchequer, Nigel Lawson, described as 'free markets, financial discipline, firm control over public expenditure, tax

cuts, nationalism, "Victorian values" (of the Samuel Smiles self-help variety), privatisation and a dash of populism'.[1] It was a combination of a determination to 'roll back the frontiers of the state' through consecutive privatising projects of Britain's nationalised industries, and an ideological commitment to the free market economy, that succeeded in changing the face of the national life during the eighties, as Britain under Thatcher strove to keep pace with the Reaganite model of enterprise culture that had already prepared the ground for these radical changes in America.

The new cultural landscape that the Reagan–Thatcher decade was responsible for constructing has remained largely intact in both countries long after the departure from office of its founding architects. This has less to do with the fact that the Republicans and the Conservatives continued to be in government for some years after Reagan and Thatcher left office, and more to do with the fact that their successors, the Democrats and New Labour, proved to be every bit as committed to the market economy as their erstwhile opponents. Far from making a radical break with the past, the centre left chose to embrace the very economic philosophy that they had so consistently denounced when in opposition. In Britain this was the price that New Labour was willing to pay in order not to alienate either the voters of Middle England or the financial sector, whose confidence it was crucial for them to secure in their bid to return to power.[2] Economic considerations were firmly at the top of their agenda, and everything else, including the arts, was regarded as secondary to the need to keep the marketplace free and open.

CLINTON'S SCORE ON THE ARTS

Across the Atlantic, when Bill Clinton was elected President of the United States in 1992, he was warmly welcomed by the American arts community. The Democratic President was believed, by some, to be a 'strong supporter of public funding for the arts', and it was thought by others that, with him in power, the arts lobbyists might finally have secured an 'open door' into the White House.[3] Despite the lack of any specific pledges, Clinton was on record as saying: 'As President, I will support and defend freedom of speech and artistic expression by opposing censorship or "content restriction" on grants made by the NEA.'[4]

To understand the hopes that people in the arts communities had come to place in Clinton by the time he arrived in power, one has to look briefly at the embattled history of the NEA during the Bush era. Back in 1989, for two small grants (of $15,000 and $30,000 respectively) that it gave to the artist Andres Serrano and to a retrospective exhibition of Robert Mapplethorpe photographs, the Endowment had come under vicious attack from right-wing Republicans and religious fundamentalists.[5] Congress subsequently imposed a mandate in 1990 requiring the Endowment to ensure that all NEA grants uphold 'general standards of decency and respect for the diverse beliefs and values of the American public'.[6] This so-called 'content restriction' resulted in a lawsuit being brought by four performance artists, known later as the NEA 4, against the NEA on the grounds that the restriction was unconstitutional because it violated their First Amendment rights. Two federal courts declared it be unconstitutional in 1992, which the incumbent President Bush vowed to appeal against, while Clinton during his presidential campaign pledged to oppose the appeal.

But Clinton's words did not have a shelf-life beyond that of the election campaign, and any hopes that he might introduce new policies capable of resolving the cultural conflicts that the American arts communities in general, and the NEA in particular, had been fighting ever since the late 1980s proved to be unfounded. Once he was in power, Clinton's Justice Department appealed against the 1992 federal ruling, seeking to re-install the Bush era content restrictions on NEA grant awards. Clinton's commitment to public funding of the arts was also in serious question when he revitalised the President's Committee on the Arts and Humanities, a Reagan creation aimed at promoting private funding for the arts, but which had lain dormant under the Bush administration. The President's Committee was honoured with a White House reception attended by the President himself and the First Lady. The committee's members were charged by the President 'to establish new partnerships between the federal agencies and the private sector'.[7]

In the meantime, opponents of public arts funding drummed up their cause with relentless vigour, finding a prominent spokesperson in Newt Gingrich, a self-declared 'definer of civilisation' who became the House Speaker after the Republicans won majorities in both the House and the Senate in 1994. Gingrich's brand of Republicanism, embodied in his

Contract with America, promised the American people a government with less regulation, a balanced budget and tax cuts of some $200 billion. With Gingrich and his like-minded conservatives in place, they openly declared, for example, as part of the 1996 Republican Party's Platform, that their policy was 'to defund or to *privatize* the NEA [italics added]', and then seized each and every opportunity to attack and eliminate the NEA.[8] Ron Athey's masochistic phlebotomy performance in 1994 was, for instance, seized upon by the conservatives as a pretext to cut 5% ($8.5 million) off the NEA 1995 budget, even though the NEA contribution towards his work was reported to be no more than $150.[9]

ARMAGEDDON FOR PUBLIC ARTS FUNDING

This kind of conservative backlash and tussle for political control over the NEA became the staple diet of the Congress and American art communities in the decade after Reagan departed from office in 1988, with both sides fighting with equal vehemence. Indeed, ever since the right-wing Republicans realised that public funding for the arts was a safe and easy target to create an issue for political gain, they never ceased to use this weapon of symbolic politics by attacking any public-funded art works that they personally considered 'obscene' or 'offensive', and never missed an opportunity to advocate the abolition of the Endowment. Was it a mere coincidence that the decade-long cultural wars of the nineties were triggered at the end of Reagan's two terms in office – at a time when the conservatives might justifiably have felt they were riding high on the tide of history? Had it not been for Reagan's eroding of the principle of public funding for the arts by constantly attempting to cut the NEA budget and to demolish it as an institution, would it have been possible for his conservative followers to sustain such an incessant and eventually successful campaign against the NEA?

Few events better sum up the changed nature of public funding for the arts in America than the current state of siege under which the NEA finds itself. The ex-Republican Patrick J. Buchanan, for example, could still in 1999 use the NEA as evidence of a persistent government evil in order to stir up popular sentiments against federal art subsidies: 'Even the dismal little

National Endowment for the Arts', he trumpeted, 'gamely soldiers on.'[10] 'Dismal little' indeed, but 'soldiers on' definitely not. The NEA has been more or less emasculated as a federal agency since its 1996 budget was cut drastically, from $160.2 million to $99 million. Such a financial straitjacket leaves the NEA no room for any programme of real national significance, and its role as a federal agency has been downsized to the point of being completely marginalised.

Money is not, of course, the real issue here. The entire budget of the NEA is barely enough to buy, for example, half of a single military cargo plane, hardly an enviable record for a country that Buchanan is proud to call the 'last best hope of Earth [*sic*]'.[11] The more problematic issue is that the NEA is not in a position to support projects of a visionary or experimental nature. Since 1996 it has been banned by Congress from funding individual artists, an area to which its now defunct Visual Arts Program had previously devoted a substantial amount of its budget in order to encourage and nourish personal creativity. Any move that the NEA now makes is subject to the strictest scrutiny by the conservatives, a policy of intimidation designed to lead to further controversy and even firmer political control. The net result is to make the NEA constantly look over its shoulder, and ready to bend its knee to the dominant political philistinism of the day.

The most serious setback for the arts community occurred in 1998 in a long campaign of cultural warfare, when the eight-year legal battle between government and a coalition of free speech and art world organisations over the 'content restrictions' on NEA grants came to a climax. The US Supreme Court ruled that it was in fact constitutional for Congress to oblige the NEA to consider 'general standards of decency' when awarding arts grants, thus ensuring a definitive victory for the Clinton administration and for the Congress conservatives.[12] With the very survival of the NEA constantly in the balance, the future of public arts funding in America is bleak indeed. This stands in stark contrast to the first 15 or so years of the NEA's existence when it enjoyed the freedom to oversee its own programmes, and when it saw its financial resources rise from $2.8 million in 1966 to $154.6 million in 1980. Then the Reagan era began. Those who looked to Clinton to redress the balance in favour of the arts waited in vain. And with the arrival of the Republican George W. Bush in the White House in 2001, the future of public arts funding in America looks set to remain a very low priority.

FROM THE CONSERVATIVES' WAY FORWARD
TO NEW LABOUR'S THIRD WAY

On this side of the Atlantic, New Labour's record on public funding of the arts is a mixed one. In many areas of public spending, the Blair government has simply continued the policies that it inherited from the Conservatives. For those who waited 18 years for the Tory Party to be defeated, Tony Blair might seem to be a born-again Thatcherite, and the celebrated 'Third Way' he so fervently champions nothing more than the decanting of the old wine of market principles into attractive new bottles, with the added ingredients of moral uplift and big smiles.

A few months before the 1997 election, Tony Blair attracted a great deal of attention from the arts communities when he spoke at the *South Bank Show* awards ceremony, stressing that the arts should not be an 'add-on on page 24 of the manifesto but something that is central to a decent country'.[13] A few days later he went on to announce Labour's 'arts policy', dubbed 'luvvies' charter' by Virginia Bottomley, the then Heritage Secretary of State. In a covert attack on Mrs Thatcher's oft-quoted dictum, the future Prime Minister declared: 'And we believe in society. The arts deny the obnoxious assertion that there is no such thing as society.'[14] Despite the rhetoric, he did not commit New Labour to any public funding for the arts, apart from the promise to transfer lottery money from the Millennium Commission in order to create a National Endowment for Science, Technology and the Arts (NESTA).

Once in power, New Labour adhered to the strict spending limits that it inherited from the Conservative government for two years until the completion of its 'Comprehensive Spending Review'. Describing it as 'the biggest ever reform of cultural funding and organisation', the Department of Culture, Media and Sports (formerly the Department of the National Heritage under the Tory government) announced its cultural budget for the next three years in February 1999. The overall department budget would see an increase from £917 million in 1998–99 to £1,038 million in 2001–02. Such an increase did indeed look impressive, particularly when viewed in the context of the successive cuts that arts funding had suffered in the previous years under the Conservatives. However, if adjusted in line with inflation, it was far from generous, and even further from the claim made for it to represent a 'revolution' in cultural funding.

LOTTERY BRITAIN

Raising taxes is, of course, the last thing that New Labour would like to contemplate in its anxiety to avoid any substantial increase in public spending, whether out of fear of being seen as party of tax-and-spend, or because in principle it simply does not like the idea. Instead New Labour made free use of National Lottery money. The Lottery had been established in November 1994 under the previous Tory government to fund projects in addition to, and not in the place of, government funding. By changing the principle of 'additionality' in Lottery grants, something that Labour had endorsed while in opposition, Labour in power was able, in 1998, to set up a 'New Opportunities Fund', sharing 13.3% of the Lottery money with other good causes. Up to January 2000, some £1.2 billion had been spent to fund specialist health, education and environmental projects for which the government would otherwise have had to raise taxes.

Although it is beyond the scope of this study to explore further the wide impact made by the National Lottery, it has undoubtedly changed the face of cultural Britain in a significant and irreversible way. The mushrooming of new arts buildings and the refurbishment of old ones has, for example, been one of the most tangible results of Lottery money becoming available for the arts, heritage and the Millennium Commission. Since 1994, some £1 billion of Lottery money has been allocated for 2,000 building schemes up and down the country.[15] The extent to which the building boom will serve the people, rather than enriching architects, construction companies and developers, remains to be seen. Some of these grand projects, such as the National Centre for Popular Music in Sheffield, the Earth Centre in Doncaster, the Centre for Visual Arts in Cardiff and the Royal Armouries in Leeds, faced financial difficulties and closure even within a few months of their opening, giving them the status of 'white elephants' in the eyes of the general public. In order to save these institutions and other possible casualties of the Lottery building boom, regulations were redrawn in 1998 to allow Lottery cash to fund people rather than merely buildings.

Lottery funding seems to have come full circle. Established initially to fund additional projects outside the limits of public spending, money from the Lottery has now become an integral part of government funding. But as long as the National Lottery remains a sort of 'voluntary' tax rather than a

compulsory one, the question of whether it is a regressive tax on the poor (studies have shown that people with low income tend to gamble more than those with higher income), or how it has affected the lives of the millions of Lottery gamblers who regularly lose week in and week out, is unlikely to become a burning issue.[16] For the recipients of Lottery money, on the other hand, what really matters is that millions of pounds now flow endlessly and effortlessly into government coffers (so far it has meant an astronomical sum of £3.1 billion up to January 2000) and into a long string of good causes (to the tune of £7.7 billion up to November 1999) of which the arts is one. Any criticism of its inherent unfairness in terms of social redistribution is likely to be silenced by the applause of those who have vested interests in the Lottery grants. It is in this sense that Nicholas Serota, director of the Tate, praised John Major by forecasting that in 10 or 15 years' time he would be best remembered as the Prime Minister who made the Lottery dream come true.[17]

It is perhaps not without irony to recall that Mrs Thatcher, who can claim to have started the wholesale privatising of Britain, was herself opposed to the setting up of a National Lottery.[18] It needed another Conservative Prime Minister, John Major, to initiate the Lottery enterprise. The various ways in which New Labour has redefined the uses of Lottery money and assimilated it to state spending tells us as much about the Conservatives' vision of Britain as about New Labour's unfailing determination to perpetuate Tory policies.

THE CORPORATE WELFARE STATE

One of the most conspicuous Tory legacies that New Labour continues to pursue with relentless enthusiasm is that of Private Finance Initiatives (PFIs), introduced under the Major government. Never mind if in opposition Labour criticised PFI as 'backdoor privatisation' or if traditional values of public service sit so uncomfortably with the profit-making concerns of private enterprise. Re-christening PFI as Private-Public Partnerships (PPPs), New Labour has not only persevered with the PFI schemes started under the Conservatives, but also enthusiastically applied them to a whole range of areas of state funding. PFI-funded schemes in the museum sector include, for

instance, the new study centre planned at the British Museum and the controversial Royal Armouries in Leeds.[19]

Although the Royal Armouries is not an art museum as such, the way in which the PFI scheme has been applied to it can be seen as a pointer to what could be in store for us should PFI or PPP be used extensively in public arts funding. The Museum, opened in March 1996 at a cost of £42.5 million, was one of the first PFI projects financed by the then Conservative government. While the Royal Armouries was responsible for the care of the national collection of weapons and armour spanning 2,500 years, its building was owned and managed by a specially formed private consortium, Royal Armouries International plc (RAI), which included companies such as Yorkshire Electricity, Electra Investment Trust and the Bank of Scotland.

Lauded by some as 'an undoubted success' after its opening, the Royal Armouries was nonetheless reported to have accumulated, within the short span of three years, a £20 million debt in 1999, and to be facing closure.[20] The threat of bankruptcy was only avoided by the intervention of Chris Smith, the Culture Secretary, by means of an extra £1 million injection of taxpayers' money each year. In a true marketplace, the Armouries would simply have gone under, but in the comfortable world of PPP, half-public-half-private institutions can always take comfort from knowing that in good days private enterprise will be free to reap profits, while in bad days the public can be counted upon to come to their rescue. Gone is the welfare state; in comes the corporate welfare state. Such PPP schemes serve only to give private enterprise unaccountable opportunities of pursuing commercial interests in the name of serving the public interest. New Labour's faith in cultural PPPs is such that, despite all the disasters at the Royal Armouries, Chris Smith was unwilling to rule out its use in the future. To quote the Culture Secretary:

> The Private Finance Initiatives that took place at the Royal Armouries in Leeds have not been a great success. It has made us all rather cautious about how to apply PFIs to museum and gallery schemes. It is not something we ever rule out, but we need to be very careful about how we do it.[21]

Like the distribution of Lottery grants, the PPP is designed to deliver maximum political capital for politicians. The short-term gain of immediate

gratification and the opportunity to show off new buildings and new services have taken precedence over the long-term planning of democratically accountable public funding. This is what Nick Cohen succinctly summed up in the title of his article: 'The Third Way: . . . Make the Third Generation Pay'.[22] Is it to think the unthinkable to envisage our national art collections becoming the tenants of corporate landlords, as is indeed already happening to schools and National Health Service hospitals throughout the country?

COOL BRITANNIA

More important than the total sum of money involved is what use is made of the money available. At a time when core public services can only be assured, so New Labour claims, by generous injections of private capital, the Lottery has endowed Britain with numerous new 'visitor attractions' and cultural amenities. Their opening was timed to coincide with the new millennium and their aim is to cater for the palate and pockets of both Middle England and overseas tourists. In the brave new Britain of the twenty-first century, a cultural landscape dotted with an assortment of attractions will be a great, glittering world of fun and excitement.

The operative word is, of course, 'attractions'. What kind of attractions and for whom? Except for the renovation of art museums or galleries or the opening of the new ones, the Lottery-inspired cultural projects are overwhelmingly centred on attractions of the theme-park variety. Gone is the old-fashioned world of fuddy-duddy museums, now to be replaced by a new interactive 'Centre for This' and 'Centre for That'. You can experience, for example, a simulated journey into space at the National Space Science Centre in Leicester, find out about geological evolution at the Dynamic Earth in Edinburgh, have fun and learn about science at the '@Bristol' in Bristol, or get hands-on experience of the steel industry at the 'Making it! Discovery Centre' at Mansfield. And throughout 2000, of course, there were the manifold attractions of the £1 billion Millennium Dome at Greenwich. The list can be extended *ad nauseam*. Some of the fanciful titles dreamt up for the new attractions, such as '@Bristol' or 'Making it!', symbolise precisely the standard of entertainment value that these ventures seek above all else to promote.

If Britain under the previous Tory government was promoted as a jigsaw of countless heritage sites, New Labour's Lottery Britain seems determined to provide endless fun and a good time for all. Whereas Heritage Britain turned each and every 'authentic' relic into a nostalgic story, harking back to the days of lost empire, Lottery Britain turns every imaginable theme it embraces, be it science, industry or popular music, into a simulacrum entertainment in a high-tech world of digitalised fanfare. The style may change, but the theme-park approach remains the same. New interactive attractions assume that science and history, for example, can no longer be seen as interesting unless coated with a honeyed gloss of fun. Could it be that people in twenty-first-century Britain are assumed to be so undiscerning that they are attracted to visit only those sites that have been sugar-coated for them in advance? Is Lottery Britain destined to be a candy-floss culture, a pre-packaged delight of toothsome but ultimately unsatisfying nibbles? It is surely no coincidence that since the late 1990s we have seen the rise to prominence of the concept of 'dumbing down'.

This is not, of course, to suggest that New Labour alone is responsible for any lowering of standards in contemporary British culture. After all, the Labour government has been in power for only four years. Despite its determination to follow Conservative policies in other domains, New Labour aimed to have reintroduced free admission to all national museums and galleries in 2001, and this was one of the central planks of its cultural policy. In order to finance its promise of free admission, it managed to find £30 million to compensate the national museums for loss of revenue. At the start of 2001, however, agreement to implement the free entrance policy had still not been reached with the museums, except in the case of children and pensioners, and the government began pressing for a minimum £1 entrance fee as a transitional measure. In contrast to the many money-spinning expedients that the Conservatives imposed on museums and galleries, however, it looks very much as if New Labour might indeed be contemplating broader public access to the arts. Could this small sign of change be more than a token concession to placate the party's liberal constituency? Might it indicate that there is after all some measure of clear water between Conservatives and New Labour, and, given time and effort, it may be possible to see them setting divergent courses? For the time being, it is difficult to predict the extent to which New Labour intends to bring about any radical new direction in its vision for the arts.

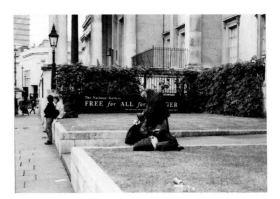

Figure 31 Social exclusion from, and free admission to, the National Portrait Gallery under New Labour, London, 1999.

ART INSTITUTIONS: EXPANSION MANIA

To gauge what has happened to art museums since the enterprising years of the Reagan and Thatcher era, one has to look at the new face of multinational museums that have been emerging in the United States, and at the obsession for expansion that has gripped British museums and art galleries over the last few years. Both are signs of their times, and each in its own way reflects the legacy that it has inherited from its past in the enterprise culture that so indelibly marked the eighties. Further, each in its own way represents the current obsession of the art establishment to be quick off the mark, to be cool, hip, big – above all, globally big. While American art museums, acting as if they were destined to become the multinationals of the twenty-first century, have established branch after branch abroad, British museums and art galleries have been content with expansion within the British Isles.

If this marks the beginning of a 'brave new world' for art museums, it is also part of the tried and tired daily routine of the capitalistic marketplace. In particular over the last few years hardly a day has gone by without news of talks or deals of corporate take-overs or mergers of one kind or another, with each deal trying hard to outperform the previous one. According to a report in *The New York Times*, there have been on average 29 deals a day in America.[23] Not only have the names of merged

companies, such as ExxonMobile or PricewaterhouseCoopers, become longer and longer, but the nature of corporate marriage involves, more often than not, cross-national or cross-continental amalgamation, as embodied in such new enterprises as BP Amoco (UK and US) or Daimler-Benz/Chrysler (Germany and US). In short, to merge is to drive profit forward and to enlarge one's market share, in particular in global terms. It therefore comes as no surprise to find multinationals embracing transnational mergers whole-heartedly and championing their specific brands of globalism.

MULTINATIONAL MUSEUMS: McGUGGENHEIM

The extent to which such business practices and the ideology of globalism have infiltrated art museums can be seen in the policies of the Guggenheim Museum and, to a lesser extent, the Boston Museum of Fine Arts over the last few years. To date, in addition to its original Frank Lloyd Wright building in Uptown Manhattan, the Guggenheim owns a Guggenheim Museum SoHo branch in Downtown New York, the Peggy Guggenheim Collection in Venice, the Guggenheim Museum Bilbao in Spain and its latest addition, Deutsche Guggenheim Berlin in Germany. This list does not, of course, include other failed franchising attempts during the last decade, such as three branches in Venice, branches in Salzburg, Massachusetts (known as MASS MOCA), the one on the Hudson River, nor those that are reported to be in the process of being set up, such as the $850 million Frank O. Gehry-designed branch over four East River piers.[24]

A decade ago, when the Whitney Museum opened its four branches, many in the art world were worried that the development would have a dumbing-down effect on the quality of the art it offered. But today, with the triumph of American-style capitalism and its associated culture, neither the Deutsche Guggenheim Berlin nor the Guggenheim Bilbao have been subjected to criticism of any significance that would have caused the Museum to re-evaluate its global ambitions. On the contrary, the Guggenheim Bilbao and its architect have been showered with accolades, a spectacle not likely to be repeated, still less surpassed, in years to come.

If Guggenheim is the epitome of the nineties' art institutions that envisage their futures in the twenty-first century as being multinational museums, it inevitably sees itself in terms similar to those of a multinational. Once business vocabulary and corporate sets of values enter an art institution, its theatre of operations will inevitably be also dominated by the ethos and practices of multinationals. How, after all, can cross-border incursions of this sort, be they economic or cultural, legitimately be made in a post-colonial world if not by multinationals? Would it have been possible for the Guggenheim to become a multinational museum if it had not enjoyed special relationships with its multinational partners? No one is better placed to articulate the policies behind these joint frontier-breaking ventures than Thomas Krens, the Guggenheim's director, who masterminded the shape of the Museum as it is today: 'We do very well at corporate support, better than most people think – no one has focused on that. We have put this programme of global partners in place, where we have long-term associations with institutions like Deutsche Bank and Hugo Boss and Samsung – and a few others that we'll announce soon.'[25] An indispensable prerequisite of being 'the globe straddler of the art world', as one of *The New York Times*'s epithets for Krens succinctly describes him, is a substantial backing of multinational capital.[26]

Indeed multinational museums and multinational corporations have become in many ways inseparable bed-fellows. Despite the fact that their proclaimed aims and purposes may be worlds apart, they share an insatiable appetite for improving their share of a competitive global market, and this ambition involves them in physical expansion and the occupation of space in other countries. It also involves making aggressive deals in an open marketplace and manoeuvring capital (money and/or art) across different borders. In creating a multinational Guggenheim, Thomas Krens has, of course, successfully deployed the same global deal-making skills as international corporations habitually use. Just as the CEOs of multinationals are forever pushing forward the frontiers of capitalism, so Krens is, in his own way, 'pursuing the American cultural system to its inevitable conclusion'.[27] Under these circumstances, do multinational museums and multinational enterprises simply feed off each other? Or do multinational museums simply serve to advance the global political and economic strategies of multinational businesses?

Guggenheim on sale

The extent to which the Guggenheim has been successful in staking its future growth and expansion prospects on its links with multinationals is made clear by its recent chequered history. The directorship of Thomas Krens at the Guggenheim over the last decade has witnessed some controversial financial operations, including the selling of three of its paintings by Chagall, Kandinsky and Modigliani for $47 million, and the issue of a $54 million public bond to pay for renovation of the Frank Lloyd Wright landmark building, a new annexe by Gwathmey Siegel, and the Arata Isozaki-designed Guggenheim SoHo. But by the mid-nineties, the Museum was yet again short of funds, and Krens had to launch a mammoth $100 million fund-raising campaign. It was around this time that the Museum found itself firmly in the embrace of the multinationals, and becoming more dependent than ever before on multinational capital.

Its first branch, the faltering Guggenheim SoHo, whose attendance dropped from some 200,000 at the time of its opening in 1992 to 125,000 in 1995, was saved from oblivion by the injection of international cash and supplies from Europe. The branch was closed for some five months in 1996, only to reopen with a dazzling display of 14 multimedia works, entitled *Mediascape*, supported by the newly privatised Deutsche Telekom. In exchange for a reported subvention of $10 million over five years, the Guggenheim baptised four of its ground-floor galleries the Deutsche Telekom Galleries – an act described by Roberta Smith, *The New York Times'* journalist, as selling 'a bit of its soul to deliver this particular slice of future shock'.[28] This partnership also broke new ground in that these were the first ever galleries dedicated to corporate sponsors in any major New York museum. Thomas Krens went so far to suggest (if we needed any reminder of the power of these high-tech companies and their cash): 'The only way museums can consistently develop and present multimedia and high-technology exhibitions is through collaborations with organisations like Deutsche Telekom which has a broad range of resources and expertise.'[29]

Deutsche Telekom Galleries are, of course, not the only corporate monuments at the Guggenheim SoHo. There are also the ENEL Virtual Reality Gallery and ENEL Electronic Reading Room, sponsored by ENEL, the largest power company in Italy and a leading developer of computers. In the

short span of a few months after the opening of the Deutsche Telekom Galleries, the Museum unveiled yet another 'permanent institutional ad' for a corporate sponsor – the Hugo Boss Gallery at the same branch. This led one *New York Times* critic to remark that the Museum, like politicians and porn stars, 'seems to be a step or two beyond embarrassment'.[30] On current showing, one might legitimately anticipate that any multinational that comes along with a fat cheque of marketing dollars will be welcomed into the ranks of the extended Guggenheim family.

If the Deutsche Telekom, ENEL and Hugo Boss spaces at the Guggenheim SoHo have much more in common with commercial lettings, the Guggenheim Museum Bilbao and the Deutsche Guggenheim Berlin are pioneering examples of global commercial franchising in the museum world. In return for lending its curatorial services and art works to its branches, the Guggenheim in New York is to receive money from its foreign collaborators, as well as art acquisitions, jointly purchased or paid for solely by its foreign hosts. In other words, just as with other forms of commercial franchising, the Guggenheim is trading on its brand name and expertise (i.e. curatorial services) for profit.

However, unlike other universally known American franchising brands such as McDonald's or Kentucky Fried Chicken, the Guggenheim is more than willing to adapt its trademark to suit the specification of its corporate sponsor, in this case, Deutsche Bank. In exchange for the pocket-sized branch, located on the ground floor of the Bank's main office in Berlin, the Museum agreed to vary its name. Instead of being called, as would have been expected, 'Guggenheim Berlin', it gave prominence to the Bank by placing the latter's name before its own. In Deutsche Guggenheim, the 'Deutsche', we are told, is to be read not as 'German' but as Deutsche Bank. In their joint literature, they draw attention to the unusual grammatical form of the name 'Deutsche Guggenheim Berlin', which they explain, without embarrassment, as a deliberate brand-identity marker to promote their sponsor's name.[31]

There is, of course, nothing new in public art institutions becoming corporate tenants, which is what the Deutsche Guggenheim effectively is. The precedent was established by the Whitney Museum in the eighties. But to expand within one's own neighbourhood is one thing, while to seek to become a player in the global cultural market is quite another. Such acts of

cultural expansionism inevitably provoked reactions from the citizens of Berlin, who naturally felt and feared that their own cultural habitat was being violated. Harald Fricke, the Berlin *Tageszeitung*'s critic, for example, accused Thomas Krens of acting like a 'corporate manager', 'for whom cultural activities cannot be separated from profit'.[32] The Bank, on the other hand, naturally claimed that in setting up its Guggenheim branch, it was seeking only to contribute to the cultural life of the German capital.

Re-branding the Basque capital

The question that remains is, however, the extent to which this sort of 'cultural profiteering', for lack of a better term, invites comparison with cultural imperialism/colonialism. Does the multinational Guggenheim represent the ultimate invasion of American high culture in the same way as agents of American popular culture such as McDonald's and Coca Cola have colonised the world? The Guggenheim empire, as it is sometimes referred to, does not, of course, always have the golden touch.[33] The Deutsche Guggenheim has, as yet, generated neither the spectacle nor the 'hype' that its Bilbao brother did. Size apart, Berlin is a truly international metropolis that prides itself on its own cultural traditions and past; no cultural import is likely to win immediate acceptance without first being subjected to rigorous scrutiny. This was not, of course, the case with Bilbao, a city almost unheard of outside Europe except for its unfortunate associations with the Basque separatists and their violent guerrilla struggle.

The subtext of the enthusiasm with which the Basque capital embraced the imported American institution has to be understood in terms of the Basque country's own turbulent political history, its declining economy in a post-industrial society, and its urgent need to reinvent itself in order to help consolidate a Basque national identity. Since it gained its semi-autonomous status in 1975, the Basque region has dedicated itself to self-transformation by investing in education and health programmes, in roads and communications infrastructure. In order to solve the economic crisis and reverse the decline of its capital Bilbao, it has also made concerted efforts to shift the city's economy away from its gritty industrial past of heavy industry and shipbuilding on to a service-oriented economy. An integrated $1.5 billion package of urban regeneration, with the cultural strategies that go with it,

is aimed at placing the Basque capital firmly on the tourist map. This regeneration includes a number of signature buildings designed by well-known architects, such as the Euskallduna Conference and Music Centre by the Madrid architects Federico Soriano and Dolores Palacios, the Uribitarte Bridge by Santiago Calatrara, and a Norman Foster underground system, to name but a few.[34] It goes without saying that the Frank Gehry Guggenheim is the flagship of them all.

There is no need to recount here the already over-reported opening of the Bilbao Guggenheim, a success described by *The New York Times* as a 'Cinderella story', completely transforming the city's fortunes from an 'eyesore' to an 'essential sightseeing stop'.[35] But what does this mean to the taxpayers who found themselves paying for this American monument on their own doorstep? The Museum building itself cost the Basques some $250 to $360 million, depending on the exchange rate at the time, on top of the $20 million down payment for the franchise fee, as well as a further $50 million to purchase art works. According to Joseba Zulaika, a Spanish anthropologist, the running of the Museum will require a public subsidy of between $7 million and $14 million per year, a figure that will take the lion's share of the already overstretched budget for all of the Basque country's museums.[36] At the time of the Museum's opening, the unemployment rate in Bilbao was at 25%, with 60% of young Bilbainos out of work. The Museum is, of course, expected to help gentrify the old shipyard waterfront and to generate jobs related to the tourism trade. It may be true that the Museum has so far attracted a million tourists 'flocking to Bilbao' every year, but behind this much vaunted figure, no one has yet to come up with a reliable hard calculation of how far the tourist trade has helped the city's balance sheet, and what return there has been, in cash terms, for the vast sum that its local taxpayers have been investing and will continue to invest in the future.

Money is not, of course, the only issue at stake here. Public art museums on such a large scale inevitably also affect civic pride and identity. To quote Carmen Garmendia, the Basque Cultural Minister: 'The rejuvenation program touches deep questions about how to act out our cultural life.'[37] Describing the museum as a civic self-confidence booster, Juan Ignacio Vidarte, director-general of the Guggenheim Bilbao, boasted: 'We want to project our real image to the world.'[38] If we are to take Vidarte's

words seriously, what greater irony could there be than embodying Basque identity in a quintessentially American cultural import? Basque cash may effectively have bought and built this pantheon of American high culture, but a city of cultural and artistic sophistication needs more than a single celebrity building to justify its existence. To add insult to injury, there is no resident artistic director at the Guggenheim Bilbao; the show is in fact run by the Guggenheim's New York masters, who in effect are pulling the artistic strings of their Basque puppets.

Such an unequal cultural relationship, and the creation of this sort of cultural dependency, cannot but remind us of the broader East–West cultural divide that we analysed in Chapter 6. While it is relatively easy to recognise the presence of cultural vulnerability in Eastern relation to Western culture, it is more difficult to accept that within the West itself there might exist different relationships of cultural power between specific nations or geographical areas. Questions of cultural imperialism can, however, legitimately be raised even within the narrow confines of the West. Is the Guggenheim Bilbao a modern Iberian outpost of American artistic colonialism? Are the Bilbainos victims or, perhaps, willing collaborators? In their desperate drive to win a place on the cultural map, the Basque country has been more than happy to take the back seat that it has been offered. If this were to situate it at the edge rather than at the centre of any spotlight, so be it. 'With this unique space and this important collection', said Vidarte, 'we can be playing a role in the periphery that we could not be otherwise.'[39] It is, of course, possible to read these words as a statement of a new-found self-confidence. At the same time, however, to perceive oneself as being situated on the margin is a form of self-denigration, the expression of a sense of cultural inferiority that equates American culture with the dominant culture and assumes it to be the centre of power.

Like any other corporate predator that sees it as its task to 'protect' vulnerable businesses by taking them over, the Guggenheim is eager to take advantage of any sign of weakness in other cities and countries in its desire to build up its centrally controlled multinational museum empire. Or to put it hypothetically: would it be possible for the Guggenheim, say, to expect Londoners or Parisians to foot the huge bill of such a gigantic branch as the Bilbao, while maintaining a superior cultural position by reserving to itself the right to appoint a non-art specialist to be the

museum's general director in order that New York headquarters can continue to set its agenda?[40] According to the latest available estimate, the Guggenheim in New York faces annual interest and principal payments of over $6.5 million each year, if not considerably more, as a result of its aggressive expansion policies and the controversial bond issues it has raised at home.[41] The system of cultural territorial control and financial exploitation overseas is deployed in such a way as to maintain the financial stability of its domestic museum. What exactly are the differences, one may ask, between the overseas Guggenheim branches and the distant outposts of the empire of old as far as the acquisition of domination and the enrichment of the home economy are concerned?

The triumph of the Frank Gehry Bilbao has undoubtedly made the Guggenheim into a global power-brand. The spirit of extravagant optimism that has followed the Bilbao venture is such that Lyons, France's second city, and Liverpool in Britain were reported to be queuing up to court the Guggenheim for a franchising branch in their cities. In an article entitled 'Liverpool Woos Guggenheim', Flo Clucas, a Liberal Democrat City councillor, was reported as saying, 'All it [the Guggenheim] would have to do is supply the pictures.'[42] The *naïveté* of Clucas's statement leaves one wondering whether there are not perhaps already enough 'pictures' and treasures in Britain. But the irony is, of course, that Liverpool, with one of the largest proportions of unemployed and socially deprived inhabitants of any British city, will have to come up with a venture capital of £60 million or so to pay for the seemingly magical 'Guggenheim' franchise label. In any case, the £60 million is, one suspects, a considerable underestimation of the sort of sum that Liverpool would actually have to gamble if it were to become a serious player in the Guggenheim casino.

The operative word is, of course, 'gamble'. What exactly is at stake, and what are the anticipated winnings? Before the opening of the Bilbao Museum in late 1997, the Basque government anticipated that it would attract a modest 400,000 tourists a year. The overwhelming popularity that it immediately enjoyed has far exceeded its wildest expectations. But the question that remains is: can this short-term success, phenomenal though it is, be a panacea for all the urban ills of Bilbao? For how long will and can the Gehry Museum hold its pulling power for cultural tourists? In practical terms, of course, not every tourist to Spain can be counted upon to go out of

his or her way just to visit the Bilbao Museum. Secondly, the success of
Bilbao depends not only on the enormous publicity that it has so far gener-
ated, but also on the novelty of the whole venture, including its architecture.
No amount of literature will be sufficient to account for the snowballing
effect of the media 'hype' generated round the Gehry Bilbao venture. But
fashion in the art world is as fickle as the world of fashion itself. When the
media turn their attention to the next big artistic jackpot, when the buzz
and glamour surrounding the Guggenheim Bilbao die out in five (or ten?)
years' time, as they undoubtedly will, what tangible inheritance will be left
for the city and its people?

Given the inherent logic of expansionism, it is only reasonable to assume
that the artistic jackpot currently enjoyed by Bilbao will shift away from
Europe to a bigger and even more eye-catching venture – to the Frank
Gehry East River branch in Lower Manhattan, for example, or even to South
America, where there are plans for a Guggenheim branch in Rio de
Janeiro.[43] Such is the pace of change that developments that were unimag-
inable a few years ago are now taking place before our startled eyes. Who,
for example, could ever have anticipated a Guggenheim Las Vegas at the
Venetian, designed by Rem Koolhaas, to turn the resort-hotel-casino com-
plex into what the Museum claims will be 'the cornerstone of the continuing
cultural renaissance of Las Vegas'?[44]

What ultimately concerns us here is not the specific case of the
Guggenheim, but where this system of overseas cultural domination has
brought us to, and where it is likely to lead us in the twenty-first century.
Going multinational is not necessarily a global ambition prerogative exclu-
sive to the Guggenheim, however quintessentially American it may be. As
a matter of fact, the Boston Museum of Fine Arts, after many years of nego-
tiation, opened its first overseas branch in April 1999 in Nagoya, one of the
largest cities in Japan. In exchange for this Nagoya/Boston Museum of Fine
Arts, as it is known, the citizens of Nagoya have to pay its Boston head-
quarters a franchise fee of $50 million over 20 years, and it is at a time of
financial crisis in the Japanese economy from which the country has still not
fully emerged. And as with the Guggenheim deal, it is the American insti-
tution that has the final say on what art its Japanese clients will actually see,
even if its curatorial decisions should prove to run counter to the wishes of
the Japanese themselves.[45]

To explain the *raison d'être* of the venture, Alan Shestack, the then director of Boston Museum and the person who initiated the deal, readily admitted that: 'Institutions like ours, like businesses, follow society in general. People are thinking globally now in a way that they didn't use to.'[46] Is this now all too familiar global talk and all that goes with it a genuine celebration of global culture based on equal partnership? Or is globalism simply another form of promoting the colonial interests of the cultural superpower? 'To colonize', Edward Said once wrote, 'meant at first the identification – indeed, the creation – of interests.'[47] It was indeed more than anything else economic self-interest that lay at the root of the multinational ventures of both the Guggenheim and the Boston Museum. Both of them also undertook their lucrative overseas expansion with a sense of cultural superiority reminiscent of the colonialists of old who took their superiority over their subject races for granted. To quote Malcolm Rogers, the current director of the Boston Museum, 'It's a win-win situation. It's a financially rewarding agreement for us, and, I believe, an artistically rewarding one for Nagoya.'[48] The terms of reference may have changed, but the cultural superiority and the financial exploitation remain the same in this new game of cultural globalism. Globalism may have its validity as a utopian ideal, but the overseas expansion of American art institutions that we have witnessed over the last few years is the antithesis of idealism; it has been an exercise in pragmatism in which cultural imperialism and multinational capitalism have joined forces to consolidate existing hegemonies.

MILLENNIUM EXPANSION IN BRITAIN

Most British art institutions have so far shown no sign of embarking on the same sort of overseas expansion that their American counterparts have. On the contrary, Lars Nittve, director of the new Tate Modern, seems explicitly to rule out the possibility of such a move when he declares:

> We have distinctively different approaches than the Guggenheim. . . . One definitely has to do with the idea of expansion and the principles for expansion. . . . Most of the time I think it is much better if a gallery has sort of grown out of its natural local or regional situation, and that it grows from within, instead of being

planted there through … a sort of franchise strategy. . . . What's really crucial, especially these days, for the success of a gallery is that it is rooted in the place where it acts and works, … even if it is an international tourist attraction.[49]

It remains to be seen whether or not this is a genuine principled stance rather than a pragmatic realisation that not many British institutions are in as strong a position as their American equivalents to embark on such projects. Over the last few years, however, thanks to the ever-increasing availability of Lottery funds, museums and galleries in Britain have expanded, are expanding or have plans to expand. The scale of the undertakings is such that the Culture Secretary, Chris Smith, felt able, shortly after the millennium, to group and launch them all together as 'Millennium Openings'. The list is long and includes: Tate Britain (the Tate's original Millbank site) opened in March 2000, Tate Modern (in the transformed Bankside Power Station) in May, and a new building for the Dulwich Picture Gallery in May. These crown jewels of London galleries are also joined by an impressive list of expanded or newly built galleries up and down the country, such as the £70 million Lowry in Manchester (opened in April 2000) or, in the Black Country, the £21 million New Art Gallery in Walsall (opened in February).

Most of these museum projects could not, of course, have been realised without the injection of substantial Lottery grants, varying between 46 and 75%. Because of the stipulations of Lottery funding, all these Lottery-funded museums and art galleries have had, in principle, to raise private money to match their Lottery grants. Since the inception of the Lottery in 1995, the Arts Lottery, the Heritage Lottery and the Millennium Commission have poured more than £4 billion of Lottery cash into the arts and culture. Lottery recipients are, therefore, required to work harder and harder to raise not insubstantial sums from the corporate and private sectors. In a world where cultural resources, even before the Lottery, were already stretched, how far does an art institution have to compromise itself in order to raise the necessary funds?

Milk cows and fat cats

After two decades of enterprising culture in Britain, every imaginable way of extracting money from donors and sponsors has, one would have thought,

been explored and exhausted. What remains after the usual channels have dried up is another, perhaps even more valuable, commodity that can be traded, namely institutional space. Naming a room of a museum or part of an art gallery after its donor is not, of course, anything new. What is new, however, is the popularity of the phenomenon amongst benefactors, and the wholehearted way in which they have been willing to embrace this new means of making them part with their cash. One of the results of this has been to change not only the face but the whole geography of public museums. These are coming more and more to resemble patchworks of divided territories, each dedicated to a different sort of private wealth eager for eternity, or multinational corporate identity thirsting after global exposure.

Even a national institution as powerful as the British Museum has not fought shy of allowing its galleries to be baptised and re-baptised with an assortment of names of individuals and corporations that traffic between the most powerful circles of corporate and social life in Britain and abroad. The development of the Great Court, a two-acre square right at the heart of the Museum, obliged the Museum to raise some £51.25 million to qualify for Lottery grants of £45.75 million. The result is a veritable mosaic of sponsored spaces: the Clore Centre for Education (at a cost of £2.5 million), within which we have the Hugh and Catherine Stevenson Theatre (donors to the tune of £1 million), the Raymond and Beverly Sackler Rooms, the Equitable Charitable Trust Room, and, the latest addition, the BP Amoco Theatre (in exchange for some £2 million). The renowned Reading Room becomes the Walter and Leonore Annenberg Centre (thanks to their £6.7 million donation), within which again we have a Paul Hamlyn Library (in exchange for an unspecified but 'substantial' donation). No list of art donations these days can be deemed complete without the magic name of Sainsbury's; they also have endowed the Museum with their £4 million Sainsbury African Galleries in addition to £1 million to support the Education Centre.

In parallel to this distinguished list of individuals and corporations runs another long catalogue of the Museum's donors and gallery sponsors over the nineties. It includes the Wolfson Gallery of Rome, City and Empire in 1991, the Joseph E. Hotung Gallery of Oriental Antiquities (£2 million donation in 1992), the Asahi Shimbun Gallery in 1992, the various Raymond and Beverly Sackler Galleries (in 1991 and 1993), the Weston

Gallery of Roman Britain (for a donation of £1.7 million in 1997), the HSBC Money Gallery (which reportedly cost the bank £2 million in 1996), the Chase Manhattan Gallery of North America (at a reported cost of £1 million and opened in 1999), the Arthur I. Fleischman Gallery of the Greek Bronze Age and Fleischman Parthenon Introductory Galleries in 1998, and Roxie Walker Galleries in 1999, not to mention the numerous Japanese and Korean companies that chipped in to refurbish the galleries that display their own national treasures at the British Museum. To this should be added various miscellaneous exhibition or event sponsors, such as the BP Ethnography Showcase or the Glaxo Wellcome Programme for education. The Museum's second £100 million development plan kicked off in 1999, not surprisingly, with another big name, in the shape of the £5.4 million Wellcome Gallery of Ethnography.

These sponsored spaces, whether corporate or individual, have at least one thing in common, namely the desire to perpetuate the names of their benefactors. Naming a public space is a way of announcing to the world one's symbolic ownership of that space and of making some sort of statement of power. In the case of Sainsbury's, for example, where the family name and the corporate brand are one and the same, the donor as individual and the donor as corporate brand are able to feed off each other. This is hardly surprising since donors are wealthy precisely because they have made, or inherited, their fortune from marketplace enterprise. For this business elite, corporate advancement and social advancement are ultimately indistinguishable.

For corporate sponsors, naming also carries with it an ever-present global exposure for their corporate brand. In particular in the new world of the Internet, corporate sponsors such as the Chase Manhattan Bank or BP Amoco can not only display their corporate logos at the British Museum itself, but also link their own websites to that of the Museum. One can, for example, easily slip into, and bank at, the Chase Bank's website when browsing through the British Museum's website, or one can log on to the British Museum website under the corporate category 'supporting the arts' on the official BP Amoco website. The Internet has not only given corporate sponsors the benefit of a new sort of digitalised exposure, transmissible simultaneously to millions of its users, but also, by linking the websites of art institutions and commercial enterprises so closely, it has facilitated the merging of the identities of the different institutions. The easy access of the

electronic age has thus extended the buying power of sponsors well beyond the physical confines of the art institution.

As one of the most powerful cultural brands in Britain, the British Museum naturally has a much bigger gravitational field with which to attract private and corporate cash than the majority of art institutions in Britain. The mosaic of divided territories that now adorns the British Museum, however, can be seen as a pointer to what the future will have in store as the process of privatising culture gathers momentum under New Labour, which is becoming more and more the party of business and of the rich.

In its drive to boost private donations, be it in the arts or elsewhere, New Labour has further liberalised the tax laws which the previous Tory government had already substantially relaxed. The Gift Aid and other tax incentives have been made so favourable under New Labour that the *Guardian* was able to announce: 'Now giving really is receiving.'[50] In making giving more favourable from the donor's point of view, Gordon Brown, the Chancellor of Exchequer, declared, no doubt without irony, that he wanted to create a 'democracy of giving', where those who could help others came to the aid of those who could not.[51] In our context, however, arts donors tend to be much more well-off than ordinary donors. By avoiding raising the level of income tax while at the same time using tax incentives to encourage donations, New Labour is actually giving more power to the seriously rich (as opposed to the middle class) to affect the way in which public institutions are to develop. The danger is obvious: that public arts institutions in Britain might run the risk of becoming named monuments to a small clan of influential businessmen and to multinational giants.

Nowhere is the combination of individual fortune and corporate wealth more powerful than in the name of Sainsbury's. The Sainsbury family have adorned a wide variety of art institutions in the country since the eighties, prominent among which are the Sainsbury Centre for Visual Arts at the University of East Anglia (opened in 1978), Norwich, complete with a Sainsbury Research Unit and an art collection funded by the family; the Sainsbury Institute for the Study of Japanese Art and Culture (established in 1999), also in Norwich; and the Sainsbury Wing at the National Gallery (reportedly at a cost to the three Sainsbury brothers of £35 million in 1991). And then there are the Sainsbury African Galleries at the British Museum (at

a cost of £4 million) and the Sainsbury Exhibition Galleries at Tate Britain (for a reported donation of £5 million).

In 2000, for example, there were also arts programmes and exhibitions closely associated with Sainsbury's, such as the Sainsbury's Pictures for Schools, Sainsbury's Choir of the Year, Sainsbury's Youth Orchestra Series, Sainsbury's Checkout Theatre, *Faces of the Century: a Sainsbury's Photographic Exhibition* at the National Portrait Gallery and *At Home with Art* at the Tate Gallery and Homebase, the do-it-yourself chain store belonging to Sainsbury's plc. Despite its historical sounding title, *Faces of the Century* in fact featured an eclectic selection of photographs made by ten celebrities, including the exhibition's sponsor, Lord Sainsbury of Preston Candover, chair of Sainsbury's Arts Sponsorship Panel. Devised by Sainsbury's but described by the host gallery as a 'unique collaboration' between the two institutions, could this exhibition have been anything other than an own-label marketing exercise by Sainsbury's plc?

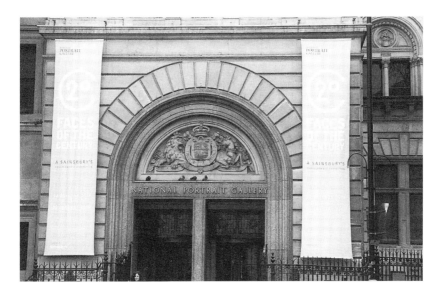

Figure 32 Banners advertising Sainsbury's exhibition at the National Portrait Gallery, London, 1999–2000.

DIY galleries

Similarly, the exhibition *At Home with Art* was billed as a 'unique collaborative project' between the Tate and Homebase. Indeed the project was so uniquely brokered that all the players involved were high-profile and powerful brand-names in the art world. Under the banner of the Tate Gallery, the project involved nine well-known artists (including four Turner Prize winners and three nominees) making objects to be mass-produced and sold at Homebase as well as the Tate's shops. The rationale was to make works by contemporary artists available, presumably at affordable prices, at non-art-gallery venues in the hope that such objects would find their way into ordinary homes. To kick off the project with style and to endow it with status, these objects were launched with a three-month front-house exhibition at the Tate Gallery. After its closure there, the exhibition was due to embark on a two-year national tour, organised by the National Touring Exhibition from the Hayward Gallery. The project also enjoyed the imprimatur of the Arts Council of England, which provided additional funding of £65,000 through its 'New Audiences' programme. No effort was spared to ensure that the project generated maximum media attention. A favourable public image was, of course, Homebase's aim for this project. As Paul Housego, the person in charge of the scheme at the store, was quoted as saying, 'We thought this project would differentiate Homebase from the competition and would be beneficial from the PR side.'[52]

This unexpected link between a mass-market DIY store and an elite national art institution like the Tate is one of the most intriguing aspects of the new intimate relationship in which public art institutions nowadays find themselves as they enthusiastically embrace private and corporate capital. Directing objects designed by artists to the mass market might have a time-honoured tradition behind it, but it is highly questionable whether the average Homebase shopper will pay £56.99 for an Anish Kapoor lamp (assuming they recognise the Kapoor label and its status in the art world) rather than its equally functional but anonymous equivalent retailing at under £10. The question that remains unanswered is, of course, to what extent the willingness of the Tate to lend its imprimatur to the project is in proportion to the cheque-writing powers of Sainsbury's, as exemplified by

their recent reported gift to Tate Britain of £5 million. Would it be think-able, one wonders, for the Tate to envisage a similar project with another, more utilitarian DIY store such as Wickes?

Nowhere is the slippery slope of privatisation more obvious than in 'the Unilever Series' that was unveiled at Tate Modern when the new gallery opened its doors in May 2000. The £1.25 million sponsorship deal that the Tate has struck with Unilever enables the Gallery to commission a piece of sculpture every year to adorn the massive 500 foot long × 115 foot high Turbine Hall at Tate Modern over the next five years. It will, of course, also provide a whole year's high-profile, high-status publicity for the sponsoring company for something that Niall FitzGerald, chairman of Unilever, calls 'our biggest art investment so far'. To quote FitzGerald:

> We've done this quite simply because it fits with our business goals. . . . Supporting what is an international commission of innovative creations in a new gallery, which will be internationally recognised, should be both a win-win for the Tate and Unilever[53]

The Tate Gallery is, of course, no newcomer to commercial sponsorship. Indeed it has been rather good in the past at enlisting art sponsors. The Gallery had, however, up until 'the Unilever Series', been rather discreet in acknowledging its sponsors. The decision to allow its displays to be adorned with a corporate name can only be regarded as a significant depar-ture, all the more so since the Tate has always in the past set the tone for other British art institutions. Does this indicate that in the future named exhibitions as well as named gallery spaces will become fixed landmarks on the cultural landscape, with multinational brands acting as its principal signposts?

A cultural landscape genetically modified by private wealth and multi-national capital presents a bleak picture. In other walks of life, popular pressure can be brought to bear on the power of the multinationals, as was seen by the retreat of Monsanto over the issue of GM food in Britain, or the massive anti-trade demonstration at the World Trade Organisation confer-ence in Seattle in 1999 and again in Prague in 2000. In art, however, no similar movement of protest or reaction seems to be forthcoming. This is likely, one might think, to continue to be the case as long as British art

institutions keep their eyes firmly fixed on self-aggrandisement and the short-term balance sheet, and as long as the artists whom they endorse continue to produce above all publicity-oriented and self-referential art designed for today's market.

TOWARDS A SAATCHI-FREE ZONE?

And there can be no doubt that, in Britain over the last two decades, the contemporary art market has been dominated by one single individual. Though his multinational business days are long behind him now, Charles Saatchi has occupied a position of unchallenged power in contemporary British art since the 1980s, and his influence continues into the new century. To give a detailed account of his art enterprise here, however, would mean adding more oxygen of publicity to his already gigantic advertising machine, and further glorifying his endeavours. Suffice it to say that his *Sensation* exhibition at the Royal Academy in London in 1997 successfully propelled his private collection into the public arena. It also thrust his pet YBA (young British artists) project into the media limelight as if it were some sort of coherent and representative art movement.[54] The publicity he enjoyed must have been music to the ears of such a past master in the art of selling images. Ever since, he has regularly been in the media headlines, first by auctioning off, in 1998, a large number of the works of artists from his stable, in order to establish art bursaries for graduate students, and then, in the following year, by donating 100 of his art works to the Arts Council Collection.[55]

Riding on the success of the *Sensation* exhibition, Saatchi authorised the publication in 1999 of a glossy coffee-table-sized art book entitled *Young British Art: The Saatchi Decade*.[56] Its audacious subtitle for the first time openly uses the name of a private collector-cum-dealer to define an entire decade of contemporary art production as if the latter owed its very existence to a single individual. No less revealing is the homage that the book pays to Saatchi's former client and erstwhile mentor, Margaret Thatcher, by having her photograph so prominently adorn its title page. As a political gesture this is not only nostalgic but also ambitious. Nostalgic because it harks back to the good old days of the Saatchi multi-national advertising empire of the eighties, the rise of which was intimately

related to the rise of Thatcherism. Ambitious because of the link it seems to be making between a general political 'achievement' of the eighties and a personal artistic claim for the nineties. What Margaret Thatcher had been for politics in the eighties, so Saatchi was, or clearly saw himself as being, for art in the nineties.

As a corporate executive Charles Saatchi is indeed the very epitome of the enterprise culture of the Thatcher decade. Like the cold-eyed shark in the work of his protégé, Damien Hirst, he has been swimming freely in the waters of the Thatcherite free market. If the multinational empire he chaired in the eighties now belongs to the past, he has nonetheless managed to continue his multinational operations through his art collecting/dealing enterprise. His *Sensation* exhibition became what, for want of a better term, could be called an 'art multinational', a show that he was only too ready to organise and bankroll to tour on the world stage. At the same time, however, as *Sensation* reached its controversial zenith in late 1999 in New York, the wheel of fortune turned: the National Gallery of Australia in Canberra cancelled its planned staging of the *Sensation* exhibition in June 2000 after the end of its New York season, and Saatchi's multinational art ambitions had their first set-back.

The advertising arm of Charles Saatchi and his brother Maurice, a mere shadow of its former self, also seems to have lost its touch of late. Despite the magical brand-name of Saatchi that had on three successive occasions succeeded in packaging and selling Margaret Thatcher's image to the British public, the £16 million contract that the brothers won from New Labour to market the Millennium Dome at Greenwich was a resounding flop. The Dome, much vaunted by the Prime Minister as 'the opening paragraph of New Labour's next election manifesto', proved to be less loved than laughed at by the media and the public. Its visual spectacles might have dazzled, but they lacked substance. Far from offering an inspiring vision of Britain in the new century, it stood as a New Labour monument to corporate sponsorship. In a January 2000 television interview the Prime Minister gave this explanation of his political project: 'The idea is that we can get beyond the traditional boundaries of left and right. You can have a pro-business, pro-enterprise, and pro-fairness political party, and that's possible to do.'[57] If the Dome could be described as a triumph of multinational capital, it was a triumph that, at the same time,

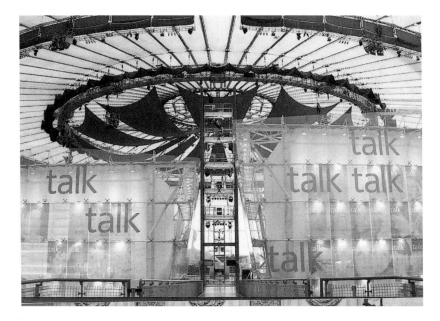

Figure 33 British Telecom's commercial showcase at the Millennium Dome, masquerading as the 'Talk' Zone, a wordplay on the BT soundbite 'It's good to talk'. It highlights the popular film character ET and associated screen music that are also featured in BT's frequent TV commercials.

received a vote of no confidence from the very people it was intended to impress. If it shows anything, it is that there is a wide culture gap not only between the government and the people who voted it into power, but also between the multinationals and the people upon whom their global empires ultimately depend. When government 'cosies up' to big business in the name of the people, or when multinationals dress up their commercial self-interest in the name of culture, it is ultimately left to the people to show how far they are willing to tolerate the unchecked power of big business. When other democratic means are ineffective, it is the people who alone have the collective power to resist.

A LAST WORD

Although the cultural and artistic developments that I have been describing had begun to emerge before 1980, it was the Reagan and Thatcher governments' pro-business ideology and their deliberate policy of encouraging corporate and private patronage that created the pervasive interlocking of the corporate and the artistic that so characterised the cultural landscapes in both America and Britain during the eighties. Their legacy is such that both the Democrats and New Labour could still claim, in 2000, to be wearing the Reagan–Thatcher mantle as they continued to advocate the values of business sponsorship and of the enterprise culture. Over the last two decades, the tentacles of the enterprise culture have not only embraced the cultural landscape of both countries, but have also reached deep into every corner of their national lives.

By taking over art museums, corporations have significantly changed the ways in which these institutions function, as well as our perception of them and of the art housed under their roofs. By enclosing art works within their premises, they have reframed the space and redefined discourse on contemporary art. While public arts funding in a capitalist democracy certainly has its limitations and its weaknesses, it is at least a forum, and one that is arguably open to public debate and criticism. Few corporations, on the other hand, could be made socially and politically accountable, not to say culturally responsible, to the same degree as the National Endowment for the Arts (and to a lesser degree the Arts Council) potentially can. No one can ever challenge effectively, for example, the ways in which corporations choose to utilise their numerous contemporary art collections, access to which is restricted to an inner circle of business associates and social elites while being denied to the general public. But can one challenge the force behind the establishment of such corporate art empires when their privileged and dominant position in the art world has been so clearly and loudly endorsed by the public policies of the Reagan and Thatcher decade and given official legitimacy? Where does the corporate end and the public begin? Without being made more accountable to the public interest, corporate America and Britain can never transform its pursuit of power and wealth into anything more than a public relations display, whatever temporary impact this may have on the art world.

To the extent that the privatising of art and culture has given rise to a host of developments – not all of them welcome or necessarily positive – that no one in the art world, particularly in Britain, could have anticipated, it is not unlike the opening of Pandora's box. But however many blessings may eventually be lost, there is perhaps comfort in the knowledge that hope will not be one of them. While the process of privatising culture in Britain and America has gone from strength to strength, there are other countries, France for example, that are more reluctant to follow down the path of this particular privatisation, and that continue to provide substantial state funding for the arts. Moreover, a hegemonic position is never absolute, depending as it does on the interplay of a whole set of different factors, and subject as it is to a never-ending process of negotiation and renegotiation. In the context of the present study, the current privileged position of corporations in the art world is not necessarily a permanent fixture – it depends, at the very least, on public policy, on business' own economic power, and, to some extent, on the ambitions and aspirations of arts institutions and their bureaucrats. Signs of impending strain and rupture within the system are admittedly few and far between, but it may well be that one day sites of resistance will form to question and challenge what for the present remains the dominant order.

NOTES

I INTRODUCTION

1. Colin Tweedy, 'Sponsorship of the Arts – An Outdated Fashion or the Model of the Future?', *Museum Management and Curatorship*, vol. 10, June 1991, p. 161.
2. Michael Useem, *The Inner Circle: Large Corporations and the Rise of Business Political Activity in the United States and United Kingdom* (New York: Oxford University Press, 1984).
3. C. Wright Mills, *The Power Elite* (New York: Oxford University Press, 1956), pp. 3–29.
4. Alan L. Feld, Michael O'Hare and J. Mark Davidson Schuster, *Patrons Despite Themselves: Taxpayers and Arts Policy* (New York: New York University Press, 1983); Don Fullerton, 'Tax Policy toward Art Museums', in Martin Feldstein, ed., *The Economics of Art Museums* (Chicago and London: University of Chicago Press, 1991), pp. 195–235. For detailed discussion, see Chapter 3.
5. Michael Useem and Stephen I. Kutner, 'Corporate Contributions to Culture and the Arts', in Paul DiMaggio, ed., *Nonprofit Enterprise in the Arts: Studies in Mission and Constraint* (Oxford: Oxford University Press, 1986), pp. 93–112, and Rosanne Martorella, *Corporate Art* (New Brunswick, NJ, and London: Rutgers University Press, 1990), pp. 137–40.
6. Pierre Bourdieu, *Distinction: A Social Critique of the Judgement of Taste*, trans. Richard Nice (London and Melbourne: Routledge and Kegan Paul, 1984), p. 228.

7. Such as James Sloan Allen, *The Romance of Commerce and Culture* (Chicago and London: University of Chicago Press, 1983).

8. Michael Useem, 'The Inner Group of the American Capitalist Class', *Social Problems*, vol. 25, 1978, pp. 225–40, and 'Corporations and the Corporate Elite', *Annual Review of Sociology*, vol. 6, 1980, pp. 41–77; Maurice Zeitlin, *The Large Corporation and Contemporary Classes* (New Brunswick, NJ: Rutgers University Press, 1989), pp. 3–60.

9. Paul DiMaggio, 'Cultural Entrepreneurship in Nineteenth-Century Boston', *Media, Culture and Society*, vol. 4, 1982, p. 35.

10. Adolf A. Berle and Gardiner C. Means, *The Modern Corporation and Private Property*, revised edition (first published 1932). (New York: Harcourt, Brace & World, 1967).

11. Useem, 'Corporations and the Corporate Elite', pp. 49–50.

12. Michael Useem argues that there are three stages of capitalism: family capitalism, managerial capitalism and institutional capitalism, in terms of organisation and ownership of the commercial enterprise. Family capitalism arose in the latter half of the nineteenth century and has been gradually replaced since the start of the twentieth century by what has come to be known as the 'managerial revolution', in which 'the priorities of the firm come to take precedence over the priorities of the founding family'. These two organisational principles are now joined by, and in part displaced by, what Useem describes as 'institutional capitalism', in which the transcorporate networks of ownership and directorships are the engines for change. According to him, 'All three simultaneously structure the ways in which business attempts to shape its environment.' See *The Inner Circle*, pp. 175–92.

13. For a discussion of David Rockefeller's power in America, see Thomas R. Dye, *Who's Running America? The Conservative Years* (Englewood Cliffs, NJ: Prentice-Hall, Inc., 1986), pp. 176–81.

14. Philip Stanworth and Anthony Giddens, eds, *Elites and Power in British Society* (Cambridge: Cambridge University Press, 1974), pp. 81–101, and Michael Useem, 'Pathways to Top Corporate Management', *American Sociological Review*, vol. 51, 1986, pp. 184–200.

15. Useem, *The Inner Circle*.

16. Paul DiMaggio, 'Social Structure, Institutions, and Cultural Goods: The Case of the United States', in Pierre Bourdieu and James S. Coleman, eds, *Social Theory for a Changing Society* (Boulder, CO: Westview Press, and New York: Russell Sage Foundation, 1991), p. 133.

17. Max Weber, 'Class, Status, and Party', *Economy and Society*, vol. 2, edited by Guenther Roth and Claus Wittich (Berkeley: University of California Press, 1978), pp. 926–40.

18. Joseph Galaskiewicz, *Social Organization of an Urban Grants Economy: A Study of Business Philanthropy and Nonprofit Organizations* (Orlando, FL: Academic Press, 1985).

19. 'Hammer Museum Nailed by Lawsuits', *Art in America*, vol. 77, no. 7, July 1989, pp. 31, 167; Suzanne Muchnic, 'Hammer's Victory', *Artnews*, vol. 89, November 1990, p. 47. The management of the Hammer Museum was assumed by the University of California, LA, in 1992.

2 PUBLIC ARTS FUNDING IN AMERICA AND BRITAIN: PRELIMINARIES

1. Although the Arts Council of Great Britain was renamed as the Arts Council of England on 1 April 1994, the ACGB was the name by which it was known throughout the eighties, and is therefore used in this book.

2. There are numerous examples of this discourse; see, *inter alia*, Thomas W. Leavitt, 'A Symposium: Issues in the Emergency of Public Policy,' in W. McNeil Lowry, ed., *The Arts and Public Policy in the United States* (Eaglewood Cliffs, NJ: Prentice-Hall, 1984), p. 40, and Robert Hutchison, *The Politics of the Arts Council* (London: Sinclair Browne, 1982), p. 13.

3. Interview, August 1992, London.

4. Carol Duncan, *Civilizing Rituals: Inside Public Art Museums* (London: Routledge, 1995), p. 57.

5. For discussion of art works in the international arena, see Judith Huggins Balfe, 'Artworks as Symbols in International Politics', *The International Journal of Politics, Culture and Society*, vol. 1, no. 2, Winter 1987, pp. 195–217.

6. Cited in Charles D. Webb, 'Museums in Search of Income', in Scottish Museums Council, ed., *The American Museum Experience* (Edinburgh: HMSO, 1985), p. 76.

7. Although the terms 'museums' and 'galleries' have different meanings in Britain from those in America, for convenience 'art museums' will hereafter be used to refer to both art museums in America and art galleries in Britain, unless the context is a specifically British one.

8. Perry T. Rathbone, 'Influences of Private Patrons', in Lowry, ed., *The Arts and Public Policy*, p. 40.

9. Craig R. Whitney, 'Britain's Needy Arts Are Looking for Patrons', *The New York Times*, 6 May 1989.

10. J. B. Thompson, *Ideology and Modern Culture* (Cambridge: Polity, 1990), pp. 238–41.

11. Raymond Williams, *Keywords* (London: Fontana/Croom Helm, 1976), p. 242.

12. Jürgen Habermas, *The Structural Transformation of the Public Sphere*, trans. Thomas Burger (Cambridge, MA: MIT Press, 1989).

13. Jürgen Habermas, 'The Public Sphere', *New German Critique*, no. 3, Fall 1974, p. 49.

14. For discussion on the Boston Museum, see DiMaggio, 'Cultural Entrepreneurship', pp. 33–50; for the Tate Gallery, see John S. Harris, *Government Patronage of the Arts in Great Britain* (Chicago and London: University of Chicago Press, 1970), pp. 17–18, and Brandon Taylor, 'From Penitentiary to "Temple of Art"', in Marcia Pointon, ed., *Art Apart* (Manchester: Manchester University Press, 1994), pp. 9–32.

15. Karl E. Meyer, *The Art Museum: Power, Money, Ethics* (New York: William Morrow and Company, 1979), p. 211.

16. Ibid., p. 26.

17. It was limited to 15% of personal taxable income.

18. Quoted in Ralph Miliband, *The State in Capitalist Society* (London: Quartet Books, 1969), pp. 72–3.

19. Feld et al., *Patrons Despite Themselves*, pp. 44–8, and Don Fullerton, 'Tax Policy toward Art Museums', in Feldstein, ed., *The Economics of Art Museums*, pp. 195–235.

20. 'Artful Management', *Art & Auction*, October 1987, pp. 164–5, and Lorraine Glennon, 'Great Gifts: Corporate Benefaction of Note', *Art & Antiques*, May 1986.

21. 'A Gift to the Renwick', *Ceramics Monthly*, vol. 42, September 1994, p. 61.

22. Fullerton, 'Tax Policy toward Art Museums', p. 208.

23. Fullerton did argue that Congress had always felt an inherent tension between the desire for incentive and the desire for actual and perceived fairness: 'Although these provisions may provide incentive for worthy goals, they become counterproductive when taxpayers are allowed to use them to avoid virtually all tax liability. The ability of high income taxpayers to pay little or no tax undermines respect for the entire tax system and, thus, for the incentive provisions themselves' (US Congress, Joint Committee on Taxation, 1986, quoted in ibid.).

24. Between 1991 and 1992, there was the so-called 'window of opportunity', an experimental measure introduced by Congress, in which the donor could deduct the current market value for appreciated tangible personal property (such as artworks and historical artefacts, but not for such things as securities and real estate). In 1993 Congress permanently reinstated the 'double incentives'. For more detail, see Andy Finch, *Congressional and IRS Actions on Museum Tax Issues* (Washington, DC: American Association of Museums, 1995).

25. Rob Kenner, 'Charity Cases', *Art & Antiques*, vol. 6, September 1989, p. 21.

26. The donor would lose the benefit of not paying capital-gains tax, and have to subject the art work to a real test of market price, rather than the appraised one, which is susceptible to overestimation.

27. Geoffrey Platt, 'Converting Private Wealth to Public Good', *Museum News*, vol. 70, May/June 1991, p. 100.

28. *A Sourcebook of Arts Statistics: 1989* (Washington, DC: NEA, 1990); *Data Report: From the 1989 National Museum Survey* (Washington, DC: Association of American Museums, 1992), and Feldstein, ed., *The Economics of Art Museums*.

29. A detailed analysis of the surveys conducted by the Association can be found in Richard N. Rossett, 'Art Museums in the United States', in Feldstein, ed., *The Economics of Art Museums*, pp. 129–77.

30. Other data on the income of art museums do not even include any item on the value of donated art works; see *A Sourcebook of Arts Statistics: 1989*, p. 570.

31. Richard W. Walker, 'Generosity Will Cost More, IRS Tells Donors', *Artnews*, vol. 84, no. 3, March 1985, pp. 25–6.

32. Karl Meyer made a similar claim: 'The explosive growth of art museums in the United States could never have taken place without the silent, generous, and usually unacknowledged partnership of the American taxpayer'; see *The Art Museum*, p. 256.

33. These were the words of British Arts Minister Norman St John-Stevas, reported in 'Government and the Arts', *Burlington Magazine*, vol. 121, December 1979, p. 753.

34. 'At the U.S. Treasury Department, Neubig and Joulfaian estimate that the total tax expenditure for the charitable deduction would have been $16.45 billion in 1988 under the old law but it was reduced to $12.87 billion by the lower rates of the Tax Reform Act of 1986'; cited in Fullerton, 'Tax Policy toward Art Museums', p. 196.

35. Feld et al., *Patrons Despite Themselves*, p. 69.

36. The Met's building actually belongs to the City of New York.

37. The property tax rate for that year was 8.795%; see Feld et al., *Patrons Despite Themselves*, p. 69.

38. Membership fees or subscriptions paid to a qualified charitable organisation are deductible as charitable contributions to the extent that payments exceed the monetary value of the benefits and privilege available by reason of such payments; see Byrle M. Abbin, Diane Cornwell, Richard A. Helfand, Michael Janicki, Ross W. Nager and Mark L. Vorsatz, *Tax Economics of Charitable Giving* (Chicago: Arthur Andersen & Co., 1991), pp. 16–17.

39. Not-for-profit organisations are ordinarily exempt from business income tax; see Finch, *Congressional and IRS Actions*, p. 49.

40. Cited in Feldstein, ed., *The Economics of Art Museums*, p. 106.

41. Charles T. Clotfelter, 'Government Policy toward Art Museums in the United States', in Feldstein, ed., *The Economics of Art Museums*, p. 254.

42. William H. Luers, 'Museum Finance', in Feldstein, ed., *The Economics of Art Museums*, p. 71.

43. Judd Tully, 'Ending of the Chilling Effect', *Artnews*, vol. 92, no. 8, October 1993, p. 44.

44. J. Carter Brown, 'General Overview', in Feldstein, ed., *The Economics of Art Museums*, p. 107.

45. Jane R. Glaser, 'USA Museums in Context', in Scottish Museums Council, ed., *The American Museum Experience* (Edinburgh: HMSO, 1985), p. 11.

46. *Commonwealth of Pennsylvania* v. *Barnes Foundation*, 398 Pa. 458, 159 A. 2d 500 (1960); cited in Feld et al., *Patrons Despite Themselves*, p. 142.

47. Quoted in Marie C. Malaro, *A Legal Primer on Managing Museum Collections* (Washington, DC: Smithsonian Institution Press, 1985), p. 16.

48. Arts Council of Great Britain, *Arts Council of Great Britain Royal Charter*, 1967.

49. John Maynard Keynes, 'The Arts Council: Its Policy and Hopes', *Listener*, 12 July 1945, p. 31.

50. Harris, *Government Patronage*, p. 26; F. M. Leventhal, '"The Best for the Most": CEMA and State Sponsorship of the Arts in Wartime, 1939–1945', *Twentieth Century British History*, vol. 1, no. 3, 1990, pp. 291–4, and B. Ifor Evans and Mary Glasgow, *The Arts in England* (London: Falcon Press, 1949), p. 35.

51. Robert Hewison, *Culture and Consensus: England, Art and Politics since 1940* (London: Methuen, 1995), p. 34.

52. *The Arts Council of Great Britain 4th Annual Report 1948–49*, p. 12.

53. Cited in Harold Baldry, *The Case for the Arts* (London: Secker and Warburg, 1981), pp. 14–15.

54. Sir W. E. Williams, 'The Pre-history of the Arts Council', in E. M. Hutchison, ed., *Aims and Action in Adult Education 1921–1971* (London: National Institute of Adult Education, 1971), p. 21.

55. *The Arts in War Time: A Report on the Work of C.E.M.A. 1942 & 1943* (London: The CEMA, n.d.), p. 18.

56. Andrew Sinclair, *Arts and Cultures* (London: Sinclair-Stevenson, 1995), pp. 27–49.

57. Kenneth Clark, *The Other Half* (London: John Murray, 1977), p. 26.

58. For Keynes' involvement in the arts, see Milo Keynes, ed., *Essays on John Maynard Keynes* (Cambridge: Cambridge University Press, 1975).

59. Raymond Williams, 'The Arts Council', *Political Quarterly*, vol. 50, no. 2, Spring 1979, p. 166.

60. Roy Shaw, 'Can a Million Flowers Bloom?', *Arts Express*, August/September 1985, p. 25.

61. Francis V. O'Connor, ed., *Art for the Millions* (Boston: New York Graphic Society, 1975).

62. In 1970, a Council of Europe symposium decided that the term 'democratisation of culture' should be replaced by 'cultural democracy', meaning 'working from the grass roots upwards instead of from the top downwards'; see Roy Shaw, *The Arts and the People* (London: Cape, 1986), p. 133.

63. Jane De Hart Mathews, 'Arts and the People: The New Deal Quest for a Cultural Democracy', *Journal of American History*, vol. 62, no. 2, September 1975, pp. 316–39.

64. Ibid., p. 322.

65. *The Pilgrim Trust 11th Annual Report 1941*, p. 17.

66. Isobel Johnstone, 'Outing Art', *The Art Quarterly*, no. 9, September 1992, p. 37.

67. Arts Council of Great Britain, *Arts Council Collection*, 1979, p. 7.

68. Arts Council of Great Britain, *Arts Council Collection Acquisitions 1979–83*, 1984, p. 6.

69. Ibid., p. 8.

70. Interview with Isobel Johnstone, curator of the Arts Council Collection, on 22 February 1995.

71. Graham Marchant Associates, *Where Do We Go Next?*, commissioned by Arts Council of Great Britain, March 1992, p. 31.

72. Sir Hugh Willat, *The Arts Council of Great Britain: The First 25 Years* (London: ACGB, 1971), p. 23.

73. Museums and Galleries Commission, *Museum Travelling Exhibitions* (London: HMSO, 1983), p. 14.

74. Graham Marchant Associates, *Where Do We Go Next?*

75. Interview with Isobel Johnstone, on 15 September 1995; see also Johnstone, 'Correspondence', *Art Monthly*, no. 148, July/August 1991, p. 31.

76. Isobel Johnstone, 'Foreword', *Arts Council Collection*, p. 6.

77. Nicholas Pearson and Andrew Brighton, *The Economic Situations of Visual Artists* (London: Calouste Gulbenkian Foundation, 1985), pp. 126, 130.

78. Tom Lubbock, 'Buy Young, Buy Cheap!', *The Independent on Sunday*, 4 March 1990.

79. 'A Publicist and Patron Presents "New" Collection', *Art and Antiques Weekly*, 19 January 1980.

80. Marina Vaizey remarked: 'The Arts Council collection of more than 6,000 works has been seen over the years by millions but nobody seems to have heard of it'; see 'Quiet Spread of Good Works', *The Sunday Times*, 4 March 1990.

81. Ibid.

82. 'Art for Everyone' is the title of an article written by Isobel Johnstone; see *National Art Collections Fund Review 1991*, pp. 78–82. 'An archive of good intentions' was Brandon Taylor's phrase to describe the Collection; see 'Shocks to the System', *Art Monthly*, no. 146, May 1991, p. 19.

83. The sculpture concerned is called *Toy* and consists of a galvanised steel wash-tub filled with metal, and an empty sardine tin 'floats' on it. The sardine tin was said to represent the Argentinian battleship *General Belgrano*, sunk during the Falklands War; see Brian Vine, 'The Great Rubbish Collection', *The Daily Mail*, 15 August 1984; 'Rage at £600 Fish Tin in Wash Tub "Sculpture"', *Liverpool Daily Post*, 14 August 1984.

84. For an analysis of the various forms of artist-managed exposure, see Batia Sharon, 'Artist-Run Galleries – A Contemporary Institutional Change in the Visual Arts', *Qualitative Sociology*, vol. 2, no. 1, 1979, pp. 3–28.

85. Lawrence Alloway, 'When Artists Start Their Own Galleries', *The New York Times*, 3 April 1983. For a comparative view on alternative spaces in Britain in particular in the nineties, see Malcolm Dickson, 'Another Year of Alienation: On the Mythology of the Artist-Run Initiative', in Duncan McCorquodale, Naomi Siderfin and Julian Stallabrass, eds, *Occupational Hazard: Critical Writing on Recent British Art* (London: Black Dog, 1998), pp. 80–93; and Julian Stallabrass, 'Artist-Curators and the "Alternative" Scene', in *High Art Lite* (London and New York: Verso, 1999), pp. 49–83.

86. Martha Gever, 'Growing Pains: Artists' Organizations in the '80s', *Afterimage*, vol. 11, no. 6, January 1984, p. 3.

87. The NEA budget grew more than ten-fold from $8.5 million in 1969 to $94 million in 1977 when Nancy Hanks was its chairwoman.

88. O'Doherty was the director of the Program from 1969 to 1976, and Melchert from 1976 to 1981. Melchert, for example, was reported to be 'interested in promoting alternatives (i.e. non-market) systems for the support of contemporary art'; see Allen, 'The (Declining) Power of Review', *New Art Examiner*, November 1981, pp. 12–13.

89. Phil Patton, 'Other Voices, Other Rooms: The Rise of the Alternative Space', *Art in America*, July/August 1977, vol. 65, no. 4, p. 81.

90. In 1982 Artists' Spaces were renamed 'Visual Artists Organizations'; see the fact sheet on 'Visual Arts Program History of Funding for Visual Artists Organizations 1971–1988', unpublished manuscript, National Endowment for the Arts, n.d.

91. The first statistical data nationwide were completed by the Endowment and the National Association of Artists' Organizations in Washington, DC, in August 1985, when these spaces had matured and become institutionalised over the years; see *Visual Artists' Organizations Fiscal Year 1982–83*, unpublished report, National Endowment for the Arts.

92. Following the museum expansion fever in the 1990s, the P.S.1 merged with the Museum of Modern Art in 1999, becoming part of the mainstream establishment. For museum expansion, see Chapter 9.

93. Nancy Foote, 'The Apotheosis of Crummy Space', *Artforum*, vol. 15, October 1976, pp. 26–36.

94. Patton, 'Other Voices', p. 81.

95. Ibid.

96. Brian O'Doherty, 'National Endowment for the Arts: The Visual Arts Program', *American Art Review*, vol. 3, no. 4, July/August 1976, p. 68.

97. Quoted in Grant Kester, 'Rhetorical Questions: The Alternative Arts Sector and the Imaginary Public', *Afterimage*, vol. 20, no. 6, January 1993, p. 11.

98. Interview with Michael Faubion, Assistant Director of the Visual Arts Program, NEA, Washington, DC, on 3 October 1990. Faubion pointed out: 'We don't set a number; sometimes, it used to be the case the board of trustees were all artists. Right now in 1990 that's rare.'

99. Kester, 'Rhetorical Questions', p. 12.

100. Judy Moran and Renny Pritikin, 'Some Thoughts: Artists' Organizations Contrasted to Other Arts Organizations', *Afterimage*, vol. 14, no. 3, October 1986, p. 17.

101. Quoted in Kester, 'Rhetorical Questions', p. 12.

102. Patricia Davidson, 'The Concept of Common Knowledge', *Afterimage*, vol. 14, no. 3, October 1986, p. 20.

103. Charles Simpson, *SoHo: The Artist in the City* (Chicago: University of Chicago Press, 1981).

104. Sharon Zukin, *Loft Living* (New Brunswick, NJ: Rutgers University Press, 1989).

105. Anne E. Bowler and Blaine McBurney, 'Gentrification and the Avant-Garde in New York's East Village', in J. H. Balfe, ed., *Paying the Piper: Causes and Consequences of Art Patronage* (Urbana and Chicago: University of Illinois Press, 1993), p. 176.

106. Andy Grundberg, 'When Outs are In, What's Up', *The New York Times*, 26 July 1987.

107. Bowler and McBurney, 'Gentrification and the Avant-Garde', p. 177.

108. Rosalyn Deutsche and Cara Gendel Ryan, 'The Fine Art of Gentrification', *October*, Winter 1984, p. 104. Another exception was the NFS (Not For Sale) project on the Lower East Side in 1983–84, as Gregory Sholette kindly reminds me.

109. Paul DiMaggio, 'Can Culture Survive the Marketplace?' in DiMaggio, ed., *Nonprofit Enterprise*, p. 90.

3 THE CHANGING ROLE OF GOVERNMENT IN THE ARTS

1. Ronald Reagan, 'Economic Recovery Will Take Time', in Alfred Balitzer, ed., *A Time for Choosing* (Chicago: Regnery Gateway, 1983), p. 240.

2. Sir Roy Shaw, in *Ministering to the Arts*, presented by Sir Roy Strong, BBC Radio 4, London, September 1992.

3. Quoted in Henri Temianka, 'Creators in a Creative Society', *Saturday Review*, 23 September 1967, p. 30.

4. Quoted in 'The Candidates Respond', *American Arts*, vol. 11, no. 2, May 1980, p. 21.

5. Carla Hall, 'Arts Reshuffle? Independent Agencies May Replace NEA, NEH', *The Washington Post*, 15 April 1981; Grace Glueck, 'Independent Corporation Weighed as Arts Agency', *The New York Times*, 14 April 1981.

6. Charles Heatherly, ed., *Mandate for Leadership* (Washington, DC: The Heritage Foundation, 1980), p. 1055.

7. Quoted in Ward Sinclair and John M. Berry, 'Reagan Budget Team Proposes Cuts Across Broad Spectrum', *The Washington Post*, 8 February 1981.

8. Fraser Barron, 'A Mission Renewed: The Survival of the National Endowment for the Arts, 1981–1983', *Journal of Cultural Economics*, vol. 11, no. 1, June 1987, p. 55.

9. 'Reagan Names Task Force to Study New Form for Endowments', *The New York Times*, 7 May 1981, and Carla Hall, 'NEA, NEH Review', *The Washington Post*, 7 May 1981.

10. David Perry, 'Committee for Change', *Horizon*, July/August 1986, p. 35.

11. Interview with Malcolm Richardson on 25 April 1995.

12. Presidential Task Force on the Arts and Humanities, *Report to the President* (Washington, DC, 1981).

13. Ibid.

14. William Keens, 'An Interview with Frank Hodsoll', *American Arts*, vol. 13, no. 1, January 1982, p. 8.

15. Lois Romano and Jennifer Hirshberg, 'Ford's Gala Pols Meet Show-Biz', *The Washington Star*, 23 March 1981, and Joseph McLellan, 'Stars and Austerity at Ford's Theater Gala', *The Washington Post*, 23 March 1981.

16. AMCON Group, Inc., *Seminar on Business Support of the Arts*, 3 June 1981, New York, p. 52.

17. National Endowment for the Arts, *National Endowment for the Arts, 1965–1985*, Washington, DC, 1985, pp. 44, 52.

18. The declaration appeared in advertisements first in *Business Week* on 24 November 1980, and was repeated elsewhere.

19. Press Release from Office of the Press Secretary, the White House, on 8 July 1991; see also President's Committee on the Arts and the Humanities, 'Summaries of Current Initiatives and Activities', revised on 19 June 1984, unpublished.

20. Louise Sweeney, 'Thank you, Helen Hayes, Rudolf Serkin, Gordon Parks . . .', *The Christian Science Monitor*, 10 August 1988.

21. Internal Revenue Code, Section 170(b)(2) and 170(d)(2).

22. Michael Useem, 'Corporate Support for Culture and the Arts', in Margaret Jane Wyszomirski and Pat Clubb, eds, *The Cost of Culture: Patterns and Prospects of Private Art Patronage* (New York: American Council for the Arts, 1989), pp. 45–62.

23. Michael Useem, 'Corporate Philanthropy', in Walter W. Powell, ed., *The Nonprofit Sector* (New Haven: Yale University Press, 1987), p. 352.

24. Other determinants include company income, the impact of leadership, and metropolitan and national business cultures; see Useem, 'Corporate Philanthropy', and Useem and Kutner, 'Corporate Contributions to Culture and the Arts'.

25. Quoted in Baldry, *The Case for the Arts*, p. 32.

26. Quoted in Richard Evan, 'Arts Cash Still Low Priority', *The Financial Times*, 28 May 1980, and Tony Conyers, 'State Cannot Be Part of Arts Revival', *The Daily Telegraph*, 28 May 1980.

27. Charles Spencer, 'Arts Get Boost and a Budget', *The Evening Standard*, 16 June 1983.

28. Baldry, *The Case for the Arts*, p. 32.

29. Nicholas de Jongh, 'Stevas Launches Drive for More Arts Sponsorship', *Guardian*, 11 June 1980.

30. The figure was quoted by ABSA, reached on the basis of scanty research and some guesswork.

31. Nicholas de Jongh, 'Businessmen Get £25,000 to Back Arts', *Guardian*, 30 April 1980.

32. Kenneth Gosling, 'Fund-Raisers for Arts Get £25,000 State Aid', *The Times*, 30 April 1980.

33. Keith Nurse, 'Firms to be Urged to Sponsor Arts', *The Daily Telegraph*, 11 June 1980.

34. Office of Arts and Libraries, *The Arts are Your Business*, London, 1981.

35. 'Richard Luce', *House Magazine*, 14 April 1990.

36. Quoted in *absa Bulletin*, Autumn 1987, p. 2.

37. The incentive funding scheme is similar to the BSIS introduced in 1984 by the government, both based on the principle of matching grant. But the main difference is, to use J. Mark Davidson Schuster's terms, that the BSIS is a 'reverse matching grant', which means that 'these grant programs reverse the logic of the traditional matching grant; they allow the private donor to make resource allocation decisions that are *followed*, rather than *led*, by the public sector's match'; see 'Government Leverage of Private Support', in Wyszomirski and Clubb, eds, *The Cost of Culture*, p. 66.

38. Arts Council of Great Britain, *Better Business for the Arts*, 1988.

39. J. Mark Davidson Schuster, 'The Interrelationships Between Public and Private Funding of the Arts in the United States', *The Journal of Arts Management and Law*, vol. 14, no. 4, Winter 1985, p. 95.

40. Peter Chippindale and Chris Horrie, 'Gentlemen's Club plc', *New Statesman*, 16 December 1988, pp. 23–4.

41. See *The Business Sponsorship Incentive Scheme Application Form valid from 1 April 1993 to 31 March 1994*, p. 3.

42. Timothy Renton MP, in *Ministering to the Arts*, as in note 2 above.

43. Bill Baker, 'British Aim to Put the Dynamo Back into Kiev', *Guardian*, 4 June 1990, and Martin Kettle, 'On the Road with Mars and Marlboro', *Guardian*, 21 June 1990.

44. Peter Palumbo, 'The Arts Council', *RSA Journal*, September 1990, p. 682.

45. It is impossible to discuss the whole range of tax policy in relation to the arts within the scope of this study. In addition to the charitable contribution/deed of covenant and gift aid, it may also include capital transfer tax and capital-gains tax, gifts in kind, secondment of staff, etc.

46. Alvin Toffler, *The Culture Consumer* (New York: St Martin's Press, 1964), p. 187.

47. Feld et al., *Patrons Despite Themselves*.

48. Basically the net cost of a taxpayer's donation varies with their tax bracket. Examples were given by Michael O'Hare: 'The taxpayer with a 50% marginal tax rate, for example, who writes a hundred dollar check to his local museum, is spending only fifty dollars of his own money, and inducing the government to spend fifty dollars of taxpayer's money to support the museum. But the tax-payer in a 14% bracket will have to spend $86.00 of his own money, because the government will only contribute $14.00, to make up a total gift of $100. If we compare instead taxpayers each willing to contribute $100 of their own funds, we will find that a taxpayer in the highest bracket can, with $100 of his own money, call forth $233 of government assistance. (He does this, of course, by writing a check for $333.) The taxpayer in the lowest bracket will find that his $100 contribution calls forth only $16 matching money from the government.' See Michael O'Hare, 'U.S. Practice & Policy', in Hamish R. Sandison and Jennifer Williams, eds, *Tax Policy and Private Support for the Arts in the United States, Canada and Great Britain* (Washington, DC: British American Arts Association, 1981), p. 50.

49. Sir William Pile, 'Chairman's Summing Up', in Sandison and Williams, eds, *Tax Policy and Private Support for the Arts*, p. 44.

50. The 'friendliness' of American tax incentives is a popular myth among most arts advocates in Western countries. They claim that the low level of private support in certain countries is due to a less generous tax policy, and have always urged the government to 'liberalise' the tax regime in relation to the arts without ever mentioning the implied social cost and tax expenditure. However, J. Mark Davidson Schuster suggested that 'the real difference in

levels of private support seems to lie more in historic patterns of patronage and modern importance of the public sector in support of artistic activities than it does in difference between tax laws'; see NEA, *Supporting the Arts: An International Comparative Study* (Washington, DC: NEA, 1985), p. 52.

51. Conservative Political Centre, *Government and the Arts* (London: Conservative Political Centre, 1962), p. 28.

52. Michael Fogarty and Ian Christie, *Companies and Communities* (London: Policy Studies Institute, 1990), p. 63. According to the Inland Revenue, a deed of covenant is 'a legal document. It is a written agreement under which one person promises to make a series of payments to another person for nothing in return. It is binding on the person who makes the promise'; see *Deeds of Covenant* (London: Inland Revenue, 1987).

53. J. Mark Davidson Schuster, 'The Non-Fungibility of Arts Funding', in Harry Hillman-Chartrand, ed., *The Arts: Corporations and Foundations* (Ottawa: The Canada Council, 1985), p. 7.

54. *Covenants: A Practical Guide to the Tax Advantages of Giving*, 2nd edition (London: Directory of Social Change, 1985), pp. 28–9.

55. A close company for tax purposes is a company 'whose ownership is controlled by a limited group of shareholders (five or fewer participators)'; see Michael Norton, *Tax Effective Giving*, 6th edition (London: Directory of Social Change, 1992), pp. 105–6.

56. The donation given in this way is made out of gross income before PAYE tax is calculated, so the donor will pay tax only on the amount left after the gift has been deducted. Accordingly, unlike the covenant, it is the donor, not the charity, that benefits from the tax relief. For basic information, see *Giving to Charity: How Individuals Can Get Tax Relief*. Inland Revenue Leaflet Series IR65 (London: Inland Revenue, 1993).

57. There is no minimum or maximum limit for a Gift Aid payment to charity by open (non-close) companies. These two kinds of companies operate under slightly different rules; see *Gift Aid: A Guide for Donors and Charities* (London: Inland Revenue, 1990) and *Giving to Charity: How Business Can Get Tax Relief*, Notes Series IR64, 1986 and 1993 editions (London: Inland Revenue).

58. *Business Support for the Arts in Europe* (London: Arthur Andersen, 1991), and Milton C. Cummings Jr. and Richard S. Katz, eds, *The Patron State: Government and the Arts in Europe, North America and Japan* (New York: Oxford University Press, 1987).

59. *Business Sponsorship Incentive Scheme Application Form valid from 1 April 1994 to 31 March 1995*.

60. Arts Council of Great Britain, *Partnership: Making Arts Money Work Harder*, 1986, p. 16.

61. Williams, 'The Arts Council', p. 160.

62. Simon Tait, 'Surprise Choice Became Able Administrator', *The Times*, 29 March 1990.

63. *Arts Council 43rd Annual Report*, p. 24.

64. The article was entitled 'Business and the Arts', see *Arts Council 44th Annual Report*, pp. 36–7.

65. *Arts Council 43rd Annual Report*.

66. Peter Palumbo, 'Chairman's Introduction', *Arts Council 44th Annual Report*, p. 3.

67. The words of Dylan Hammond, Director of Marketing and Resources, *Arts Council 45th Annual Report*, p. 29.

68. Midland Bank leaflet, *Help the Arts: Use an Artscard*. The Midland Bank has since been taken over by HSBC.

69. Telephone conversation with Denise Farrow, Midland Bank, on 21 February 1995.

70. Telephone conversation with Toby Scott, Business Assessment and Planning, Arts Council of England, on 31 January 1995, and further interview with him on 14 February 1995.

71. Prudential Corporation, London, *Prudential Awards for the Arts 1992*, p. 18.

72. 'Independent' galleries or museums form part of a peculiarly British arts bureaucrats' terminology. It certainly does not mean financially 'independent' from the Arts Council or any other public funding agencies.

73. Antony Thorncroft, 'South Bank Savings', *The Financial Times*, 15 November 1986.

74. Chris Tighe, 'English Estates Puts its Faith in the Market', *The Financial Times*, 12 July 1991.

75. The leaflet is entitled, *Arts Council Collection: The Collection Visits You*, published by the South Bank Centre, n.d.

76. Peter Palumbo, 'Preface', *Arts Council Collection Acquisition 1984–88* (London: ACGB/South Bank Centre, n.d.), p. 9.

77. Tim Hilton, 'The Style Council', *Guardian*, 7 March 1990, and 'Hung, Drawn but not yet Slaughtered', *Guardian*, 27 August 1992.

78. National Endowment on the Arts and Humanities Act of 1965, Public Law 209-89th Congress.

79. Fannie Taylor and Anthony L. Barresi, *The Arts at a New Frontier: The National*

Endowment for the Arts (New York: Plenum Press, 1984); see also Margaret Jane Wyszomirski, 'The Politics of Art', in Jameson W. Doig and Erwin C. Hargrove, eds, *Leadership and Innovation* (Baltimore: Johns Hopkins University Press, 1987), pp. 207–45.

80. The chairman of the NEA is appointed by the president for a four-year term upon Senate confirmation. But unlike the chairman of the Arts Council, the NEA chairman is the chief administration officer within the Endowment.

81. Francis S. H. Hodsoll's *résumé*, from the White House, 22 September 1981, unpublished.

82. *Hearing before the Committee on Labor and Human Resources United States Senate*, 97th Congress, 1st session, 6 November 1981, p. 26.

83. Keens, 'An Interview with Frank Hodsoll', p. 7.

84. John K. Urice, 'Planning at the National Endowment for the Arts: A Review of the Plans and Planning Documents, 1978–1984', *The Journal of Arts Management and Law*, vol. 15, no. 2, Summer 1985, p. 86.

85. Robert Pear, 'Reagan's Arts Chairman Brings Subtle Changes to the Endowment', *The New York Times*, 10 April 1983.

86. Quoted in Richard Swaim, 'The National Endowment for the Arts: 1965–1980', in Kevin V. Mulcahy and Richard Swaim, eds, *Public Policy and the Arts* (Boulder, CO: Westview Press, 1982), p. 180.

87. Pear, 'Reagan's Arts Chairman'.

88. Catherine Lord, 'President's Man: The Arts Endowment under Frank Hodsoll', *Afterimage*, vol. 10, no. 7, February 1983, p. 3.

89. According to Michael Faubion, for instance, the Washington Project for the Arts applied to the Inter Arts for a billboard-like project in the early eighties where an artist would create works on the side of a large truck that then would travel around the city. One of the proposed sites was across from the White House, and this particular artist's work was known to be political; interview with Michael Faubion, on 26 April 1995.

90. Cynthia Grassby, 'Foreword', in Diane J. Gingold, *Business and the Arts: How They Meet the Challenge* (Washington, DC: National Endowment for the Arts, 1984), p. vii.

91. Interview with Michael Faubion on 26 April 1995.

92. David Trend, 'The Power and the Glory', *Afterimage*, vol. 11, no. 3, October 1983, p. 5.

93. Gerald Marzorati, 'The Arts Endowment in Transition', *Arts in America*, vol. 71, no. 3, March 1983, p. 9.

94. Ibid., p. 13.

95. Ibid.

96. The members of former policy panels were appointed for three-year terms; see Martha Gever, 'New Criteria for NEA's Visual Arts Program', *Afterimage*, vol. 11, no. 5, December 1983, p. 3.

97. National Endowment for the Arts, *Visual Artists' Organizations Fiscal Year 1982–83*, 1985, unpublished report.

98. Hilton Kramer, 'The Prospect Before Us', *The New Criterion*, vol. 9, September 1990, p. 7.

99. Elsie B. Washington, 'Taking Away the Mystique of the NEA', *Artnews*, vol. 85, no. 2, February 1986, p. 156. The Art Critics Fellowship was established, according to the National Council on the Arts, to 'set criticism on a more professional basis, improve standards of criticism, and eventually to make first-class critics available across the country'; quoted in John Beardsley, *The Art Critics Fellowship Program*, National Endowment for the Arts, unpublished report, August 1983, p. 5.

100. Martha Gever, 'Blowing in the Wind: The Fate of NEA Critics' Fellowships', *Afterimage*, vol. 12, no. 1, Summer 1984, p. 3.

101. Beardsley, *The Art Critics Fellowship Program*, p. 12.

102. Hilton Kramer, 'Criticism Endowed', *New Criterion*, November 1983, pp. 1–5.

103. 'Artists: An Endangered Species', *The Village Voice*, 13–19 May 1981.

104. Ted Potter, 'Preface', *Awards in the Visual Arts 3*, exhibition catalogue (Winston-Salem, NC: SECCA, 1984).

105. Personal correspondence from Virginia Rutter, Public Relations and Marketing Coordinator, SECCA, Winston-Salem, NC, on 16 June 1995.

106. Miranda McClintic, *Awards in the Visual Arts Program*, National Endowment for the Arts, 1985, unpublished report, p. 11.

107. Ibid., p. 12.

108. According to Virginia Rutter, who was associated with the program for eight years, 'These receptions were a tremendous cost that the museums didn't have to absorb and they were extremely appreciative of that saving' (personal correspondence from Virginia Rutter).

109. McClintic, *Awards in the Visual Arts Program*, p. 11. The advisory role of SECCA was taken over by the Whitney Museum of American Art in New York; see Chapter 7. I spoke to Pari Stave, curator of the Equitable Collection and the Equitable Gallery, and Francine Lynch, director of Equitable Foundation, in May 1995, but no data were available from company sources.

110. William H. Honan, 'Congressional Anger Threatens Arts', *The New York Times*, 20 June 1989, and Barbara Gamarekian, 'Senate Asks Ban on Grants to 2 Arts Groups', *The New York Times*, 26 July 1989.

111. Whether or not Equitable withdrew its sponsorship before or after the Serrano controversy is nowhere clear. According to Virginia Rutter, 'the Equitable had already decided to end its commitment to the AVA program before the Serrano controversy. . . . However, the Serrano controversy caused them to change their mind about a departure grant to SECCA and decided not to do so'; personal correspondence from Virginia Rutter, on 8 September 1995. What is known is that the chairman of the Equitable Life Assurance Society, Richard H. Jenrette, reportedly wrote to apologise to Wildmon within days of Wildmon's campaign against Serrano's work; see Honan, 'Congressional Anger'. Largely because of the media campaign launched by Wildmon and his like-minded conservatives, hundreds of Equitable policy holders apparently wrote to the company threatening to withdraw their policies if Equitable continued to fund art works like Serrano's.

112. Honan, 'Congressional Anger'.

113. Personal correspondence from Virginia Rutter, on 8 September 1995.

114. *Awards in the Visual Arts 10*, exhibition catalogue (Winston-Salem, NC: SECCA, 1991). For more details on the 'BMW Gallery', see Chapter 7.

115. ABSA changed its name to Arts and Business in spring 1999.

116. 'We are a private organisation,' said Nicholas Wood, Head of BSIS/Program Director, ABSA, London. He also pointed out that, although they held files on business sponsorship, these were only for private purposes and he could not grant 'the public' access to them; telephone conversation with Nicholas Wood on 13 February 1993. Nor was the BCA any more helpful. They refused to give me a face-to-face interview and asked me not to put any more pressure on them when an American colleague with an academic title called them on my behalf in 1990. I attempted to contact them again in 1995 but without success.

117. David Rockefeller, *Culture and the Corporation*, reprinted by the BCA in 1985, p. 9.

118. Telephone conversation with Kim Maier, Director of National Programs, BCA, New York, 1 August 1990.

119. The BCA operates a network of twelve affiliates for smaller businesses in the local area, but the national BCA is exclusively for blue-chip chief executives.

120. Quoted in Alvin Reiss, 'BCA: The First Act', *Cultural Affairs*, vol. 5, March/April 1967, p. 39.

121. Quoted in Joseph James Akston, 'Editorial', *Arts Magazine*, vol. 42, no. 7, 1968, p. 5.

122. William E. Phillips, *Involving the Arts in Advertising* (New York: BCA, 1986), p. 4.

123. Alison Roberts, 'The Maturity of Modern Maecenas', *The Times*, 11 December 1992, special issue 'Business and the Arts'.

124. Deanna Petherbridge, 'Patronage and Sponsorship: The PS at the Bottom of the Art Balance Sheet', *Art Monthly*, no. 38, July/August 1980, p. 10.

125. Antony Thorncroft, 'An Honest Broker', *Classical Music*, 22 September 1979, p. 9.

126. Special issue 'Business and the Arts', *The Times*, 21 November 1994.

127. Since the change of name to Arts and Business in spring 1999, these awards have been replaced by the *FT*/Arts and Business Awards in a different format.

128. Antony Thorncroft, 'Sponsorship: Coming of Age', *The Financial Times*, 7 September 1987.

129. Quoted in Simon Tait, 'Sponsor's Broadest Spectrum', *The Times*, 11 December 1992, special issue 'Business and the Arts'.

130. BSIS was renamed 'Pairing Scheme' in 1995, and replaced, in a different format, by 'Arts and Business New Partners' from April 2000.

131. Schuster, 'Government Leverage of Private Support', p. 80.

132. Arts Council of Great Britain, *The Arts Funding System: An Introduction to the Components of the UK Arts Funding System*, n.d.

4 GUARDIANS OF THE ENTERPRISE CULTURE: ART TRUSTEES

1. The topic was not mentioned in the collection *A Sourcebook of Arts Statistics: 1987* (Washington, DC: National Endowment for the Arts, 1988) or in *Data Report: From the 1989 National Museum Survey*.

2. Alan and Patricia Ullberg, *Museum Trusteeship* (Washington, DC: American Association of Museums, 1981); Peter J. Ames and Helen Spaulding, 'Museum Governance and Trustee Boards', *The International Journal of Museum Management and Curatorship*, vol. 7, March 1988, pp. 33–6.

3. Brian Wallis, ed., *Hans Haacke: Unfinished Business* (New York: New Museum of Contemporary Art, 1986), pp. 110–17.

4. Quoted in Grace Glueck, 'Power and Esthetics: The Trustee', *Art in America*, vol. 59, no. 4, July/August 1971, p. 78; see also Meyer, *The Art Museum*, p. 224.

5. National Endowment for the Arts, *Museums USA: Art, History, Science and Others* (Washington, DC: Government Printing Office, 1975), pp. 73–4.

6. Glueck, 'Power and Esthetics', pp. 80–2.

7. Ibid., pp. 81–2.

8. Quoted in Francie Ostrower, *Why the Wealthy Give: The Culture of Elite Philanthropy* (Princeton, NJ: Princeton University Press, 1995), p. 36.

9. George C. Seybolt, '. . . and the Trustee's', *Art in America*, vol. 59, no. 6, November/December 1971, p. 31.

10. Meyer, *The Art Museum*, p. 225.

11. Glueck, 'Power and Esthetics', p. 83.

12. Anthony Sampson, *The Midas Touch* (New York: Truman Talley Books/Plume, 1991), p. 194.

13. Quoted in Paul Gardner, 'What Price Glory?', *Artnews*, vol. 87, no. 8, October 1988, p. 124.

14. Amy Goldin and Roberta Smith, 'Present Tense: New Art and the New York Museum', *Art in America*, vol. 65, no. 5, September/October 1977, p. 96.

15. American Association of Museums, *Data Report*, p. 64.

16. This is the figure given by Goldin and Smith, 'Present Tense', p. 98. It is impossible to work out the precise number of trustees at this stage as the names of the trustees in the mid-seventies are unavailable.

17. See *Bulletin of the Whitney Museum of American Art*, vol. 1, Fall 1978. The total of 27 does not include the director and another four honorary trustees.

18. Terry Trucco, 'The Growing Number of Women Trustees', *Artnews*, vol. 76, no. 2, February 1977, pp. 54–5.

19. Ostrower, *Why the Wealthy Give*, pp. 78–9.

20. G. William Domhoff, *The Higher Circles* (New York: Random House, 1970), p. 41.

21. Thorstein Veblen, *The Theory of the Leisure Class* (Harmondsworth: Penguin Books, 1979) (originally published in 1899).

22. James Kraft, the Whitney's development officer, was reported as saying: 'board members have to give at least $100,000 a year.' Quoted in Grace Glueck, 'Mogul Power at the Whitney', *The New York Times Magazine*, 4 December 1988, Section 6, Part II, p. 74.

23. The number does not include the director and three honorary trustees; see *Bulletin of the Whitney Museum of American Art 1988–89*, 1989, p. 4.

24. The other two real estate men were George S. Kaufman, a trustee from 1981/82 to 1988/89, and Benjamin D. Holloway, from 1984/85 to 1989/90.

25. Taubman bought Woodward & Lothrop in Washington, DC, in 1984 and Philadelphia's Wanamaker chain for $174 million in 1986. According to *Forbes*, both were up for sale again in 1988; see *Forbes*, 24 October 1988, p. 158. For his listing in the *Forbes 400*, see *Forbes*, 1 October 1984, p. 92; 28 October 1985, p. 127; 27 October 1986; 26 October 1987, p. 122; and 24 October 1988, p. 158.

26. See *Bulletin of the Whitney Museum of American Art 1984–85*, vol. 7, 1985, p. 8.

27. Quoted in Lorraine Glennon, 'The Museum and the Corporation: New Realities', *Museum News*, vol. 66, January/February 1988, p. 42. For detailed discussion on the Whitney branches, see Chapter 7.

28. DiMaggio, 'Cultural Entrepreneurship', p. 35.

29. Adolf A. Berle and Gardiner C. Means, *The Modern Corporation and Private Property*.

30. Trucco, 'The Growing Number of Women Trustees', p. 55.

31. Sam Hunter, *Art in Business: The Philip Morris Story* (New York: Abrams and BCA, 1979), p. 172.

32. Quoted in Andrew Decker, 'Trustees and Trust', *Artnews*, vol. 88, no. 10, December 1989, p. 51.

33. For a discussion of conflicts of interest, see Ullberg and Ullberg, *Museum Trusteeship*, pp. 78–86; and Albert Elsen and John Henry Merryman, *Law, Ethics and the Visual Arts* (Philadelphia: University of Pennsylvania Press, 1987), pp. 677–96. See also the footnote on p. 94.

34. Douglas A. Johnston, 'Legal Notes: Directors and Trustees: Personal Liability for Their Actions', *The International Journal of Museum Management and Curatorship*, vol. 7, March 1988, p. 77.

35. Quoted in Gordon H. Marsh, 'Governance of Non-Profit Organizations: An Appropriate Standard of Conduct for Trustees and Directors of Museums and Other Cultural Institutions', *The Journal of Arts Management and Law*, vol. 13, no. 3, Fall 1983, p. 33.

36. Glueck, 'Mogul Power', p. 76. Taubman resigned his chairmanship of Sotheby's in Februray 2000 as a result of a criminal anti-trust investigation into the auction house and its related financial scandals.

37. Quoted in Albert Elsen, 'Conflicts of Interests', *Artnews*, vol. 89, no. 4, April 1990, p. 190.

38. Lee Rosenbaum, 'Will Robert Abrams Raise the Ethical Consciousness of Museums?', *Artnews*, vol. 78, no. 10, December 1979, pp. 50–8.

39. See Glueck, 'Mogul Power', p. 27. The other two trustees in question were Sondra Gilman Gonzalez-Falla and A. A. Taubman.

40. Diana B. Henriques and Floyd Norris, 'The Wealthy Find New Ways to Escape Tax on Profits', *The New York Times* (via Web), 1 December 1996. For an updated history of the Whitney Museum, see Arthur Lubow, 'The Curse of the Whitney', *The New York Times Magazine* (via Web), 11 April 1999.

41. Andrew Faulds, 'The State and the Arts in Great Britain', *Studio International*, vol. 182, November 1971, p. 202.

42. Martin Kemp, 'The Crisis at the V & A', *Burlington Magazine*, no. 1034, May 1989, p. 356.

43. Norman Reid, 'The Limits of Collecting', *Studio International*, vol. 182, July/August 1971, p. 38.

44. Williams, 'The Arts Council', p. 160.

45. Kemp, 'The Crisis', p. 356.

46. The phrase 'men of quality and spirit' was Lord Robbin's, a former trustee of the National Gallery; see Faulds, 'The State and the Arts', p. 205. The phrase 'non-partisan representation of diverse interests' is Kemp's; see 'The Crisis', p. 356.

47. The fact that I include architectural practices here does not imply that they are not in the same rank as other businessmen, despite their association with visual culture. Some of them at least are multinationals.

48. The Clarendon Commission of 1861–64 listed nine schools as 'significant of the position that a few schools had gained in the public eye'. They were: Eton, Harrow, Charterhouse, Merchant Taylors', Rugby, St Paul's, Shrewsbury, Westminster and Winchester.

49. Before the Gallery went 'independent' in 1987, 92% of its income came from the Arts Council, with the rest from earned income. In the 1990s, grants from public sources decreased to less than 50%.

50. For a discussion of the change of board membership in general, see Jeremy Paxman, 'The Arts Tsars', in *Friends in High Places: Who Runs Britain?* (Harmondsworth: Penguin Books, 1990).

51. Andrew Knight, the chief executive of the Telegraph Group and a former trustee at the V & A, commented that he 'had led the cry for a real museum shop', and was 'also the loudest voice in favour of admission charges' among fellow trustees; see 'I was a Trustee of the V & A', *The Spectator*, 4 March 1989, p. 14. Sir Roy Strong, then director of the V & A, was quoted as saying, 'It [the shop] could be the Laura Ashley of the Eighties'; see Sarah Drummond, 'Hanging Judges', p. 85,

unidentified article in documentary archive of Resources Centre, Department of Arts Policy and Management, City University, London.

52. For the restructuring at the V & A, see 'Letters', *Burlington Magazine*, May 1989, pp. 357–8.

53. Kemp, 'The Crisis', p. 356.

54. As it stands now, the Tate Gallery has four branches: Tate Britain, Tate Modern, Tate Liverpool (established in 1988) and Tate St Ives (opened in 1993). The original Tate Gallery on Millbank was re-launched as Tate Britain in March 2000 while Tate Modern was opened on the Thames Bankside site in May 2000. The Tate Gallery has a Board of Trustees, appointed by the Prime Minister, which oversees the operation of the Gallery as a whole, while each of these four branches has its own Advisory Council. The analysis that follows bears only on the principal Board of Trustees.

55. Tim Hilton, 'The Taking of the Tate', *Guardian*, 23 December 1988. The trustees of the National Gallery always appoint one of their number to be a 'liaison trustee' on the Tate board, and vice versa. At present, the Tate board consists of 12 members; see *Museums and Galleries Act 1992*, p. 16.

56. Hilton, 'The Taking of the Tate'.

57. According to Tim Hilton, Stevenson's appointment as chairman was not as precipitate as it might seem to be. Stevenson was brought in 18 months earlier as a special adviser to the trustees; see ibid.

58. Bernard Levin, 'The Tate Rejected Master', *The Times*, 17 October 1988.

59. Paxman, *Friends in High Places*, pp. 299–300.

60. Ibid., p. 126.

61. Levin, 'The Tate Rejected Master'.

62. Paxman, *Friends in High Places*, p. 301.

63. And the fact that Sir Alan Bowness had approached Sir John Burgh to be the chairman of the Tate clearly showed the different political sensitivities of Bowness and Serota.

64. Petherbridge, 'Patronage and Sponsorship', p. 17.

65. Patrons of British Art was established to assist with the acquisition of British painting and sculpture from 1500 to the 1930s, while the Patrons of New Art is primarily concerned with the purchase of contemporary works for the Tate.

66. Stephen Pile, 'Want to be an Arbiter of Art? That'll be £650', *The Daily Telegraph*, 15 July 1995.

67. Mrs Jill Ritblat was the events organiser from 1984 to 1986 and was on the

Executive Committee of the Patrons of New Art in 1986 and became its chairman until 1991. The British Land Company plc, for example, sponsored the Ben Nicholson exhibition in 1993.

68. The two women were Felicity Waley-Cohen and Mrs Sandra (William) Morrison.

69. The information I have from this source constitutes only three lines on three trustees; that is, Janet de Botton (the year of her birth and name of her father), Felicity Waley-Cohen (the year of her birth and the name of the gallery she ran in the 1970s) and John Botts (the name of his company).

70. Telephone conversation on 29 August 1996.

71. The only woman on the board in the sixties was the artist trustee Dame Barbara Hepworth (1965–72) and in the seventies the artist trustee Rita Donagh (1977–84).

72. She was appointed in December 1982 and reappointed in January 1990, only to retire in December 1994. See also 'Lesson in Waiting', *The Sunday Telegraph*, 7 October 1984.

73. The occupation of a few trustees falls into more than one category; the classification is based on that at the time of appointment.

74. Quoted in Paxman, *Friends in High Places*, p. 300.

75. Peter Marsh, William Lewis et al., 'Conservative Party Funding', *The Financial Times*, 19 December 1994. In another report dated 30 June 1995, the figure of the Lazard Brothers' political donation was suggested as £90,000 over the previous four years; see Peter Marsh, 'The Tory Leadership Contest', *The Financial Times*, 30 June 1995.

76. Keith Nurse, 'Puttnam is New Tate Trustee', *The Daily Telegraph*, 4 January 1986.

77. Anthea Hall, 'New Masters at the Tate', *The Weekend Telegraph*, 15 January 1989. Dennis Stevenson became a trustee in 1988, and became its chairman from January 1989 until he retired in 1998.

78. 'Another Tate Takeover', *The Evening Standard*, 25 July 1984.

79. Raymond Snoddy, 'BSkyB to Float with 19 on Board', *The Financial Times*, 14 November 1994.

80. 'Tate Gallery Trustees: Background Information', provided by the gallery.

81. Fay Brauer, 'Tate Sponsorship', *Art Monthly*, no. 91, November 1985, p. 2.

82. He was a trustee of the Tate from May 1985 to March 1992.

83. Christian Tyler, 'The Active Citizen: Charity Begins in the Office', *The Financial Times*, 10 March 1990.

84. The phrase is Jeremy Paxman's, *Friends in High Places*, p. 255.

85. Jacob Rothschild was appointed as a trustee of the National Gallery in 1984, and became its chairman in 1985 until he retired from the board in 1991. For his profile and power in the art world, see Andrew Graham-Dixon, 'A Modern Medici', *Vogue* (Britain), November 1990, pp. 236–9, 311, and Fiammetta Rocco, 'Power and Glory to Those on High – Who Really Runs the Arts in This Country Today?', *The Independent on Sunday*, 18 June 1995.

86. Gilbert de Botton was the general manager of Rothschild Bank, the Zurich-based affiliate of N. M. Rothschild of London; see Jan Rodger, 'Rothschild Pays the Price of a Swiss Scandal', *The Financial Times*, 16 June 1993, p. 26. One of the Rothschild companies, St James's Place, owned 29% of Global Asset Management in 1994; see Peter Rodgers, 'Weill Funds Embarrass Lord Rothschild with $600m Loss', *The Independent*, 30 September 1994.

87. Hilton, 'The Taking of the Tate'.

88. Norma Cohen, 'Rothschild and Weinberg Form Assurance Company', *The Financial Times*, 1 August 1991.

89. Christopher Price, 'Pearson Shares Slide After Warning on Earnings Hopes', *The Financial Times*, 14 December 1995.

90. For Pearson's party donations, see John Gapper, 'Pearson to End Political Party Donations', *The Financial Times*, 8 April 1998. Pearson sold Lazard Brothers in late June 1999.

91. For the date and information on de Botton and Janet Green, see *Tate Gallery Biennial Report 1986–1988*, p. 40. Gilbert de Botton was a trustee of the Tate from 1985 to 1992, and of the Gallery Foundation from 1986 to 1992.

92. The Great Universal Stores, founded by Sir Isaac Wolfson, was by far Britain's largest mail order concern, controlling about 40% of sales by the time of his death; see Ben Laurance, 'GUS Shares Soar on Founder's Death', *Guardian*, 22 June 1991, and Aubrey Newman, 'A Wealth of Generosity', *Guardian*, 22 June 1991. Janet de Botton is his granddaughter.

93. Compare Alain de Botton's surprising categorisation of his stepmother's taste in art: 'She likes canvases with "Fuck" written all over them.' See Sabine Durrant, 'The Agonies of Doctor Love', *Guardian*, 20 March 2000.

94. Robert Mason, 'Board Stuff', *Museums Journal*, March 1995, p. 15.

95. Hall, 'New Masters at the Tate', p. 6.

96. Alice Rawsthorn, 'Specialist Purveyors of Tomorrow's Ideas', *The Financial Times*, 18 June 1990.

97. Paul Taylor, 'Dennis Stevenson to Chair GPA', *The Financial Times*, 31 August

1993, and Roland Rudd, 'Tough Task for a Master of Low Profile', *The Financial Times*, 1 November 1993, to name but two.

98. Waldemar Januszczak, 'No Way to Treat a Thoroughbred', *Guardian*, 15 February 1986.

99. Gilbert de Botton, 'Sponsorship of Art', transcript of a speech given at *Art at Work* conference organised by Art for Offices on 8 November 1985.

100. The appointment of Gilbert de Botton and Mark Weinberg to the Tate board was announced in the middle of April; see 'Tate Trustees', *The Daily Telegraph*, 17 April 1985. They took office in May 1985.

101. Brauer, 'Tate Sponsorship'.

102. According to de Botton, 'Corinne Bellow, who is in charge of sponsorship at the Tate, went into quick action, because the catalogue had already been printed and many other aspects such as posters, display and the like had not been geared to sponsorship'; see de Botton, 'Sponsorship of Art'.

103. De Botton, 'Sponsorship of Art' (as note 99).

104. Dawn Ades and Andrew Forge, *Francis Bacon* (London: Thames and Hudson/Tate Gallery, 1985), p. 237. The same point was made by Brauer, 'Tate Sponsorship'.

105. Among the 58 exhibitions held at the Tate between the late sixties and June 1996, three Picasso exhibitions are in the top-ten league table of attendance, with *Late Picasso* ranking as the 10th. The information on attendance figures was provided by the gallery.

106. The phrases in quotation marks are Gilbert de Botton's; see 'Sponsorship of Art' (as note 99).

107. *Late Picasso: Paintings, Sculpture, Drawings, Prints 1953–1972* (London: Tate Gallery, 1988), p. 309.

108. According to Ian Rodger, de Botton left Switzerland to work in London for Jacob Rothschild in 1981; see 'Rothschild Pays the Price of a Swiss Scandal'. Dominic Prince also mentioned in passing that de Botton founded Global Asset Management in 1983 'after his departure from Rothschild Bank in Zurich'; see 'Bunhill: Bright Future for Alain de Botton', *The Independent on Sunday*, 16 June 1993. According to Brauer, Global Asset Management was incorporated on 10 August 1982; see 'Tate Sponsorship' (as note 81).

109. Gilbert de Botton died in August 2000. Tate Modern named a major gallery on Level 5 West in the History/Memory/Society zone in honour of him; see David Landau, 'Self-Made Financier Who Revelled in Money, Markets and

Modern Art', *Guardian*, 20 September 2000. The name of his wife, Janet Wolfson de Botton, is given to another gallery on Tate Modern Level 5 East in the Nude/Action/Body zone. According to an anonymous source at the Tate, the honour of being a Tate Modern gallery sponsor requires a donation of anywhere between £500,000 and £2 million, on which scale Gilbert de Botton's gallery would, one assumes, presuppose a gift of at least £1 million.

110. Hans Haacke, 'Taking Stock (unfinished)', in Wallis, ed., *Hans Haacke*, p. 260. The relationship between Patrons of New Art and the Tate seems to have changed over time.

111. Nick Rosen, 'Artopoly: A Giant Game for Dealers, Museum Curators and Artists', *The Guardian*, 19 December 1983.

112. Ibid.

113. *The Real Saatchis: Master of Illusions*, broadcast by Channel 4 on 10 July 1999.

114. Dalya Alberge, 'A Very Private Collector', *The Independent*, 3 March 1992. For more evidence of Saatchi's buying and selling activities, see Rita Hatton and John A. Walker, *Supercollector* (London: Ellipsis, 2000).

115. Drummond, 'Hanging Judges' (as note 51).

116. National Galleries of Scotland, 'Code of Best Practice for the Board of Trustees of the National Galleries of Scotland', n.d., p. 4.

117. 'Trusting the Trustees' was the phrase used in the report on the national museums and galleries by the Museums and Galleries Commission, *The National Museums* (London, 1988), p. 17.

5 EMBRACING THE ENTERPRISE CULTURE: ART INSTITUTIONS SINCE THE 1980s

1. Quotation from a special Chase Manhattan advertising supplement, 'American Business and the Arts', *Forbes*, 27 October 1986.

2. Petherbridge, 'Patronage and Sponsorship', p. 9.

3. Winton M. Blount, *Business Support to the Arts is Just Good Sense* (New York: BCA, 1984).

4. Willard C. Butcher, *Going Public for the Private Enterprise System* (New York: Chase Manhattan Bank, 1980); cited in Useem, *Inner Circle*, p. 89.

5. Hunter, *Art in Business*, p. 37.

6. Useem and Kutner, 'Corporate Contributions to Culture and the Arts', pp. 99–100.

7. For detailed analysis of the survey and its methodology, see Chin-tao Wu, *Privatising Culture: Aspects of Corporate Intervention in Contemporary Art and Art Institutions during the Reagan and Thatcher Decade*, PhD thesis, University of London, 1997.

8. DiMaggio, 'Cultural Entrepreneurship', p. 35.

9. See Veblen, *The Theory of the Leisure Class*.

10. Quoted in Louisa Buck and Philip Dodd, *Relative Values or What's Art Worth?* (London: BBC, 1991), p. 63.

11. Bourdieu, *Distinction*.

12. Paul DiMaggio and Michael Useem, 'Social Class and Arts Consumption', *Theory and Society*, vol. 5, 1978, pp. 141–61.

13. According to Schuster, tax incentives are essentially the same for charitable contributions and business sponsorship; see 'The Non-Fungibility of Arts Funding', p. 46.

14. Sponsorship is a legitimate business expense and thus tax-deductible in calculating the trading profits of the business, if the expenditure is 'wholly and exclusively for the purposes of the trade, and is revenue, as opposed to capital, expenditure'; see *Business Support of the Arts: A Tax Guide* (London: Arthur Andersen, 1991), p. 17. See also Inland Revenue, *Giving to Charity: How Business Can Get Tax Relief*, Business series IR 64 (London, 1993), pp. 6–7.

15. Their answers, of course, are not necessarily accurate; understandably companies tend to emphasize the degree to which their sponsorship is successful. Nevertheless the percentages are a useful indication of what they perceive their rationale for sponsorship to be.

16. According to the Conference Board, printing and publishing corporations provide the highest proportion of their charitable contributions, 20.4%, to culture and the arts; financial institutions provide 19.3%; and petroleum and gas companies 18.4%. In terms of the total amount of money given, however, petroleum companies are the largest contributors. See Kathryn Troy, *Annual Survey of Corporate Contributions* (New York, 1983), p. 30; cited in Schuster, 'The Non-Fungibility of Arts Funding', p. 12.

17. Cultural Affairs Department, Philip Morris Companies, *Philip Morris and the Arts: 35 Year Report* (New York, 1993).

18. Quoted in Robert Metz, 'The Corporation as Art Patron: A Growth Stock', *Artnews*, vol. 78, no. 5, May 1979, p. 45.

19. Hunter, *Art in Business*, p. 84.

20. *Philip Morris and the Arts*, p. 8.

21. Cited in Rick Rogers, 'The Ethics of Sponsorship', *Arts Express*, June 1986, p. 10. For more details, see Chapter 6.

22. See Conference Board, *Annual Report of Corporate Contributions*, 1988 edition, Advance Report (New York, 1988); cited in Useem, 'Corporate Support for Culture and the Arts', p. 54.

23. See Association for Business Sponsorship of the Arts, *Business Support for the Arts 1993/94* (London, 1994). The figures for museums are not a precise guide for sponsorship given to contemporary art since they include museums of different kinds.

24. For a detailed discussion, see Paul DiMaggio, Michael Useem and Paula Brown, *Audience Studies of the Performing Arts and Museums: A Critical Review*, Research Division Report # 9 (Washington, DC: National Endowment for the Arts, 1978).

25. James Odling-Smee, 'Refreshing the Arts', *Art Monthly*, no. 178, July/August 1994, pp. 20–3.

26. Victoria Dean Alexander, *From Philanthropy to Funding: The Effects of Corporate and Public Support on Art Museums*, PhD thesis, Stanford University, 1990, p. 91.

27. Libet Nilson, 'How Will Museums Survive in Tomorrow's World?', *Artnews*, Summer 1982, p. 81.

28. Hilton Kramer, 'The Hoving Era at the Met', in Kramer, *The Revenge of the Philistines: Art and Culture, 1972–1984* (London: Secker and Warburg, 1986), pp. 320–4.

29. Antony Thorncroft, 'Museums and Art Galleries', *The Financial Times*, 11 June 1988.

30. Quoted in Penelope Cagney, 'Can US Fund-Raising Help British Arts?', *Fund Raising Management*, vol. 19, no. 8, October 1988, p. 77.

31. Waldemar Januszczak, 'The Shock of Serota', *Guardian*, 26 November 1988.

32. Quoted in Petherbridge, 'Patronage and Sponsorship', p. 17.

33. Ernest Beck, 'Nicholas Serota', *Artnews*, vol. 88, no. 3, March 1989, p. 118.

34. Ibid.

35. Antony Thorncroft, 'Contemporary Backers Feel Safe at the Tate Sponsorship', *The Financial Times*, 5 May 1995.

36. AMCON Group, Inc., *Seminar on Business Support of the Arts*, p. 59.

37. Leonard Sloane, 'Is Big Business a Bonanza for the Arts?', *Artnews*, vol. 79, no. 8, October 1980, p. 115.

38. Quoted in Hans Haacke, 'Museums, Managers of Consciousness', in Wallis, ed., *Hans Haacke*, pp. 69–70.

39. *Tate Gallery Corporate Membership Programme*, brochure, p. 5.

40. Tate Gallery, *Cézanne* (London, 1996), p. 597.

41. Jeremy Lewison, 'New Directions for a National Direction', *Museum Management and Curatorship*, vol. 10, June 1991, p. 201. Commercial art consultants and dealers such as Mary Boone in New York, Sonia Coode-Adams and Anthony d'Offay Gallery in London are also donors to the Tate Gallery.

42. Januszczak, 'No Way to Treat a Thoroughbred'.

43. The Arts Council went so far as to issue a guideline requesting a 'decent acknowledgement' from its funded arts organizations; see Thorncroft, 'An Honest Broker'; also his 'Two Paymasters for the Arts', *The Financial Times*, 19 March 1980.

44. Brian Angel was director of ART/London 89; see 'Success at Last: The Media Credit Breakthrough', *absa Bulletin*, Autumn/Winter 1989, p. 3. A similar complaint was made by Lynette Royle, the public relations manager of Guinness, 'But I am fearful that unless people wake up a bit, sponsors for whom publicity is an expressed objective will choose the sports sector as their vehicle in preference to the arts.' See 'Credit the Connection', *absa Bulletin*, Autumn 1993, p. 13.

45. Gingold, *Business and the Arts*, p. 40.

46. Andy Lavender, 'Patronage by Numbers', *The Times*, 12 July 1994.

47. The Pairing Scheme was launched in 1995 to replace the BSIS (Business Sponsorship Incentive Scheme), which was set up by the Conservative government in 1984 to encourage arts sponsorship by giving cash to corporate sponsors.

48. Claire Armitstead, 'Risky Business', *Guardian*, 13 January 1993.

49. Alys Hardy, 'Luce Vows "No Artistic Interference"', *The Stage*, 11 May 1989, p. 2.

50. See Fredric Jameson, 'Postmodernism, or the Cultural Logic of Late Capitalism', *New Left Review*, no. 146, July/August 1984, pp. 64f; reprinted in a modified form in Jameson, *The Cultural Turn: Selected Writings on the Postmodern, 1983–1998* (London: Verso, 1998), pp. 4f.

51. Robert Hewison, 'Out to Change the Message on a Bottle', *The Sunday Times*, 28 May 1995.

52. Paul Goldberger, 'Philip Morris Calls In IOU's in the Arts', *The New York Times*, 5 October 1994. A similar story was mentioned in passing two days

earlier in *The New York Observer* but it was too brief to raise any controversy: 'Philip Morris' Blackmail Scam', *The New York Observer*, 3 October 1994.

53. Quoted in Jeffrey Hogrefe, 'Secondhand Smoke Hits Arts Angel', *The New York Observer*, 17 October 1994.

54. Ibid.

55. Mary Brandenberg, 'Sustenance: From the City', *Accountancy*, September 1988, p. 69.

56. Ibid.

57. Antony Thorncroft, 'Identity Crisis', *The Financial Times*, 3 February 1992, and 'A Trend Towards the Multinational Approach', *The Financial Times*, 9 March 1992.

58. Quoted in Matthew Fletcher, 'The Art of Patronage', *Accountancy Age*, July/August 1991, p. 9.

59. Raymond Williams, 'Advertising: The Magic System', in *Problems in Materialism and Culture* (London and New York: Verso, 1997), p. 193.

60. Dalya Alberge, 'The Art Donors', *The Independent*, 25 February 1992.

61. Alexander, *From Philanthropy to Funding*.

62. Hewison, 'Message on a Bottle'.

63. Quoted in ibid.

64. Ibid.

65. Janet Minihan, *The Nationalization of Culture: The Development of State Subsidies to the Arts in Great Britain* (London: Hamish Hamilton, 1977).

66. Leaflet entitled '10 Good Reasons Why You Should be a Friend of MOMA', Museum of Modern Art, Oxford.

67. 'Absolut Vision' was held from 10 November 1996 to 23 February 1997.

68. Among the more well-known names figuring on this list are Keith Haring, Kenny Scharf and Francesco Clemente.

69. From a section entitled "From the Fine Art of Advertising to the Advertising of Fine Art" in *The Story*, a brochure published by The Absolut Company, 1997 (republished 2001), p. 16; see also 'Absolut Beginner', *Guardian*, 11 October 1995.

70. Göran Lundqvist (President of the Absolut Company), 'Absolut Vision', in *About Vision: New British Painting in the 1990s* (Oxford: Museum of Modern Art, 1996), no page number.

71. *The Story*, p. 15 (see note 69).

72. The Museum is funded by the Arts Council of England, Southern Art, Oxfordshire County Council and Oxford City Council.

73. Kevin V. Mulcahy, 'Government and the Arts in the United States', in Cummings, Jr. and Katz, eds, *The Patron State*, p. 313.

74. Richard Luce, 'Government Goals', *Greater London Arts Quarterly*, issue 9, Summer 1987, p. 11.

75. Trades Union Congress, *The TUC Working Party Report on the Arts* (London, 1976), p. 30.

76. An earlier version of this chapter was published in *New Left Review*, no. 230, July/August 1998, pp. 28–57.

6 CORPORATE ART AWARDS

1. Andrew Graham-Dixon, 'Winning Strokes', *The Independent*, 4 October 1988.

2. Alison Roberts, 'Sponsors Step into the Spotlight', *The Times*, 9 December 1993.

3. David Fishel, *The Arts Sponsorship Handbook* (London: Directory of Social Change, 1993), p. 14.

4. Mick Newmarch, foreword to *Prudential Awards for the Arts 1992* (London: Prudential, 1992), p. 1. The Award continued until 1999.

5. 'The Art from the PRU', *absa Bulletin*, Spring/Summer 1991, p. 8.

6. The five winners from each category received £25,000 and one of them would go on to win the overall prize of £75,000.

7. *Prudential Awards for the Arts 1993* booklet (London: Prudential, 1993).

8. Interview on 10 July 1992.

9. The 10 regional competitions came to a halt in 1998 as a result of a change in the financial circumstances of the company. On current showing, the regional competitions seem to be held on an irregular basis (personal conversation with the spokeswoman on 1 March 2000).

10. Interview on 10 July 1992.

11. William Packer, 'True to Herself', *The Financial Times*, 11 February 1997.

12. Quoted in Christine Doyle, 'Old Masters Health Warning', *Observer*, 12 September 1980, and personal correspondence with Colin Stockall at Gallaher Group plc, dated 20 July 1999.

13. The press notice read: 'Imperial Tobacco Portrait Award in association with the National Portrait Gallery', dated 26 February 1980.

14. Ibid.

15. 'Magical Portrait Wins £100 for Mick', *Bexhill-on-Sea Observer*, 8 August 1985.
16. 'Local Artists Triumph in National Portrait Competition', *Hackney Gazette*, 19 October 1982.
17. Antony Thorncroft, 'Traditional Group of Big Spenders', *The Financial Times*, 2 December 1981.
18. National Portrait Gallery, *The Portrait Award 1980–1989* (London, 1992).
19. Sarah Boseley, 'Tobacco Ads and Sports Sponsorship to Disappear', *Guardian*, 18 June 1999 and 'Government Signals End for Tobacco Advertising', *Guardian*, 17 June 1999.
20. For a detailed history of the Turner Prize, see Virginia Button, *The Turner Prize* (London: Tate Gallery, 1999).
21. Maggie Brown, 'Promotions Boost Channel 4 Figures', *The Independent*, 19 March 1992.
22. The most recent attendance figures available from the Tate Gallery for the Turner Prize exhibition are 57,000 (for 1996), 85,000 (1997), 122,000 (1998) and 133,000 (1999).
23. The viewer figures for the Turner Prize's live transmission ceremony are 605,000 (1992), 679,000 (1993), 710,000 (1996), 645,000 (1997), 584,000 (1998), 700,000 (1999) and 1 million (2000).
24. Leaflet of Turner Prize's nomination form 1999.
25. For example, 56.8% of viewers of the 1998 Prize ceremony are ABC1 and 29.5% are between 16 and 34 years old, and 35.1% between 35 and 54 years old. The comparable figures for 1997 are 50.1% (ABC1), 24.3% (16–34 years old) and 31% (35–54 years old). Figures are provided by Channel 4's research division.
26. Interview with Janey Walker, 12 May 1999.
27. Ibid.
28. Waldemar Januszczak, 'Sponsor's Foreword', *The Turner Prize 1995* (London: Tate Gallery, 1995).
29. The figures are for 1998, provided by Channel 4.
30. David Lister, 'Avant-Garde Bows to Commerce in Bid for Fame and Fortune', *The Independent*, 3 November 1993.
31. Press release 'Guggenheim Museum/Hugo Boss AG Collaboration: Q&A', undated.
32. Ibid.
33. See special section on fashion and art, *The Art Newspaper*, no. 76, December 1998, pp. 16–21.

34. Between 20 October 2000 and 17 January 2001 Giorgio Armani, following a gift of $15 million, found his designer label the object of a solo exhibition at the Guggenheim. The Museum was, understandably, reluctant to admit to any causal connection between the gift and the 'exhibition'; see Roberta Smith, 'Memo to Art Museums: Don't Give Up on Art', *New York Times on the Web*, 3 December 2000.

35. Holland Cotter, 'A Soho Sampler: Shortlist for Prize', *The New York Times*, 22 November 1996; Roberta Smith, 'The Annotated Calendar', *The New York Times*, 8 September 1996; and Ken Johnson, 'Eyes on the Prize', *Art in America*, vol. 85, April 1997, p. 41.

36. Peter Plagens, 'SoHo Hum', *Artforum*, vol. 36, no. 9, May 1998, p. 50.

37. Lisa Dennison and Nancy Spector, 'The Genesis of an Award', in *The Hugo Boss Prize 1996* catalogue (New York: The Solomon R. Guggenheim Foundation, 1996), p. 19.

38. Ibid.

39. Carol Vogel, 'Inside Art,' *The New York Times*, 7 February 1997; see also Mary Rozell Hopkins, 'Art as an Element of Corporate Culture', *The Art Newspaper*, no. 76, December 1997, p. 16.

40. Anita Chaudhuri, 'Suiting Stars', *Guardian*, 25 June 1997.

41. Carol Vogel, 'Artful Back-Scratching is Hitching Couture Names to Needy Museums', *The New York Times*, 4 January 1997. On the revelation that the firm's founder, Hugo Boss, had used Polish inmates and French prisoners of war to tailor uniforms for the German SS, the Storm Troopers, Hitler Youth and the Wehrmacht, see Kate Connolly, 'Hugo Boss Firm Made Uniforms for the Nazis', *Guardian*, 13 August 1997.

42. Joachim Vogt, 'Sponsor's Statement', *The Hugo Boss Prize: 1998* (New York: The Solomon R. Guggenheim Foundation, 1998), p. 5.

43. Quoted in 'The 1998 Hugo Boss Prize', Guggenheim Online, 29 July 1998.

44. Press release 'Guggenheim Museum/Hugo Boss AG Collaboration: Q&A', undated.

45. 'Yasumasa Morimura', *The Hugo Boss Prize: 1996* (New York: The Solomon R. Guggenheim Foundation, 1996), p. 74.

46. Compare Slavoj Žižek, 'Multiculturalism, or the Cultural Logic of Multinational Capitalism', *New Left Review*, no. 225, September/October 1997, pp. 28–51.

47. ASEAN stands for Association of South East Asian Nations, and includes Brunei Darussalam, Indonesia, Malaysia, the Philippines, Singapore, Thailand and Vietnam.

48. 'Brunei: Artists' Big Break', *Borneo Bulletin* (Indonesia), 3 May 1999.

49. 'Malaysian Wins ASEAN Art Awards' Grand Prize', *Vietnam News*, 26 November 1998.

50. 'Win Last Year Gives Our Artists New Confidence', *New Straits Times* (Malaysia), 1 May 1999.

51. 'Hanoi to Host Philip Morris Art Awards', *The Saigon Times Daily*, 20 November 1998.

52. Hoang Anh, 'Anti-Smoking Remains an Unequal Fight', *Vietnam Economic News*, 23 January 1997, and 'More Die From Cigarettes in Third World', *Bernama* (via Web) (Malaysia), 5 November 1998.

53. Linus Gregoriadis, 'The Independent Smokers in Front Line of a New World War', *The Independent*, 26 May 1998.

54. 'Singapore Uses Shock Strategy Against Smoking', *Agence France Presse International*, 11 May 1999.

55. 'Philip Morris ASEAN Art Awards to Open at Hanoi Opera House', *Manila Bulletin* (via Web), 21 November 1998; see also Amy Bickers, 'Winning Images', *Far Eastern Economic Review*, 26 March 1998.

56. Susan Heller Anderson, 'Ever Pragmatic Singapore is Making Art its Business', *The New York Times on the Web*, 25 July 1999.

57. Barry Meier, 'Tobacco Industry, Conciliatory in US, Aggressive in Third World', *The New York Times on the Web*, 18 January 1998.

58. Nigel Holloway, 'Now's Your Chance', *Far Eastern Economic Review*, 30 January 1997.

59. William H. Webb, 'Sponsor Statement', *The First Steps: Emerging Artists from Japan* (New York: Grey Art Gallery and Study Centre, 1997), p. 8.

60. For information on the Philip Morris Art Award, see *Philip Morris Art Award 1996* and *Philip Morris Art Award 1998* (exhibition catalogues) (Tokyo: Philip Morris KK, 1996 and 1998). For *First Steps*, consult the following website: http://www.nyu.edu/greyart/exhibits/steps3

61. 'Foreign Tobacco Firms: Smoking in Japanese Market', *The Mainichi Daily News*, 8 October 1996; see also James Simms, 'New Ad Curbs may Aid Japan Tobacco, Hurt Foreign Companies', *Dow Jones Online News*, 1 October 1997.

62. Press Release of ABN-AMRO Bank dated 7 April 1998. All the translations from Chinese are my own.

63. Press Releases of ABN-AMRO Bank dated 7 April 1998 and 6 June 1998.

64. 'Storming the Crisis, The ABN-AMRO Bank Successfully Lands on Taiwan' (in Chinese), *Liberty Times* (Taiwan), 10 July 1998. The local manager in

Taiwan declined to confirm the reported number of cards issued (personal correspondence on 12 October 1999).

7 SHOWCASES OF CONTEMPORARY ART WITHIN CORPORATE PREMISES

1. Herbert Schmertz, *Patronage That Pays* (New York: BCA, 1987), p. 7.
2. The High Museum of Art in Atlanta, for example, had a branch at the Georgia-Pacific Center, Atlanta; see Douglas Brenner, 'The Framer's Art', *Architectural Record*, November 1986, pp. 124–31.
3. Speaking in 1986 on the financial arrangements for branches of the Whitney Museum of American Art, the then director, Tom Armstrong, pointed out in an interview: 'We're being courted all over the country. . . . And if someone calls me and says, "Mr Armstrong, I'm developing a building and I want a branch," then I say, "Have you got $400,000 a year to spend, plus start-up costs?" That usually stops the conversation . . .'; see William Keens, 'Serving Up Culture: The Whitney and Its Branch Museums (Interview)', *Museum News*, vol. 64, no. 4, March/April 1986, p. 26.
4. Ibid., p. 22.
5. Quoted in Glennon, 'The Museum and the Corporation', p. 42.
6. Downtown Manhattan refers to the Wall Street area where the Downtown Whitney branch was located. The Midtown Manhattan district is the area between 3rd and 8th Avenues and 34th and 60th Streets where the Philip Morris branch is located, and where the Equitable branch was; interview with Tony Levy, Deputy Director, Zoning Study Group, Department of City Planning, New York City, on 3 May 1995.
7. Bonusable public space includes 'open plazas', 'through block arcades' or 'covered pedestrian spaces'. As pointed out by Marilyn Mammano, director of Zoning and Urban Design, Department of City Planning, New York City: 'A branch of an art or science museum is permitted to occupy a frontage along the perimeter of a bonusable public space if it is kept open to the public for the same hours as the covered public space. In most cases, the floor space occupied by such museums is exempted from the floor area computation of these buildings.' Personal correspondence with Mammano, on 14 December 1992.
8. The bonus which a developer receives is very substantial: for *x* square feet of bonus floor area of every square foot of bonus amenities, he can get up to a

maximum of 20% of the floor ratio. For example, if the developer puts in 1,000 square feet, and the bonus ratio is 10:1, then he will have 10,000 extra square feet of floor area that he can add to his building, provided that is not more than 20% beyond what he is allowed for the bonus; Tony Levy, as in note 6 above.

9. Paul Goldberger, 'Plazas, like Computers, are Best if User-Friendly', *The New York Times*, 22 March 1987.

10. Personal correspondence with Marisa Lago, General Counsel, Economic Development Corporation, New York City, on 22 April 1993.

11. Interview with Pamela Gruninger Perkins, Head of Branch Museums and Coordinator, Whitney Museum of American Art, New York, on 13 August 1990.

12. Personal correspondence with Mark R. Husted, Corporation Tax Technician II, New York State Department of Taxation and Finance, Albany, New York, on 12 April 1993.

13. Suzanne Stephens, 'An Equitable Relationship?', *Art in America*, vol. 74, May 1986, p. 118.

14. Deborah Gimelson, 'The Tower of Art: Art, the Handmaiden to Real Estate', *Art & Auction*, October 1985, p. 152. See also Grace Glueck, 'What Big Business Sees in Fine Art', *The New York Times*, 26 May 1985.

15. Quoted in Roger Kimball, 'Art and Architecture at the Equitable Center', *The New Criterion*, vol. 5, November 1986, p. 31.

16. Keens, 'Serving up Culture', p. 24.

17. Michael Brenson, 'Museum and Corporation – A Delicate Balance', *The New York Times*, 23 February 1986, p. 28.

18. Ibid.

19. Interview with Josephine Gear, former director at the Whitney Museum of American Art at Philip Morris, on 4 May 1995, and personal correspondence with her on 10 August 1995.

20. Ibid.

21. Quoted in Rachel Barnes, 'Dream Factory', *Guardian*, 3 June 1994.

22. 'Dean Clough: An Overview', booklet published by Dean Clough, undated.

23. Barnes, 'Dream Factory'; Stuart Rock, 'The Importance of Being Ernest', *Director*, December 1988, pp. 95–8; and '"Exploit the Legacy of our Industrial Past", Urges Prince', *The Daily Telegraph*, 27 April 1999.

24. Rachel Barnes wrote: 'the financial independence of the Henry Moore Trust, which administers Dean Clough . . .'; see 'Dream Factory'.

25. George Melly, 'Bleak Pieces in a Surrealist Jigsaw Puzzle', *Guardian*, 23 July 1991.
26. According to Victor J. Danilov, corporate museums are 'a corporate facility with tangible objects and/or exhibits, displayed in a museum-like environment, that communicates the history, operations or interests of a company to employees, customers and/or the public'. The Corning Museum of Glass, which is dedicated to the history, art and science of glass, is one example in America; see Victor J. Danilov, 'The New Thrust of Corporate Museums', *Museum News*, vol. 64, June 1986, pp. 36–47.
27. Visit to Harvey's Wine Museum and interview with its curator, Margaret B. Pigott, on 17 August 1993. The fact that Margaret Pigott has a public relations background clearly illustrates the nature of the corporate museum.
28. Interview on 5 May 1995.
29. *The Lobby Gallery: 31 W 52*, leaflet published by the Deutsche Bank in New York.
30. IBM no longer owns the building; it was sold for an undisclosed sum to the developer Edward J. Minskoff in 1994.
31. The IBM Gallery was an exception. As it was located at the cellar level of the IBM building, it did not receive any floor area bonus or floor area exemption, as it did for the garden plaza on its ground floor; personal correspondence with Marilyn Mammano, Director, Department of City Planning, New York City, on 22 December 1993.
32. Interview with Susan Gyorgy, Curator, PaineWebber Group, Inc., New York, on 9 August 1990.
33. There is no information available to draw any definite conclusion as to which sector of business is the most active organiser of exhibitions in office space.
34. Mary C. Hickey, 'Area Law Firms Host Exhibits of Fine Art', *The Washington Lawyer*, 1989, pp. 18–20.
35. Interview on 6 May 1992, London.
36. *Corporate Artnews*, vol. 3, no. 10, February 1987, and *Corporate Artnews*, vol. 8, no. 8, December 1991.
37. Interview with Nigel Frank, assistant for curator Glenn Sujo, Arts Guidelines, on 3 April 1995, and personal correspondence with him on 25 August 1995.
38. See the leaflet for the exhibition *Drive!*, published by the company. It was held between October 1988 and March 1989.
39. Interview on 31 August 1990.

40. Interview on 5 September 1990, and my personal observations made while attending a lecture by the photographer Steve Gottlieb at the opening view of the exhibition at the firm on 27 September 1990.

41. Lorraine Glennon, 'The New Patrons', *Art & Antiques*, May 1986, p. 108. With the success of converting the SoHo space into a bank-as-gallery, the Bank further relocated the branch to Broadway in 1990. It occupied 5,000 square feet of renovated warehouse space, specially designed to showcase new acquisitions of Chase's art collection, which changed three times a year; see *BCA News*, May/June 1990, p. 5.

42. This sentence was quoted in one of Hans Haacke's works, 'Alcoa: We Can't Wait for Tomorrow', in Wallis, ed., *Hans Haacke*, p. 197.

43. Interview with Campbell Gray (outside consultant for NatWest Art Prize) on 28 February 1995; see also 'NatWest Launches Unique 1990s Art Collection and New Competition for Art Students', draft press release, NatWest Bank, 6 December 1990.

44. 'Outline Job Description' for the post of NatWest Group curator, undated.

45. Adrian Searle, 'Withdrawal Symptoms', *Guardian*, 22 May 1999.

46. Nicholas Bannister, 'Writing on the Wall for IBM's $25m Collection of Paintings', *Guardian*, 15 February 1995.

8 CORPORATE ART COLLECTIONS

1. Interview, September 1990, Washington, DC.

2. For a wider perspective of the ever-expanding economic importance of the service sector, for example, compare David Harvey, *The Condition of Postmodernity: An Enquiry into the Origins of Cultural Change* (Oxford: Blackwell, 1989).

3. *Bates* v. *State Bar of Arizona*, quoted in Philip A. Thomas, ed., *Law in the Balance* (Oxford: Martin Robertson, 1982), p. 146.

4. Lord Chancellor's Department, *The Work and Organisation of the Legal Profession* (London: HMSO, 1989), Cm. 570.

5. Christopher Stanley, 'Justice Enters the Marketplace', in Russell Keat and Nicholas Abercrombie, eds, *Enterprise Culture* (London/New York: Routledge, 1991), pp. 206–15.

6. Stephen Whybrow, 'A Toe in the Sponsorship Water', *Arts Review*, 14 June 1991, p. 18.

7. Accelerated depreciation is 'a method of cost recovery which allows a deduction for the wear and tear of property used in a trade or business, or of property held for the production of income'. Personal correspondence dated 15 July 1991 from the London office of one of the top international chartered accountancy firms.

8. Investment tax credit (valid for the years 1980–85) 'permitted a reduction in tax liability based upon a taxpayer's qualified investment in certain kinds of property. Thus, investment tax credit was an incentive device intended to stimulate the purchase or modernisation of certain kinds of productive assets. Its purpose was achieved by permitting a reduction in income tax liability by a percentage (generally 10%) of the amount the taxpayer (corporation) spends for the assets.' Same personal correspondence as in note 7 above.

9. Daniel Grant, 'Corporate Collecting', *Art & Auction*, October 1985, p. 168.

10. See note 7 above.

11. Personal correspondence dated 9 February 1993 with Michael D. Finley, Office of the Assistant Chief Counsel (Income Tax and Accounting), IRS, Washington, DC.

12. Personal correspondence dated 13 April 1992 with another accountant at the same firm as in note 7 above.

13. Personal correspondence dated 16 May 1991 with an international law firm in Washington, DC.

14. See note 11 above.

15. The case was further taken to the United States Court of Appeal, but the original Tax Court's ruling was affirmed; see *Federal Reporter*, 2d, 6th Cir. 1985, pp. 38–40.

16. Personal correspondence dated 24 January 1994 with Susanna Waterhouse, Technical Adviser, Business Profits Division 4 (Schedule D), Inland Revenue, London.

17. An example was given by a chartered accountant in the London office of one of the top international accountancy firms, who was deeply involved in his firm's art collecting and sat on the trustee board of one of the leading independent galleries in Britain: 'If a painting is "plant and machinery", the amount spent on its acquisition can be offset against taxable profits at a rate of 25% on a reducing balance. If the painting cost £100, a deduction of £25 would be available in the first year, £18.75 in the second year (being 25% of 75% of £100), £14.06 in the third year (being 25% of 75% of 75% of £100), and so on.' Personal correspondence dated 15 December 1993.

18. Personal correspondence with Susanna Waterhouse, and interview with Nick Hagan, Tax Inspector, Moorgate, Inland Revenue, London, 20 November 1992.

19. According to Susanna Waterhouse, 'In general, a company can claim a deduction only for an expense which is incurred "wholly and exclusively for the purpose of its trade". . . . If, therefore, a company operated as an art dealer, the cost of buying works of art for sale by way of trade would be deductible in computing trading income. . . . In the case where a work of art was bought for its investment potential, it would not be a deductible expense because it would be capital, and there would be no allowance for depreciation.' Same personal correspondence as in note 16 above.

20. To qualify for capital allowances, works of art have to be classified as 'plant and machinery', which is 'actually being used to carry on the trade of the company. It is not sufficient for the asset to be used in the trade. The distinction may not be immediately obvious, but works of art are a particularly good example. A company may have paintings in its offices, for example. Although these are being used in the company's trade, they are not used to carry on the trade. Paintings in a restaurant perform both purposes – they are used to carry on the trade as they create an "atmosphere" in order to attract customers.' Sources the same as note 17. 'Another situation in which works of art might qualify as "plant", would be the pictures on the walls of a stately home which has a trade of opening to members of the public in return for admission fees, or a privately run art gallery.' Personal correspondence with Susanna Waterhouse, as in note 16 above.

21. Interview with the accountant on 13 June 1994, London.

22. Here is an example given by the accountant referred to above to illustrate the point: If you purchase a work of art for £100, for tax purposes you are allowed, say, 25% written down allowances against your expenses in tax computation, which means the tax written down value of that purchase is now £75 {£100 – (£100 × 25%)}. If you keep it for a year and then sell it, say, for £125, you have made a real profit of £25. But for tax purposes, you already have £25 allowances, which brought down the value to £75 and for tax purposes, you made a profit of £50. So in the year of acquisition, you are being allowed £25, and in the following year when you dispose of it, you pay tax on a £50 profit. If you did not obtain any tax allowances, you buy in year one for £100 and you sell it in year two for £125. You would pay tax on £25. As far as the net present value is concerned, it is therefore better to get the

allowances today and pay a higher profit tax tomorrow, because, according to him, 'your net present value of this £100 investment will have diluted in a year's time.'

(1) claiming capital allowances	£	(2) not claiming capital allowances	£
original cost	100	original cost:	100
(25% written down allowances)	−25	value in year two:	100
value in year two	75	if sold for £125,	
if sold for £125, profit:	50	profit:	25
Then pay tax on £50.		Then pay tax on £25.	

23. Robert Hiscox, 'Hiscox Holdings Ltd', in National Art Collections Fund (NACF), *The New Patrons: Twentieth-Century Art from Corporate Collections* (London: National Art Collections Fund, 1992), p. 50.

24. An early version of British corporate collectors was published by Chin-tao Wu, 'Corporate Collectors of Contemporary Art in Britain', in Rosanne Martorella, ed., *Art and Business: An International Perspective on Sponsorship* (Westport, CT/London: Praeger Publishers, 1996), pp. 89–100; cf. Chin-tao Wu, 'Art Amongst the Brokers: The Art Patronage of Finance Houses in America and Britain since the '80s', in Jutta Held, ed., *Kunst und Politik: Jahrbuch der Guernica-Gesellschaft*, vol. 1 (Osnabrück: Universitätsverlag Rasch, 1999), pp. 55–67.

25. Montgomery Museum of Fine Arts, *Art Inc.: American Paintings from Corporate Collections* (Alabama, 1979), pp. 10–24.

26. Allen, *The Romance of Commerce and Culture*, pp. 29–32.

27. IBM, *50 Years of Collecting*.

28. Simon Houfe, 'Art Treasures of the British Banks', *Bankers' Magazine*, December 1977, pp. 10–14.

29. The only treatment of American corporate art collecting is Rosanne Martorella's *Corporate Art*.

30. Shirley Reiff Howarth, ed., *International Directory of Corporate Art Collections* (Largo, FL: International Art Alliance and New York: Artnews Associates, 1989).

31. Beth Mintz and Michael Schwartz, 'Capital Flows and the Process of Financial Hegemony', in Sharon Zukin and Paul DiMaggio, eds, *Structures of Capital* (Cambridge: Cambridge University Press, 1990), p. 209.

32. John Scott, 'Intercorporate Structures in Western Europe', in Mark S. Mizruchi and Michael Schwartz, eds, *Intercorporate Relations: The Structural Analysis of Business* (Cambridge: Cambridge University Press, 1987), p. 221.

33. Beth Mintz and Michael Schwartz, 'Corporate Interlocks, Financial Hegemony, and Intercorporate Coordination', in Michael Schwartz, ed., *The Structure of Power in America: The Corporate Elite as a Ruling Class* (New York: Holmes and Meier, 1987), pp. 34–47; see also James Bearden, 'Financial Hegemony, Social Capital, and Bank Boards of Directors', in ibid., pp. 48–59.

34. According to William N. Goetzmann, there have been three apparent bull markets in art since 1720: 1780–1820, 1840–70, and finally the post-Depression era, 1940–86, with the last one being the longest and strongest of all; see 'Accounting for Taste: Art and the Financial Markets Over Three Centuries', *The American Economic Review*, vol. 83, no. 5, December 1993, pp. 1370–6.

35. George Soules, 'Does Art Belong in Pension Funds?', *Contingencies*, September/October 1989, pp. 31–2.

36. Robert C. Anderson, 'Paintings as an Investment', *Economic Inquiry*, vol. 12, March 1974, pp. 13–26.

37. Goetzmann, 'Accounting for Taste'.

38. See note 23 above.

39. Arnold and Porter, 'Art at Arnold and Porter', press release, Washington, DC, n.d.

40. Nancy Zeldis, 'Firms Get Serious About Art: Birds Are "Out"; Abstracts "In"', *The New York Law Journal*, 3 August 1988.

41. Jonathan Ames and Nick Hilborne, 'Art for Law's Sake', *Gazette* (Law Society), vol. 93, no. 32, 4 September 1996, p. 28.

42. David Cohen, 'Art for Everybody's Sake', *Accountancy*, April 1991, pp. 70–1.

43. This is a point made by several lawyers and accountants in the interviews.

44. For Coopers & Lybrand's collection, see Elspeth Moncrieff, 'Smart Art', *Apollo*, no. 133, March 1991, pp. 196–9. Coopers & Lybrand merged with Price Waterhouse in 1998.

45. Glenn Sujo, 'The Arthur Andersen Collection', *Arts Review Year Book 1990*, p. 53; Caroline Palmer, 'Hidden Treasure', *Accountancy Age*, October 1993, p. 31; and David Young, 'Corridor Show to Rival the Best', *The Times*, 9 December 1993.

46. Glaxo merged with Wellcome in early 1995, to become Glaxo Wellcome, and in turn merged with SmithKline Beecham in January 2000, and is now known as GlaxoSmithKline.

47. The nature of conglomerates is such that most of their products are not sold under the company's name. In addition to tobacco, Philip Morris business interests included, as of 1989, Kraft foods, Oscar Mayer foods, the Miller Brewing Company, financial services and real estate.

48. Simon Caulkin, 'Value for Money', *Observer*, 24 April 1994.

49. Joseph E. Seagram & Sons, New York, *Drawings by Sculptors: Two Decades of Non-Objective Art in the Seagram Collection*, 1984.

50. A total of over 300 works is given in its catalogue, although a report on the Unilever collection in 1989 gave a different figure of 1,000 works; see Andrew Gibbon Williams, 'The Secret Art of the City', *The Sunday Times*, 9 April 1989.

51. Mary Rose Beaumont, 'An Introduction to the Collection', *Unilever House London Contemporary Art Collection: The First Twelve Years*, catalogue published by Unilever plc (London, n.d.).

52. In a statement entitled 'TI Group and the Arts', contained in the *TI Group Art Collection 1992–3*, pack of postcards (Abingdon, Oxon.: TI Group plc, n.d.).

53. Ibid.

54. For this specific purpose, I do not mean the collections owned by the developers in their own offices, but the art works sited in the buildings which they develop.

55. Stephen Knapp, 'Working with Artists', *Urban Land*, September 1987, p. 20.

56. Albert Scardino, 'Marketing Real Estate with Art', *The New York Times*, 1 February 1987.

57. Marion Roberts, Chris Marsh and Miffa Salter, *Public Art in Private Places: Commercial Benefits and Public Policy* (London: University of Westminster, 1993).

58. Vanessa Houlder, 'Broadgate Extravaganza Masks Gloom', *The Financial Times*, 5 December 1991.

59. Colin Amery, 'Where Patronage Proves a Point', *The Financial Times*, 14 October 1991, p. 15.

60. According to a different account, the developers of the Broadgate 'poured several million pounds' into their public art programme; see Deyan Sudjic, 'Changing the Face of the City', *Guardian*, 4 December 1991.

61. Sir Nicholas Goodison, 'Art is Life', *Arts Review*, May 1992, p. 168. Goodison was the chairman of the TSB group, whose total revenue was £1.8 billion at the time when he started buying art for the group headquarters at the City of London with a budget of £100,000 in 1989.

62. Quoted in Mark Archer, 'The City's Best Kept Secret', *Telegraph Weekend Magazine*, 19 January 1991.

63. Interview, September 1990, Washington, DC.

64. DiMaggio, 'Cultural Entrepreneurship', pp. 33–50.

65. Useem, *The Inner Circle*, p. 175.

66. See Chapter 1, note 12.

67. Zeitlin, *The Large Corporation and Contemporary Classes*, pp. 73–109.

68. TSB merged with Lloyds Bank in December 1995 and is now known as Lloyds TSB.

69. Sara Webb, 'Finance and the Family', *The Financial Times*, 5 May 1990.

70. Antony Thorncroft, 'Rix Rattles the Arts Council', *The Financial Times*, 12 June 1993.

71. See note 61 above.

72. Alex Bernstein, 'Granada Television Ltd', in National Art Collections Fund, *The New Patrons*, p. 48.

73. Quoted in Rupert Morris, 'Radical Change of Art', *The Financial Times*, 7 January 1994.

74. A company brochure, *Windlesham*, published by the BOC Group, Windlesham, Surrey, n.d.

75. Personal correspondence with a foreign bank in London, 8 December 1992.

76. Chemical Bank Corporation, New York, *Art of the '80s from the Collection of Chemical Bank* (exhibition catalogue), 1989.

77. Interview, January 1995, London.

78. In a written statement given to me by one of the firms that I visited in Washington, DC, n.d.

79. Faye Rice, 'The Big Payoff in Corporate Art', *Fortune*, 25 May 1987, p. 106.

80. Personal Correspondence with the Works of Art Officer, Railpen Investments, dated 22 June 1994. The Pension Fund held only a few early twentieth-century paintings and prints.

81. 'British Rail Pension Fund – Investment in Works of Art', background information on art investment provided by the Works of Art Officer at the Pension Fund.

82. Bernstein, 'Granada Television Ltd', p. 48.

83. Interview with one of the top managers of a financial house in London in May 1992.

84. Diane Cochrane, 'Corporate Support of the Visual Arts', *American Artist*, vol. 42, 1978, p. 60.

85. DiMaggio, 'Social Structure, Institutions, and Cultural Goods', p. 133.

86. Bruce Serlen, 'Projecting an Image – You Are What You Buy', *The New York Times*, 12 February 1989.

87. ICI, London, *Contemporary Art at 9 Millbank: ICI Group Headquarters*, n.d.

88. John Hoole, 'Foreword', in *Capital Painting: Pictures from Corporate Collections in the City of London* (London: Barbican Art Gallery, 1984), p. 5.

89. Quoted in 'Taking Stock: Art for Art's Sake', *Accountancy Age*, 3 December 1987.

90. Interview, Washington, DC, September 1990.

91. Bonnie Barrett Stretch, 'Bankable Images', *American Photographer*, November 1986, p. 26.

92. Paula A. Poda, 'Mao Prints Kept, Over Objections', *Milwaukee Sentinel*, 27 June 1987, reprinted in Bruce Ferguson, Jane Swingle and Kobi Conway, eds, *TalkBack-Listen: The Visual Arts Program at First Bank System 1980–1990* (Winnipeg Art Gallery, 1989).

93. Joyce Tognini, 'Banking on Art', *American Craft*, February/March 1988, pp. 48–53; Jolie Solomon, 'A Minnesota Bank Banishes Artwork That Offends Staff', *The Wall Street Journal*, 19 December 1989, pp. 1, 6.

94. Walter Robinson, 'Minnesota Bank Loses Interest in Provocative Art', *Art in America*, vol. 78, March 1990, p. 37; see also Richard Bolton, 'The Contradiction of Corporate Culture', *New Art Examiner*, April 1990, pp. 18–21; Marjory Jacobson, *Art and Business: New Strategies for Corporate Collecting* (London: Thames and Hudson, 1993), pp. 18–22.

95. Lynne Sowder and Nathan Braulick, 'A Decade of Corporate Art Programming at First Bank System', in Ferguson et al., eds, *TalkBack-Listen*, p. 9.

96. Lynne Sowder and Nathan Braulick, 'First Bank Visual Arts Program Manifesto', in ibid., no page number.

97. Janice Steinberg, 'When Artists Advertise', *High Performance*, vol. 11, no. 3, Fall 1988, p. 42.

98. Archer, 'The City's Best Kept Secret', p. 19.

99. Beth A. Kerrigan, 'KPMG Peat Marwick Opens its Doors and Walls to Local Artists', *The Washington Accountants*, vol. 3, no. 3, May/June 1989.

100. 'Medicis of the Corporate World', *The Economist*, 21 February 1981; Mark Lilla and Isabella Frank, 'The Medici and the Multinationals', *Museum News*, vol. 66, no. 3, January/February 1988, pp. 32–5; Frank Lipsius, 'Modern Medicis', *The Financial Times*, 9 January 1986; and Birgitta Hjalmarson, 'The Modern-Day Medicis', *Private Clubs*, June 1986, pp. 17–23.

101. *American Paintings at the Equitable*, leaflet published by the Equitable for its art collection, New York, n.d.

102. Schmertz, *Patronage That Pays*, p. 5.

103. Jerry C. Welsh, *Involving the Arts in Marketing* (New York: BCA, 1986), p. 9.

104. Archer, 'The City's Best Kept Secret'.

105. Jean Lawlor Cohen, 'Sculpture: It's Here and Thriving at the Washington Law Firm', *The Washington Lawyer*, vol. 2, no. 3, January/February 1988, p. 45.

106. *Arthur Andersen Graduate Opportunities*, recruitment brochure produced by the firm in 1992.

107. Michael Norman, 'Office Art, Buyer, Beware', *The New York Times*, 19 February 1978.

108. Nancy Marx, 'Professional Class', *Manhattan Inc.*, September 1986, pp. 189–93.

109. Valerie F. Brooks, 'Confessions of the Corporate Art Hunters', *Artnews*, vol. 81, no. 6, Summer 1982, p. 108.

110. Marx, 'Professional Class', p. 190.

111. Ibid., p. 189.

112. Tate Gallery, *Corporate Membership Programme* brochure, n.d., p. 11.

113. Nancy Balfour, 'Getting Art into Business', *Arts Review Year Book 1986*, p. 32.

114. Ibid.

115. Serlen, 'Projecting an Image'.

116. Laguna Gloria Art Museum, Austin, Texas, 'Collecting on the Cutting Edge: Frito-Lay, Inc.', press release, dated 3 December 1987. Frito-Lay is a large US food manufacturing company. The Laguna Gloria Art Museum became the Austin Museum of Art in 1995.

117. Terry A. Fassburg, 'Introduction', in *Selections from the Frito-Lay Collection* (Dallas, Texas: Frito-Lay, Inc., 1987), p. 3.

118. Bonnie Barrett Stretch, 'The New Age of Corporate Art', *Artnews*, vol. 87, no. 1, January 1988, p. 71.

119. See note 116 above.

120. Martorella, *Corporate Art*, p. 162.

121. Quoted in Cohen, 'Sculpture', p. 42.

122. Interview, April 1992, London.

123. Ibid.

124. Interview, April 1992, London.

125. Interview, April 1992, London.

126. Pierre Bourdieu and Alain Darbel, *The Love of Art: European Art Museums and Their Public*, trans. Caroline Beattie and Nick Merriman (Cambridge: Polity, 1991).

127. Interview, September 1992, London.

128. Interview, January 1995, London.

129. Archer, 'The City's Best Kept Secret'.

130. Cohen, 'Sculpture'.

131. Brian O'Doherty, *Inside the White Cube: The Ideology of the Gallery Space* (San Francisco: The Lapis Press, 1986).

132. Michael Fried, 'Art and Objecthood', in Gregory Battcock, ed., *Minimal Art* (Berkeley: University of California, 1995), pp. 125–7.

133. Ibid., pp. 120–5.

134. Zeldis, 'Firms Get Serious about Art'.

135. Wallis, ed., *Hans Haacke*, pp. 152–5.

136. Sam Hunter, 'Corporate Patronage and the Commodities Corporation Art Collection', *National Art Guide*, vol. 2, no. 6, 1980, pp. 24–5.

137. James F. Cooper, '(Interview with Malcolm S. Forbes) . . . Nothing will Destroy Our Culture While People are Free to Create', *Forbes*, 2 October 1989, p. 20.

138. Goodison, 'Art is Life', p. 169.

139. Jon Kessler, quoted in 'Downtown Style', *Vogue* (US), vol. 178, no. 9, September 1988, p. 127.

140. Quoted in 'Pharmaceutical Giant Sponsors Art', *Arts Review*, September 1992, p. 440.

141. Clare Dyer, 'Glaxo Litigants in Plea to Judge', *Guardian*, 24 February 1990, p. 4; '£7m Settlement in "Back Pain" Action', *Guardian*, 1 August 1995, p. 8.

142. 'Downtown Style', p. 125.

143. Ruth Berger, 'The Corporation as Art Collector', *Across the Board*, January 1983, p. 50.

144. This is hardly the first time that artists have been put to work for business, or that art has served to enhance a corporate identity and glamorise its products. In the 1920s, for example, the American painter Charles Sheeler used fashionable avant-garde forms to make advertising photographs for typewriters, spark plugs and other products; see Terry Smith, *Making the Modern: Industry, Art and Design in America* (Chicago/London: University of Chicago Press, 1993), pp. 111–35.

145. Sharon Shinn, 'Banking on Art', *Decor*, February 1990, p. 88.

146. Robert Hughes, 'Whose Art is it, Anyway?' *Time*, 4 June 1990, p. 47.

147. Cf. T. J. Jackson Lears, 'The Concept of Cultural Hegemony: Problems and Possibilities', *American Historical Review*, vol. 90, no. 3, June 1985, p. 568.

9 CONCLUSION: FROM CONSERVATISM TO NEO-CONSERVATISM

1. Nigel Lawson, *The View From No. 11* (London: Bantam Press, 1992), p. 64.

2. On the increasingly important role that corporations, multinational included, are playing nationally in Britain under New Labour, see George Monbiot, *Captive State: The Corporate Takeover of Britain* (London: Macmillan, 2000).

3. Robin Cembalest, 'Clinton and the Arts', *Artnews*, vol. 92, no. 1, January 1993, pp. 122–5.

4. Roth Evan, '*Kulturkampf*: How Bush and Clinton Score', *Museum News*, vol. 71, September/October 1992, p. 47.

5. Andres Serrano was attacked for his work *Piss Christ*, a photograph that depicts a crucifix immersed in Serrano's own urine; see also Chapter 3.

6. In 1989 Congress imposed an obscenity restriction on the NEA, prohibiting it from funding anything that could be considered as obscene, sado-masochistic, homo-erotic or sexually exploitative of children. The obscenity restriction was held to be unconstitutional by a Federal Court in 1991.

7. 'Remarks by the President and the First Lady at the President's Committee on the Arts and Humanities Ceremony', Press Release, the White House Office of the Press Secretary, 21 September 1994.

8. 'Excerpts from the Republican Party's Platform', *The New York Times*, 13 August 1996.

9. Ann Landi, 'The Unkindest Cut', *Artnews*, vol. 93, September 1994, p. 46.

10. 'Patrick J. Buchanan in his own Words', *The New York Times*, 26 October 1999.

11. Ibid.

12. 'Excerpts from Ruling to Uphold Decency Tests for Awarding Federal Arts Grants', *The New York Times*, 26 June 1998, and Linda Greenhouse, 'Justices Uphold Decency Test in Awarding Arts, Backing Subjective Judgement', *The New York Times*, 26 June 1998.

13. Quoted in Dan Glaister, 'Blair Escapes the Critics in Role as Arts Champion', *Guardian*, 1 February 1999.

14. Quoted in Dan Glaister, 'Labour Vows to Support Artistic Talent', *Guardian*, 4 February 1999.

15. David Hencke and Amelia Gentleman, 'Auditors Say Arts Council is Soft Touch', *Guardian*, 14 May 1999.

16. According to Camelot, the social class distribution of Lottery gamblers is 21% AB, 25% C1, 26% C2 and 28% DE. Data provided by Camelot on 4 February 2000.

17. Speaking at a press conference on 17 December 1999, Serota commented: 'The great legacy of John Major to this country was to create the Lottery. And it's quite clear to me that in 10 or 15 years' time John Major, who served as Prime Minister for 7 years, will probably be best known for establishing the Lottery.'

18. Margaret Thatcher, *The Downing Street Years* (London: HarperCollins, 1993), p. 610 note.

19. The British Museum abandoned its original plan to use PFI to fund the study centre after the collapse of the Royal Armouries PFI.

20. David Ward, 'Smith Drums Up Cash to Save Arms Museum', *Guardian*, 2 August 1999.

21. Personal conversation with Chris Smith on 20 January 2000.

22. Nick Cohen, 'The Third Way . . . Make the Third Generation Pay', *Guardian*, 7 November 1999.

23. Laura M. Holson, 'The Incredible Shrinking Banker', *The New York Times*, 2 August 1998.

24. Ken Johnson, 'Showcase in Arcadia', *Art in America*, vol. 76, July 1988, pp. 94–103; Anni Landi, 'And Peggy Makes Four', *Artnews*, vol. 94, September 1995, p. 58; and Ralph Blumenthal and Carol Vogel, 'Guggenheim Plans a Branch at the Hudson', *The New York Times*, 19 November 1998 and 'The Guggenheim Proposes Gehry Museum for New York', *The New York Times*, 28 September 1999.

25. David D'Arcy, 'No Populist, No Colonialist – Just Loved by Business', *Art Newspaper*, vol. 10, October 1998, p. 37.

26. Michael Kimmelman, 'Thomas Krens: The Globe Straddler of the Art World', *The New York Times*, 19 April 1998.

27. Ibid.

28. Roberta Smith, '"Mediascape": High-Tech Art and Entertainment', *The New York Times*, 18 June 1996.

29. Jason Edward Kaufman, 'Guggenheim Goes Virtual', *Art Newspaper*, vol. 7, May 1996, p.17.

30. Holland Cotter, 'A SoHo Sampler: Shortlist for Prize', *The New York Times*, 22 November 1996. For more detail on Hugo Boss sponsorship at the Guggenheim, see Chapter 6.

31. 'Das Deutsche Guggenheim Berlin', information leaflet produced by Deutsche Bank, 1999.

32. Quoted in Christopher Philips, 'Guggenheim Opens Berlin Outpost', *Art in America*, vol. 86, January 1998, p. 29.

33. Kimmelman, 'Thomas Krens'.

34. Joseph Giovannini, 'Reshaping Bilbao', *Architecture*, vol. 86, December 1997, pp. 39–42.

35. Warren Hoge, 'Bilbao's Cinderella Story', *The New York Times*, 8 August 1999.

36. Joseba Zulaika, 'The Seduction of Bilbao', *Architecture*, vol. 86, December 1997, pp. 60–3. The figure for the cost of the museum building has been generally reported as $100 million, but Zulaika quoted Ramon Zallo's calculation of $250 to 360 million. No one outside the deal really knows the cost of the whole enterprise, as a clause within the agreement forbids its disclosure. See also François Chaslin, 'Bilbao, en toute franchise', *L'Architecture d'aujourd'hui*, no. 313, October 1997, pp. 44–51.

37. Giovannini, 'Reshaping Bilbao', p. 42.

38. Ibid.

39. Robin Cembalest, 'First We Take Bilbao', *Art Forum*, vol. 36, September 1997, p. 64.

40. Juan Ignacio Vidarte was a former tax and finance director in the regional government.

41. Andrew Decker, 'Can the Guggenheim Pay the Price?', *Artnews*, vol. 93, January 1994, pp. 142–9.

42. Quoted in David Ward, 'Liverpool Woos Guggenheim', *Guardian*, 9 July 1999.

43. 'Mayor Giuliani Awards Solomon R. Guggenheim Foundation Waterfront Site to Build Major New Museum in New York City', Guggenheim Museum press release, 28 November 2000, and 'Guggenheim Foundation to Undertake Feasibility Study in Brazil', Guggenheim Museum press release, 10 November 2000.

44. 'Guggenheim Foundation Announces New Exhibition Space at the Venetian in Las Vegas Designed by Rem Koolhaas to Open Summer 2001', Guggenheim Museum press release, 20 October 2000.

45. The Japanese would have liked to have works of art in two areas that would most appeal to the ordinary Japanese, i.e. Asian antiquities and Impressionism,

but the Boston Museum insisted on loaning works from all sections of its collection; see 'Branching out in Nagoya', *Newsweek International*, 2 August 1999, and Kay Itoi, 'Boston–Nagoya Deal Finalised', *Artnews*, vol. 94, February 1995, p. 52.

46. Quoted in Robin Cembalest, 'Building a Pioneering Partnership', *Artnews*, vol. 91, January 1992, p. 47.
47. Edward W. Said, *Orientalism* (Harmondsworth: Penguin Books, 1985), p. 100.
48. 'Branching out in Nagoya'.
49. At a talk by Lars Nittve and Stephen Deuchar (director of Tate Britain), chaired by Tim Marlow at Art 2000 on 18 January 2000.
50. Patrick Collinson, 'Now Giving Really is Receiving', *Guardian*, 13 November 1999.
51. David Brindle and Terry Macalister, 'Good Causes Welcome Incentives for Donors', *Guardian*, 10 March 1999.
52. Charlotte Abrahams, 'Art to DIY for', *Guardian Weekend*, 9 October 1999.
53. Speaking at a press conference on 17 December 1999.
54. For a critical review of Charles Saatchi and the young British artists, see Stallabrass, *High Art Lite*, pp. 196–222; cf. also Hatton and Walker, *Supercollector*.
55. To honour the gift, the Arts Council Collection published a special catalogue, which Saatchi had offered to pay for; see Arts Council Collection, *The Saatchi Gift to the Arts Council Collection* (London: South Bank Centre, 2000).
56. *Young British Art: The Saatchi Decade* (London: Booth-Clibborn Editions, 1999).
57. In *Blair's Thousand Days*, broadcast on BBC2 on 30 January 2000.

BIBLIOGRAPHY

Abbin, Byrle M., Diane Cornwell, Richard A. Helfand, Michael Janicki, Ross W. Nager and Mark L. Vorsatz, *Tax Economics of Charitable Giving*. Chicago: Arthur Andersen & Co., 1991.

Ades, Dawn and Andrew Forge, *Francis Bacon*. London: Thames and Hudson/Tate Gallery, 1985.

Alberge, Dalya, 'The Art Donors', *The Independent*, 25 February 1992.

—— 'A Very Private Collector', *The Independent*, 3 March 1992.

Alexander, Victoria Dean, *From Philanthropy to Funding: The Effects of Corporate and Public Support on Art Museums*. Unpublished PhD thesis, Stanford University, California, 1990.

Allen, James Sloan, *The Romance of Commerce and Culture*. London and Chicago: University of Chicago Press, 1983.

Allen, Jane, 'The (Declining) Power of Review', *New Art Examiner*, November 1981, pp. 12–13.

Altias, Elaine, 'British Budget Battle: Funding Cuts Mobilize Arts Community', *The Washington Post*, 9 January 1985; quoted in Penelope Cagney, 'Can US Fund Raising Help British Arts?', *Fund Raising Management*, vol. 19, no. 8, October 1988, pp. 76–9.

AMCON Group, Inc., *Seminar on Business Support of the Arts*, 3 June 1981, New York.

American Association of Museums, *Data Report: From the 1989 National Museum Survey*. Washington, DC, 1992.

Ames, Peter J. and Helen Spaulding, 'Museum Governance and Trustee Boards', *The International Journal of Museum Management and Curatorship*, vol. 7, March 1988, pp. 33–6.

Anderson, Robert C., 'Paintings as an Investment', *Economic Inquiry*, vol. 12, March 1974, pp. 13–26.

Anderson, Susan Heller, 'Ever Pragmatic Singapore is Making Art Its Business', *The New York Times on the Web*, 25 July 1999.

Anon, 'American Business and the Arts', *Forbes*, 28 October 1985 (special advertising supplement).

—— 'American Business and the Arts', *Forbes*, 27 October 1986 (special advertising supplement).

—— 'Arts Beat Sports for Successful Corporate Hospitality', *absa Bulletin*, Autumn 1991, p. 6.

—— 'Business Brief: Medicis of the Corporate World', *The Economist*, 21 February 1981.

—— 'Downtown Style', *Vogue* (US), vol. 178, no. 9, September 1988, pp. 125–8.

—— 'Hammer Museum Nailed by Lawsuits', *Art in America*, vol. 77, no 7, July 1989, pp. 31, 167.

—— 'Letters', *Burlington Magazine*, May 1989, pp. 357–8.

—— 'Pharmaceutical Giant Sponsors Art', *Arts Review*, September 1992, p. 440.

—— 'Philip Morris' Blackmail Scam', *The New York Observer*, 3 October 1994.

—— 'Reagan Names Task Force to Study New Form for Endowments', *The New York Times*, 7 May 1981.

—— 'Sponsorship's Decade of Growth', *Classical Music*, no. 290, 21 December 1985, p. 1.

—— 'Success at Last: The Media Credit Breakthrough', *absa Bulletin*, Autumn/Winter, 1989, p. 3.

—— 'Taking Stock: Art for Art's Sake', *Accountancy Age*, 3 December 1987.

Archer, Mark, 'The City's Best Kept Secret', *Telegraph Weekend Magazine*, 19 January 1991.

Armitstead, Claire, 'Risky Business', *Guardian*, 13 January 1993.

Arthur Andersen, *Business Support for the Arts in Europe*. London, 1991.

—— *Business Support of the Arts: A Tax Guide*. London, 1991.

Arts Council of Great Britain (ACGB), *Arts Council Collection Acquisitions 1979–83*. 1984.

—— *Arts Council Collection Acquisitions 1984–88*. London: ACGB/South Bank Centre, n.d.

—— *Arts Council/British Gas Awards – Working for Cities* (entry form), 1990.

—— *Arts Council of Great Britain Royal Charter*. 1967.

—— *The Arts Funding System: An Introduction to the Components of the UK Arts Funding System*. n.d.

—— *British Gas Properties/Arts Council Awards 1995: Working for Cities* (entry form), 1995.

—— *The Glory of the Garden: A Strategy for a Decade*. 1984.

—— *Rewarding Enterprise*. 1987.

Associates for Arts Research and Technical Services, *Visual Artists' Organizations Fiscal Year 1982–83*. Unpublished report, Washington, DC, 1985.

Association for Business Sponsorship of the Arts (ABSA), *Business Sponsorship of the Arts: A Tax Guide*. London, 1984.

—— *Business Support for the Arts 1993/94*. London, 1994.

Association of American Museums, *Data Report: From the 1989 National Museum Survey*. Washington, DC, 1992.

Baldry, Harold, *The Case for the Arts*. London: Secker and Warburg, 1981.

Balfour, Nancy, 'Getting Art into Business', *Arts Review Year Book 1986*, p. 32.

Bannister, Nicholas, 'Writing on the Wall for IBM's $25m Collection of Paintings', *Guardian*, 15 February 1995.

Barbican Art Gallery, *Capital Painting: Pictures from Corporate Collections in the City of London*. London, 1984.

Barnes, Rachel, 'Dream Factory', *Guardian*, 3 June 1994.

Beardsley, John, *The Art Critics Fellowship Program: Analysis and Recommendations*. National Endowment for the Arts, Washington, DC, unpublished report, August 1983.

Beaumont, Mary Rose, 'An Introduction to the Collection', *Unilever House London Contemporary Art Collection: The First Twelve Years*. Catalogue published by Unilever plc, London, n.d.

Beck, Ernest, 'Nicholas Serota: Getting the Hang of it', *Artnews*, vol. 88, no. 3, March 1989, pp. 117–18.

Berger, Ruth, 'The Corporation as Art Collector', *Across the Board*, January 1983, pp. 42–50.

Berle, Adolf A. and Gardiner C. Means, *The Modern Corporation and Private Property*. Revised edition (first published 1932). New York: Harcourt, Brace & World, 1967.

Bickers, Amy, 'Winning Images', *Far Eastern Economic Review*, 26 March 1998.

Blount, Winton M., *Business Support to the Arts is Just Good Sense*. New York: BCA, 1984.

Blumenthal, Ralph and Carol Vogel, 'Guggenheim Plans a Branch at the Hudson', *The New York Times*, 19 November 1999.

—— 'The Guggenheim Proposes Gehry Museum for New York', *The New York Times*, 28 September 1999.

Bois, Yve-Alain, 'The Antidote', *October*, no. 39, 1986, pp. 128–44.

Bois, Yve-Alain, Douglas Crimp and Rosalind E. Krauss, 'A Conversation with Hans Haacke', *October*, no. 30, 1984, pp. 24–48.

Bolton, Richard, 'Enlightened Self-Interest: The Avant-Garde in the '80s', *Afterimage*, vol. 16, no. 7, February 1989, pp. 12–18.

Boseley, Sarah, 'Tobacco Ads and Sports Sponsorship to Disappear', *Guardian*, 18 June 1999.

Bourdieu, Pierre, 'Cultural Reproduction and Social Reproduction', in Richard Brown, ed., *Knowledge, Education, and Cultural Change*. London, Tavistock Publications, 1973, pp. 71–112.

—— *Distinction: A Social Critique of the Judgement of Taste*, trans. Richard Nice. London and Melbourne: Routledge and Kegan Paul, 1984.

Bourdieu, Pierre and Alain Darbel, *The Love of Art: European Art Museums and Their Public*, trans. Caroline Beattie and Nick Merriman. Cambridge: Polity, 1991.

Bowler, Anne E. and Blaine McBurney, 'Gentrification and the Avant-Garde in New York's East Village', in J. H. Balfe, ed., *Paying the Piper: Causes and Consequences of Art Patronage*. Urbana and Chicago: University of Illinois Press, 1993, pp. 161–82.

Brandenberg, Mary, 'Sustenance: From the City', *Accountancy*, September 1988, pp. 65–9.

Brauer, Fay, 'Tate Sponsorship', *Art Monthly*, no. 91, November 1985, pp. 2–3.

Brenson, Michael, 'Museum and Corporation – A Delicate Balance', *The New York Times*, 23 February 1986.

Brindle, David and Terry Macalister, 'Good Causes Welcome Incentives for Donors', *Guardian*, 10 March 1999.

Brooks, Valerie F., 'Art & Business in the '80s: A Billion Dollar Merger', *Artnews*, advertising supplement, vol. 86, no. 1, January 1987.

—— 'Confessions of the Corporate Art Hunters', *Artnews*, vol. 81, no. 6, Summer 1982, pp. 108–12.

Buck, Louisa and Philip Dodd, *Relative Values or What's Art Worth?* London: BBC, 1991.

Button, Virginia, *The Turner Prize*. London: Tate Gallery, 1999.

Cagney, Penelope, 'Can US Fund-Raising Help British Arts?', *Fund Raising Management*, vol. 19, no. 8, October 1988.

Carles, Richard and Patricia Brewster, *Patronage and the Arts*. London: Conservative Political Centre for the Bow Group, 1959.

Carter, Malcom N., 'The Hoving Years', *Artnews*, vol. 76, no. 1, January 1977, pp. 37–40.

Cembalest, Robin. 'Clinton and the Arts', *Artnews*, vol. 92, no. 1, January 1993, pp. 122–5.

Chaslin, François, 'Bilbao, en toute franchise', *L'Architecture d'aujourd'hui*, no. 313, October 1997, pp. 44–51.

Chaudhuri, Anita, 'Suiting Stars', *Guardian*, 25 June 1997.

Chemical Bank Corporation, *Art of the '80s from the Collection of Chemical Bank* (exhibition catalogue). New York, 1989.

Cohen, David, 'Art for Everybody's Sake', *Accountancy*, April 1991, pp. 70–1.

Cohen, Jean Lawlor, 'Sculpture: It's Here and Thriving at the Washington Law Firm', *The Washington Lawyer*, vol. 2, no. 3, January/February 1988, p. 45.

Cohen, Nick, 'The Third Way . . . Make the Third Generation Pay', *Guardian*, 7 November 1999.

Collinson, Patrick, 'Now Giving Really is Receiving', *Guardian*, 13 November 1999.

Connolly, Kate, 'Hugo Boss Firm Made Uniforms for the Nazis', *Guardian*, 13 August 1997.

Conservative Political Centre, *The Arts – The Way Forward*. London, 1978.

—— *Government and the Arts*. London, 1962.

Conyers, Tony, 'State Cannot be Part of Arts Revival', *The Daily Telegraph*, 28 May 1980.

Cooper, James F., '(Interview with Malcolm S. Forbes) . . . Nothing Will Destroy our Culture While People are Free to Create', *Forbes*, 2 October 1989.

Council for the Encouragement of Music and the Arts (CEMA), *The Arts in War Time: A Report on the Work of C.E.M.A. 1942 & 1943*. London, n.d.

Cummings, Milton C., Jr. and J. Mark Davidson Schuster, eds, *Who's to Pay for the Arts?* New York: American Council for the Arts, 1989.

Cummings, Milton C., Jr. and Richard S. Katz, eds, *The Patron State: Government and the Arts in Europe, North America and Japan*. New York: Oxford University Press, 1987.

D'Arcy, David, 'No Populist, No Colonialist – Just Loved by Business', *Art Newspaper*, vol. 10, October 1998, p. 37.

de Botton, Gilbert, 'Sponsorship of Art'. Transcript of a speech given at *Art at Work* conference organised by Art for Offices on 8 November 1985.

Decker, Andrew, 'Trustees and Trust', *Artnews*, vol. 88, no. 10, December 1989, p. 51.

de Jongh, Nicholas, 'Businessmen Get £25,000 to Back Arts', *Guardian*, 30 April 1980.

—— 'Luce Way with Cash', *Guardian*, 16 November 1985.

—— 'Stevas Launches Drive for More Arts Sponsorship', *Guardian*, 11 June 1980.

—— 'Thatcher Pledge on Aid for the Arts', *Guardian*, 28 May 1985.

Deutsche, Rosalyn and Cara Gendel Ryan, 'The Fine Art of Gentrification', *October*, Winter 1984, pp. 91–111.

DiMaggio, Paul, 'Cultural Entrepreneurship in Nineteenth-Century Boston', *Media, Culture and Society*, vol. 4, 1982, pp. 33–50 and 303–22.

—— Ed., *Nonprofit Enterprise in the Arts: Studies in Mission and Constraint*. New York: Oxford University Press, 1986.

—— 'Social Structure, Institutions, and Cultural Goods: The Case of the United States', in Pierre Bourdieu and James S. Coleman, eds, *Social Theory for a Changing Society*. Boulder, CO: Westview Press, and New York: Russell Sage Foundation, 1991.

DiMaggio, Paul and Michael Useem, 'Cultural Democracy in a Period of Cultural Expansion: The Social Composition of Arts Audiences in the United States', *Social Problems*, vol. 26, no. 2, 1978, pp. 179–97.

—— 'Cultural Policy and Public Policy: Emerging Tensions on Government Support for the Arts', *Social Research*, vol. 45, 1978, pp. 356–89.

—— 'Social Class and Arts Consumption', *Theory and Society*, vol. 5, 1978, pp. 141–61.

DiMaggio, Paul, Michael Useem and Paula Brown, *Audience Studies of the Performing Arts and Museums: A Critical Review*. Research Division Report # 9. Washington, DC: National Endowment for the Arts, 1978.

Directory of Social Change, *Covenants: A Practical Guide to the Tax Advantages of Giving*, 2nd edition. London, 1985.

Domhoff, G. William, *The Higher Circles*. New York: Random House, 1970.

Doulton, Anne-Marie, *The Arts Funding Guide*. London: Directory of Social Change, 1988.

Duncan, Carol, *Civilizing Rituals: Inside Public Art Museums*. London: Routledge, 1995.

Dye, Thomas R., *Who's Running America? The Conservative Years*. Englewood Cliffs, NJ: Prentice-Hall, 1986.

Elsen, Albert and J. H. Merryman, *Law, Ethics and the Visual Arts*. Philadelphia: University of Pennsylvania Press, 1987.

Evan, Roth, 'Kulturkampf: How Bush and Clinton Score', *Museum News*, vol. 71, September/October 1992.

Faulds, Andrew, 'The State and the Arts in Great Britain', *Studio International*, vol. 182, November 1971, pp. 202–5.

Feld, Alan L., Michael O'Hare and J. Mark Davidson Schuster, *Patrons Despite Themselves: Taxpayers and Arts Policy*. New York: New York University Press, 1983.

Feldstein, Martin, ed., *The Economics of Art Museums*. Chicago and London: University of Chicago Press, 1991.

Ferguson, Bruce, Jane Swingle and Kobi Conway, eds, *TalkBack-Listen: The Visual Arts Program at First Bank System 1980–1990*, Winnipeg Art Gallery, 1989.

Finch, Andy, *Congressional and IRS Actions on Museum Tax Issues*. Washington, DC: American Association of Museums, 1995.

Fletcher, Matthew, 'The Art of Patronage', *Accountancy Age*, July/August 1991, pp. 8–9, 11.

Fogarty, Michael and Ian Christie, *Companies and Communities*. London: Policy Studies Institute, 1990.

Foote, Nancy, 'The Apotheosis of Crummy Space', *Artforum*, vol. 15, October 1976, pp. 26–36.

Frito-Lay, Inc., *Selections from the Frito-Lay Collection*. Dallas, Texas, 1987.

Gardner, Paul, 'Tainted Money', *Artnews*, vol. 88, no. 4, April 1989, pp. 180–3.

—— 'What Price Glory?', *Artnews*, vol. 87, no. 8, October 1988, pp. 123–5.

Gever, Martha, 'Blowing in the Wind: The Fate of NEA Critics' Fellowships', *Afterimage*, vol. 12, no. 1, Summer 1984, pp. 3, 37.

—— 'Growing Pains: Artists' Organizations in the '80s', *Afterimage*, vol. 11, no. 6, January 1984, pp. 3, 22.

Gimelson, Deborah, 'The Tower of Art: Art, the Handmaiden to Real Estate', *Art & Auction*, October 1985, p. 152.

Gingold, Diane J., *Business and the Arts: How They Meet the Challenge*. Washington, DC: National Endowment for the Arts, 1984.

Giovannini, Joseph, 'Reshaping Bilbao', *Architecture*, vol. 86, December 1997, pp. 39–42.

Glaister, Dan, 'Blair Escapes the Critics in Role as Arts Champion, *Guardian*, 1 February 1999.

—— 'Labour Vows to Support Artistic Talent', *Guardian*, 4 February 1999.

Glennon, Lorraine, 'The Museum and the Corporation: New Realities', *Museum News*, vol. 66, January/February 1988, pp. 36–43.

Glueck, Grace, 'Independent Corporation Weighed as Arts Agency', *The New York Times*, 14 April 1981.

—— 'Mogul Power at the Whitney', *The New York Times Magazine*, 4 December 1988, Section 6, Part II, p. 74.

—— 'Power and Esthetics: The Trustee', *Art in America*, vol. 59, no. 4, July/August 1971, pp. 78–83.

—— 'What Big Business Sees in Fine Art', *The New York Times*, 26 May 1985.

Goetzmann, William N., 'Accounting for Taste: Art and the Financial Markets Over Three Centuries', *The American Economic Review*, vol. 83, no. 5, December 1993, pp. 1370–6.

Goldberger, Paul, 'Philip Morris Calls In IOUs in the Arts', *The New York Times*, 5 October 1994.

—— 'Plazas, like Computers, are Best if User-Friendly', *The New York Times*, 22 March 1987.

Goldin, Amy and Roberta Smith, 'Present Tense: New Art and the New York Museum', *Art in America*, vol. 65, no. 5, September/October 1977, pp. 92–104.

Goodison, Nicholas, 'Art is Life', *Arts Review*, May 1992, pp. 168–70.

Gosling, Kenneth, 'Fund-Raisers for Arts Get £25,000 State Aid', *The Times*, 30 April 1980.

Graham Marchant Associates, *Where Do We Go Next? A Review of Touring in England.* Commissioned by Arts Council of Great Britain, 1992.

Graham-Dixon, Andrew, 'A Modern Medici', *Vogue* (Britain), November 1990, pp. 236–39, 311.

—— 'Winning Strokes', *The Independent*, 4 October 1988.

Grant, Daniel, 'Corporate Collecting', *Art & Auction*, October 1985, pp. 166–8.

Greenhouse, Linda, 'Justices Uphold Decency Test in Awarding Arts, Backing Subjective Judgements', *The New York Times*, 26 June 1998.

Grossberg, Shelley Jane, 'Artful Management', *Art & Auction*, October 1987, pp. 164–5.

Grundberg, Andy, 'When Outs are In, What's Up', *The New York Times*, 26 July 1987.

Habermas, Jürgen, 'The Public Sphere', *New German Critique*, no. 3, Fall 1974, pp. 49–55.

Hall, Anthea, 'New Masters at the Tate', *The Weekend Telegraph*, 15 January 1989.

Hall, Carla, 'NEA, NEH Review', *The Washington Post*, 7 May 1981.

Hardy, Alys, 'Luce Vows "No Artistic Interference"', *The Stage*, 11 May 1989.

Harris, John S., *Government Patronage of the Arts in Great Britain.* London/Chicago: University of Chicago Press, 1970.

Hatton, Rita and John A. Walker, *Supercollector.* London: Ellipsis, 2000.

Hawkins, Ashton, 'Income Taxes and Museums in America', *Apollo*, no. 128, November 1988, pp. 340–4.

Hayward Gallery, *The Saatchi Gift to the Arts Council Collection*. London, 2000.

Hencke, David and Amelia Gentleman, 'Auditors Says Arts Council is Soft Touch', *Guardian*, 14 May 1999.

Henriques, Diana B. and Floyd Norris, 'The Wealthy Find New Ways to Escape Tax on Profits', *The New York Times on the Web*, 1 December 1996.

Hewison, Robert, *Culture and Consensus: England, Art and Politics since 1940*. London: Methuen, 1995.

—— 'Out to Change the Message on a Bottle', *The Sunday Times*, 28 May 1995.

Hillman-Chartrand, Harry, ed., *The Arts: Corporations and Foundations*. Ottawa: The Canada Council, 1985.

Hilton, Tim, 'Hung, Drawn but not yet Slaughtered', *Guardian*, 27 August 1992.

—— 'The Taking of the Tate', *Guardian*, 23 December 1988.

Hoelterhoff, Manuela, 'The Arts Endowments: Battling over the Muses', *The Wall Street Journal*, 5 August 1981.

Hoge, Warren, 'Bilbao's Cinderella Story', *The New York Times*, 8 August 1999.

Hogrefe, Jeffrey, 'Secondhand Smoke Hits Arts Angel', *The New York Observer*, 17 October 1994.

Honan, William H., 'Congressional Anger Threatens Arts', *The New York Times*, 20 June 1989.

Hoole, John, 'Foreword', in *Capital Painting: Pictures from Corporate Collections in the City of London*. London: Barbican Art Gallery, 1984.

Hopkins, Mary Rozell, 'Art as an Element of Corporate Culture', *The Art Newspaper*, no. 76, December 1997.

Houfe, Simon, 'Art Treasures of the British Banks', *Bankers' Magazine*, December 1977, pp. 10–14.

Howarth, Shirley Reiff, ed., *International Directory of Corporate Art Collections*. Largo, FL: International Art Alliance and New York: Artnews Associates, 1989.

Hughes, Robert, 'Whose Art is it, Anyway?', *Time*, 4 June 1990, pp. 46–8.

Hunter, Sam, *Art in Business: The Philip Morris Story*. New York: Abrams/BCA, 1979.

—— 'Corporate Patronage and the Commodities Corporation Art Collection', *National Art Guide*, vol. 2, no. 6, 1980, pp. 24–5.

Hutchison, Robert, *The Politics of the Arts Council*. London: Sinclair Browne, 1982.

IBM, *50 Years of Collecting: Art at IBM*. New York, 1989.

ICI, *Contemporary Art at 9 Millbank: ICI Group Headquarters*. London, n.d.

Inland Revenue, *Giving to Charity: How Business Can Get Tax Relief.* Notes Series IR64, 1986 and 1993 editions. London: Inland Revenue.

Jacobson, Marjory, *Art and Business: New Strategies for Corporate Collecting.* London: Thames and Hudson, 1993.

Januszczak, Waldemar, 'No Way to Treat a Thoroughbred', *Guardian*, 15 February 1986.

—— 'The Shock of Serota', *Guardian*, 26 November 1988.

Johnstone, Douglas A., 'Legal Notes: Directors and Trustees: Personal Liability for Their Actions', *The International Journal of Museum Management and Curatorship*, vol. 7, 1988, pp. 77–8.

Johnstone, Isobel, 'Correspondence', *Art Monthly*, no. 148, July/August 1991, p. 31.

—— 'Outing Art', *The Art Quarterly*, no. 9, September 1992.

Joseph E. Seagram & Sons, Inc., *Drawings by Sculptors: Two Decades of Non-Objective Art in the Seagram Collection.* New York, 1984.

Kaufman, Jason Edward, 'Guggenheim Goes Virtual', *Art Newspaper*, vol. 7, May 1996.

Kay, Caroline, 'Getting Credit Where Credit is Rightly Due', *The Times*, 11 December 1992.

Keens, William, 'An Interview with Frank Hodsoll', *American Arts*, vol. 13, no. 1, January 1982, pp. 4–9.

—— 'Serving Up Culture: The Whitney and Its Branch Museums (Interview)', *Museum News*, vol. 64, no. 4, March/April 1986.

Kemp, Martin, 'The Crisis at the V & A', *Burlington Magazine*, no. 1034, May 1989, pp. 355–7.

Kerrigan, Beth A., 'KPMG Peat Marwick Opens its Doors and Walls to Local Artists', *The Washington Accountants*, vol. 3, no. 3, May/June 1989.

Kester, Grant, 'Rhetorical Questions: The Alternative Arts Sector and the Imaginary Public', *Afterimage*, vol. 20, no. 6, January 1993, pp. 10–16.

Kettle, Martin, 'On the Road with Mars and Marlboro', *Guardian*, 21 June 1990.

Keynes, John Maynard, 'The Arts Council: Its Policy and Hopes', *Listener*, 12 July 1945, p. 31.

Keynes, Milo, ed., *Essays on John Maynard Keynes.* Cambridge: Cambridge University Press, 1975.

Kimball, Roger, 'Art and Architecture at the Equitable Center', *The New Criterion*, vol. 5, November 1986, p. 31.

Kimmelman, Michael, 'Thomas Krens: The Globe Straddler of the Art World', *The New York Times*, 19 April 1998.

Knapp, Stephen, 'Working with Artists', *Urban Land*, September 1987, pp. 20–3.

Knight, Andrew, 'I was a Trustee of the V & A', *The Spectator*, 4 March 1989.

Kramer, Hilton, 'Criticism Endowed: Reflections on a Debacle', *New Criterion*, November 1983, pp. 1–5.

—— 'The Hoving Era at the Met', in *The Revenge of the Philistines: Art and Culture, 1972–1984*. London: Secker and Warburg, 1986, pp. 320–4.

—— 'The Prospect Before Us', *The New Criterion*, vol. 9, September 1990.

Landau, David, 'Self-made Financier Who Revelled in Money, Markets and Modern Art', *Guardian*, 20 September 2000.

Lavender, Andy, 'Patronage by Numbers', *The Times*, 12 July 1994.

Lears, T. J. Jackson, 'The Concept of Cultural Hegemony: Problems and Possibilities', *American Historical Review*, vol. 90, no. 3, June 1985, pp. 567–93.

Leventhal, F. M., '"The Best for the Most": CEMA and State Sponsorship of the Arts in Wartime, 1939–1945', *Twentieth Century British History*, vol. 1, no. 3, 1990, pp. 289–317.

Levin, Bernard, 'The Tate Rejected Master', *The Times*, 17 October 1988.

Lewison, Jeremy, 'New Directions for a National Direction', *Museum Management and Curatorship*, vol. 10, June 1991, pp. 198–203.

Lilla, Mark and Isabella Frank, 'The Medici and the Multinationals', *Museum News*, vol. 66, no. 3, January/February 1988, pp. 32–5.

Lister, David, 'Avant-garde Bows to Commerce in Bid for Fame and Fortune', *The Independent*, 3 November 1993.

Lord, Catherine, 'President's Man: The Arts Endowment under Frank Hodsoll', *Afterimage*, vol. 10, no. 7, February 1983, pp. 3–4.

Lowry, W. McNeil, ed., *The Arts and Public Policy in the United States*. Englewood Cliffs, NJ: Prentice-Hall, 1984.

Lubbock, Tom, 'Buy Young, Buy Cheap!', *The Independent on Sunday*, 4 March 1990.

Lubow, Arthur, 'The Curse of the Whitney', *The New York Times Magazine on the Web*, 11 April 1999.

Luce, Richard, 'Government Goals', *Greater London Arts Quarterly*, issue 9, Summer 1987, pp. 10–11.

McClintic, Miranda, *Awards in the Visual Arts Program*. National Endowment for the Arts, unpublished report, 1985.

McCorquodale, Duncan, Naomi Siderfin and Julian Stallabrass, eds, *Occupational Hazard: Critical Writing on Recent British Art*. London: Black Dog, 1998.

Malaro, Marie C., *A Legal Primer on Managing Museum Collections*. Washington, DC: Smithsonian Institution Press, 1985.

Marsh, Gordon H., 'Governance of Non-Profit Organizations: An Appropriate Standard of Conduct for Trustees and Directors of Museums and Other Cultural Institutions', *The Journal of Arts Management and Law*, vol. 13, no. 3, Fall 1983, pp. 32–53.

Martorella, Rosanne, *Corporate Art*. New Brunswick, NJ/London: Rutgers University Press, 1990.

Marx, Nancy, 'Professional Class', *Manhattan Inc.*, September 1986, pp. 189–93.

Marzorati, Gerald, 'The Arts Endowment in Transition', *Art in America*, March 1983, vol. 71, no. 3, pp. 9, 11, 13.

Mathews, Jane De Hart, 'Arts and the People: The New Deal Quest for a Cultural Democracy', *Journal of American History*, vol. 62, no. 2, September 1975, pp. 316–39.

Meier, Barry, 'Tobacco Industry, Conciliatory in US, Aggressive in Third World', *The New York Times on the Web*, 18 January 1998.

Meltzer, Richard, 'This Temporary Tax Break Could Make 1991 a Banner Year', *Museum News*, vol. 70, March/April 1991, pp. 76–8.

Metz, Robert, 'The Corporation as Art Patron: A Growth Stock', *Artnews*, vol. 78, no. 5, May 1979, pp. 40–6.

Meyer, Karl E., *The Art Museum: Power, Money, Ethics*. New York: William Morrow and Company, 1979.

Miller, Lori B., 'Customizing Art to Fit Architecture', *The New York Times*, 18 May 1986.

Mills, C. Wright, *The Power Elite*. New York: Oxford University Press, 1956.

Minihan, Janet, *The Nationalization of Culture: The Development of State Subsidies to the Arts in Great Britain*. London: Hamish Hamilton, 1977.

Mintz, Beth and Michael Schwartz, 'Capital Flows and the Process of Financial Hegemony', in Sharon Zukin and Paul DiMaggio, eds, *Structures of Capital*. Cambridge: Cambridge University Press, 1990, pp. 203–55.

Mizruchi, Mark S. and Michael Schwartz, eds, *Intercorporate Relations: The Structural Analysis of Business*. Cambridge: Cambridge University Press, 1987.

Monbiot, George, *Captive State: The Corporate Takeover of Britain*. London: Macmillan, 2000.

Moncrieff, Elspeth, 'Smart Art (the Merits of Corporate Collections)', *Apollo*, no. 133, March 1991, pp. 196–9.

Montgomery Museum of Fine Arts, *Art Inc.: American Paintings from Corporate Collections*. Montgomery, AL, 1979.

Morris, Rupert, 'Radical Change of Art', *The Financial Times*, 7 January 1994.

Museum of Modern Art, New York, *Services for Corporate Members* (brochure).

Museum of Modern Art, Oxford, *About Vision: New British Painting in the 1990s*, 1996.

Museums and Galleries Commission, *The National Museums*. London, 1988.

National Art Collections Fund (NACF), *The New Patrons: Twentieth-Century Art from Corporate Collections*. London, 1992.

National Endowment for the Arts (NEA), *Evaluation of Visual Artists' Fellowship Category*, prepared by Skidmore, Owings & Merrill for the National Endowment for the Arts, 1981.

—— *Museums USA: Art, History, Science and Others*. Washington, DC: Government Printing Office, 1975.

—— *A Sourcebook of Arts Statistics: 1989*. 1990.

—— *Visual Artists' Organizations Fiscal Year 1982–83*. Unpublished report, 1985.

National Portrait Gallery, London, *The Portrait Award 1980–1989*. 1992.

Norman, Geraldine, 'Thomas Krens's High-Wire Act', *Art & Antiques*, vol. 8, Summer 1991, pp. 82–4, 113.

Norman, Michael, 'Office Art, Buyer, Beware', *The New York Times*, 19 February 1978.

Norton, Michael, *Tax Effective Giving*, 6th edition. London: Directory of Social Change, 1992.

O'Connor, Francis V., ed., *Art for the Millions*. Boston: New York Graphic Society, 1975.

O'Doherty, Brian, *Inside the White Cube: The Ideology of the Gallery Space*. San Francisco: The Lapis Press, 1986.

—— 'National Endowment for the Arts: The Visual Arts Program', *American Art Review*, vol. 3, no. 4, July/August 1976, pp. 67–71.

Odling-Smee, James, 'Refreshing the Arts', *Art Monthly*, no. 178, July/August 1994, pp. 20–3.

Office of Arts and Libraries, *The Arts are Your Business*. London, 1981.

Ostrower, Francie, *Why the Wealthy Give: The Culture of Elite Philanthropy*. Princeton, NJ: Princeton University Press, 1995.

Palmer, Caroline, 'Hidden Treasure', *Accountancy Age*, October 1993, pp. 28, 31–2.

Palumbo, Peter, 'The Arts Council', *RSA Journal*, September 1990, pp. 677–80.

Patton, Phil, 'Other Voices, Other Rooms: The Rise of the Alternative Space', *Art in America*, July/August 1977, vol. 65, no. 4, pp. 80–89.

Paxman, Jeremy, *Friends in High Places: Who Runs Britain?* Harmondsworth: Penguin Books, 1990.

Pear, Robert, 'Reagan's Arts Chairman Brings Subtle Changes to the Endowment', *The New York Times*, 10 April 1983.

Pearson, Nicholas, *The State and the Visual Arts*. Milton Keynes: Open University, 1982.

Pearson, Nicholas and Andrew Brighton, *The Economic Situations of Visual Artists*. London: Calouste Gulbenkian Foundation, 1985.

Petherbridge, Deanna, 'Patronage and Sponsorship: The PS at the Bottom of the Art Balance Sheet', *Art Monthly*, no. 38, July/August 1980, pp. 3–22.

Philip Morris Companies, *Philip Morris and the Arts: 35 Year Report*. New York, 1993.

Phillips, William E., *Involving the Arts in Advertising*. New York: BCA, 1986.

Pile, Stephen, 'Want to be an Arbiter of Art? That'll be £650', *The Daily Telegraph*, 15 July 1995.

Pilgrim Trust, *The Pilgrim Trust 11th Annual Report 1941*. Harlech, North Wales, n.d.

Platt, Geoffrey, 'Converting Private Wealth to Public Good', *Museum News*, vol. 70, May/June 1991, p. 100.

Presidential Task Force on the Arts and Humanities, *Report to the President*. Washington, DC, 1981.

Prudential Corporation, *Prudential Awards for the Arts 1992*. London, 1992.

Rawsthorn, Alice, 'Specialist Purveyors of Tomorrow's Ideas', *The Financial Times*, 18 June 1990.

Reiss, Alvin, 'BCA: The First Act', *Cultural Affairs*, vol. 5, March/April 1967, pp. 38–9.

Rice, Faye, 'The Big Payoff in Corporate Art', *Fortune*, 25 May 1987, p. 106.

Roberts, Alison, 'The Maturity of Modern Maecenas', *The Times*, 11 December 1992, special issue 'Business and the Arts'.

Roberts, Marion, Chris Marsh and Miffa Salter, *Public Art in Private Places: Commercial Benefits and Public Policy*. London: University of Westminster, 1993.

Rocco, Fiammetta, 'Power and Glory to Those on High – Who Really Runs the Arts in This Country Today?', *The Independent on Sunday*, 18 June 1995.

Rogers, Rick, 'The Ethics of Sponsorship', *Arts Express*, June 1986, p. 10.

Rosen, Nick, 'Artopoly: A Giant Game for Dealers, Museum Curators and Artists', *Guardian*, 19 December 1983.

Rosenbaum, Lee, 'Can the Art World Live with the Tax Reform Act?', *Artnews*, vol. 85, January 1986, pp. 95–102.

Rothstein, Mervyn, 'Uneasy Partners: Arts and Philip Morris', *The New York Times*, 18 December 1990.

Saltzman, Cynthia, 'Companies Doubt Their Arts Giving would Rise to Offset Reagan's Cuts', *The Wall Street Journal*, 26 February 1981.

Sandison, Hamish R. and Jennifer Williams, eds, *Tax Policy and Private Support for the Arts in the United States, Canada and Great Britain*. Washington, DC: British–American Arts Association, 1981.

Scardino, Albert. 'Marketing Real Estate with Art', *The New York Times*, 1 February 1987.

Schiller, Herbert, *Culture Inc.: The Corporate Takeover of Public Expression*. Oxford/New York: Oxford University Press, 1989.

Schmertz, Herbert, *Patronage That Pays*. New York: BCA, 1987.

Schuster, J. Mark Davidson, 'Government Leverage of Private Support', in Margaret Jane Wyszomirksi and Pat Clubb, eds, *The Cost of Culture: Patterns and Prospects of Private Art Patronage*. New York: American Council for the Arts, 1989, pp. 63–97.

—— 'The Interrelationships Between Public and Private Funding of the Arts in the United States', *The Journal of Arts Management and Law*, vol. 14, no. 4, Winter 1985, pp. 77–105.

—— 'Issues in Supporting the Arts Through Tax Incentives', *The Journal of Arts Management and Law*, vol. 16, no. 4, 1987, pp. 31–50.

—— 'The Non-Fungibility of Arts Funding', in Harry Hillman-Chartrand, ed., *The Arts: Corporations and Foundations*. Ottawa: The Canada Council, 1985, pp. 1–30.

—— *Supporting the Arts: An International Comparative Study*. Washington, DC: National Endowment for the Arts, 1985.

—— 'Tax Incentives as Arts Policy in Western Europe', in Paul DiMaggio, ed., *Nonprofit Enterprise in the Arts*. New York and Oxford: Oxford University Press, 1986, pp. 320–60.

Schwartz, Michael, ed., *The Structure of Power in America: The Corporate Elite as a Ruling Class*. New York: Holmes and Meier, 1987.

Scottish Museums Council, ed., *The American Museum Experience*. Edinburgh: HMSO, 1985.

Seneker, Harold, ed., 'The 400 Richest People in America', *Forbes*, 24 October 1988, pp. 142–273.

Serlen, Bruce, 'Projecting an Image – You Are What You Buy', *The New York Times*, 12 February 1989.

Seybolt, George C., '. . . and the Trustee's', *Art in America*, vol. 59, no. 6, November/December 1971, pp. 30–1.

Sharon, Batia, 'Artist-Run Galleries – A Contemporary Institutional Change in the Visual Arts', *Qualitative Sociology*, vol. 2, no. 1, 1979, pp. 3–28.

Shaw, Roy, *The Arts and the People*. London: Cape, 1986.

Shinn, Sharon, 'Banking on Art', *Decor*, February 1990, p. 88.

Sinclair, Andrew, *Arts and Cultures*. London: Sinclair-Stevenson, 1995.

Sinclair, Ward and John M. Berry, 'Reagan Budget Team Proposes Cuts Across Broad Spectrum', *The Washington Post*, 8 February 1981.

Sloane, Leonard, 'Is Big Business a Bonanza for the Arts?', *Artnews*, vol. 79, October 1980, pp. 111–15.

Smith, Chris, *Creative Britain*. London: Faber and Faber, 1998.

Smith, Roberta, '"Mediascape": High-Tech Art and Entertainment', *The New York Times*, 18 June 1996.

—— 'Memo to Art Museums: Don't Give Up on Art', *New York Times on the Web*, 3 December 2000.

Solomon, Jolie, 'A Minnesota Bank Banishes Artwork that Offends Staff', *The Wall Street Journal*, 19 December 1989.

Solomon R. Guggenheim Museum, New York, *The Hugo Boss Prize 1996* and *The Hugo Boss Prize 1998*.

—— *Right Time, Wright Place: Corporate Membership at the Guggenheim* (brochure).

Soref, Michael and Maurice Zeitlin, 'Finance Capital and the Internal Structure of the Capitalist Class in the United States', in Mark S. Mizruchi and Michael Schwartz, eds, *Intercorporate Relations: The Structural Analysis of Business*. Cambridge: Cambridge University Press, 1987, pp. 56–84.

Soules, George, 'Does Art Belong in Pension Funds?', *Contingencies*, September/October 1989, pp. 28–32.

Southeastern Center for Contemporary Art, Winston-Salem, NC, *Awards in the Visual Arts 3*. 1984.

—— *Awards in the Visual Arts 10*. 1991.

Squiers, Carol, 'Diversionary (Syn) Tactics: Barbara Kruger Has· Her Way with Words', *Artnews*, vol. 86, no. 2, February 1987, pp. 76–85.

Stallabrass, Julian, *High Art Lite*. London and New York: Verso, 1999.

Stanley, Christopher, 'Justice Enters the Marketplace: Enterprise Culture and the Provision of Legal Service', in Russell Keat and Nicholas Abercrombie, eds, *Enterprise Culture*. London/New York: Routledge, 1991, pp. 206–15.

Stanworth, Philip and Anthony Giddens, 'An Economic Elite: A Demographic Profile of Company Chairmen', in Philip Stanworth and Anthony Giddens, eds, *Elites and Power in British Society*. Cambridge: Cambridge University Press, 1974, pp. 81–101.

Stephens, Suzanne, 'An Equitable Relationship?', *Art in America*, vol. 74, May 1986, pp. 116–23.

Stretch, Bonnie Barrett, 'Bankable Images', *American Photographer*, November 1986, p. 26.

Strong, Roy (presenter), *Ministering to the Arts*, BBC Radio 4, London, September 1992.

Sudjic, Deyan, 'Changing the Face of the City', *Guardian*, 4 December 1991.

Sujo, Glenn, 'The Arthur Andersen Collection', *Arts Review Year Book 1990*, p. 53.

Tait, Simon, 'Rittner Quits Arts Council in Funding Clash', *The Times*, 29 March 1990.

—— 'Sponsor's Broadest Spectrum', *The Times*, 11 December 1992, special issue 'Business and the Arts'.

—— 'Surprise Choice Became Able Administrator', *The Times*, 29 March 1990.

Tate Gallery, London, *Cézanne*. London: Tate Publishing and Philadelphia: Philadelphia Museum of Art, 1996.

—— *Late Picasso: Paintings, Sculpture, Drawings, Prints 1953–1972*. 1988.

Taylor, Peter, *Smoke Ring: The Politics of Tobacco*. London: Bodley Head, 1984.

Thompson, J. B., *Ideology and Modern Culture*. Cambridge: Polity, 1990.

Thompson, Robert L., 'Prosperity Without Charitable Tax Deductions', *Museum News*, vol. 66, January/February 1988, pp. 70–1.

Thorncroft, Antony, 'Art Acquisition for Canny Companies', *The Financial Times*, 20 January 1990.

—— 'Contemporary Backers Feel Safe at the Tate Sponsorship', *The Financial Times*, 5 May 1995.

—— 'An Honest Broker', *Classical Music*, 22 September 1979, pp. 9–10, 38.

—— 'Recluse Brings Out the Crowds', *The Financial Times*, 10 February 1996.

—— 'Shake Up for Pairing Scheme', *The Financial Times*, 2 February 1996.

—— 'Sponsorship: Coming of Age', *The Financial Times*, 7 September 1987.

—— 'Two Paymasters for the Arts', *The Financial Times*, 19 March 1980.

TI Group plc, 'TI Group and the Arts', in the *TI Group Art Collection 1992–3*, pack of postcards, Abingdon, Oxon, n.d.

Trades Union Congress (TUC), *The TUC Working Party Report on the Arts*. London, 1976.

Trucco, Terry, 'The Growing Number of Women Trustees', *Artnews*, vol. 76, no. 2, February 1977, pp. 54–5.

Tully, Judd, 'End of the Chilling Effect', *Artnews*, vol. 92, no. 8, October 1993, p. 44.

Tweedy, Colin, 'Sponsorship of the Arts – An Outdated Fashion or the Model of the Future?', *Museum Management and Curatorship*, vol. 10, June 1991, pp. 161–6.

Ullberg, Alan and Patricia, *Museum Trusteeship*. Washington, DC: American Association of Museums, 1981.

Unilever plc, *Unilever House London Contemporary Art Collection: The First Twelve Years* (catalogue). London, n.d.

Useem, Michael, 'Corporate Philanthropy', in Walter W. Powell, ed., *The Nonprofit Sector*. New Haven: Yale University Press, 1987, pp. 340–59.

—— 'Corporate Support for Culture and the Arts', in Margaret Jane Wyszomirski and Pat Clubb, eds, *The Cost of Culture: Patterns and Prospects of Private Arts Patronage*. New York: American Council for the Arts, 1989, pp. 45–62.

—— 'Corporations and the Corporate Elite', *Annual Review of Sociology*, vol. 6, 1980, pp. 41–77.

—— *The Inner Circle: Large Corporations and the Rise of Business Political Activity in the United States and United Kingdom*. New York: Oxford University Press, 1984.

Useem, Michael and Stephen I. Kutner, 'Corporate Contributions to Culture and the Arts', in Paul DiMaggio, ed., *Nonprofit Enterprise in the Arts: Studies in Mission and Constraint*, Oxford: Oxford University Press, 1986, pp. 93–112.

Vaizey, Marina, 'Quiet Spread of Good Works', *The Sunday Times*, 4 March 1990.

Veblen, Thorstein, *The Theory of the Leisure Class*. Harmondsworth: Penguin Books, 1979 (originally published in 1899).

Vogel, Carol, 'Artful Back-Scratching is Hitching Couture Names to Needy Museums', *The New York Times*, 4 January 1997.

Walker, Richard W., 'Generosity will Cost More, IRS Tells Donors', *Artnews*, vol. 84, no. 3, March 1985, pp. 25–6.

—— 'Making it Easier to be a Donor', *Artnews*, vol. 91, no. 5, May 1992, pp. 29–30.

—— 'A Permanent Tax Window', *Artnews*, vol. 92, no. 4, April 1993, p. 31.

—— 'Reforming the Tax Reform Act', *Artnews*, vol. 88, no. 9, November 1989, p. 45.

Wallis, Brian, ed., *Hans Haacke: Unfinished Business*. New York: New Museum of Contemporary Art, 1986.

Ward, David, 'Liverpool Woos Guggenheim', *Guardian*, 9 July 1999.

—— 'Smith Drums Up Cash to Save Arms Museum', *Guardian*, 2 August 1999.

Welsh, Jerry C., *Involving the Arts in Marketing: A Business Strategy*. New York: BCA, 1986.

Whitney, Craig R., 'Britain's Needy Arts Are Looking for Patrons', *The New York Times*, 6 May 1989.

Whybrow, Stephen, 'A Toe in the Sponsorship Water', *Arts Review*, 14 June 1991, pp. 18–19.

Williams, Andrew Gibbon, 'The Secret Art of the City', *The Sunday Times*, 9 April 1989.

Williams, Raymond, 'Advertising: The Magic System', in *Problems in Materialism and Culture*. London and New York: Verso, 1997, pp. 170–95.

—— 'The Arts Council', *Political Quarterly*, vol. 50, no. 2, Spring 1979, pp. 157–71.

—— *Culture*. London: Fontana, 1981.

—— *Keywords*. London: Fontana/Croom Helm, 1976.

Williams, W. E., 'The Pre-history of the Arts Council', in E. M. Hutchison, ed., *Aims and Action in Adult Education 1921–1971*. London: National Institute of Adult Education, 1971, pp. 18–23.

Wise, Michael Z., 'Mammon and the Muse', *Artnews*, vol. 94, no. 4, April 1995, pp. 138–41.

Wu, Chin-tao, 'Art Amongst the Brokers: The Art Patronage of Finance Houses in America and Britain since the '80s', in Jutta Held, ed., *Kunst und Politik: Jahrbuch der Guernica-Gesellschaft*, vol. 1. Osnabrück: Universitätsverlag Rasch, 1999, pp. 55–67.

—— 'Corporate Collectors of Contemporary Art in Britain', in Rosanne Martorella, ed., *Art and Business: An International Perspective on Sponsorship*. Westport, CT/London: Praeger Publishers, 1996, pp. 89–100.

Zeitlin, Maurice, *The Large Corporation and Contemporary Classes*. New Brunswick, NJ: Rutgers University Press, 1989.

Zeldis, Nancy, 'Firms Get Serious About Art: Birds Are "Out"; Abstracts "In"', *The New York Law Journal*, 3 August 1988.

Žižek, Slavoj, 'Multiculturalism, or the Cultural Logic of Multinational Capitalism', *New Left Review*, no. 225, September/October 1997, pp. 28–51.

Zukin, Sharon, *Loft Living*. New Brunswick, NJ: Rutgers University Press, 1989.

Zulaika, Joseba, 'The Seduction of Bilbao', *Architecture*, vol. 86, December 1997, pp. 60–3.

INDEX

ABC NO Rio 46

ABN-AMRO Bank 183–7

ABSA *see under* Association of Business
Sponsorship of the Arts

Absolut Vodka 156–7

access to the arts 47, 281

ACGB *see under* Arts Council of Great
Britain

Adam & Company and the *Spectator* Annual
Art Award 166

Airlie, Countess of 105–6, 108, 115

Alcoa 208

Alexander Howden Group 223

alternative spaces 36, 41–46, 73–4, 155

Altschul, Arthur G. 89

American Association of Museums 25

American Express 254

Anderson, Laurie 175

Andrews, Benny 73

Antoni, Janine 175

apartheid 147

armaments industry 147 *see also* weapons
industry

Armand Hammer Museum of Art and
Cultural Center 12

Armani, Giorgio 173, 338 n 34

arm's length 21, 65, 94, 101

Armstrong, Lord Robert 99

Armstrong, Thomas H. 88, 96, 136–7,
193–4

Arnold & Porter 200, 203–4, 231, 259,
263

Arnolfini Gallery 96

art and stock markets 230–31

Artangel 146

art awards 2, 14, 67–8, 75–7, 80–81,
130–31, 159–87, 205, 208–10, 236,
276

art consultants 255–6

art establishment 36, 45, 159, 162, 282

Art for Offices 255

Arthur Andersen 205, 232–3, 251, 255
Arthur Andersen Art Award 160, 205

Art Institute of Chicago 21, 86

art investment 221, 230–31, 299

art market 14, 209, 225, 230–31, 235,

237, 248, 254–5, 259, 300

art patrons 10–11, 52, 122, 159, 199, 207, 221–41, 243, 250, 254

arts audiences 67, 131, 171, 298

Arts Council Collection 36–40, 43, 68–70, 164, 198, 209, 300

Arts Council of England 298, 307 n 1

Arts Council of Great Britain (ACGB) 16–17, 19, 21, 32– 40, 47, 53, 56, 63–71, 77–8, 82, 96–7, 99, 142–3, 303

see also Arts Council of England

Arts Council Award 67–8

Arts Council/British Gas Awards 67

Arts Council/Midland Bank Artscard 67

Department of Marketing and Resources 66

Enterprise Fund 56

Progress Fund 56

Visual Arts Department 68–70

arts policy 21, 33, 49, 55–6, 276

ASEAN countries 178–81, 338 n 47

Association for Business Sponsorship of the Arts 3,12, 55, 63, 65, 78, 80–81, 128, 142, 152, 322 n115

ABSA/Daily Telegraph Awards 80

Association of Corporate Art Curators 256

' @ Bristol' 280

Atchison, Topeka and Santa Fe Railway 222

Athena Art Awards 160

Athey, Ron 274

avant-garde 43, 44, 45, 125, 132, 154, 157, 161, 252, 265, 268

Avery, Milton 254

Awards in the Visual Arts (AVA) 75–7

Bacon, Francis 70, 116–18

Bank of Scotland 279

Bankside Power Station 138, 293

Barclays Young Artist Awards 144, 160

Baring Asset Management 255

Barnes, Albert Coombs 31

Barnes Foundation 31

Barney, Matthew 175

Barr, Alfred 256

Baselitz, Georg 248

Basque country, the 287–90

Basque separatists 287

BAT 166

Battersea Arts Centre 81

BBC 142, 269

Beck's beer 132–3, 146–7, 154

Benson & Hedges 130, 166

Benson & Hedges Gold Award 166

Berenson, Ruth 71–2

Bernstein, Alex 244

Biddle, Flora Miller 90, 94–5 *see also* Flora Miller Irving

Biddle, Livingston 72

Bilbao 287–91

Blair, Tony 276, 301

'Third Way' 276, 280

Block, Mrs Leigh B 86

blockbusters 135–8, 140, 154

Bloomsbury Group 34

Blount Inc. 124

Blount, Winton 124

BMW 77, 123, 174, 206–7

'BMW Gallery' 77, 200, 206

BOC 235–6

Boltanski, Christian 198

The Lost Workers Archive 197

bonusable public space 340 n 7, 340 n 8

Boston Museum of Fine Arts 19, 21, 86,

283, 291–2

Bottomley, Virginia 276

Botton, Gilbert de 111–13, 116–18, 120, 151–2, 330 n 109

Botton, Janet Wolfson de 112–14, 120

Botts, John 105

Boulton, Jack 256

Bourdieu, Pierre 7–10, 244, 261, 269

Bowness, Sir Alan 38, 103, 116, 120, 137

BP *see under* British Petroleum

BP Amoco 283, 294–5

brand marketing 68

Breuer, Marcel 88

British Council 101–2

British Land Company plc 104

British Museum 21, 279, 294–5
 Walter and Leonore Annenberg Centre 294
 Asahi Shimbun Gallery 294
 BP Amoco Theatre 294
 BP Ethnography Showcase 295
 Chase Manhattan Gallery of North America 295
 Clore Centre for Education 294
 Equitable Charitable Trust Room 294
 Arthur I. Fleischman Gallery of the Greek Bronze Age 295
 Feischman Parthenon Introductory Gallery 295
 Glaxo Wellcome Programme 295
 Paul Hamlyn Library 294
 Joseph E. Hotung Gallery of Oriental Antiquities 294
 HSBC Money Gallery 295
 Raymond and Beverly Sackler Galleries 294
 Raymond and Beverly Sackler Rooms 294
 Sainsbury African Galleries 294
 Hugh and Catherine Stevenson Theatre 294
 Roxie Walker Galleries 295
 Wellcome Gallery of Ethnography 295
 Weston Gallery of Roman Britain 294–5
 Wolfson Gallery of Rome, City and Empire 294

British Petroleum (BP) 129, 133, 143, 151, 154, 166
 BP New Contemporaries 160
 BP Portrait Award 160, 162

British Rail Pension Fund 249

British Telecom (BT) 129, 133, 144
 BT New Contemporaries 144, 154
 BT Scottish Ensemble 144

Broadgate development 115, 237–41, 246, 302

Brody, Mrs Sidney 86

Brooklyn Academy of Music 149

Brown, Gordon 296

BSIS *see under* Business Sponsorship Incentive Scheme

Buchanan, Patrick J. 274–5

Burgh, Sir John 101–2, 117

Burton, Scott 192

Bush, George W 273

Bush Jr, George W 275

Business Committee for the Arts 12, 78–80, 124

business elite 4, 11, 121, 126–7, 295 *see also* corporate elite, elite

Business in the Community 111

Business Sponsorship Incentive Scheme (BSIS) 6, 56–7, 62–3, 81, 236, 316 n 37, 323 n 130, 334 n 47 *see also* Pairing

Scheme
Butcher, Willard C. 124
Butler, Sir Michael 99

Cahill, Holger 35
Cai, Guo Qiang 175
Calatrata, Santiago 288
capital allowances 218–19, 221, 344 n 17,
 345 n 20, 345 n 22
capital-gains tax 23–4, 96, 219
capitalism 3–4, 9–10, 44–5, 150, 158,
 186, 228, 243, 283–4, 292
 late capitalism 44–5, 150, 158, 228
 global capitalism 161
capitalist democracy 6, 40, 86, 147, 303
Caro, Anthony 98
Carreras Rothman 130
Carter administration 48–9
Castello di Rivoli Museo d'Arte
 Contemporanea 182
CEMA see under Council for the
 Encouragement of Music and the Arts
 33–7
censorship 194
Centre for Visual Arts, Cardiff 277
ceremonial consumers 90
challenge funding 56
challenge grant 56
Champion International Corporation 189,
 195
Chanel 173
Channel Four 169–72
Channon, Paul 56
charitable contributions 22–3, 27, 52–3,
 57–62, 126, 201
charity 21, 31, 58–62, 78, 81, 126, 195,
 199, 257

Chase Manhattan Bank 10, 122, 124,
 207–8, 243, 256–7, 269, 295
 art committee 256–7
Chemical Bank 42, 200
Chen, Shui-pien (also known as Chen Shui-
 bian) 184
Chetwood, Sir Clifford 99
China 177, 186
Christenberry, William 263
Christie's 113, 230
Citicorp 191
City of London 201, 205, 209, 214, 224,
 231, 238, 245, 250–51, 259–61
Clarendon schools 106, 326 n 48
Clark, Sir Kenneth 34
class 7–8, 10–11, 34, 44, 60, 67, 86, 89,
 97, 106, 123, 126–7, 171, 243–5, 270,
 296
Clemente, Francesco 118
Cleveland Museum of Art 85
Clinton administration 14, 272–3, 275
Clinton, Bill 272–3
close companies 62, 318 n 55
colonialism 179, 183, 287, 289
conflict of interest 94–5, 98, 116–17,
 119–20
conservatism 1, 271
Conservative government 57, 66, 97, 100,
 102, 105, 110, 119, 122, 145, 155,
 166, 213, 236, 276, 279
Conservative Party 6, 109–10, 112–13 see
 also Tory
Conservatives, the 57, 60, 81, 122, 152,
 272, 276, 278, 281
conspicuous consumption 90
Container Corporation of America 222
Contemporary Art Society (CAS) 257

'content restriction' 272–3, 275, 353 n 6
cool Britannia 280–81
Coopers and Lybrand 67, 232–3 *see also*
 PricewaterhouseCoopers
Courtauld Institute of Art 244
Corcoran Gallery of Art 89
corporate art collections 2, 9–10,13–14,
 76, 159, 205, 208–10, 212–70
 and corporate elite 242–5
 and image making 250–55
 and relocation of firms 245–6
 and tax issues 215–21
 and working environment 246–8
 as investment 248–9
 legitimising of 255–8
 in financial institutions 225–31
 in legal and accounting circles 231–3
 in manufacturing sector 233–6
 in property development 237–41
corporate colonialism 183
corporate curator 208, 249, 256
corporate elite 6–12, 83, 125–6, 242–5 *see
 also* business elite, elite
corporate giving 11, 52–3, 57, 62
corporate hospitality 134–5
corporate image 128–9, 132–4, 164, 193,
 246, 250–55
corporate museums 199–200, 342 n 26
corporate patrons 193–4, 212, 258–70
corporate welfare state 278–9
corporation tax 191
'corporatised public space' 190–92, 201,
 241
Cossons, Neil 136
Council for the Encouragement of Music
 and the Arts 33–7
Covington & Burling 200, 203

Crossley's Carpet Mill 195, 197
cultural capital 7–9, 16, 120, 126–7, 149,
 244–5, 269
cultural capitalists 10, 91, 126
cultural democracy 35–6, 311 n 62
cultural hegemony 270
cultural imperialism 287, 289, 292
cultural managerial capitalists 10, 91, 126
cultural policies 77, 281
Czechoslovakia 152

Daimler-Benz/Chrysler 283
Davison, Ian Hay 99
Dayton Hudson Foundation 52
Dean Clough Industrial Park 188, 195–9
De Beers Consolidated Mines 222
deed of covenant 58, 60–62, 128
democracy 21, 32, 36, 40, 102, 115, 147,
 153, 157, 296, 303
Democrat administration 3, 272
Democrats 303
Department of Culture, Media and Sports
 63, 276
Department of National Heritage 63, 145,
 276
depreciation 215–16, 218, 344 n 7, 345 n 19
deregulation 4, 121, 238
de Sade, Marquis 81 *120 Days of Sodom* 81
Deutsche Bank 200, 284, 286–7
Deutsche Telekom 285–6
devolution 66
Dewey, John 35
Dillon, Mrs C Douglas 86
DiMaggio, Paul 9–11, 46, 91, 126–7, 243,
 250
Domhoff, G. William 89
donors 4, 6, 25, 27, 52, 58–61, 85, 95,

113, 120–21, 294–6
Douglas, Stan 175
Drexel Burnham Lambert 169
Dubuffet, Jean *Group of Four Trees* **229**
Dulwich Picture Gallery 293
'dumbing down' 281, 283
Duncan, Carol 18
Dynamic Centre, Edinburgh 280

Earth Centre, Doncaster 277
Economic Development Corporation 191
Economist 199, 112, 203, 207
Ehrenkranz, Joel Stanley 89
Electra Investment Trust 279
elite 4, 6–12, 21, 24, 83–6, 90, 106, 121,
 123, 126–7, 180, 242–5, 295, 298, 303
 see also business elite, corporate elite
Elliott, David 157
Emin, Tracey 161
ENEL 285–6
English Estates 69
English National Opera 57, 164, 244
'enlightened self-interest' 16
enterprise culture 1–2, 4, 6, 9, 20, 46, 48,
 66, 83, 110, 120, 122–58, 213–14,
 272, 282, 301, 303
Episcopalianism 85
Equitable Life Assurance Society 75–7, 91,
 189–94, 198–9, 237–9, 254
 Equitable Gallery 201
Ernst & Young 140, 232
Establishment 21, 34, 82, 97–8, 161–2 *see*
 also art establishment
Eton 106–7
Evans, Dennis 252
Exxon 75, 129, 267
ExxonMobile 283

Faubion, Michael 72
Federal Art Project (FAP) 35
federal indemnification program 30
Finance Act 61–2
First Amendment 273
First Bank System, Minneapolis 249,
 251–2, 260
Flanagan, Barry *Hare on Bell* **239**
Fleming, Robert 253
Flood, Mik 145–6
Forbes, Malcolm S. 268
forces of conservatism 1
Formosa 186
Forte, Sir Charles 55
Foster, Norman 288
franchising of museums 286
free adminission to national museums
 281–2
free enterprise 3, 47, 108
free market 3, 6, 63, 97, 124, 213, 232,
 271–2, 301
Freshfields 203
Fried, Frank, Harris, Shriver & Jacobson
 231, 265
Frink, Elizabeth 261
Frito-Lay 258

Galbraith, John Kenneth 243
Gallaher 166
Gehry, Frank O. 283, 288, 290–91
gentrification 44–5
Gianelli, Ida 182
Gift Aid 58, 62, 296, 318 n 57
gifts of property 22–3
Gilbert and George 132, 249
Gilman, Mrs Charles 89
Gilman Paper Company 89, 235, 267

Gingrich, Newt 273–4
Giuliani, Rudolph 149
Give as You Earn *see under* Payroll Giving
Glaxo 233, 268
Global Asset Management 111–12,
 116–17, 152
globalisation 15, 175
globalism 187, 283, 292
Goldman Sachs 89
Gonzalez, Manuel 269
Goodison, Sir Nicholas 244, 268
Goodman, Lord 146
Gordon, David 112
Gordon, Douglas 173
Govett, Penelope 104
Govett, William 104, 111
Gowrie, Lord 54, 56, 70, 137
Gramsci, Antonio 270
Granada Group 244
Grant, Duncan 33
grants-in-aid 99
Great Universal Stores 113
Greater London Council 66
Green, Hon. Mrs Janet *see under* Janet
 Wolfson de Botton
Grey Art Gallery 182
Guggenheim Museum, Solomon R. 141,
 149, 162, 172–5, 194, 283–92
 Deutsche Guggenheim Berlin 283,
 286–7
 Guggenheim Las Vegas at the Venetian
 291
 Guggenheim Museum Bilbao 283,
 286–91
 Guggenheim Museum Soho 283, 285–6
 Peggy Guggenheim Collection, Venice
 283

Guinness 133
Gund, Agnes 93

Haacke, Hans 72, 84–5, 194, 267
 *Solomon R. Guggenheim Museum Board of
 Trustees* 85
 On Social Grease 267
Häagen-Dazs 154
Habermas, Jürgen 20
Hale, Robert 257
Hall, Sir Ernest 195, 199
Hambros Bank 263
Hammer, Armand 12
Hanks, Nancy 70, 75
Hanoi Opera House 178–9
Harvey's Wine Museum 200
Havel, Václav 152
Hayes, John 166
Hayward Gallery 68, 123, 132, 142, 298
Head, Tim 132
Henry Moore Foundation 197, 199
Henry Moore Foundation Studio 188, 195,
 197–9
Hepworth, Barbara 262–3
Herbert Smith 246
Heresies Collective 72
Heritage Foundation 49
Heseltine, Michael 104
Hirst, Damien 154–5, 161, 301
Hiscox, Robert 221
Hockney, David 70
Hodgkin, Howard 241
Hodsoll, Frank 50, 52, 70–75
Holland 186
Holloway, Benjamin D. 91–2, 193–4
Homebase 297–9 *see also* Sainsbury's
Hoving, Thomas 127, 135, 137

Huang, Yong Ping 176–7
Hubbard, Caryl 108
Hughes, Robert 269
Hugo Boss 160, 172–7, 187, 284, 286
 Hugo Boss Prize 160, 162, 172–7
Hume, Cardinal Basil 167
Hunting and *Observer* Art Prizes 166
Hunting Art Prizes 160, 166
IBM 189, 199–202, 210–11
 IBM Gallery of Science and Art
 200–202, 207, 210, 342 n 31
ICA *see under* Institute of Contemporary
 Arts
ICI 67, 235–6, 250
imperialism 186–7, 197–8, 287, 289–90
Imperial Tobacco 55, 80, 130, 166–8
 Imperial Tobacco Portrait Award 166 *see
 also* John Player Portrait Award
incentive funding 56, 316 n 37
income tax 4–5, 27, 59, 60–61, 218, 296
'independent galleries' 96
indirect public subsidies 26–7, 29–32, 121
Indonesia 177–8
Inland Revenue 61, 218
Institute for Art and Urban Resources 42
Institute of Contemporary Arts (ICA)
 145–6
Institute of Museum Services 49–50
Internal Revenue Service (IRS) 27, 58, 191,
 215, 218
internationalism 174–5
investment tax credit 215–6, 218, 344 n 8
Ironbridge 136
Irving, Flora Miller 88
Irving, Michael H. 88

Jameson, Fredric 146

Japan 153, 177, 181–3, 291
Japan Tobacco 183
John Player Portrait Award 160, 167–8
Johns, Jasper 96, 136
Jones, Thomas 33–5
Judd, Donald 265
 Untitled 266

Kahn, Otto 106
Kapoor, Anish 298
Katz, Alex 254
Kemp, Martin 97–8, 100
Kessler, Jon 268
Keynes, John Maynard 33–4
K Foundation 146
Kithen 41–2
Koolhaas, Rem 291
Koons, Jeff 161
Koshalek, Richard 182
Kounellis, Jannis 198
Kow, Leong Kiang 178
KPMG Peat Marwick 23, 232, 253
Kramer, Hilton 74–5, 135
Krasner, Lee 254
Kren, Thomas 172, 284–5, 287
Kruger, Barbara 45

Labour government 80, 168, 281 *see also*
 New Labour
Labour Party 112
Laguna Gloria Art Museum 258
Laing, John plc 164–5
 Laing Art Competition 160, 164–5
Lasker, Mary 86
Lauder, Estée 89, 95
Lauder, Leonard A. 89, 95–6
Lauder, Ronald 96

Lawson, Nigel 271
Lazard Brothers 109, 112
Le Brun, Christopher 115
Lee, Bul 177
Leeds Art Gallery and Museum 96–7
legal service, commodification of 214
Levin, Bernard 101–2
Lewitt, Sol *Wall Drawing: Bands of Lines in Four Colors and Four Directions, Separated by Gray Bands* **Plate 9**
Lichtenstein, Roy 191
 Mural with Blue Brushstroke **Plate 5**
Lincoln Center 122
Lintas Worldwide 205
Lipman, Howard 89
Lipman, Samuel 71, 74
Lippard, Lucy 72
Liverpool 290
Loews Corporation 89
loft living 44
London Arts Boards 96
London Docklands Development Corporation 154
Long, Richard 132, 198
Los Angeles County Museum of Art 86, 122
Los Angeles Museum of Contemporary Art 182
Lothbury Gallery 199, 201, 209–10 *see also* NatWest Bank
Lottery, National 276–81, 293–4, 354 n 17
 New Opportunities Fund 277
 social class of gamblers 354 n 16
Lowry 293
Luce, Richard 56, 146, 158
Lyons 290

Macready, Sir Nevil 55, 99
Major, John 110, 151, 278, 354 n 17
'Making it! Discovery Centre', Mansfield 280
Malaysia 178
managerial revolution 10, 243–4
Manufacturers Hanover 132
Mapplethrope, Robert 273
Marlboro 130
matching grant 63, 71, 316 n 37
McCartney, Paul 167
McKenna & Co. 214
McLean, Bruce 132, 268–9
 Pestle and Mortar 268
media coverage 142–3
Medici 11, 253–4
Melchert, Jim 75
Mellon, Andrew W. 31
Menil, John de 86
Messer, Thomas M. 141
Metropolitan Museum of Art 21–2, 26–31, 86–7, 135–8, 149–50, 181, 257
Meynaud, John 23
Midland Bank Artscard 67–8
Millennium Commission 138, 276–7, 293
Millennium Dome 280, 301
Miller, Dorothy 256
Miller, F Whitney 88
Millhouse, Barbara B. 89
Mills, C Wright 4
minimal art 265
Ministers for the Arts 54–7, 142, 158
Mobil 50, 55, 99, 129, 188, 254
Monsanto 299
Moore, Henry 70
Morimura, Yasumasa 175
 Self-Portrait (Actress/Red Marilyn) 176

Morley, Malcolm 118–19
Morrison, Mrs Sandra 105
multinational museums 283–92
multinationals 9, 15, 17, 19, 99, 111, 133, 136, 145–6, 151–3, 157, 161, 174–87, 199, 224, 241, 253, 268, 282–92, 294, 296, 299–302
Musée d'Art Moderne de la Ville de Paris 182
museum expansion 282–99
Museum of Fine Arts, Houston 257
Museum of Modern Art, New York 18, 29, 86–7, 92–3, 96, 139, 257
Museum of Modern Art, Oxford 155–7
Museum of New York 87
Museums and Galleries Commission 37, 82

Nagoya 291–2
Nagoya/Boston Museum of Fine Arts 291–2, 355 n 45
Nanjo, Fumio 173
National Art Collections Fund 244, 257
National Association of Corporate Art Management 256
National Centre for Popular Music, Sheffield 277
National Council on the Arts 71–2, 74, 84
National Endowment for the Arts (NEA) 16–18, 32–3, 36, 41–43, 49–50, 56, 63, 70–77, 79, 84, 124, 237, 256, 272–5, 303
 art in public places 237
 Artists' Spaces 42
 Art Critics Fellowship Program 74–5, 321 n 99
 challenge grant program 56
 Office for Private Partnership 72

Visual Artists Organizations 36, 74
Visual Arts Program 36, 38, 42–3, 72–5, 275
National Endowment for the Humanities (NEH) 49–51
National Endowment for Science, Technology and the Arts (NESTA) 276
National Galleries of Scotland 115, 121
National Gallery, London 21, 96, 101, 112, 115, 282, 296
National Gallery of Art, Washington, DC 31, 130, 135
National Gallery of Australia 301
National Health Service 1, 280
National Lottery see under Lottery, National
National Medal of Arts 52
National Museum of Western Art, Tokyo 182
National Portrait Gallery 131, 162, 166–8, 297
 BP Portrait Award 162
 John Player Portait Award 160,167–8
 Portrait Award 130–31, 167–8
National Space Science Centre, Leicester 280
National Touring Exhibition 69, 164, 298
National Westminster Bank see under NatWest Bank
NatWest Bank 67,199, 201, 208–210 see also Lothbury Gallery
 NatWest Art Prize 208–10
Nauman, Bruce 266–7
 Double Poke in the Eye II 266–7
NEA see under National Endowment for the Arts
NEA Four 273
neo-conservatism 271
Neuberger & Berman 89

New Art Gallery, Walsall 293
New Deal 35–6
New Labour 1, 3, 14, 121, 272, 276–81, 296, 301, 303
New York City Council 148–9
Nittve, Lars 182, 292–3
Nixon administration 49
Nolan Committee of Inquiry 121
Nomura Securities 151–3
non-close companies 62
non-profit sector 21, 78

OAL *see under* Office of Arts and Libraries
Occidental Petroleum 12
O'Doherty, Brian 41–2
Office of Arts and Libraries (OAL) 55, 63
Ofili, Chris 156–7
 Imported, also known as *Absolut Ofili*
 Plate 2
Ogilvey, Lord 106
Olympia & York 154
Oulton, Thérèse 69
'own label' marketing 162
'Oxbridge mafia' 106

Pagé, Suzanne 182
PaineWebber Group 201–2
 PaineWebber Art Gallery 200–201, 207
Pairing Scheme 145, 334 n 47 *see also* BSIS
Palacios, Dolores 288
Palumbo, Lord Peter 19, 58, 65, 67–8, 69–70
Park Tower Realty 189
Passmore, Victor 98
patronage 38, 45, 54, 58, 63, 74, 128, 182, 188, 193, 200, 214, 221, 237, 244, 253, 259, 269, 303

Payroll Giving 62
Payson, Sandra 88
Pearson 111–12, 234
peer review panels 72
Penone, Giuseppe 198
Per Cent Club 57, 111
Peter Stuyvesant Foundation 130
Petrie, Donald A. 89
Petrie, Elizabeth 89
petroleum industry 129
Peyton-Jones, Julia 68–9
Philadelphia Museum of Art 89
philanthropy 5, 12, 46, 132
Philip Morris 9, 51–2, 91, 125, 130, 141, 148–50, 177–83, 187, 188–90, 194–5, 199, 234
 Philip Morris Art Award (in Japan) 161, 181–2
 Philip Morris ASEAN Awards 161, 171–181
 Philip Morris KK 181–2
Philippines, the 178
Picasso, Pablo 117–18, 255
Pilgrim Trust 33
Piper, John 33
planning incentives 188, 190–91
plural funding 158
Political Art Documentation and Distribution 45, 72
political lobbying 133
post-industrial economy 228
PPPs see *under* Private-Public Partnerships
Prenn, Oliver 169
President's Committee on the Arts and Humanities 50, 55, 273
Presidential Award for Service to the Arts 52

Presidential Task Force on the Arts and Humanities 50–51

Price Waterhouse 232 *see also* PricewaterhouseCoopers

PricewaterhouseCoopers 199, 203, 283

Prince of Wales 57, 81

Private Finance Initiatives (PFIs) 278–9

Private-Public Partnerships (PPPs) 278–80

private / public 3–4, 6, 19–21, 31, 46, 59, 100

private sector 19–20, 31, 42, 54–5, 62, 64, 67, 69, 71, 74, 77, 81, 116, 137, 273, 293

privatisation 2–4, 6, 12, 47, 56, 58, 64, 69, 99, 158, 272, 278, 299, 304

privatising culture 296, 304

Prudential 68, 163–5

 Prudential Arts Awards 67–8, 160, 163–5

P.S.1 42

'public art' competition 183–4

public arts agencies 16–19, 32–46, 64–78 *see also* ACGB, NEA

public arts funding 3, 16–19, 22, 34, 46, 48–51, 64, 71, 272–6, 279, 303

public interest 21, 25, 31, 78, 92, 114–15, 117, 120–21, 201, 214, 221, 279, 303

public relations 2, 9, 14, 76–7, 82, 122, 127–30, 136, 141–2, 155, 157, 159, 164–5, 210, 217, 220, 263, 267, 269, 298, 303

'public school' 11, 97, 106–7

public sector 20, 32, 54, 70, 81, 134, 154

public sphere 20, 86

public *see* private

Puttnam, David 110

quangos 21, 65, 97, 111

Queen Elizabeth II 57

R. J. Reynolds 89

Rank Xerox 58

Reader's Digest 256

Reagan, Ronald 2–4, 14, 23–4, 43, 46–52, 56–7, 63–5, 71, 77, 87, 91, 122–3, 126, 159–61, 212–13, 215, 221, 271–4, 282, 303

real estate 189, 191–4, 198, 237–41

Rees-Mogg, Lord William 65–6

Rego, Paula 69

Reid, Sir Norman 97

Renton, Timothy 57

Republicans, the 58, 272–5

revenue expenditure 218–19, 345 n 19

Richter, Gerhard *Untitled* **Plates 6, 7**

Riley, Bridget *Midsummer* **Plate 10**

Ritblat, Jill 104

Ritblat, John 104

Rittner, Luke 65–6, 143

Robinson, Kenneth 53, 65

Rockefeller Center 238

Rockefeller, David 10, 79, 124, 243

Rockefeller, John D. 243

Rockefeller, Mrs J. D. 92

Rockefeller family 71

Rockefeller Foundation 71, 75–6

Rogers, Malcolm 292

Rogers, Lord Richard 101, 110

Rosehaugh and Stanhope 238

Rosler, Martha 72

Rothschild & Co., J. 111

Rothschild, Lord Jacob 112, 116

Royal Academy 54, 123, 132, 300

 Sensation exhibition 300–301

Royal Armouries International 279
Royal Armouries, Leeds 277, 279
Royal Bank of Scotland 210
Royal College of Art, London 63, 236
Royal Festival Hall 123
Royal Insurance 66
Royal National Theatre 151–2
Royal Opera House 70, 99
Rückriem, Ulrich 198

Saatchi, Charles 104, 118–20, 300–301
 Sensation exhibition 300–301
Saatchi, Lord Maurice 99–100, 119–20,
 301
Saatchi & Saatchi 99–100, 119
Said, Edward 292
Sainsbury of Preston Candover, Lord 297
Sainsbury's 296–9 *see also* Homebase
 Sainsbury African Galleries at British
 Museum 294
 Sainsbury Centre for Visual Arts and
 Sainsbury Research Unit 296
 Sainsbury Exhibition Galleries at Tate
 Britain 297
 Sainsbury Institute for the Study of
 Japanese Art and Culture 296
 Sainsbury Wing at National Gallery 296
Salomon Brothers 230
Samsung 284
Schnabel, Julian 118
Schuster, J Mark Davidson 81
Science Museum 136
Scott, William 261–2
Scottish and Newcastle Breweries (S & N)
 132–3
Scottish Ballet 164
Scully, Sean 119

Seagram & Sons, Joseph E. 157, 200,
 235–6
SECCA *see under* Southeastern Center for
 Contemporary Art
Serota, Sir Nicholas 102–3, 118, 136–8,
 278
 on National Lottery 354 n 17
Serpentine Gallery, London 39, 68, 99, 154
Serra, Richard 115
 Fulcrum **240**, 241
Serrano, Andres 77, 273
 Piss Christ 77, 353 n 5
Seybolt, George C. 86
Shaw, Roy 35, 142
Sherman, Cindy 175, 268
Shestack, Alan 292
Singapore 179–80
Singapore Art Museum 180
Singer & Friedlander and the *The Sunday
 Times* Painting Competition 166
Smith, Chris 279, 293
social capital 7, 127
social redistribution 278
Solinger, David M. 89
Soriano, Federico 288
Sotheby's 70, 91, 94, 210, 230
South Bank Centre 66, 69
South East Asia 177–81,186
Southeastern Center for Contemporary Art
 75–7
South Korea 177, 185
sponsorship 3, 12–13, 14, 17, 53–8, 62–4,
 65–70, 76–8, 80–81, 92, 116–17,
 122–58, 161–3, 165–9, 172–3,
 180–81, 183, 186, 188, 208, 214, 297,
 299, 301, 303, 332 n 14
 'brand sponsorship' 162

sponsorship *(cont'd)*
 'designer sponsorship' 162
 'title sponsorship' 144
SRU 116
Standard Oil of Indiana 249
Stanhope Properties 115
state power 16–18
status group 9
Stevenson, Lord Dennis 101, 110, 112,
 115–16
St John-Stevas, Norman 54–6, 142
Sutherland, Graham 33
Sweeney, James 257
symbolic capital 7

Taiwan 177, 183–6
Takashina, Shuji 182
Tate Gallery 14, 18, 21, 38, 80, 83, 96–8,
 100–121, 129, 136–42, 150–53,
 169–72, 210
257, 278, 292–3, 297–9 *see also* Serota, Sir
 Nicholas, Turner Prize
 At Home with Art 297–8
 branches 327 n 54
 Cézanne exhibition 138, 140
 Corporate Membership Programme
 138–40
 Development Office 138–9, 141
 Nomura Room 151–3
 Patrons of British Art, 103–4, 327 n 65
 Patrons of New Art 103–4, 118, 169,
 327 n 65
 policy on sponsorship 150–51
 trustees 101–18
Tate Britain 115, 292, 297, 299
Tate Gallery Foundation 103–5, 109, 113,
 140

Tate Liverpool 137
 Tate Gallery Liverpool Advisory Council
 113
Tate Modern 113, 138, 182, 292–3, 299
Tate St. Ives 18, 137
Taubman, Adolph Alfred 90–91, 94–5,
 113, 325 n 36
tax deductions 86,128, 191, 215–6 *see also*
 capital allowances, capital-gains tax,
 depreciation, investment tax credit
tax expenditure 5, 22, 26–7, 29–30, 58
tax incentives 5, 23–5, 27, 30, 55–6,
 58–62, 80, 128, 201, 296, 317 n 48,
 317 n 50 *see also* charitable
 contributions, deed of covenant
Tax Reform Act of 1986 23–5
tax relief 55, 58, 61–2, 134
Texaco Philanthropic Foundation 52
Thailand 179
Thatcher, Margaret 2–6, 14, 23, 46–8,
 53–65, 70, 77, 81, 83, 97, 99–103,
 105, 109–10, 113, 119–22, 122–3,
 126, 128, 136, 146, 151–2, 155,
 159–61, 163, 212–14, 221, 236, 238,
 271–2, 276, 278, 282, 300–301, 303
 'one of us' 54, 102
 tax reforms 58–62
 Thatcherism 56, 65, 69, 155, 271, 301
 Thatcherite revolution 213
third sector 21
TI Group 63, 236
Times-Mirror Corporation 50
Tisch, Laurence A. 89
tobacco advertising 168
tobacco arts sponsorship 166–9, 177–83
tobacco industry 92, 129–31, 147–50,
 166–9, 177–83 *see also* Imperial

Tobacco, Philip Morris
tobacco sports sponsorship 129,168
Tory 6, 58, 81, 83, 109, 163, 276–8, 281,
 296
Toshiba 145
 Toshiba Gallery of Japanese Art at V &
 A 145
 Toshiba Information Systems 145
Trade Union Congress 158
trustees 4, 11, 14, 18, 21–2, 31–2, 43, 60,
 83–121, 151, 256–7
TSB 244
Tucker, Marcia 136
Turner Prize 132, 140, 146, 154, 162,
 169–73, 210, 298, 337 n 23, 337 n 25
 and Channel Four 337 n 23, 337 n 25
 attendance figures 170, 337 n 22
Turrell, James 198
Tweedy, Colin 3, 152

Unilever 235–6, 299
United Technologies Corporation 144
unrelated business income taxes (UBIT) 30
urban regeneration 197–8, 287–8

V & A see under Victoria & Albert Museum
Van Gogh, Vincent 183–5, 255
 Irises 230, Irises as credit card Plate 3
 Sunflowers 230
Veblen, Thorstein 90, 127
Verey, David 109–10, 112
Victoria & Albert Museum 81, 97, 99–100,
 119, 145
Vietnam 178
Vin & Sprit 157
visitor attractions 280–81
voluntary sector 21

Walker Art Center 252
Warhol, Andy 157, 252
Washington Project for the Arts (WPA) 41,
 43, 45
weapons industry 129 see also armaments
 industry
Weber, Max 9, 11
Weinberg, Sir Mark 111–12
Weissman, George 91–2, 130
Wentworth, Richard 39
 Toy 40
Westminster 141
Wexner, Leslie Herbert 91, 94
Whitechapel Art Gallery 96, 103, 118,
 130, 137
 Whitechapel Art Gallery Foundation
 103
Whiteread, Rachel 132, 146
 House 146–7, 147
 House label for Beck's beer 148
Whitney, Gertrude Vanderbilt 88
Whitney Museum of American Art 14, 18,
 29, 83, 88–96, 100, 136–7, 188–90,
 193–5, 201, 257, 283, 286
 Whitney branches 136, 189–95, 340
 n 3
 Whitney Branch at Equitable 189,
 191–4
 Whitney Branch at Philip Morris 189,
 194
welfare state 1, 3, 56, 278–9 see also
 corporate welfare state
Wildmon, Donald 77
William, William Emrys 33
Williams, Raymond 20, 34, 65, 97, 153
Wolfson, Lord 113
Works Progress Administration (WPA) 35

World Trade Organisation 299
Wright, Frank Lloyd 283, 285
Wyllie, George 132

YBA (young British artists) 300
Yorkshire Electricity 279
Yves Saint Laurent (YSL) 173

zoning concessions 189–90, 201